The Internationalist Moment

Thank you for choosing a SAGE product! If you have any comment, observation or feedback, I would like to personally hear from you. Please write to me at contactceo@sagepub.in

—Vivek Mehra, Managing Director and CEO,
SAGE Publications India Pvt Ltd, New Delhi

Bulk Sales

SAGE India offers special discounts for purchase of books in bulk. We also make available special imprints and excerpts from our books on demand.

For orders and enquiries, write to us at

Marketing Department
SAGE Publications India Pvt Ltd
B1/I-1, Mohan Cooperative Industrial Area
Mathura Road, Post Bag 7
New Delhi 110044, India
E-mail us at marketing@sagepub.in

Get to know more about SAGE, be invited to SAGE events, get on our mailing list. Write today to marketing@sagepub.in

This book is also available as an e-book.

The Internationalist Moment

South Asia, Worlds, and World Views, 1917–39

Edited by
Ali Raza, Franziska Roy,
and Benjamin Zachariah

SAGE www.sagepublications.com
Los Angeles • London • New Delhi • Singapore • Washington DC

First published in 2015 by

SAGE Publications India Pvt Ltd
B1/I-1 Mohan Cooperative Industrial Area
Mathura Road, New Delhi 110 044, India
www.sagepub.in

SAGE Publications Inc
2455 Teller Road
Thousand Oaks, California 91320, USA

SAGE Publications Ltd
1 Oliver's Yard, 55 City Road
London EC1Y 1SP, United Kingdom

SAGE Publications Asia-Pacific Pte Ltd
3 Church Street
#10-04 Samsung Hub
Singapore 049483

Published by Vivek Mehra for SAGE Publications India Pvt Ltd, typeset in 10/13 Minion Pro by RECTO Graphics, Delhi, and printed at Saurabh Printers Pvt Ltd, New Delhi.

Library of Congress Cataloging-in-Publication Data Available

ISBN: 978-81-321-1979-1 (HB)

The SAGE Team: N. Unni Nair, Sandhya Gola, Anju Saxena, and Anupama Krishnan

Contents

Preface vii

Introduction: The Internationalism of the Moment—
South Asia and the Contours of the Interwar World xi
 Ali Raza, Franziska Roy, and Benjamin Zachariah

1. Internationalisms in the Interwar Years: The Traveling of Ideas 1
 Benjamin Zachariah

2. India and the League Against Imperialism: A Special "Blend"
 of Nationalism and Internationalism 22
 Michele L. Louro

3. Uniting the Oppressed Peoples of the East: Revolutionary
 Internationalism in an Asian Inflection 56
 Carolien Stolte

4. Straddling the International and the Regional: The Punjabi
 Left in the Interwar Period 86
 Ali Raza

5. Meeting the Rebel Girl: Anticolonial Solidarity and
 Interracial Romance 124
 Maia Ramnath

6. International Utopia and National Discipline: Youth and
 Volunteer Movements in Interwar South Asia 150
 Franziska Roy

7. Srečko Kosovel and Rabindranath Tagore: Universalist
 Hopes from the Margins of Europe 188
 Ana Jelnikar

8. Meghnad Saha's Two International Faces: Politics in
 Science and Science in Politics between the Wars 229
 Robert S. Anderson

 About the Editors and Contributors 263
 Index 266

Preface

The years between the First and Second World Wars comprise a critical moment in the history of the world. In the aftermath of the First World War and the Bolshevik Revolution, individuals and countries sought new solutions and blueprints for a world of greater stability, equality, and interdependency. The League of Nations or the Communist International inspired many with their models, while other fora for international organization brought together an unlikely range of interests such as pacifism, Pan-Islamism, Pan-Asianism, national sovereignty, Aryanism, religious mobilization, various forms of anti-imperialism, demands for suffrage, the organization of youth movements, ideologies of feminism, birth control, socialism, communism, civil liberties, romanticism, temperance, nudism, eugenics, or fascism. Their divergent ends and objectives were held together, if temporarily, by a euphoria for the vastness and integratedness of the world and the desire and optimism to remake it and shape the future of humanity.

The essays presented together in this volume are attempts to begin to understand these experiments in political and social mobilization that comprise the "internationalist moment," through the lens of South Asians' interactions with a wider world, and the wider world's interactions with South Asia. Histories of South Asia in the 1920s and 1930s have largely focused on local, community, and national narratives, and have only recently begun to break out of this mould. Earlier histories that have noted these international engagements have subordinated them to the narratives of Indian nationalism or of the particular ideological trends that have interested them, notably the histories of "international communism." We believe that it is necessary to go further than this. What we present here is also intended to contribute to a growing but as yet inadequate field of the intellectual history of South

Asia; and since ideas are notoriously unable to observe national boundaries, it is unsurprising that such intellectual histories cannot be confined to or by the entity "South Asia," or to paraphrase Rudyard Kipling via C.L.R. James, "what do they know of South Asia, who only South Asia know?"[1]

Why do we call this period the "internationalist moment"? That there were engagements, people, goods and ideas, crossing (proto-)"national," state, and/or geographical boundaries before the period between 1917 and 1939 was obvious. But that period is also qualitatively important as a window of time in which an array of movements comprising mostly *nonstate or supra-state actors* were linking up with each other (often becoming more institutionalized in the process), a reminder that the contemporaneous term "international" has in more recent times been almost exclusively appropriated by *states*. The period under consideration is one in which frameworks for understanding the world and one's place in it included not only the local or national but also relatively distant elements as diverse as the work of Sigmund Freud in Vienna, fascism in Italy or Germany, or Bolshevism in the Soviet Union, as well as those events, tendencies, or trends that had a direct impact on distant places (such as the Great Depression). These frameworks of understanding the world as interconnected became part of the everyday. "Europe" or "America," San Francisco, New York, Berlin, London, Paris, Tokyo, Shanghai, or Moscow were part of the worlds and world views of people not necessarily involved only in elitist discussions and "cosmopolitan" solidarities. This is also an indication that "internationalist" is itself far from an unproblematic category; there were many forms that internationalism could take, and the essays that follow explore some of these, including those that sought to build a strong potential state. The "moment" then faded away in the 1940s. The next phase of cross-border engagements,

[1] C.L.R. James, *Beyond a Boundary: A Social History of West Indies Cricket* (London: Hutchinson, 1963), preface: "What do they Know of Cricket who only Cricket Know?"; borrowed from "And what should they Know of England who only England know?", Rudyard Kipling, "The English Flag" (1891), *Collected Verse of Rudyard Kipling* (New York: Doubleday, Page & Co., 1914), 128, though James' borrowing is quite against the spirit of Kipling. "South Asia" is a clumsy abbreviation used in this book for the territories that are roughly congruent with the present-day states of India, Pakistan, and Bangladesh; this does not comprise all of the region bearing that name, but a rough congruence is all that this volume pretends to, especially when speaking of intellectual history.

such as is evident in the Cold War, for instance in "non-alignment," is an era of *states* acting within rather rigid rules of a post-Second World War "international"—by which is now meant "interstate"—order.

Perhaps because of its once-close association with the proletarian internationalism of the Communist International (Comintern), "internationalism" has not been the favored term of recent historiography. Cosmopolitanism, transnational history, and global history are the buzzwords of our times. We shall not outline our differences with the approaches used therein in this preface, as we individually have divergent differences with them. Suffice it to say here that we are instead interested in what might be more usefully rendered in terms of *relevant encounters and sites of engagement* rather than impose retrospective categories on the historical actors and contexts that we study; we attempt to identify what might have been spaces, ways of making sense of the world, and modes of communication relevant to contemporaries. A picture emerges from the work presented here of a great flexibility of ideological tendencies: Our historical actors are able to put together for themselves, from the intellectual buffet of the interwar period, a set of ideas that is, at least to an observer in retrospect, far from internally consistent. This might be far more problematic in retrospect than it would seem to contemporaries; as ideologies settle down into recognizable and standardized forms, the uncertainty and ambiguity that begets them are forgotten.

We would like to thank Daud Ali, Richard Immerman, and Mrinalini Sinha for their comments on some of the papers. We also thank Subhas Ranjan Chakraborty and Ranabir Samaddar for their comments on the manuscript.

Ali Raza, Franziska Roy, and Benjamin Zachariah

Introduction:
The Internationalism of the Moment—South Asia and the Contours of the Interwar World

Ali Raza
Franziska Roy
Benjamin Zachariah

> There is a tide in the affairs of men
> Which, taken at the flood, leads on to fortune;
> Omitted, all the voyage of their life
> Is bound in shallows and in miseries.
> —William Shakespeare, *Julius Caesar*, Act IV, Scene 3

A little over twenty years is not a long time by historical standards. The internationalist moment can broadly be seen in terms of the unity of the period 1917–39, book-ended by the Russian Revolution and the Second World War. Beginning with the hope that humanity would create a new future for itself, with the help of movements linking up with each other, disregarding the sanctity of states, empires, and governments, it ended with movements diminished or destroyed, disorganized by and organized as states, at war with one another. That the moment passed bears no repeating. We are here, however, to recount the flood and not the shallows; and to place South Asia in the history of that internationalist

flood, from which subsequently the ubiquitous narrative of "nationalist movement(s)" has wrested it.

The internationalism of the times had a number of facets, and although in retrospect a number of classificatory labels suggest themselves—socialist, communist, fascist, Pan-Islamic—the sentiment (and it was often a sentiment) was far less differentiated, more amorphous, than these labels can describe. In a world of apparently infinite hopes and possibilities, individuals journeyed across the terrain of internationalist engagements, geographically and intellectually, while promiscuously drawing from all that these labels describe. The diverse ideologies floated at the time were not seen as mutually exclusive or opposed to one another, but were seen as converging and complementary routes toward a supra-political project that aimed at transforming the future of humanity and, in fact, humanity itself.

At the same time, as movements attempted to resist the confines of states, states resisted and restricted the movements of movements, of people, and of ideas; this is the time of the institution of international— in this case meaning interstate—forms of control and surveillance, when cooperation between police forces, the institution of passport and visa regimes, and the restrictions on international travel that we have come to take for granted were made commonplace.[1] Perhaps, then, the ironic outcome of the internationalist moment was that it created the conditions for its destruction, or at least for the destruction of the internationalism of a nonstatist variety; but we are getting ahead of our story here.

This introduction sets out a context for the essays that follow. It makes a case for the distinctiveness of and relevance of our focus on the period under consideration; it outlines the contours and dynamics of the internationalist moment that we identify; and it sets out the principal approaches that we find useful, situating these in the light of current academic trends.

[1] Radhika V. Mongia, "Race, Nationality, Mobility: A History of the Passport," *Public Culture* 11, 3 (1999): 527–56; Radhika V. Mongia, "Historicising State Sovereignty: Inequality and the Form of Equivalence," *Comparative Studies in Society and History* 49, 2 (2007): 384–11. For a history of this phenomenon in the "quasi-colonial states" of the Maghreb and the Middle East, see Martin Thomas, *Empires of Intelligence: Security Services and Colonial Disorder After 1914* (Berkeley and London: University of California Press, 2008).

The Moment(um) of Internationalism and the Nature of the Moment

Why do we call it the "internationalist moment"? The period 1917–39 was of course not entirely without precedent in terms of the interconnectedness of the world and the engagement of South Asians with that world. Such engagements had long been in evidence in political and intellectual life before 1917. Notable among these were the 1905 Russo-Japanese War,[2] the 1911–13 Balkan Wars,[3] various nationalist movements and their intellectuals and heroes (Mazzini and Garibaldi,[4] the Young Turks, Egypt,[5] the Irish nationalist movement[6]). Intellectual engagements

[2] See, for instance, Amiya K. Samanta (ed.), *Terrorism in Bengal: A Collection of Documents* (Calcutta: Government of West Bengal, 1995), Volume I, 224; Steven G. Marks, "'Bravo, Brave Tiger of the East!' The Russo-Japanese War and the Rise of Nationalism in British Egypt and India," in *The Russo-Japanese War in Global Perspective*, ed. John Steinberg et al. (Boston and Leiden: Brill, 2005), 609–27.

[3] The Balkan Wars had, for instance, in conjuncture with the Tripolitan war, led to fears among Indian Muslims regarding the future of the Ottoman Empire and the safety of the holy places of Islam, and were the direct impetus which led to the founding of the Anjuman-Khuddam-i-Ka'aba. Cf. Gail Minault, *The Khilafat Movement: Religious Symbolism and Political Mobilization in India* (New York: Columbia University Press, 1982), 22–23, 34–37.

[4] Peter Heehs, *The Bomb in Bengal: The Rise of Revolutionary Terrorism in India 1900–1910* (Delhi: Oxford University Press, 1993). See also excerpts from the Jugantar in Kabita Ray, *Revolutionary Propaganda in Bengal. Extremist and Militant Press 1905–1918* (Calcutta: Papyrus, 2008), 48–49. A Bengali book on the lives of Mazzini and Garibaldi was also standard literature to be read by every member of the early Anushilan Samiti (along with one on Napoleon and another on George Washington): see RH Syned Hutchinson, DIG of Police, IB, Calcutta, May 1, 1914, "Note on the Growth of the Revolutionary Movement in Bengal, Eastern Bengal and Assam, and United Bengal," Appendix C, "Rules for the Membership of the Anushilan Samiti," in *Terrorism in Bengal*, ed. Amiya K. Samanta, Volume I, 272–74.

[5] K.F. Nariman, *What Next* (Bombay: Bombay Book Depot, 1934), see esp. Chapters 2 and 3.

[6] Michael Silvestri, "'The Sinn Fein of India': Irish Nationalism and the Policing of Revolutionary Terrorism in Bengal," *The Journal of British Studies*, 39, 4 (October, 2000): 454–86; Michael Silvestri, "The Bomb, Bhadralok, Bhagavad Gita, and Dan Breen: Terrorism in Bengal and its Relation to the

reached back to the mid-nineteenth century, incorporating Friedrich List on political economy,[7] Theosophy and esoteric Christianity centered on India as the spiritual lynchpin of the world,[8] an assumption taken on board by early (Hindu) nationalists, convinced of the special destiny of India in the world.[9] Anarchism, socialism, the Suffragettes, Romanticism, various theories of nationalism and nationality[10] were discussed by politically conscious circles in India and in exile.[11] Revolutionary "terrorists" in Bengal and "extremist" nationalists were acquainted with events

European Experience," *Terrorism and Political Violence* 21, 1 (2009): 1–27; Kate O'Malley, *Ireland, India and Empire: Indo-Irish Radical Connections, 1919–1964* (Manchester: Manchester University Press, 2008); Michael Silvestri, *Ireland and India: Nationalism, Empire and Memory* (New York: Palgrave Macmillan, 2009).

[7] Bipan Chandra, *The Rise and Growth of Economic Nationalism in India* (Delhi: People's Publishing House, 1966).

[8] Any number of references coming from people with diverse views could be given here, from Tagore's pacifist pan-Asianism and its "eastern" virtues to the radical nationalists and their religious symbolism. See, for instance, the article in the militant paper *Bande Mataram*, March 2, 1908, stating that "India is the *guru* of the nations, the physician of the human soul in its profound maladies; she is destined once more to new-mould [sic] the life of the world and restore the peace of the human spirit. But *swaraj* is the necessary condition of her work and before she can do the work, she must fulfill the condition." Quoted in Kabita Ray, *Revolutionary Propaganda in Bengal*, 132–33.

[9] Benjamin Zachariah, *Playing the Nation Game: The Ambiguities of Nationalism in India* (New Delhi Yoda Press, 2011), 88, 180–82.

[10] See Chetan Bhatt, *Hindu Nationalism. Origins, Ideologies and Modern Myths* (Oxford and New York: Berg, 2001), esp. pp. 7–15 on the impact of "Western" romanticist notions (Fichte, Hegel, Herder, Schlegel) on the conceptualization of the nation among Indian nationalists. Reading Savarkar's *Hindutva* or Golwalkar's *We or our Nationhood Defined* (which he himself claimed was based on Savarkar's *Hindutva*) one can see in both texts the importance not only of German romanticists but also British influences (which were in turn partly taken over from German ideas). V.D. Savarkar, *Hindutva: Who is a Hindu?* (Nagpur: Bharat Publications, 1928); M.S. Golwalkar, *We, or Our Nationhood Defined* (Nagpur: Bharat Publications, 1938).

[11] See, for instance, the speech by the Congressmen Dr Nalinaksha Sanyal at the World Youth Peace Congress: "India and the World Youth" (Speech of Dr Sanyal at the Eerde Conference, August 19, 1928) in *To the Youth of My Country*, ed. Durlab Singh (Lahore: Hero Publications, 1946), 15–24.

and literatures across the world.[12] Iconic moments which brought these engagements into focus include Swami Vivekananda's colorful turbans at the Chicago World Congress of Religions in 1893 and his American lecture-tours thereafter;[13] and Madame Cama's hoisting of an Indian national flag at the 1907 Stuttgart meeting of the Second International; the latter is also a reminder that among earlier attempts to create platforms and movements that transcended state boundaries, the most obvious were the First and Second Internationals.[14]

The global arena also played host to a variety of political networks that engaged with South Asian politics. Movements and networks that did so included circles surrounding the clergyman J.T. Sunderland in the United States,[15] and the *Gaelic American*, whose support of the Irish nationalist cause included space for other national liberation movements such as the Indian.[16] Others were founded and run by South Asians themselves. The best-known and most celebrated example of this was the Ghadar Party that was founded in North America in 1913 and which issued a revolutionary call for the overthrow of the British Empire in India.[17] Across the Atlantic, such efforts had already been preceded by Shyamji Krishnavarma, founder of the Indian Home Rule Society and

[12] There was an intense engagement with strike movements and forms of passive resistance in Europe in the militant press of the time, predating Gandhi's *Satyagrahas*. See, for instance, articles in the *Bande Mataram* referring to practices of passive resistance to eighteenth century America and contemporary Europe (*Bande Mataram*, April 1907, in Kabita Ray, *Revolutionary Propaganda in Bengal*, 134–35).

[13] Gwilym Beckerlegge, *The Ramakrishna Mission: The Making of a Modern Hindu Movement* (New Delhi: Oxford University Press, 2000).

[14] Amit Kumar Gupta, "Defying Death: Nationalist Revolutionism in India, 1987–1938," *Social Scientist* 25, 9–10 (September–October, 1997): 3–27.

[15] On the circle of Christian American anti-imperialists cf. Alan Raucher, "Anti-Imperialists and the pro-India Movement, 1900–1932," *Pacific Historical Review*, 43, 1 (February 1974): 83–110.

[16] Michael O'Dwyer, relating the Indian to the Irish troubles in his statement before the Hunter Committee, actually referred to the Sinn Fein as Irish "Swadeshists" who aimed for Irish "swaraj," and following in the footsteps of their counterparts in Punjab had allied themselves with the enemy of the King. Cited in Verney Lovett, *History of the Indian Nationalist Movement* (London: John Murray, 1921 [1920]), Appendix V, 293.

[17] Maia Ramnath, *Haj to Utopia: How the Ghadar Movement Charted Global Radicalism and Attempted to Overthrow the British Empire* (Berkeley: University

India House in London in 1905, and a newspaper, the *Indian Sociologist*, whose intellectual deity was Herbert Spencer, posthumously appropriated for the Indian nationalist cause.[18] Further eastward in Europe, the Berlin India Committee was founded in 1914, coordinated largely by Virendranath Chattopadhyaya, a former inmate of India House and co-worker of Shyamji Krishnavarma, who was among those of the "Berlin India Committee" who worked with the German government during the First World War in conspiring to end British rule in India.[19] "Chatto" was joined from America by another former India Houser, Har Dayal, by now associated with the beginnings of the Ghadar Party, marking the renewed crossing of paths of old colleagues on different personal and historical trajectories.[20]

Clearly then, there were a series of engagements between South Asia and the wider world prior to 1917, and many of these engagements became the basis for the interwar internationalism which is the subject of this book: Ghadar networks, the Berlin India Committee,[21] the Irish connection.[22] Lest it be forgotten, pre-existing networks coalesced or engaged with other networks. In particular, the Khilafat Movement was a continuation of a Pan-Islamic internationalism whose greatest success was at its moment of obsolescence at the end of the Ottoman empire;[23] this particular internationalist sensibility was flexible enough to connect with an unlikely ally in the internationalism of the Bolshevik Revolution,

of California Press, 2011); Harish K. Puri, *Ghadar Movement: Ideology, Organisation and Strategy* (Amritsar: Guru Nanak Dev University, 1993).

[18] Harald Fisher-Tine, "Indian nationalism and the 'World Forces': transnational and diasporic dimensions of the Indian freedom movement on the eve of the First World War," *Journal of Global History* 2 (2007): 325–44.

[19] Nirode K. Barooah, *India and Official Germany 1886–1914* (Frankfurt: Lang, 1977); Nirode K. Barooah, *Chatto: The Life and Times of an Indian Anti-imperialist in Europe* (Delhi: Oxford University Press, 2004).

[20] Horst Krüger, "Har Dayal in Deutschland," *Mitteilungen des Instituts für Orientforschung*, X, 1 (1964):141–69.

[21] Frank Oesterheld, *Der Feind meines Feindes ist mein Freund: Zur Tätigkeit des Indian Independence Committee (IIC) während des Ersten Weltkrieges in Berlin* (unpublished *Magisterarbeit*, Humboldt-Universität zu Berlin, 2004).

[22] O'Malley, *Ireland, India and Empire.*

[23] See Gail Minault, *The Khilafat Movement: Religious Symbolism and Popular Mobilisation in India* (New York: Columbia University Press, 1982).

as the Hijrat Movement was diverted by force of circumstance and a fast-moving geopolitics toward Soviet Central Asia.[24] The onset of the Bolshevik Revolution marked the beginning of an interwar moment that was qualitatively different from earlier and later phases of cooperation and movements across geographical and political boundaries. What differentiates this moment is the peculiar convergence of varying political and intellectual strands that prominently emerged to the fore in the immediate aftermath of the revolution. A conjunctural situation thus emerged that opened a window to internationalism, through which various breezes would blow before the window closed again.[25]

The year 1917, therefore, stands out as the moment's defining moment. The October Revolution had a momentous impact on European politics; its shock waves also reverberated across the globe, and especially in colonized territories, with its call for the overthrow of imperialism and support for "national self-determination." What is extremely important to note here is that the engagement of South Asians—and more generally "oppressed peoples"—with the Bolshevik Revolution was not necessarily an ideological or theoretically informed one. This was in other words the "Leninist Moment" within the internationalist moment, which was far more sustained and far-reaching than its "Wilsonian" counterpart;[26] perhaps it is better to call it the Brest-Litovsk moment, after the Soviet declaration of its principles of peace and reconstruction of a postwar world.[27]

[24] For an account, see Shaukat Osmani, *Historic Trips of a Revolutionary: Sojourn in the Soviet Union* (New Delhi: Sterling, 1977), 3–36. See also Ali Raza's essay as follows.

[25] We are aware of the mixed metaphors here: the "window" that opens and closes comprises the "moment," which is comprised of (sub-)"moments." We should add here that the window we have in mind is that peculiar to Mediterranean and Indian imperial architecture: wooden shutters on the outside, with slats that can be raised and lowered, and glass on the inside.

[26] Erez Manela, *The Wilsonian Moment: Self-Determination and the International Origins of Anticolonial Nationalism* (Oxford: Oxford University Press, 2007). Compare, for an earlier and far more insightful analysis, Arno Mayer, *Wilson vs Lenin: Political Origins of the New Diplomacy 1917–1918* (New Haven: Yale University Press, 1963 [1959]); for the engagement of Indian nationalists with the October Revolution, see Panchanan Saha, *The Russian Revolution and the Indian Patriots* (Calcutta: Man Sanyal, 1987), on the dissemination in contemporaneous press and literature see esp. pp. 110–37.

[27] E.H. Carr, *International Relations Between the Two World Wars, 1919–1939* (London: Macmillan, 1947).

The Bolshevik and Wilsonian declarations on national self-determination were accompanied by other intellectual and political trends related to world peace, international cooperation, universal suffrage, and women's rights. All of these emerged before or during, and merged decisively with the end of, the Great War. The war itself was decisive in the perceived destruction of the old world and the creation of the hopes and possibilities for a new one. After the cessation of hostilities, there was a heightened awareness of the interconnectedness of the world and a renewed hope for its future prosperity. A stumbling block for future peace and understanding was considered to be the petty, vested-interest-based politics of the "old guard" that had brought the world to the brink of destruction. Mere politics became associated with something "low" and linked to the "Western" system of states. Hence, we see a distrust of "politics" rather than a distrust of the state (seen as a necessary building block in the balance and progress of the world). The platforms we deal with here tended to view peace as something that would naturally flow from cultural encounters and real interhuman interactions that transcended ostensibly rigid political divisions. Keeping away from such disagreements based on "mere politics" was part of the etiquette of many of the cross-cultural meetings taking place. Where, before the war, a belief in a possible utopia of peace had often been somewhat romantic and optimistic, the postwar period was simultaneously marked by a darker and more dystopian undercurrent to visions and ideologies. The (elusive) program of disarmament at the level of institutional international politics was watched warily.

There was also a greater realization of the importance of India to the world and the importance of the world to India.[28] This was evident not just to intellectuals; a wider awareness of such interconnectedness was achieved not least through the experiences of large numbers of soldiers and laborers that were sent across the world in the service of the British

[28] The introduction to a 1922 publication reads "India is the centre of world politics and none can ignore importance of India in world politics. In short, [the author] has tried to show that world peace depends upon freedom of Asia through India independence and thus Indian question should attract keenest interest of the statesmen of all countries. He urges his countrymen to make the question of Indian independence an international issue." Introduction "by an Asian Statesman," Tokyo, Japan, June 15, 1922, to Taraknath Das, *India's Position in World Politics* (Calcutta: Saraswaty Library, 1922), 14.

Empire.[29] The destruction of the certainties, social stability, and hierarchies of the old world by the new post-Great War world, in Europe and elsewhere, was an enabling factor in creating a new perception of the world. An earlier, narrower set of knowledge and experiences of interconnection among Indian elites, soldiers, or seamen (for it was the lascars who were the largest group of South Asian travelers across the world before the Great War), was far enlarged by the war.[30]

[29] For a bibliographical overview of the available literature, see Franziska Roy and Heike Liebau, "Introduction," in 'When the War Began We Heard of Several Kings': South Asian Prisoners in World War I Germany, ed. Franziska Roy et al. (New Delhi: Social Science Press, 2011), 1–14. On the Indian labor corps, see Radhika Singha, "Finding Labor from India for the War in Iraq: The Jail Porter and Labor Corps, 1916–1920," Comparative Studies in Society and History 49, 2 (2007), 412–45. More extensive writing exists on the larger contingents of Chinese and African labor corps. On soldiers' letters from the theatres of war, see David Omissi, Indian Voices of the Great War. Soldiers' Letters, 1914–1918 (New York: St Martin's Press, 1999). Among the newest studies are Santanu Das's collection of essays dealing with engagements and involvement across the Empire: Santanu Das (ed.), Race, Empire and First World War Writing (Cambridge: Cambridge University Press, 2011). On Indian soldiers specifically, a newer study is Gajendra Singh, The Testimonies of Indian Soldiers and the Two World Wars: Between Self and Sepoy (London: Bloomsbury, 2014); see also Gajendra Singh, "The Anatomy of Dissent in the Military of Colonial India During the First and Second World Wars," Edinburgh Papers In South Asian Studies 20 (2006): 1–45.

[30] Gopalan Balachandran, Globalizing Labour? Indian Seafarers and World Shipping, c. 1870–1945 (Delhi: Oxford University Press, 2012); Rosina Visram, Ayahs, Lascars and Princes: Indians in Britain 1700–1947 (London: Pluto Press, 1986); Gopalan Balachandran, "Searching for the Sardar. The State, Precapitalist Institutions, and Human Agency in the Maritime Labour Market, Calcutta 1880–1935," in Institutions and Social Change in South Asia, eds Sanjay Subramanyam and Burton Stein (New Delhi: Oxford University Press, 1996), 206–36; Ravi Ahuja "Networks of Subordination: Networks of the Subordinated. The Case of South Asian Maritime Labour under British Imperialism (c. 1890–1947)," in Spaces of Disorder in the Indian Ocean Region, eds Harald Fischer-Tiné and Ashwini Tambe (London: Routledge, 2008), 13–48; Franziska Roy, "South Asian Civilian Prisoners of War in First World War Germany," in When the War Began, We Heard of Several Kings, eds Franziska Roy et al., 149–84, 51–95; Ali Raza and Benjamin Zachariah, "To Take Arms Across a Sea of Trouble: The 'Lascar System,' Politics and Agency in the 1920s," Itinerario 36, 3 (December 2012): 19–38.

It was the confluence and fusion of these trends which made the inter-war period a particularly heady and exciting moment for political actors around the world. This era was marked by the spirit of internationalism which tied together the struggles of oppressed peoples (of various variet-ies) around the world. This was a spirit which enabled its actors to imag-ine themselves as citizens of the world. In their world-view, India was inextricably tied to struggles across the globe. Thus, an eloquent "Appeal to the Oppressed Peoples of the East" could be issued:

> Oh, sufferers of the East dreaming of freedom from iron, chains, it is your duty to follow the example of India....
> India has offered thousands of sacrifices for freedom. India, which had been baked and burnt in the fire of repression, calls upon all the oppressed nations. It is your duty to heed its call and act.
> India proclaims by beat of drum that if you wish to free your homes, liber-ate your countries from the grip of tyrannical oppression, come, sympa-thize and unite with us, struggle for India's liberation and your freedom will automatically be won. It is India's freedom alone on which depends the honour and safety of your homes.[31]

Quantitatively, the movement of people to places far away, though contested and obstructed by the vicissitudes of geography, by states, by passport and visa regulations, and international and imperial police forces, became more frequent in the interwar period, with Indians in motor cars stranded on the continent, or Indians on bicycles wandering around Europe or North Africa no longer uncommon incidents.[32]

The internationalist moment was also marked, at least in its initial years, by the amorphous contours of its politics. This is not to suggest that "left" and "right" in the conventional sense did not matter, but rather that owing to the nearly seamless confluence of multiple political and intellectual trends, a number of political, intellectual, or social trends in the initial phase of the interwar period were difficult to neatly cat-egorize or classify. Drawing clear boundaries between a variety of politi-cal and intellectual tendencies, upon which political and social actors of

[31] G. Adhikari (ed.), *Documents of the History of the Communist Party of India*, Vol. 1 1917–22 (New Delhi: People's Publishing House), 138–37.

[32] There were regular articles on world tours by youth published in a variety of papers, the *Bombay Chronicle* being among the more interested ones. See also the column "adventures..." in the *Volunteer*, the journal of the Indian National Congress' youth wing, the Seva Dal.

the times drew, was therefore no easy task for our actors, irrespective of whether they were placed in "international" or "national" contexts, or more often than not an amalgamation of the two. Toward the end of the 1920s a distinction between "fascists" and "socialists" began to be more strongly made, but this did not stop people from crossing the now-strongly-drawn battle lines between the two, or from wandering along these lines in a drunken straight line, not always conscious of the route.

Conceptual Tools and Historiographical Perspectives

Given this fluidity, where do we begin to place the internationalist moment in historiography? Terminologically, the contemporaneously favored term "internationalism" seemed apt for the purposes of this volume. Yet that term has not been in favor of late, perhaps because of its once-close association with the proletarian internationalism of the Communist International (Comintern).[33] Instead, in what we might call a historiographical "scramble for the transnation," new terminologies have taken center stage; "transnational" or "global" histories are written with a focus on a concern with "cosmopolitanism."[34] It is necessary,

[33] There have been instances in which this term has been used by historians, but more often than not, rather loosely, as a label that is devoid of meaning. More recently, this term has been resuscitated by Emily S. Rosenberg who has drawn attention to prewar groups who called themselves "internationalists." She points out how "internationalism" was conceived in many circles as an idea that sought to bind nation-states in peaceful coexistence through a parallel attempt to strengthen national and imperial borders. See Emily S. Rosenberg, "Transnational Currents in a Shrinking World," in *A World Connecting 1870–1945*, ed. Emily S. Rosenberg (Cambridge, Mass and London: Belknap Press of Harvard University Press, 2012). This is a useful corrective to the assumption that internationalism is merely the province of (in our period) the Third and Fourth Internationals: the decentering of statist perspectives that we refer to in this volume was not the only internationalism on offer.

[34] See, for instance, Sugata Bose and Kris Manjapra (ed.), *Cosmopolitan Thought Zones: South Asia and the Global Circulation of Ideas* (New York: Palgrave Macmillan, 2010); Mrinalini Sinha, *Specters of Mother India: The Global Restructuring of an Empire* (Durham: Duke University Press, 2006); Kevin Grant, Philippa Levine, and Frank Trentmann (eds), *Beyond Sovereignty: Britain,*

therefore, to explain our reservations about these terms, and about some of these debates, in which we do not intend to get entangled—without thereby implying that they might not be useful in some contexts (indeed, some of the essays in this volume engage with different uses of the terms), nor that the change is not in some respects refreshing.

The historiography of South Asia has long remained centered on nationalism, with local or community histories as legitimate variants that are nevertheless related back to the national.[35] In the 1980s and 1990s, even critical studies of nationalism treated each individual nationalism separately, devoid of context and interconnections: Even as one set of debates pondered the "modular" nature of nationalisms,[36] or their "derivative" but nonetheless different natures, the "nation" managed to remain the point of focus.[37] Earlier histories that noted the international engagements of South Asians nevertheless tended to subordinate these to the narratives of nationalism or of particular ideological trends that interested particular historians, notably the histories of "international communism."[38] There was very little to be found outside of these perspectives. Yet, as the beginnings of a breaking out of this pattern become discernible, old clichés of nationalist or communist historiography are in danger of giving way to new clichés of the transnational, the global, or the cosmopolitan, in which the old clichés still manage to survive.[39] Most resilient in this regard have been the meta-narratives of

Empire and Transnationalism, c. 1880–1950 (Basingstoke: Palgrave Macmillan 2007). See also contributions to the *Journal of Global History* for a sense of the uses of the term "global;" and note the use of all three terms in the above titles. Is the "global" larger than the "transnational"?

[35] See Zachariah, *Playing the Nation Game*, 31–78, for a study of this tendency.

[36] Benedict Anderson, *Imagined Communities* (London: Verso, 1983); Partha Chatterjee, "Whose Imagined Community?" *The Nation and its Fragments* (Princeton: Princeton University Press, 1993), 3–13.

[37] Partha Chatterjee, *Nationalist Thought and the Colonial World: A Derivative Discourse?* (London: Zed Books, 1986).

[38] Most recently Sobhanlal Datta Gupta, *Comintern and the Destiny of Communism in India 1919–1943* (Calcutta: Seribaan, 2006). Earlier, the 'Indian revolutionaries abroad' theme was important: see, for example, Tilak Raj Sareen, *Indian Revolutionary Movement Abroad (1905–1920)* (New Delhi: Sterling, 1979). For more specific references, see the essays as follows.

[39] For instance, Sugata Bose, *A Hundred Horizons: The Indian Ocean in the Age of Global Empire* (Cambridge, MA: Harvard University Press, 2006); or the collection of essays that comprise Bose and Manjapra (eds), *Cosmopolitan*

nationalism. For instance, there remains an assumption that the route to "cosmopolitan" solidarities lie *through* nationalism, which thus becomes a necessary "stage" *en route* to a higher stage, or a necessary prerequisite for its transcendence.[40] This is rather in the manner of the claim that a "transitional object," psychoanalytically speaking, is required, before one can make the transition away from the mother/nation.[41]

In contrast, this volume deals with unanticipated trajectories which cannot be reduced to nationalist tendencies: It deals with the everydayness of the internationalism of the time, which is difficult to reduce (or enlarge) to a larger-than-national entity, since it does not necessarily grow out of or transit through a national one. It is nonetheless the case that the internationalist moment exists in an age in which a national principle is for the first time acknowledged as axiomatic, and that many of the actors studied here are engaging in what they see as *national* liberation movements. However, the *directions* of national engagements, when they are national ones, are as often via the international as vice versa, or indeed via the international to the local and thence to the national (see the essay by Raza). As we believe the essays show, the boundaries, conceptually as well as spatio-temporally, of local, international, and national, are often so blurred that it makes perfect sense to speak of an internationalist engagement in the broadest possible terms that also makes perfect sense at the smallest possible level. Ironically, the internationalist moment was framed by the principle of nationalism, which at its moment of acceptance was already on the road to obsolescence for many.

It would, then, be too easy to simply align our intervention with the growing literature on "cosmopolitanism." "Cosmopolitan" is a paradoxical category—a priori it implies a utopian integratedness and participating in the world beyond the specific boundaries of one's own polis.[42]

Thought Zones, in which one of the contributors to this special issue also has a contribution: Benjamin Zachariah, "Rethinking (the Absence of) Fascism in India, c. 1922–1945," 178–209.

[40] Benedict Anderson, *Under Three Flags: Anarchism and the Anti-Colonial Imagination* (London: Verso, 2005).

[41] Julia Kristeva, *Nations Without Nationalism* [1990] (New York: Columbia University Press, 1993).

[42] Timothy Brennan, "Cosmopolitanism and Internationalism," in *Debating Cosmopolitics*, ed. Daniele Archibugi (London: Verso, 2003), 40–50, argues that cosmopolitanism and internationalism are "theoretically incompatible":

However, as soon as one tries to analyze it in specific terms, it becomes at best a "hyphenated cosmopolitanism," thereby losing the flexibility the term implies.[43] There has recently, however, been an insistence on giving the term "cosmopolitan" specific (and often normative) characteristics as an a priori, analytic category, robbing it *both* of its flexibility as an indicator of a being-at-home-in-different-contexts, *as well as* of its applicability to actual contexts.[44] One of our questions here is what specific characteristics an interwar "cosmopolitanism" actually took, if one wishes to use the word at all, among South Asians in different spaces and contexts (see the essays by Stolte, Ramnath, Raza, and Roy). This, in turn, historicizes and complicates the idea of cosmopolitanism. Cosmopolitanism in this view is not merely a state of being that is frozen in time and place; it is contingent on specific circumstances and contexts in which the interplay between parochialism (assuming that parochialism is noncosmopolitanism) and cosmopolitanism is far messier and complicated than is otherwise acknowledged. "[M]an's articulate misery or articulate delight has never been a respecter of frontiers."[45] This is the context for the transnational and international intellectual histories attempted here (there are views that suggest that intellectual history, a "history of ideas" and histories of "thought" or "thinking" are different things, but let us leave that aside for now).

a "unified polychromatic culture" and "world government" (cosmopolitanism) versus a "principle of *national* sovereignty" (internationalism) (41–42). This returns us to the point made above: that "international" has recently been appropriated by "states"; not to mention that where one stands in these debates depends very often on how one glosses the terms that one wishes to adopt or oppose. See also Stephen Vertovec and Robin Cohen (eds), *Conceiving Cosmopolitanism: Theory, Context and Practice* (Oxford: Oxford University Press, 2002); Pheng Cheah and Bruce Robbins (eds), *Cosmopolitics: Thinking and Feeling Beyond the Nation* (Minneapolis: University of Minnesota Press, 1998); Kwame Anthony Appiah, *Cosmopolitanism: Ethics in a World of Strangers* (New York: W.W. Norton, 2005).

[43] David Harvey, "Cosmopolitanism and the Banality of Geographical Evils," *Public Culture* 12, 2 (2000): 529–64, 530.

[44] Sheldon Pollock, Homi K. Bhabha, Carol A. Breckenridge, and Dipesh Chakrabarty, "Cosmopolitanisms," *Public Culture* 12, 3 (2000): 577–89.

[45] Peter Gay, *Weimar Culture: The Outsider as Insider* (New York: WW Norton, 2001 [1968]): 7.

Another set of problems is posed by the prefix "trans-." "Transnational" history, by marking every border-crossing as exceptional, tends to reify the very borders it claims to transcend. In contrast, the actors we are concerned treat this "transgression" as very ordinary and as a regular occurrence. One possible compromise, "translocal," while avoiding the implication that anyone's framework of experience can be "national," let alone "transnational," begs the question of what a "locality" is, although it has the advantage of invoking a framework in terms of scale—the "local"—that a historical actor can actually experience, implying thereby that an actor with experiences of more than one locality might be considered to be translocal. "Transcultural" might pose the same problem as "transnational" with a different category, reifying "culture" instead; the boundaries of a "culture" are of course far more difficult to identify than the boundaries of the "national," if the "national" is represented by a state. "Global" history, on the other hand, invokes a totality (what, then, is outside the "global?") in a more or less utopian way of implying connectedness (often resting on the global circulation of goods and people), but requiring an externalist view on what it is that connects the world. A tendency, therefore, to discuss the retrospective normative aspirations of historians as if they were already the social realities of the pasts they study, a kind of wishful thinking that projects a cosmopolitan openness, a global consciousness or a transnational nationalism—even as the centrality of nationalism to the historians' own consciousness remains unchallenged—should be resisted.[46]

[46] One of our central objections to much of the writing on transnationalism, cosmopolitanism, or globalism is its tendency to shrink the complexities of historical situations into an easy understanding of positive outcomes. For instance, Bose and Manjapra introduce the idea of a South Asian "cosmopolitanism" that overcomes the narrowness of identity, as does Nico Slate in describing the solidarities of Indians abroad with other oppressed peoples such as African Americans in the United States, but much of this appears as uncritically celebratory. See Kris Manjapra, "Introduction," 1–19; Sugata Bose, "Different Universalisms, Colourful Cosmopolitanisms: The Global Imagination of the Colonized," 97–111; or Nico Slate, "A Coloured Cosmopolitanism: Cedric Dover's Reading of the Afro-Asian world," 213–35, all in Bose and Manjapra (eds), *Cosmopolitan Thought Zones*. Nico Slate, *Colored Cosmopolitanism: The Shared Struggle for Freedom in the United States and India* (Ranikhet: Permanent Black, 2012) goes so far as to claim Lajpat Rai, the Hindu supporter of the Arya Samaj as a contributor to Negro liberties (pp. 40–41) and Swami Vivekananda, the misogynist

This refusal to partake of the terminology of our times is not merely a gesture toward (a modified) historicism[47] (in that "international" would have made more sense to the times we refer to), but an attempt not to get entangled in a terminology which might actually distract from meaning. For after all, the same term could mean different things to different people, and different terms could mean the same thing, either to the same people or to different people. That much we ought to have learned from the debates of the last twenty years or so. "Internationalism" is not an unproblematic term either, and there were various varieties of internationalism to dispute and discuss in the interwar period; these must be addressed and disaggregated. Similarly, when contemporaries invoked

supporter of caste distinctions, as an anti-racist (pp. 17–20). These are convenient readings in a book that collects diverse Indians who engaged with America in the same framework; but such feel-good readings do not stand up to scrutiny: the poet Sarojini Naidu demanded, from a Congress platform, the right of Indians to colonise East Africa at a time when British imperial officials were discussing the restriction of white settlement in the region, on the grounds of Indians' allegedly superior civilization. Naidu was of course "cosmopolitan" in the classical sense of being at home in several contexts, but this was hardly solidarity with oppressed Africans. See Dhruba Gupta, "Indian Perceptions of Africa," *South Asia Research*, 11, 2 (November 1991): 158–74. Ironically, Sarojini Naidu's brother was Viren Chattopadhyay, the organizer of the Congress of Oppressed Peoples in Brussels in 1927, and a consistent anti-imperialist in his international solidarities as well. The question of reading an intervention in its context rather than in terms of its retrospective resonances for historians or critics has echoes in Quentin Skinner's arguments about meaning and context: see Zachariah's essay in this volume for a discussion of the relevance of this framework.

[47] "Historicism" here is used not in Karl Popper's sense of the term, as in Karl Popper, *The Poverty of Historicism* (New York: Harper & Row, 1961 [1957]); the argument appeared under that title in 1944–45 in the journal *Economica*] or Karl Popper, *The Open Society and its Enemies* (London: Routledge, 1945) 2 Vols, in which there is an end in the beginning, but in the sense attributed often to Leopold von Ranke on the historian's judgment not being imposed in retrospect on the past (though Ranke was reliant on ideas of God, the German people, or Destiny, among other things: see Leopold von Ranke, *Geschichten der romanischen und germanischen Völker von 1494 bis 1514* [Leipzig: Duncker und Humblot, 1874]), the latter view modified by the understanding that the *questions* one asks are based on one's own interests; but a distinction between a contemporary and a retrospective judgment "as recognized by a historian" is maintained.

the "cosmopolitan," they typically meant no more than a broad openness to as well as awareness of being part of the world.[48]

The sensibility of internationalism that forms the topos of this collection transcends what is usually considered "politics." Yet it is always political in the wider sense of the term, not merely in the radical sense of there being nothing outside the political, but that the transformative projects described were aiming at a higher form of political involvement that included the personal and moral alongside the social and economic. Thus, as it was used contemporaneously, "internationalism" evoked an explicitly political project which cast a net that was broad and flexible enough to incorporate colonized and working class politics with scientific, literary, aesthetic, and gender sensibilities (see the essays by Ramnath, Jelnikar, and Anderson).

An argument in detail with these frameworks often amounts to quibbling over terminology, and is outside the framework of this book; if glossed appropriately, any of the aforementioned terms can be bent to our purposes. More importantly, it is important to stress that thus far, there has been no attempt to identify and understand this internationalist moment from a South Asian perspective. Previous attempts at the integration of South Asian history into the world have been through the themes of trade and commerce, labor networks, and diasporas, or within a regional paradigm, such as the field of Indian Ocean studies.[49] Taken

[48] The *Amrita Bazar Patrika* quoted Maulavi Abdul Hafiz Sharifabadi, the secretary of the Indian Seamen's Association, in 1923: the Association "was a cosmopolitan body, he said, as its laborers were not only simply confined to the Indian seamen, but there had been cases of seamen from other Asiatic countries who had been stranded in Calcutta and the Association had responded to their appeal for help in distress." Clipping from the *Amrita Bazar Patrika*, December 25, 1923, in file on Indian National Seamen's Union, IB Files, West Bengal State Archives [WBSA], Calcutta, IB Sl. No. 135/1920, File No. 294/20, f.53. Indians in New York during the First World War were members of both the "Hindusthan Club" and the "Cosmopolitan Club." IB Files, WBSA, Calcutta, IB Sl. No. 12/1915, File No. 102/1915, f.186.

[49] See, for instance, K.N. Chaudhuri, *Asia before Europe: Economy and Civilisation of the Indian Ocean from the Rise of Islam to 1750* (Cambridge: Cambridge University Press, 1990); Visram, *Ayahs, Lascars and Princes*; Ashin Das Gupta, *Malabar in Asian Trade 1740–1800* (Cambridge: Cambridge University Press, 1967); Rudrangshu Mukherjee and Lakshmi Subramanian (eds), *Politics and Trade in the Indian Ocean World* (Delhi: Oxford University

together, these narratives, focused on earlier and different trends, provide a welcome respite from particularistic narratives that emerge as a consequence of examining retrospectively reified borders. Viewed this way, the "internationalist moment" provides another perspective on how South Asia was integrated with the world at large. Around this period in South Asia, as elsewhere, people were all too aware of the global "web" that wove the fate of peoples, nations, and states together.[50]

These were not simply vague assertions or intellectual engagements, as had been some of the pre-1917 international engagements of South Asians; these were actual experiences of world events, whether perceived through traveling or by staying at home: The Great Depression did not require a trip to Germany or Wall Street for its effects to be felt.[51] And lest we be in danger of implying that the borders and boundaries of the time weren't physical and didn't have an impact at all, we should clarify that this is not what we mean: Indeed, it was the paradox of living constrained lives in an interconnected world, of understanding the dichotomies of freedom and unfreedom, that made the world a connected place. As the world attempted to remake itself in the aftermath of the Great War, the opportunity to imagine alternatives to the old states-and-empires system, to mould the world anew, presented itself to many people. And a problem solved or question addressed in one part of the world quite logically lent itself to replication, and to discussions as to its replicability and applicability in new contexts. With the seemingly imminent collapse of the old order, the emergence of a new one seemed to be not only plausible but inevitable. A dizzying array of ideas and politics that accompanied these changes in world order had to be engaged with and made

Press, 1998); Ashin Das Gupta and M.N. Pearson, *India and the Indian Ocean World 1500–1800* (Delhi: Oxford University Press, 1987).

[50] For Nehru it was technological advance and science that had made the world interdependent. See Speech by Jawaharlal Nehru at the Students Conference held in Shraddhanand Park, Calcutta, September 22, 1928, in Durlab Singh (ed.), *To the Youth of My Country*, 76–90, see esp. 79. But even people with a less self-avowedly internationalist outlook, could not but feel the pull of the "world forces." See for instance on the world forces and the necessity for "world mindedness," Dr Shastri's speech at the Second Youth Conference held at Madras, over which he presided, speech reproduced in "The Indian Youth Conference," *The Volunteer*, December 1927, 278–82.

[51] See, for instance, Dietmar Rothermund, *India in the Great Depression 1929–1939* (Delhi: Manohar, 1992).

sense of, and the question was how to assist in the making of, and to find one's place in that order, for the option of simply adjusting to existing worlds seemed to have vanished.

Our Contribution

What binds the contributions in this volume together is their focus on "intermediate histories." The "intermediacy" these essays refer to is not merely in terms of social and class positioning, though that too is featured prominently in our analysis. Our actors transcend the often unimaginatively drawn dichotomy between "elite" and "subaltern." In other words, we are not examining the mythical "autonomous domain" of "subaltern" agency that the Subaltern Studies Collective introduced three decades ago.[52] Rather, as has been pointed out, both "elite" and "subaltern" are relational and relative categories that are contingent on time, place, and context.[53] As a result, we find the term "subaltern" unhelpful, and in most cases refrain from using it. Our actors frequently find themselves situated in multiple settings and involved in diverse engagements. This, in turn, implies that it is nearly impossible to situate them in fixed social categories.

One of the key acts which makes movement across social categories possible is the act of traveling. This is one of the important themes which connects the contributions in this volume. As an act, traveling necessitates transmutation and enables an individual to reposition themselves in response to new and shifting contexts. Politics, personality, beliefs, undergo changes by close engagements with new and different worlds. This liminality also offers the prospect of freeing an individual from markers of class or caste that are otherwise bound up with an "original" social context. In turn, this freedom encourages new self-definitions and enables our actors to act as go-betweens between these ostensibly fixed categories. Thus, to return briefly to the elite/subaltern dichotomy, it is

[52] Ranajit Guha, "On Some Aspects of the Historiography of Colonial India," in *Subaltern Studies I*, ed. Ranajit Guha (Delhi: Oxford University Press, 1982), 1–8.

[53] Partha Chatterjee coined the expression "the subalternity of an elite": see Partha Chatterjee, *The Nation and its Fragments* (Princeton: Princeton University Press, 1993).

perfectly possible for an individual to be elite in certain circumstances and not so in others, and elite status in one context can easily evaporate in a new one. Examples might include an ordinary immigrant worker in the United States who becomes an important actor in the Soviet Union, where a different set of markers determine hierarchy and status,[54] or a political exile from an affluent family in India who spends a precarious life in poverty wandering across the world: "member of a famous family in India, ... [h]e was always hard up, his clothes were very much the worse for wear, and often he found it difficult to raise the wherewithal for a meal."[55]

Obviously, this is not to suggest that an individual has infinite freedom to reinvent themselves like the proverbial homunculus. Rather, it is simply to point out that changed contexts open up rifts into which the individual fits themselves with varying degrees of space to maneuver. Neither do we wish to suggest that such possibilities were restricted only to those who physically traveled (or indeed to suggest that all who did travel underwent these transformations). Indeed, it was perfectly possible to engage with new possibilities—though perhaps not to the same extent as itinerant individuals—whilst situated in a "local" context.

There are of course other ways in which we can conceptualize "intermediate histories." One of these is related to another aspect of traveling, that is, the traveling of ideas. Given the intellectual milieu of this period, mapping and classifying ideas can be tricky for the historian. Those who have done so, have inevitably confined their actors to a limited number of ideological boxes (communist, fascist, nationalist et al.), which do little to convey a sense of their untidiness or where they overlap with or merge into other intellectual impulses (see the essay by Zachariah). What is more important then, is to uncover, as our contributors do, how and in what shape and form ideas traveled to and from South Asia. It is also important to ask if there is a sense of a "common grammar" within ostensibly different discourses that enabled individuals to select certain elements from them and put them together. It follows then that the notion of a "derivative discourse" can make little sense unless we can ask, "derivative of what?" Since the idea of an "original" is highly

[54] See Amir Haider Khan's memoirs: Amir Haider Khan, *Chains to Lose: Life and Struggles of a Revolutionary* (2 vols, New Delhi: Patriot Publishers, 1988).

[55] Jawaharlal Nehru on Virendranath Chattopadhyay, in Jawaharlal Nehru, *An Autobiography* (London: Bodley Head, 1941 [1936]), 153.

problematic (ideologies are after all retrospectively constructed ideal-types), we need to suspend the usual judgment that we make on "copies" and "misreadings." This is where these ideas become "intermediate" and this is also where their histories become "intermediate histories." The late Michel Foucault might have referred to this as *histories of thinking* rather than as histories of thought.

The amorphousness of these histories perhaps explains why they are so marginalized in South Asian historiography. A part of that also has to do with where such histories should adequately be located. Are they transnational or national? Are they local or global (or even "glocal" for that matter)? In this volume, we locate these actors in spaces that again, can be described as "intermediate": We look at certain meeting spaces, often ephemeral and short-lived, where actors converge to engage with the ideas and politics that distinguish the internationalist moment. These are cities that are linked together through a unique geography of radical politics that transcends state frontiers, and also institutional spaces which serve as platforms for a variety of different agendas (see essays by Louro, Stolte). These sites of engagement also include a sense of the diversity of communication, the engagement with different publics and public arenas, and a sense that ideas travel with or without people. Thus, one's site or zone of engagement might be international without one's having traveled,[56] or despite one's cosmopolitan credentials by virtue of travel might still be relatively parochial and nationalist. Also embedded within these spaces were possibilities of cross-"national" solidarities and (or as) affective encounters (see the essay by Jelnikar), and the fraught subjects of inter-"racial" intercourse, social, political, romantic, or sexual (Ramnath, Raza). And if "science" was often viewed at the time as universalist and neutral, and therefore axiomatically internationalist, the experiences of both world wars can be a useful corrective to such views: In the interwar period, scientific internationalists had consciously to hold on to their wider ideals of service to humanity against the specific claims made upon them by their nation-states, which they were all too aware had no such ideals (Anderson).

[56] Dilip M. Menon, "A Local Cosmopolitan: 'Kesari' Balakrishna Pillai and the Invention of Europe for a Modern Kerala," in *Cosmopolitan Thought Zones*, eds Bose and Manjapra, 131–55.

The End(s) of the Moment

It is important, though, not to overly romanticize this moment. For all the excitement and headiness that accompanied it, the internationalist moment also contained within it the seeds of its own destruction. Over the course of the interwar period, ideas of internationalism were battered by circumstances. Yet, given the fact that there were a variety of internationalisms, the end of this moment too had multiple beginnings, which were in a sense almost concurrent with the beginning of the moment itself, and arguably inherent in it. This might be a useful reminder that it would be too simplistic to see the internationalist moment as a somewhat homogeneous period frozen in time between 1917 and 1939, and instead to note that it contains within itself a number of shifts and departures, a number of "moments."

This was most starkly manifested in the gradual crystallization of hitherto diffuse and amorphous political strands within "national" and "international" politics. A polarization of politics eventually overwhelmed the possibilities of the internationalism of the era. Nationalism and internationalism co-existed for a time with re-armament and specters of another global confrontation growing, and the nation(-state) more often than not trumped internationalism. A growing trend could best be described as a disavowed internationalism,[57] especially obvious in the case of the fascisms, whose interconnectedness and similarities, not to mention their conscious attempts at coordination or mutual imitation, were often hidden by their insistence on the particularities and glories of each particular nation.[58] This went together with a social Darwinist vision of international relations (see essay by Roy). By the late 1920s, there was a widening gap between the extremes of the political spectrum.

[57] We owe this phrase to Javed Majeed, from his talk at the workshop "Ideas, Ideologies and Intellectual Histories: Problems of Methodology and Sources," *Zentrum Moderner Orient*, Berlin, February 18, 2011.

[58] On this fascist coordination one might think of the Fascist International, modeled of course on the Comintern. See Michael Arthur Ledeen, *Universal Fascism: The Theory and Practice of the Fascist International, 1928–1936* (New York: H. Fertig, 1972). See also Federico Finchelstein, *Transatlantic Fascism: Ideology, Violence, and the Sacred in Argentina and Italy, 1919–1945* (Durham: Duke University Press, 2010), for writing from another historical context.

Another dynamic that contributed to an eroding of an internationalism "from below" is the successive institutionalization of formerly open-ended platforms, thus eventually rendering it into a state-led internationalism with the intermediate stage of parties (communists especially) vying for a hold over existing platforms, or creating their own exclusive ones. Perhaps one could take a paradigmatic example: The League of Nations was an early manifestation of the institutionalized forms of interstate "internationalism" that existed side by side with the more unstructured or nonstatist platforms, and the League and its associated agencies were sites of a larger attempt to control the more radical tendencies of states as well as nonstate actors in the politics of the interwar period, and channel it in more acceptable directions.[59] The League's attempts to institutionally occupy spaces that were sought to be controlled by movements parallels the waning of internationalist networks via another dynamic, in which fora such as the League Against Imperialism (see essay by Louro) were sought to be taken over and controlled by state-sponsored entities (the Communists under the control of the USSR); "socialism in one country" and the increasing Stalinization of the communist movement led to the erosion of the consciously internationalist Comintern's autonomy and the gradual predominance of conventional statist foreign policy within a Great Russian chauvinist framework.[60]

What also made the moment a finite one as far as contemporary actors were concerned was the widespread perception that the post-Great War era was one in which a soon-to-arrive future was being constructed—it was meant to give way to a new dawn (or doom) seen in the prevailing framework of linear historical development or a move toward an "age of freedom."[61] The longer it took, the less plausible this seemed. Depending on one's political perspectives, the emergence of the "Hitler state" in

[59] See Stephen Legg, "Of Scales, Networks and Assemblages: The League of Nations Apparatus and the Scalar Sovereignty of the Government of India," *Transactions of the Institute of British Geographers*, NS 34 (2009): 234–53.

[60] The classic analysis of this dynamic is in Isaac Deutscher, *Stalin: A Political Biography* (Harmondsworth: Pelican Books, 1966 [1949]), in his two chapters on "Foreign Policy and Comintern," 383–450.

[61] Dr Shastri's speech at the Second Youth Conference held at Madras, over which he presided, speech reproduced in "The Indian Youth Conference," *The Volunteer*, December 1927, 278–82.

1933 was the end of the achievement of many of these hopes.[62] (Benoy Kumar Sarkar, the iconic academic admirer of fascism and Nazism, described Hitler as "Vivekananda multiplied by Bismarck."[63]) The Great Depression threw states back into their own shadows, as protective and defensive blocs began to form, undermining any pretensions to speak for wider causes. The Hitler state was the apotheosis and reification of nationalism, but both trends also gave impetus to the internationalists of the time, where the immunity of the Soviet economy to the effects of the Depression inspired many to look closely at this new experiment, and the tragedy of Nazism managed to recreate, formally in the Popular Fronts and informally in wider groupings, a sense of urgency for the internationalists.[64] Engagements with other events or movements were not as clear: If admiration for Mussolini had been widespread in India, the Abysinnian invasion of 1935 did not altogether create the revulsion against fascism that might have been expected in a country subject to imperialism, and long-admired Japan, whose defeat of Russia in 1905 had been seen across the colonized world as a vicarious victory for "the East" over "the West," made it difficult for Indians to come up with unambiguous feelings when it was China that was at the receiving end of Japanese aggression. China had become a focal point of Indian anti-imperialist sentiment.[65] A consistent internationalism of a nonstate variety, uncontaminated by thinking within nationalist boxes, would of course have made such distinctions as needed to be made between regimes and people infinitely easier than they were.

In retrospect this period has been associated with the rise of "totalitarianism," of both the communist and the fascist variety;[66] yet, to view this era as "the totalitarian moment" would be to render it in simplistic

[62] For two contrasting South Asian responses to the Hitler State, see Benoy Kumar Sarkar, *The Hitler State: A Landmark in the Political, Economic and Social Remaking of the German People* (Calcutta: Insurance and Finance Review, 1933), and Soumyendranath Tagore, *Hitlerism: The Aryan Rule in Germany* (Calcutta: Ganashakti, 1934).

[63] Sarkar, *The Hitler State*, 13.

[64] Benjamin Zachariah, *Developing India: An Intellectual and Social History, c. 1930–1950* (Delhi: Oxford University Press, 2005), 28–43, 246–52.

[65] Benjamin Zachariah, *Nehru* (London: Routledge, 2004), 112–13, 159.

[66] For a recent intervention on the subject, see Slavoj Žižek, *Did somebody say totalitarianism? Five interventions in the (mis)use of a notion* (London: Verso, 2001).

terms that ignore the possibilities that were latent within it, of which our actors were all too aware. There was a sense of opportunity and destiny that marked the beginning of this moment, and a sense of the impending end of an opportunity, the closing of an important window, as it drew to an end, though different actors saw the end as having arrived at different points in time. The defeat of Republican Spain in the Spanish Civil War, the Munich Pact, and the dismemberment of Czechoslovakia, watched in agonizing close-up by Indians in exile in Europe, among others by Jawaharlal Nehru as a correspondent for his own newspaper, the *National Herald*, and the Nazi-Soviet Pact that underlined the inevitability of another conflagration to all but the deliberately obtuse, were moments along the path to disenchantment.[67] By the time the "low, dishonest decade" drew to a close with the outbreak of the Second World War in September 1939,[68] much of the optimism had long vanished.

These developments can be exemplified by trajectories in Indian politics. The initial excitement that greeted the Bolshevik Revolution and the upheavals of the Non-Cooperation and Khilafat movements soon gave way to parochial and communitarian divisions within mainstream political debate. Yet, there still remained considerable space for an inclusionary politics that was in touch with internationalist sentiments around the world. This was particularly true for the mid- and late 1920s when references to Bolshevik Russia were part and parcel of political discourse in South Asia, regardless of political tendency. Right-wing political leaders such as Lala Lajpat Rai welcomed developments in Russia,[69] and the Hindu communalist Madan Mohan Malaviya celebrated the success of the Bolshevik Revolution (see the essay by Raza). Yet by the end of the decade, with the hardening of communitarian claims to the future "nation," the deadlock over constitutional reform, and a slew of "conspiracy cases" which sought to criminalize "communism" in and of itself, the growing distance between "nationalism" and "internationalism" was evident in that the concerns and aspirations of

[67] Zachariah, *Nehru*, 94–97.

[68] W.H. Auden, "September 1939," *New Republic* October 18, 1939, 297, quoted from Nehru's own copy, in Jawaharlal Nehru Papers, Nehru Memorial Museum and Library, New Delhi, Part V Nos. 46–55, f 3.

[69] Karuna Kaushik, *Russian Revolution and Indian Nationalism: Studies of Lajpat Rai, Subhas Chandra Bose and Rammanohar Lohia* (Delhi: Chanakya, 1984).

an anticipated nation-state were increasingly viewed as distinct from and more important than the politics of internationalism. The internationalism of the working class, a central plank of left-wing thinking in theory, was undermined gradually in practice through the separate and combined working of state repression and the Stalinization of the international communist movement, which can be exemplified by the Meerut Conspiracy Case and the Great Purges, respectively (see the essay by Stolte). This was particularly evident with the outbreak of the Second World War and the divisions it caused within the political spectrum. By the end of the war, the very same Nehru who had insisted on the inseparability of international politics from domestic problems in India (see the essay by Louro) was denouncing the communists for privileging their internationalist commitments over their nationalist duties.[70]

It would, therefore, be easier to identify the beginning of the internationalist moment than the point at which it ended for various players. With all these qualifications and differentiations of its internal dynamics, we would nevertheless stress the intrinsic unity of that moment. As moments go, it was perhaps a long moment, and it had its phases, as a moment that contained other moments. The term "moment" captures its immediacy, but also its fragility and transience; those who lived through it were aware of this, and of its potential waning.

The Essays

A brief outline of the essays we present here, beyond the oblique references to them provided above, is in order, if only to establish their relationship to the larger project. Benjamin Zachariah's contribution traces networks of itinerant Indians and their engagements with a wide array of political and social possibilities that are the hallmark of the internationalist moment. The essay raises methodological questions about the connections between international social histories and intellectual histories, as it tracks channels of ideas and ideological exchange via the movements of relatively unknown socialists, pro-fascists, Pan-Asianists, students and professionals of Indian origin, many of them lacking the

[70] Z.A. Ahmad's talk with Jawaharlal Nehru, June 1945, "not to be shown to anyone else without PC Joshi's [General Secretary, CPI] permission," 1945/9, PC Joshi Archive, Jawaharlal Nehru University, New Delhi.

ideological clarity demanded by intellectual histories of their actors. This exemplifies our larger point about the multiplicity and diversity of the international engagements of the times.

Other essays flesh out the nature and extent of the internationalist connections. Michele Louro examines the making of the networks and intellectual exchanges that were constitutive of international anti-imperialism, tracing in particular Jawaharlal Nehru's role in building networks through the League Against Imperialism (LAI), an organization representing colonies, mandates, and dependencies in Asia, Africa, and Latin America as well as North American and European social reformers concerned with working class and racial equality. Nehru became deeply involved in the politics of the LAI, and his work on the executive council firmly established him as a pivotal partner in the international struggle against empires and in networks of solidarity beyond empires and imperialism that survived the demise of the LAI, notable among them being his contact with Roger Baldwin of the American Civil Liberties Union. A set of networks and a corresponding internationalist vocabulary of politics was thereby created and sustained: enabled, perhaps, by the organizational capacity of communist and communist-influenced individuals and organizations, but containing much that was merely, in the language of the "front organizations" themselves, merely "progressive."

Carolien Stolte examines a specific form of internationalist engagement, that of the South Asian trade union movement, with a specific geographical imaginary, that of Asia. In the interwar years, visions of an Asian continent united in the anti-imperial struggle played an important part in the political imaginary of many South Asian individuals and groups. Notable among these was the militant trade union wing of the All-India Trade Union Congress, inspired by the Bolshevik Revolution in general and the Asian policies of the Red International of Trade Unions in particular. Through the 1920s, their ranks swelled with returning revolutionaries trained in Tashkent and Moscow, who brought with them valuable networks. The trade unionists' engagement with Asia was given further impetus by the exchange of trade union leaders, the establishment of the Pan-Pacific Trade Union Secretariat at Hankou in 1927 and support from Soviet organizations of local strikes. The essay examines the Asian engagements of the militant trade union leadership in India in this period and the importance of revolutionary networks enabled and sustained by the communist movement.

Ali Raza's essay follows on from Stolte's, dealing with the linkages between a regional leftist movement and the internationalist moment. He examines the varying political and intellectual strands that fed into the development of a regional leftist movement that, while operating in local contexts, situated its politics within a global shift toward revolutionary change. The varying political and intellectual strands that fed into the development of a regional Punjabi leftist movement sought legitimation in national as well as international registers. The interwar period was remarkable for providing a number of trajectories to political radicalism that often originated in the global arena. Among others, the networks of Ghadarites, organized in North America shortly before the First World War, of Muhajirs and Lascars, were quite distinctive in being rooted in local contexts that were nevertheless tied in with a global movement toward revolutionary change. This essay, then, highlights the internationalist dimension of a Punjabi leftist movement, broadly and non-ideologically construed, and encourages a reassessment of how regional politics is viewed in dominant historiography: perhaps the "regional" reaches the "national" via the "international," or the "international" provides the impetus for the "regional" or the "national."

These last three essays, taken together, highlight the centrality of an international communist movement and its networks to South Asian political engagements in the interwar years, while at the same time demonstrating that such centrality cannot be understood in terms of the one-dimensional explanations either of financial support or ideological affiliation that many accounts rely upon; indeed, the importance of communists and communism in the period should not be confused with ideological faithfulness or clarity, and the nature of a broadly united-front-style politics, before and after the term was invented, and beyond the vicissitudes of Comintern policy and official party lines, needs to be noted more centrally.

The two essays that follow move the focus away from communist-influenced networks and politics per se to return to some of the wider ambiguities and indeterminacies addressed by the first essay. Maia Ramnath brings in the question of interracial romantic and sexual relationships within the framework of international engagements, contrasting an example shortly before the window of "internationalism" opened with one written at the height of that "moment," though set in a period before it. For both the writers she draws upon, the nationalist and feminist Madame Cama in her Paris-based journal *Bande Mataram* (1912),

and Irish poet and patriot Brian Padraic O'Seasnain in New York's
Independent Hindustan (1920), the notion of an anticolonial love
depended upon where boundaries of self and other are drawn, and
when crossed. The exemplification of internationalism through affec-
tive relationships between men and women illustrates the immediacy of
the engagements of which we speak beyond the abstract or the explicitly
political. That actual human relationships of love, sex, and politics were
at the heart of a great many internationalist engagements and encounters
is of course a truism; but it is hard to exemplify any of this via the ordi-
narily accessible documentary traces relied upon by historians. Ramnath,
thus, is able to engage in an implicit debate with the few accounts of
interpersonal encounters that we possess, notably Agnes Smedley's
divergent accounts of her relationship with Viren Chattopadhyay, the
one anguished and fictionalized, the other narrated as memoir and suit-
ably toned down.[71]

Franziska Roy points to the significance of international engagements
among Indian "youth" and "volunteer" organizations, at the same time
as their goals were expressed in terms of parochial objectives at home,
the latter being framed largely with reference to the former. These move-
ments were concerned with elements of national discipline: the question
of mass mobilization, its success or failure. The (selective) international
engagements of Indian nationalists connected with these programs of
youth and volunteer mobilization points to what might be a common
grammar of politics linked to a contemporaneous weltanschauung,
which was shared by actors from a variety of backgrounds, and cuts
across specific ideologies. The essay examines deeper structures and
an implicit consensus among actors across organizations with avowed
political differences, such as the Muslim National Guards, the Congress's
Hindustani Seva Dal, the Khaksars, and the Rashtriya Swayamsevak
Sangh, about the necessary structure of mobilization and form of orga-
nizations, and the factors of (assumed) progress or (dreaded) degener-
ation of nations and humanity at large—for instance, eugenics, social
Darwinism, or organicist readings of the nation.

Ana Jelnikar introduces a crucial comparative framework to our study
of internationalism, in a study of a close, and rather one-sided, encounter
between a Slovenian poet, Srečko Kosovel, and an Indian whom he never

[71] Agnes Smedley, *Daughter of Earth* (London: Virago, 1979 [1927]); Agnes
Smedley, *Battle Hymn of China* (London: Victor Gollancz, 1944), 12–24.

met, Rabindranath Tagore, who was most probably completely unaware of the former's existence. What is remarkable about this encounter is not just the fact that Kosovel read Tagore and took inspiration from him, but that the two shared a very similar set of preoccupations, at the core of which was a creative ideal of universality rather than the readily available nationalisms that were the easier choices at the time. Jelnikar contends that these similarities have a backdrop in *structurally* similar forces of political and cultural subjugation that both Kosovel and Tagore experienced, to illustrate which she situates Kosovel in his historical contexts and Tagore in his, illuminating the similarities at work in their creative and political expression. Thus, the similarities of an international context that unites two writers who never met could produce strong similarities in their world views such that the one could identify strongly with the other. While she acknowledges the limitations and occasional stereotyping of India in Kosovel's internationalism of "situational identification," to use her term, Kosovel's ability to appropriate his fellow poet as an equal and not as a guru or an inferior Oriental is an indication of the importance of the internationalism of the times. In addition, this contribution is a reminder of the irrationality of nationalism in the age of nationalisms, and the difficulties inherent in the struggle to escape nationalist thinking even with the best of intentions.

Robert Anderson tracks the internationalist engagements of a Bengali scientist, born the son of a small grocery-shop owner in East Bengal, whose achievements as a physicist and scientific educator connected well with his activities as a concerned public intellectual connected with economic planning, irrigation projects, and science policy. Meghnad Saha, in many ways, epitomized the need for traversing various moods of internationalism in the interwar period, starting of course from the dilemma of the scientist as structurally internationalist, aspirationally and ideologically operating within a scholarly community, with nonetheless a recognition that that community only existed in theory. An "Indian" or a colonial subject had to win internationalist credibility via imperial and often impenetrable institutions such as the Royal Society, which again was often the route to national importance. Saha was a participant in the optimistic internationalism of science in the 1920s, and his international expertise and recognition was closely connected to both a socialist vision and an activist conception of state intervention in the lives of its citizens, which were for Saha not separate from a national struggle for an independent state. The extent to which his political

engagements and his scientific concerns affected, enabled or obstructed one another is addressed here. Political internationalism, in Saha's case, nearly succeeded in being the grounds for his exclusion from scientific internationalism. Anderson traces the career of Saha into the Second World War, where the contrast between the interwar years of nonstatist internationalisms and the era of strong states during and after the war is made clear. The receding of some of Saha's internationalist perspectives under pressure of practical politics, and his transformation into a statist thinker, even if a left-of-center one, follows the trajectories of the histories of the time.

These essays are part of a wider attempt to reconnect South Asian history to the contexts within which it belongs, from which national histories detach it to its impoverishment. It may perhaps be added that to look at the assumed center from the perspective of the assumed periphery can not only add much to an understanding of what the periphery is, but renegotiate our understanding of the center as well.

1

Internationalisms in the Interwar Years: The Traveling of Ideas

Benjamin Zachariah

In Search of an In-between History of Ideas

This essay is a preliminary attempt to trace channels and networks of ideas and ideological exchange between the two world wars. It also raises a few methodological questions about the connections between international social histories and intellectual histories. I am interested here in what I might call intermediate intellectual histories. What follows, therefore, is something of a programmatic statement. Is the tracing of the movement of ideas something that is only an elite possibility, tracking down references in footnotes and citations, looking at academic texts and manifestos? Or can the influence of ideas, at a less rarefied level, also be traced and tracked by a historian?

First, though, a few preliminaries to the preliminary attempt. There is a long-standing prejudice about intellectual history as the history of elites. And perhaps it is. It looks at the movements of ideas, and insofar as it relies upon written sources, it isn't necessarily about the by-now

mythologized "subaltern"—by which I mean the human being, not the sign they have become in late subaltern studies. If intellectual history is written as the history of successive publications and who thought what and then presented it in public, and the methodology is merely chasing down the footnotes to trace influences and sources, it can of course be resolutely elitist. Can there be a social history of ideas, and through that a social history of the "carriers" of ideas? Of the networks that sustain and amplify them?

The other large question has always been to what extent ideas can or should be traced directly or indirectly to actual events. Let us take "fascism" as an example here. Zeev Sternhell has written, for instance, on fascism as a set of ideas already in place before the First World War. That it became important in practice only after the war is not to suggest that it was entirely a postwar phenomenon. It had its best successes in the postwar environment, but if we aren't to take ideas as social movements, he says, we ignore more than a generation of writings by leading intellectuals (he says European intellectuals, because that is his field). He also insists that intellectual history is also social history, or in his words, "the relationship between the history of ideas, politics and culture is a direct one."[1] The dangers of a teleological reading are clear here—Kevin Passmore's argument that many ideas that went into fascism also went into other ideologies needs also to be stressed.[2]

A worldwide fin-de-siècle and post-Great War set of phenomena that finds ideological expression and geographical focal point first in Italian fascism and then in German Nazism: this might be an explanation that broadens understandings of fascism, but then we also need to take into account that some of these ideas did not "lead to" fascism, were a part, but not always a necessary part, of several fascisms, and in some cases survived their encounter with and incorporation into fascism with their legitimacy only partially compromised, to rise again in different forms—and represented by different terms. This distinction between *terms* and

[1] Zeev Sternhell, "How to Think About Fascism and its Ideology," *Constellations* 15, 3 (2008): 280–90; quote from p. 284.

[2] Kevin Passmore, "The Ideological Origins of Fascism Before 1914," in *The Oxford Handbook of Fascism*, ed. R.J.B. Bosworth (Oxford: Oxford University Press, 2009), 11–31.

the *ideas* the terms attempt to describe needs to be kept in mind, not merely in terms of the now-proverbial arbitrariness of the sign, but to account for the fact that wheels are sometimes separately invented in separate "cultures" (a problematic but interim term for the purposes of this essay)—and then when the "cultures" come into contact, they might recognize each other's wheels as the same thing, although it might take them a little longer to agree to call it by one name, whether that be "wheel" or non-"wheel."

Then again, there is the question whether ideas only need to be taken seriously when they manifest themselves in practices—in other words, we need only take "successful" ideas seriously. To my mind this is a rather instrumental reading of ideas. How coherent has a set of ideas to be before it is considered worthy of study? (According to the criteria of coherence and internal consistency, many would argue that fascism is not an ideology.)

Too much of the writing on the "reception" of "European" or "foreign" ideas in India has been overdetermined by retrospectivist or nativist readings about the separation of the "indigenous" and the "foreign," a trope that was common during the colonial period. The formula mapped onto the "spiritual" and "material" spheres (Gandhi and the Gandhians), and this distinction was more or less continued in a different form in a "dominance without hegemony" argument in which the "subalterns" inhabited a separate mental world from elites, colonial and "national" (Ranajit Guha),[3] or in another version in which the Indian "elites" are colonized and inauthentic, cut off from the true people by their "foreign" education and ideas.[4]

Clearly, from this perspective, histories of ideas in use in India cannot be about the interaction of various strands, taking place in a public domain in which spheres of communication are not separate—the

[3] Ranajit Guha, "Dominance without Hegemony and its Historiography," in *Dominance without Hegemony: History and Power in Colonial India*, ed. Ranajit Guha (Cambridge, MA: Harvard University Press, 1997), 60–80; Ranajit Guha, "On Some Aspects of the Historiography of Colonial India," in *Subaltern Studies I*, ed. Ranajit Guha (Delhi: Oxford University Press, 1982), 1–8.

[4] For instance, Ashis Nandy, "The Political Culture of the Indian State," *Daedalus* 118, 4 (1989): 1–26; Ashis Nandy, *The Intimate Enemy: Loss and Recovery of Self-Under Colonialism* (Delhi: Oxford University Press, 1983).

tendency is to assume the relatively stability and completeness of a set of ideas coming in from "outside." When such an idea is adapted in usage to something that is not immediately recognizable as the "original," it is perceived as a "misreading." One approach to avoid, therefore, is an "impact–response theory" (as Paul Cohen put it in the 1980s—he had then called for a more "Sino-centric" approach with an attention to mutual moving together of ideas, and without assuming that the "West" has an "impact" on "China": there are no stable sets of ideas, and a creative re-working of ideas is not a "distortion"; Cohen of course stated in later work that "Sino-centrism" has led in large measure to forms of indigenism, and that was not his point earlier).[5]

There is also often a sense that an idea has a supposedly recognized form, and so you assume that it moves in such shape. Instead, ideas develop as they move (in the 1920s, "communism" was hardly the Stalinized beast that is invoked with the term nowadays, so what was a "proper" set of communist ideas supposed to look like?) If the assumption is that there "ain't nothing like the real thing" outside the metropolis, then it is worth considering that we are making teleological readings on the basis of things that are not "fully developed" in the metropole—unless we know when an idea is "fully matured," after which, in the Stalinist sense, we can only be deviationists or revisionists.

As already mentioned, we need to address the problem of terminology. This can be confusing, as the same terms might be used by some protagonists in both metropole and periphery, but used for different ideas or different purposes, in different immediate contexts, or vice versa: different terms for the same thing. This is made more complicated in language switches, both literally and figuratively—as terms in different languages or idioms find themselves gravitating towards each other, one needs to develop a language to express new ideas in the language that's going to be used as the central (agitational?) language, even if it originates in another, and its resonances in the new language might be different. We need not to keep in mind the world as a language game, in

[5] Paul Cohen, *Discovering History in China* (New York: Columbia University Press, 1984); Paul Cohen, "Revisiting *Discovering History in China*," in *China Unbound: Evolving Perspectives on the Chinese Past*, ed. Paul Cohen (London: Routledge Curzon, 2003), 185–99.

which we are imprisoned in language alone, but that new experiences and new ideas require innovations of linguistic expression for someone in order to make sense of them. The problem of language thus has several dimensions: In a bi- or multilingual context, there is a question of translations of *terms*, and the gravitation of similar *ideas* toward one another, with the resultant transformation of both or all. There is the question of whether the term retains a *semantic range* that belongs to one group of users, from an earlier usage, whether for a bi- or multilingual set of users the term retains *all* of the semantic ranges in all the languages into which they now habitually and/or unconsciously translate the term, whether writer or reader can switch between these semantic ranges, and of course whether a historian can read the wider semantic range that is relevant for a particular communicative context. Then there is the question of what we might call a *language of legitimation*, in the sense of rhetorical register and political vocabulary: of what can be said in public, and to different publics, as opposed to what might be said outside those spaces, among people convinced of one's point of view.

We could summarize the set of problems we encounter with reference to a number of schools of thought that have been influential in studying ideas. The Skinner/Pocock school of thought stresses close attention to context, intention, and communication in addition to content. Political language, they stress, is always both normative and descriptive, and it is impossible to treat it as transparent across contexts. What is important is to read from the context in which a statement appeared what its author intended to say to the audience in their own times and spaces.[6] It is to be wondered how helpful these hints are in spaces where there is more than one audience to consider, and where a statement must operate across a number of contexts, linguistic, class, culture, etc. Here, different audiences would have their own conventions of reading statements; a stability of meaning cannot be predicted. In addition, there is the problem of the opacity of intention to the historian in retrospect: What we have is

[6] See James Tully (ed.), *Meaning and Context: Quentin Skinner and his Critics* (Cambridge: Cambridge University Press, 1988). Political language is both normative and descriptive; "liberalism," "pluralism," "democracy," "nationalism," etc. are normative claims that seek to legitimate political activity (that is, political "claims" are made in these terms) but are often in danger of lacking any agreed-upon descriptive content.

proclaimed intention, according to the normative rules of a given space, and it is a case, as Skinner himself might have put it, of tailoring your argument to fit an available language.[7] Given that intention may even be opaque to the subject himself or herself (if we take on board anything at all of the psychoanalytic tradition), we are in difficult territory.

According to the "*Begriffsgeschichte*" approach pioneered by the editors of the *Geschichtliche Grundbegriffe*, and associated with the name of Reinhart Koselleck, one cannot understand the politics of a given society without understanding the relevant political concepts or categories through which that politics is rendered intelligible and practiced: one must understand the key *Begriffe* with which a society speaks about itself.[8] This can end up as elite history at its strongest: The inflections of different groups of users of the same *Begriff* need to be grappled with, and of course a term that has specific specialist uses might be the same term that is in common circulation with a less rigid or wholly different set of meanings. The problem seems to be one of wanting to map *terms* too closely onto *concepts*, which is perhaps a problem of translation of "*Begriff*," which is both term and concept. The same term could refer to different concepts and the same concept could be rendered by different terms. The difficulties with the arbitrary sign have not been fully grappled with in this tradition, although *Begriffsgeschichte* makes something of the Saussurean distinction between the synchronic and the diachronic.

[7] Quentin Skinner, "Language and Social Change," in *Meaning and Context*, ed. James Tully, 132.

[8] On the issues involved, see for instance Reinhart Koselleck's programmatic introduction in Volume 1 of Otto Brunner, Werner Conze and Reinhart Koselleck (eds), *Geschichtliche Grundbegriffe: Historisches Lexikon zur politisch-sozialen Sprache in Deutschland* (8 vols., Stuttgart: Klett, 1972–1993), which many reviewers have pointed out is not entirely in consonance with the approaches of all contributors to the *Geschichtliche Grundbegriffe*. See also Reinhart Koselleck, "Richtlinien für das Lexikon politisch-sozialer Begriffe der Neuzeit," *Archiv für Begriffsgeschichte*, XI (1967): 81–99, and Reinhart Koselleck, "*Begriffsgeschichte and Social History*"in *Futures Past*, ed. Reinhart Koselleck (Cambridge, MA: MIT Press, 1985, transl. Keith Tribe), 73/91 (in original: Koselleck, "Begriffsgeschichte und Sozialgeschichte" in *Vergangene Zukunft*, ed. Koselleck [Frankfurt a. M.: Suhrkamp, 1979], 107–29).

This is not a school of thought that can grapple with the problems of translation; there is a certain arbitrariness in its identifying a set of users, and an elitism of assuming that terms have a set of agreed-upon meanings even within the same linguistic context.[9]

Things begin to look even trickier if we begin to consider Michel Foucault's idea of a "discourse" as not what is explicitly said, but the implicit assumptions that confine what we can plausibly think, let alone say, within certain boundaries.[10] How does a historian read the silences without imposing their assumptions on the readings? And if we look at Roland Barthes' studies of surrounding sets of semiological significances, of *surplus meanings* in what he formulated as the hamburger and caviar question, we are indicating our problem of different, coexisting, and overlapping semantic ranges.[11]

I am not suggesting that there are no potential answers to a number of these questions from within the traditions mentioned earlier, if they are handled flexibly. The intention here is not to adopt or exonerate any particular school(s) of thought, but to set up a series of questions. In the remainder of this essay, I shall try to exemplify some of these questions: in particular, I shall engage with the question of alleged inconsistency, and of that of potential sources for the intermediate intellectual histories that we propose to examine.

[9] An assessment of the possibilities of *Begriffsgeschichte* from the early 1990s stressed "the extraordinary difficulty of translating the meaning of terms and concepts from one language into another, from one cultural tradition into another, and from one intellectual climate into another." Detlef Junker, "Preface," in *The Meaning of Historical Terms and Concepts: New Studies on Begriffsgeschichte*, Occasional Paper No. 15, eds Hartmut Lehmann and Melvin Richter (Washington, DC: German Historical Institute, 1996), 6.

[10] Michel Foucault, *The Archaeology of Knowledge* (London: Tavistock, 1972) [1968]; Michel Foucault, *The History of Sexuality*, Vol. 1 (New York: Pantheon, 1978 [1976]).

[11] Roland Barthes, *Mythologies* (transl. Annette Lavers) (New York: Hill and Wang, 1972 [1957]).

Travelers with Ideas: A Few Examples

One can piece together a reasonably clear narrative on the activities of Indians in exile in Europe in the interwar period—and this choice of geographical area for the purposes of this essay is a relatively arbitrary example for which there happens to be some secondary literature, in addition to being an area for which I am somewhat familiar with the primary sources. The narrative, greatly truncated for the purposes of this essay, runs as follows: Indians from the United States and Europe, and some who were in Germany before the war, started to gather in Berlin at the outbreak of the First World War to use the opportunity to subvert the British Indian Empire. The German government was happy and willing to use them to further their cause. Clusters of Indian exiles built up in Berlin, and to some extent in Switzerland. They built on the groups and connections created earlier by the revolutionary terrorists in London and Paris, in particular the group surrounding the architect of the London and Paris "India Houses," Shyamji Krishnavarma, though he himself stayed aloof from the German-Indian machinations, remaining in Switzerland, claiming old age (this was in part the world Vinayak Damodar Savarkar left behind when he was arrested). The Ghadar networks, created among others by Har Dayal, who also made his way to Germany at the outbreak of war, also became the basis for some of these activities.[12] After the First World War they stayed on in Europe—many were more or less stranded in Europe, because as "seditionists" potentially facing charges of treason, they could not return to India. The new Weimar government could not just get rid of them—they were part of the German foreign relations system in some ways, and although they were awkward customers to have around, they could not be entirely disowned or expelled without good reason. Occasionally, due to pressure from

[12] Tilak Raj Sareen, *Indian Revolutionary Movement Abroad (1905–1920)* (New Delhi: Sterling, 1979); Nirode K. Barooah, *India and Official Germany 1886–1914* (Frankfurt: Lang, 1977); Nirode K. Barooah, *Chatto: The Life and Times of an Indian Anti-imperialist in Europe* (New Delhi: Oxford University Press, 2004); Emily C. Brown, *Har Dayal: Hindu Revolutionary and Rationalist* (Tucson: University of Arizona Press, 1975); *Politisches Archiv des auswärtigen Amtes* [PA-AA], Berlin: WK11f; WK11s.

the British government, the German government made a few moves to make things difficult for the exiles. Some made successful appeals to be allowed to return home, such as Bhupendranath Datta, others, such as Har Dayal or Chattopadhyay, never made it back.[13] Some of the exiles became active in the communist movement. Some were more amorphously anti-British or anticolonial, perhaps nationalist without entirely defining a positive content to their nationalism. They set up organizations of Indians for political purposes, with front organizations that were intended to promote trade, or student welfare, or were in fact companies that traded things as diverse as furs or live animals to the Hamburg Zoo (legally) and arms (illegally).[14] Over the interwar period they were joined by other activists (Soumyendranath Tagore, ACN Nambiar). Some were ideologically clear in their choices (Chattopadhyay remained a communist, and died in a Stalinist gulag).[15] Others were less so. Many were influenced by Italian fascism and German Nazism. Some stayed in Europe into the Second World War, and clustered once again in Berlin under the Nazi regime to subvert the British Empire, although it was unclear to what extent they accept Nazi ideas. After the Second World War, they returned to India. Some became important in the new Indian republic; Nambiar became the Republic of India's Ambassador in Bonn.[16]

Many of the existing narratives focus on those who led movements, on those who were articulate and active, and on activities rather than ideas. It is nevertheless expected of such persons that they are relatively coherent and consistent in their positions; it is not always the case that they were. But there is more to be said in this regard. The term "elite" is used historiographically as a delegitimator: Because historically certain actors were important enough to leave substantial traces on the historical record, they must retrospectively be reduced to an unrepresentative (of nationalism? Of democratic or revolutionary aspirations?) "elite" by those of us who claim to write histories of "the people." This act of

[13] National Archives of India [NAI], New Delhi: External Affairs (External), 1939, 234-X (Secret); IOR: L/PJ/12/221, British Library, London.

[14] See file on Indo-Swiss Company; IB Sl. No. 9/1920; File No. 167/20, WBSA, Calcutta.

[15] Barooah, *Chatto*, 320–22.

[16] Oral History Transcripts: ACN Nambiar, Nehru Memorial Museum and Library, New Delhi; IOR: L/PJ/12/73–74, British Library, London.

normative inversion is not always justified: Elite and nonelite are relational categories, statuses can change as people travel through different contexts, and *one can often lose elite status in cases where one moves context*. Social status is thus not completely transferable, although some abilities (language skills or literacy, for instance) might equip persons better to adapt to and make their way in new contexts.[17]

But not all testimony or surviving narrative is necessarily "elite" either, and if it is, relationally speaking, elite, then perhaps there is more to be said on the distance between a leadership and a set of people whose casual and partial engagement with that leadership, or with the environment of ideas in which both operate. These are often the carriers of ideas at a more informal level. And this might well be the point: *Whereas an argument made at a consistently philosophical level in a forum dominated by textual exchanges is easier to trace in retrospect, it may well be the least effective way in which an idea can travel.*

Since much of the activity I seek to study is either actually illegal or takes place underground or both, it is sometimes hard to find traces of opinions actually recorded, or actually recorded when they go against the grain of the legitimate political language of the time and context. Much of the material that makes its way to us is filtered through what Ranajit Guha called the "prose of counterinsurgency."[18] Only the police and intelligence agencies that gathered the material had an interest in *letting the subject speak for themselves*, not least in pursuit of the legal basis for prosecution. As a result, the "colonial state" perpetuates different voices: *its own, at various levels, which turn out often to be different voices*; and those of the insurgent, *whom the colonial state requires to speak for themselves, but who must speak in the formulaic language of the state (or at least in what he understands to be this language) in order to protect themselves*. This can be seen as "approver's testimony,"[19] or

[17] Franziska Roy, "South Asian civilian prisoners of war in First World War Germany," in *When the War Began We Heard of Several Kings*, eds Franziska Roy et al. (Delhi: Social Sciences Press, 2011), 53–95.

[18] Ranajit Guha, "The Prose of Counter-Insurgency," in *Subaltern Studies II*, ed. Ranajit Guha (Delhi: Oxford University Press, 1983), 45–88.

[19] Shahid Amin, "Approver's Testimony, Judicial Discourse: The Case of Chauri Chaura," in *Subaltern Studies V*, ed. Ranajit Guha (Delhi: Oxford University Press, 1987), 166–202.

more usefully, a way of gesturing to the requirements of the formulas of communication that protect an individual from the powers of the state that he seeks to resist[20]—a phenomenon that has been examined, for instance, in the conventions of the petition letter.[21] There is, thus, a delicate act of sifting to be done by a historian who reads an alleged "prose of counter-insurgency" in the voice of the state reproduced, or to some extent subverted, by the subject, who themselves have to learn to use and reproduce the language that will to some extent formularize the encounter—in order *not to speak*.

The following is an excerpt from a copy of Special Branch, Madras, officer's report, dated Dhanushkodi (port), October 4, 1929. It was routine for police authorities to keep a complete record of all Indians entering and leaving India, and for historians it can be quite convenient that such invasions of privacy left traces, indeed even narratives, albeit refracted through the report of the interviewing policeman, or the unknown police informer, to whom the information was divulged. The report states that:

> T.K. Roy, s/o Taraknath Roy, 87 Park Street, Calcutta—Indian student returning from abroad.
>
> This individual arrived at Dhanushkodi from London via Colombo on 4.10.29 having graduated as an Electrical Engineer from Sheffield University. He took an apprentice course in a German factory and spent about a month in Berlin. His travel and studies abroad for nearly two years and his own observations of the state of affairs in India have, he says, convinced him that India cannot exert any influence among the nations so long as she remains a subject country and that British administrators in India do not represent the real mind of the British people at large. Roy is of the opinion that the average Britisher knows nothing about India and its importance in relation to his own country. All the friction between the ruling and ruled nations is due entirely to the exploitation of British Bureaucrats in India. From the trend of his talk it would appear that Roy is rather disaffected with the British administration of India.

[20] Roy, *Several Kings.*

[21] Majid Siddiqi, *The British Historical Context and Petitioning in Colonial India* (Dr M.A. Ansari Memorial Lecture), (New Delhi: Jamia Millia Islamia, 2005).

He further said he happened to see Raja Mahendrapratap in company with one Chatterjee [a margin note adds: Virendra] at the Indian (Hindustan) Association Berlin about a month ago. He was pointed out to be the Indian Ambassador abroad. Roy learnt that these two individuals were exiles having been forbidden by the Government of India from entering India. This Chatterjee is reported to be connected with the Pacifist Movement which draws together the Subject Countries and Minor States in an alliance against the great powers. Roy says the movement indirectly fights against Imperialism.

These two exiles met the Indian students at the association in connection with a tea party; had personal talk with the members assembled, enquiring about their welfare and native place. Roy was not much impressed by the personality of Mahendra Pratap; but learnt that this exile has been fomenting trouble against the British in China and Afghanistan.

The report goes on to say that nothing incriminating found in his luggage and that he went to stay a day or two with another Mr Roy, an engineer, in Madura.[22]

The interesting part of such stories is that the subject is being examined for what he *thinks*, not what he has done, because what he thinks is perhaps a clue to what he might in the future do. And since the subject is aware of what he is being examined for, he is able to avoid saying what he doesn't want to—which is of course easier in an interview

[22] IB Sl No. 44/1928, File No. 53/28, ff. 150-149, WBSA, Calcutta. The same Tarun Kumar Roy, recorded a couple of years earlier as the son of late Tarak Nath Roy of Arkandi, Faridpur, and of 67 Dhurrumtolla St, Calcutta, applied for a passport to visit England via Italy, Switzerland and France in 1927. No objection was raised; the only information on record being from an Intelligence Bureau agent who stated that on May 21, 1924, the said person was present at a meeting attended, among others, by S.C. Sengupta, friend and assistant of the communist leader Muzaffar Ahmed. SB office letter signed SHH Mills to MF Cleary, Personal asst to director, IB, Shimla. Dated Calcutta October 17, 1927. IB Sl No. 44/1928, File No. 53/28, f. 158, WBSA, Calcutta. It is possible that the police did not associate the two, but more probable that he was watched for that reason; also, he was alert enough in the interview with the police on his return to India not to pretend that he had not met the subversives he was suspected of having met, saying instead that he was unimpressed by them.

with a policeman than in a conversation with an informant he doesn't know is one. Either way, the question of what a legitimate language of political expression is, and how to stay on the right side of that line, plays an important role. But given corroborating evidence of what a person said or did, or the circles in which he (or occasionally she) moved, one can read an avoidance as an awareness of what must not be said—which is good information on the context in which any statement had to be placed.[23] You would not, of course, say the same thing to a policeman as to a fellow traveler, but such conversations are less often recorded unless the fellow traveler turned out to be a police informant, as the following case, of one Dr M. Ukil, shows.[24]

This Ukil was the then director of the Tuberculosis Enquiry conducted by the Indian Research Fund Association and was deputed by Calcutta University to travel extensively for tuberculosis research. He was a Bengali who has been abroad more than once. The narrative, from a "source" (an informant), suggests men at ease with their surroundings. Ukil gave Monoranjan Gupta (on record as a supporter of the "terrorist movement" and a major figure in the "Saraswati Press"[25]) an account of Indian students abroad (after Gupta had told him about the successes of the Civil Disobedience Movement and asked whether the

[23] Skinner, *Meaning and Context*, 119–32. This is not a world of stable political terms in which one has an accepted set of *Begriffe* whose usage one can unproblematically trace: See on this question, though not in the South Asian context, Melvin Richter, "Reconstructing the History of Political Language: Pocock, Skinner and the *Geschichtliche Grundbegriffe*," *History and Theory* 29, 1 (February 1990), 38–70.

[24] W.R. John, office of Dy Insp-Gen of Police, Rys & CID, Madras, June 17, 1930, to Cowgil, Personal Asst to DIB Simla, copy to Bengal IB DIG, with enclosure of a report on one Prof Ukil, who travelled with one ER Mahajani [information not on file] and left India via Dhanushkodi on 23 July 1929, f.173. Enclosure, "Copy of a report from a source, regarding Prof. Doctor Ukil, and Manoranjan Gupta," ff.172–171. IB Sl No. 44/1928, File No. 53/28, WBSA, Calcutta.

[25] See file on Saraswati Press, connected to the Saraswati Library, which handled anarchist and communist literature from abroad, and the publications of various radical groups in India. IB Sl No. 115/1923, File No. 368/23, WBSA, Calcutta.

mystic, Aurobindo, might come back into politics—Ukil, who had been in Pondicherry on his tuberculosis travels, said no).[26]

Ukil had more to say on Indian students abroad and the state of world politics:

> He was full of praise of the new spirit in Germany and told Gupta that not-withstanding the international pressure to stifle her growth Germany was today becoming a virile and most powerful entity. He told Gupta that by a system of gymnasium and physical exercise the youth of Germany was today becoming sturdy and in that way a new race was coming to the fore. Ukil stated that it was his intention to write a series of books on student life abroad and on the adoption of a system of physical regeneration by the Indian people. When Gupta asked Ukil whether the Indian case for immediate independence had the sympathy of the French and whether they would be able to materially help Indian workers [sic]. The latter replied that France had no sympathy with the Indian nationalist movement much less with the revolutionary programme of the Independencewalahs. The truth was French Imperialists were afraid of the civil disobedience movement penetrating into their colonies. In Germany, there was genuine sympathy for Indian leftwing aspirations. Ukil told Gupta that at Munich a book called Gandhi Revolution was selling like hotcakes [sic]. Interest in Indian matters had been recently roused to a great extent.

> Ukil expressed surprise that Indian revolutionaries had not yet come to the fore as he expected an epidemic of terrorist outrages. Gupta stated that while it was true that there was not much of activity in that line yet it would be a mistake to presume that the revolutionaries are dormant. Gupta told Ukil that Gandhi was compelled to launch the present civil disobedience campaign only by the growing influence of the Revolutionary Party under the guidance of Subash Bose.[27]

Here was a mixture of support for a Gandhian movement, an endorsement of violence, and an implicitly eugenicist argument that, in some readings, could be seen as an endorsement of the rising National Socialist movement in Germany, though that might not be quite clear

[26] IB Sl No. 44/1928, File No. 53/28, f.172, WBSA, Calcutta.
[27] IB Sl No. 44/1928, File No. 53/28, ff.172–171, WBSA, Calcutta.

from the references to race and physical fitness that cut across such political divides at the time. The report further stated that:

> Enquiries show that Doctor Ukil was given a commission during the war and that when he was about to board a steamer at Bombay he was arrested and detained under the Defence of India Act. According to Gupta Ukil was in touch with the old revolutionary groups in Bengal and during war time was extremely helpful to those quarters. Ukil is in touch with workers for India abroad including Sailendranath Gosh [sic] and Chattopadhyaya.[28]

If we are to regard a strange mixture of ideas that the zeitgeist made available as the normal context for its times, we are engaged in a form of history of ideas that is not as rarefied as that which studies the well-worked-out academically respectable and properly footnoted ideas of traditional intellectual history; but in both cases, the question of their social impact needs asking. Who was it who came into contact with these ideas? And what difference did it make to anything? Are we, in asking this, instrumentalizing ideas? Or are we, instead, asking what forms of action are enabled by certain political ideas' acceptability or unacceptability? I have argued elsewhere that an often unselfconsciously held set of eugenicist assumptions enabled a form of thinking about "development" that could instrumentalize the "masses" even as "development" was to be conducted in the name of the masses and for their future prosperity.[29]

Consistency is perhaps not what one is looking for at this in-between or intermediate level. Consider the following:

> Satyendra Bimal Sen, son of S.B. Sen, of Feringi Bazaar, Chittagong, arrived in Madras via Dhanushkodi on the 2nd instant, and left the same day for Calcutta by Mail.
>
> From an interview by a source it was gathered that he left India about six years ago, for Europe, where he qualified himself as a Locomotive engineer, and now hopes to obtain employment in the Railway Services after interviewing the Railway Board [sic].

[28] IB Sl No. 44/1928, File No. 53/28, ff.171, WBSA, Calcutta.

[29] Benjamin Zachariah, *Developing India: An Intellectual and Social History, c. 1930–1950* (Delhi: Oxford University Press, 2005).

> While in Berlin he came in contact with several Indian revolutionaries and was deeply impressed by the simple life of M.P. Tirumal Achari.
>
> He enquired about the Independence movement in this country, and stated that Britishers are afriad [sic] of it, and that many in Manchester were starving on account of it.
>
> He was wearing foreign clothes at the time, and seemed to be ashamed of the fact, as he advanced a plea that he was unable to secure Khaddar suits in Colombo.
>
> He seems to be inclined towards carrying on of anti-British propaganda.[30]

Tirumal Acharya was no Gandhian (and it could be argued that his "simple life" was related to his poverty as much as to any ideological imperative, though perhaps this was not widely known). Sen himself took only a part of Gandhi's teachings on board: Khaddar, but a government job.[31] Had this man indeed been set on a life of "anti-British propaganda," this propaganda might not have looked very coherent; but if we are interested in the set of engagements represented in this statement, coherence need not concern us. The urge to self-sustenance (a job), the emotional and political engagement with Indians in exile (the simple life of Tiramul Acharya), and nationalist sentiment (the urge to self-respect) are at any rate psychologically compatible, if not always intellectually so.

Asia and the World

One of the most colorful examples of traveling ideas can be provided by the exile Mahendra Pratap and Pan-Asianism, in his version. Ideological coherence has not been considered a particular virtue of Mahendra Pratap's, although he had some relatively constant concerns through his long period of exile, notably the ideal of Pan-Asianism as the first step

[30] Strictly Confidential. Office of the Dy Insp-Gen of Police, Railways and CITD Mylapore, Madras, dated February 5, 1931, signed "John," to MK Johnston, Spl Asst to DIG of Police, IB, Bengal. IB Sl No. 44/1928, File No. 53/28, f. 203, WBSA, Calcutta.

[31] Working for the government had of course been denounced by Gandhi in *Hind Swaraj* (1909), as also earlier by the Swadeshi movement.

toward a world federation.[32] Pratap operated largely in an Asian environment, although he was in and out of Europe as well.

In 1929, it was concluded by the Intelligence Bureau that "the Pan-Asiatic League is supporting the cause of the U.S.S.R."[33] In the Far Eastern Mail arriving at the GPO Calcutta on July 17, 1929, a packet was intercepted addressed to the Editor, "The New Forward," 19 British Indian Street, Calcutta. It contained one copy of the *Weekly News Bulletin* Vol. V No. 15–16, dated April 15–22, 1929 published by Press Section of the Society for Cultural Relations with Foreign Countries, and one copy of the *Economic Review of the Soviet Union*, Vol. IV No. 8 dated April 15, 1929, published by the Amtorg Trading Corporation, 165 Broadway, New York City, and these were wrapped up in a copy of a leaflet entitled "Declaration of the Pan-Asiatic League"—emanating, judging by the writing on the cover, from Rash Behari Bose in Japan.[34] The leaflet urged all Asian peoples to unite and come together to stop British machinations to deprive King Amanullah Khan of Afghanistan of his throne, and said the British wanted to prevent a modern, progressive Afghanistan from coming into being, which might obstruct British imperialist designs. The leaflet urged readers to help Amanullah "by all legitimate means" to regain his throne. It was signed by the "Board of Directors of the Pan-Asiatic League," whose president was one Kungshu Whang, and its directors, Rash Behari Bose and M. Pratap.[35] Afghanistan, it might be recalled, was one of the bases from which a German-sponsored Indian armed force was to have successfully invaded India during the First World War; also, Mahendra Pratap had, on his exile from India, taken Afghan citizenship.

[32] For a sense of these engagements, see Pratap's autobiographical writings: Raja Mahendra Pratap, *Reflections of an Exile* (Lahore: Indian Book Co., 1946); Raja Mahendra Pratap, *My Life Story of Fiftyfive [sic] Years (December 1886–December 1941)* (Dehradun: World Federation, 1947). Also Carolien Stolte, "'Enough of the Great Napoleons!' Raja Mahendra Pratap's Pan-Asian Projects (1929–1939)," *Modern Asian Studies* 46, 2 (2012): 403–23.

[33] IB Sl No. 126/29, File No. 234/29, f.3. note, July 30, 1929, WBSA, Calcutta.

[34] IB Sl No. 126/29, File No. 234/29, f.16, 'F.P. Mc.' To Cleary, July 23, 1929, WBSA, Calcutta.

[35] IB Sl No. 126/29, File No. 234/29, ff. 15–4, WBSA, Calcutta.

How did this version of a progressive Pan-Asianism fit into Japanese versions in their "Greater East Asia" policy? It didn't. Mahendra Pratap, however, interpreted it differently, at least in 1933, on a tour of Manchukuo, reported on assiduously by British consular authorities:

> Mr. Pratap advocates freedom for the Asiatic races not only politically, but also socially and economically. He calls on the Asiatic nations to unite in order to cast off the yoke of European and American domination which, he claims, is responsible for the present division in Asia and the confused state of affairs in China. In Japan he naturally sees the leader who should lead the Great Asia Movement.[36]

Pratap was accompanied by one A.M. Nair and a Mongol Lama named as Yang Chin-tsang. In Hsinking (Changchun), he spoke on June 6.[37] Then he returned to Mukden and made speeches alongside Nair to the Manchukuo Association, attended by students.[38]

> The speakers [Pratap and Nair] dwelled on the oppression of the Indians by the British, the fundamental unity between the Japanese and the Chinese, which had only been disturbed by foreign influences, the benefits which would result from a prosperous Manchukuo and above all the need for the races of Asia to combine to throw off the yoke of the White Races.
> Pratap spoke mostly in English, his efforts in Chinese being barely intelligible to the Consulate writer, and Nair at one meeting in Indian [sic] and at the other in Japanese.[39]

According to a further report, Nair "graduated from the Engineering College of the Kyoto Imperial University in March 1932 and now works for the Kurimoto Iron Works in Osaka." The report continued:

> outwardly the main object of Pratap's tour [in Manchuria] is to preach the doctrine of "Asia for the Asiatics", to which many Japanese seem to listen

[36] Letter, 7.6.33, from Consul-General A.G. Major in Mukden, Manchukuo, to Sir Miles Lampson, British Delegation, Peking, on a report of the Manchukuo News Service, IOR: L/PJ/12/16, f.22, British Library, London.

[37] L/PJ/12/16, f.22

[38] Major to Lampson, June 21, 1933, L/PJ/12/16, ff.23–24.

[39] Major to Lampson, June 21, 1933, L/PJ/12/16, ff.23–24.

with no unwilling ear nowadays, if indeed they are not actually sponsoring the movement.

It would presumably be denied that Mr. Pratap is receiving any official encouragement and it is probable that his utterances receive the close attention of the police, lest he should venture beyond a denunciation of mere British imperialism to attack the more active imperialism of Japan. But there seems little doubt that his intention is to foster Anglo-Japanese discord, under the guise of Pan-Asianism, and there is no suggestion that the Japanese or their new offspring the Manchukuo, will do anything to hinder the dissemination of doctrines of this nature, if indeed they do not actively welcome them.[40]

In using a Japanese rhetoric of Pan-Asianism, without pointing to its obvious contradictions, Pratap was not necessarily on steady ground, and British consular reports about the possibilities of discord proved relatively correct. Pratap spoke to a delegation of the local Press at Harbin, after his arrival on June 10. He

explained to them that his object in coming to Manchuria was to promote the Pan-Asiatic movement under the leadership of Japan. Dwelling on the oppression of Asiatic races by Western Powers, he cited Great Britain as the principal offender, and referred to Soviet Russia as a champion of the cause which he had at heart. The rajah was apparently unaware that the majority of his audience consisted of "White" Russians, and his tactless reference to their great enemy provoked from one of the reporters present a sharp question as to whether the rajah had in mind the activities of the Soviet Government in Outer Mongolia. The answer is not recorded...

After the interview was over, the White Russian Press representatives lost no time in reporting to the Japanese authorities Mahendra's reference to Soviet Russia; and it is possible that in consequence of this indiscretion his visit to Harbin was curtailed.[41]

Thus, in stepping outside the boundaries of legitimate political expression in the political context in which he was operating, Mahendra Pratap found himself unable to continue to reach his audiences.

[40] M.E. Dening, British Consulate, Dairen to H.B.M. Charge d'Affaires at Tokyo, June 6, 1933, L/PJ/12/16, ff.30–31.

[41] F. Garstin, Consul-General, H.B.M. Consulate General, Harbin, to Sir Miles Lampson, H.M. Minister, Peking, June 21, 1933, IOR: L/PJ/12/16, ff.41–42, British Library, London.

Mahendra Pratap was widely considered a well-meaning but difficult personality in his own times. "Mahendra Pratap's activities are of course ludicrous," Jawaharlal Nehru wrote to Viren Chattopadhyay in 1928. "He seems to be a good-hearted and straight individual but entirely lacking in grey matter in the brain. I do not take him seriously at all."[42] These comments, of course, come from communication between two men whose ideological proclivities were clearly on the left, and who were trained to separate left and right, idealist and materialist, and so on. This latter sort of internationalism is what we are most familiar with, and what we are inclined to recognize and to value—in retrospect.

Some Conclusions

If we are to regard a strange mixture of ideas that the zeitgeist made available as the normal context for its times, we are engaged in a form of history of ideas that is not as rarefied as that which studies the well-worked-out academically respectable and properly footnoted ideas of traditional intellectual history; but in both cases, the question of their social impact needs asking. Who was it who came into contact with these ideas? And what difference did it make to anything? Are we, in asking this, instrumentalizing ideas? Or are we, instead, asking what forms of action are enabled by certain political ideas' acceptability or unacceptability?

If it's so tricky to try and trace ideas at this nonintellectual, and to some extent nonelite level, why bother? Is it worth the effort? Or is it just an exercise in speculating or sifting through various levels of refraction? Perhaps histories of ideas that are also social histories must be histories of ideas that are actually in circulation at a level at least relatively accessible to relatively non-educated people, those who don't read all the theory and write books and articles themselves, but who have some acquaintance with the ideas concerned. We are trained, perhaps, to hear

[42] Jawaharlal Nehru to Virendranath Chattopadhyay, AICC Files, on League Against Imperialism (XI), 1929, Nehru Memorial Museum and Library, copies of letters intercepted by the Bombay Government, copy in Archives on Contemporary History, Jawaharlal Nehru University, New Delhi.

resonances or dissonances with the "real thing": eugenics as practiced in elitist circles or laboratories, Nazi ideas of race, the incompatibility of Japanese imperialism with Soviet-style liberationism—and it might well be said that both the resonances and dissonances are the result of seeing the whole to which the part is connected in the "complete" idea (as discussed earlier). Why are we allowed to assume, however, that these resonances and dissonances are not available to those who do not observe the boundaries that their perception of the resonances and dissonances *should* lead them to? Had they been academics or intellectuals, they might have taken the time to tell us. But is this a process of selection, appropriation, disassembly or reassembly, or is it necessarily a failure to "get the ideas right"?

Unfortunately, in most cases we don't know whether the protagonists in these in-between spaces, neither academic nor entirely popular, had read the "real thing" (a foundational text, perhaps—*Mein Kampf? The Communist Manifesto?*) and had *decided* to use apparently contradictory ideas in a self-conscious or at least deliberate way, or had collected elements in a more accidental way. But if we are interested in a social milieu (which includes, surely, ideas that are commonly held), we need to try and find these ideas in unrewarding sources, and accept their contradictoriness, their inconsistencies, the sometimes happy coexistence of the progressive and the regressive, rather than look for the ideas cleaned up and presented in academically compatible forms.

There is much more to be said: on the question of translations and the consequences of multilingual contexts of communication; on networks and mechanisms of the circulation of ideas, of attempts to divert, censor, or suppress ideas; and perhaps most importantly, on the assumption that it is "elites" who absorb, receive and transmit ideas. But these are best saved for a later essay, and many of these points are exemplified in other essays in this volume.

2

India and the League Against Imperialism: A Special "Blend" of Nationalism and Internationalism[*]

Michele L. Louro

On February 10, 1927, the Congress against colonial oppression and imperialism met in Brussels in an effort to bring together a diverse collection of anticolonial nationalists, socialists, communists, and leftists

[*] I accumulated many debts in the writing of this essay. I am indebted especially to Ali Raza, Franziska Roy, Carolien Stolte, Maia Ramnath, and Benjamin Zachariah. I also owe special thanks to Howard Spodek, who read and commented on many drafts of this paper, as well as Richard Immerman, Lynn Hollen Lees, and Thomas Metcalf for guidance. For comments in panels and various presentations along the way, I am thankful to Mrinalini Sinha, Daud Ali, David Engerman, Durba Ghosh, Brad Simpson, Jason Parker, Vijay Prashad, and Maria Framke. None of this research would be possible without the support of the U.S. Fulbright Program, the Center for the Study of Force and Diplomacy (CENFAD) at Temple University and Salem State University.

to unite against the imperialist powers of the interwar world. The Congress was significant for many reasons. The nearly 170 delegates attending Brussels came from some of the most influential and radical mobilizations of the time. Well-known figures such as Mohandas Gandhi, Albert Einstein, Ernst Toller, Romain Rolland, Upton Sinclair, and Madame Sun Yat-Sen sent messages of support. The Congress also marked an unprecedented moment of encounter for representatives from colonies, mandates, and dependencies in Asia, Africa, and Latin America as well as North American and European social reformers concerned with working class and racial equality. Ultimately, the proceedings laid the groundwork for further anti-imperialist collaboration worldwide and established the League Against Imperialism (LAI) as the institutional home to coordinate the politically and geographically diverse membership.

The Brussels Congress Chairman, George Lansbury, delivered the keynote address. He called for the breakdown of boundaries between representatives of the working class and oppressed nations in order to challenge the symbiotic forces of capitalism and imperialism. He especially appealed to his comrades from the colonies: "Do not be fooled by the cry of mere nationalism.... Get your national ownership, get your national control, that is right and proper, but do not stop there because if you do you will have only gone half way." Instead, Lansbury emphasized that "nationalism is to be blended with internationalism, because until it is, until the world is built on the foundation of international comradeship ... all our Labour is in vain."[1]

Lansbury was not alone in the endeavor to "blend" nationalism and internationalism in an effort to challenge imperialism worldwide. Jawaharlal Nehru, the Indian National Congress representative to Brussels, echoed the chairman's sentiment in his press statements by arguing that India's "nationalism is based on the most intense internationalism."[2] Increasingly after the Brussels Congress, Nehru's letters

[1] George Lansbury, Presidential Address to the Congress against Colonial Oppression and Imperialism, Brussels, File G-29 1927, All-India Congress Committee (AICC) Papers, Nehru Memorial Museum and Library, New Delhi India. (Here after AICC).

[2] Nehru, Press Statement made in Brussels, February 9, 1927, *Selected Works of Jawaharlal Nehru*, Vol. 2, (New Delhi: Orient Longman, 1972), 280. (Hereafter cited as *SWJN*).

and publications to Indian audiences underscored the need to think internationally and avoid the "dangers of narrow-minded nationalism."[3]

The history of Nehru's special "blend" of Indian nationalism and anti-imperialist internationalism is the focus of this essay. Although Lansbury, a key figure of the British Labour Party, intended for international socialism to be the basis of the "special blend," Nehru and others in Brussels found anti-imperialist internationalism to be a more effective and inclusive framework for uniting working class and nationalist mobilizations. The League's anti-imperialist internationalism opened a unique opportunity for dialogue and collaboration across politically divisive borders that separated socialists, communists, and nationalists. Certainly, the League produced neither a wholesale conversion of anti-colonial nationalists to socialism or communism, nor did it entirely dispel mistrust amongst the leaders of the international proletariat toward their bourgeois counterparts from the colonies. However, the League's anti-imperialist platform provided a meeting ground for individuals and organizations to rethink new ways of connecting with like-minded leftists across and through political and territorial boundaries. For Nehru, access to the internationalist platforms and anti-imperialist networks of the League, itself, became a defining feature of his nationalist campaign against the restrictions of the colonial state. Through the LAI, he also developed for the Indian National Congress (INC) a set of contacts and networks with anti-imperialists that endured beyond the interwar years.

A reading of Nehru and the LAI offers a refreshing case study for thinking about interwar internationalism with and through the nation. For Nehru, the League experience accentuated the interplay of anti-imperialist internationalism and Indian nationalism. In other words, nationalism and internationalism were not mutually exclusive, but overlapped and informed one another. Central to this point is the underlying argument that the meaning of Indian nationalism developed not only in relation to people within Indian borders, but also in relation to the world beyond its borders. One of the striking characteristics of histories of anticolonial resistance in India, particularly in the wake of areas studies

[3] He often deployed this critique of the Indian National Congress in his writings in 1927. See, for example, Nehru, "On the Indian Situation," in *SWJN*, Vol. 2, 297.

and subaltern studies scholarship, is the concentration on the local, provincial, and national dimensions of the subcontinent.[4] While these micro-histories have challenged scholars in profound ways, the people and ideas that worked across and through such boundaries of the local and national have been neglected.[5] Instead, this essay seeks to widen the frame for analyzing Indian history by examining the significance of anti-imperialist internationalism to Nehru.

A study of the LAI also necessitates a broader conceptualization of internationalism. It has been fashionable in recent scholarship to cast historical events and characters as transnational, global, or international. This essay opts for the term internationalism to characterize the anti-imperialism that Nehru adopted during the interwar years. First, internationalism, as Lansbury's statement eloquently demonstrated, was the language that the members of the League used to characterize their movement. Secondly and more significantly, internationalism best describes the collaborations forged within the League. Internationalisms are projects much like nationalisms. There is no dearth of literature on nationalism as a project seeking to assimilate citizens into a shared

[4] Seminal works on the fragments of Indian nationalism include Ranajit Guha and Gayatri Chakravorty Spivak (eds), *Selected Subaltern Studies* (New York: Oxford University Press, 1988); Partha Chatterjee, *The Nation and its Fragments: Colonial and Postcolonial Histories* (Princeton: Princeton University Press, 1993); *Nationalist Thought and the Colonial World: A Derivative Discourse?*(Minneapolis: University of Minnesota Press, 1986).

[5] There are some recent notable exceptions. See Maia Ramnath, *Haj to Utopia: How the Ghadar Movement Charted Global Radicalism and Attempted to Overthrow the British Empire* (Berkeley: University of California Press, 2011); Mrinalini Sinha, *Specters of Mother India: The Global Restructuring of an Empire* (Duke University Press, 2006); Thomas Metcalf, *Imperial Connections: India and the Indian Ocean Arena, 1860–1920* (Berkeley: University of California Press, 2007); *Beyond Sovereignty: Britain, Empire and Transnationalism, 1880–1950,* eds Kevin Grant, Philippa Levine, and Frank Trentman (New York: Palgrave, 2007); *De-centering Empire,* eds Durba Ghose and Dane Keith Kennedy (Hyderabad: Orient Longman, 2006); Sugata Bose, *A Hundred Horizons: The Indian Ocean in the Age of Global Empire* (Cambridge: Harvard University Press, 2006); and *Cosmopolitan Thought Zones: South Asia and the Global Circulation of Ideas,* eds Sugata Bose and Kris Manjapra (New York: Palgrave Macmillan, 2010).

spatial and cultural imaginary within a set of territorial borders.[6] Internationalism, too, aims to construct an imagined community sharing in a common historical experience and future. However, for internationalism, the boundaries of the community extend beyond the territorial borders of nations.

Internationalist imaginings might also be understood in contradistinction to interstate relations. The role of the state is significant here. Interstate relations—often misleadingly referred to as internationalism—are the interactions between states. This necessitates a different set of approaches, practices, and ideas than those deployed by internationalism. Interstate platforms recognize difference, negotiate state interests, and establish normative relations between nation-states as distinct, geopolitical units.[7] The League of Nations (LON), for example, was the preeminent interstate platform of the 1920s.[8] In contrast, the LAI appealed to delegates to think beyond state borders and to create a space for the shared and universal commonalities that could break down geographic, ideological, and territorial boundaries among constituent members.

[6] The seminal text is Benedict Anderson, *Imagined Communities: Reflections on the Origin and Spread of Nationalism* (London: Verso, 1983). There have been many revisions to this study of nationalism, yet few expand the study of imagined community beyond national frames.

[7] This point especially came out of my ongoing discussions with Ali Raza, Franziska Roy, Carolien Stolte, Maia Ramnath, and Benjamin Zachariah at the Temple University workshop, "India and the World," as well as our panels at the Madison Conference on South Asian Studies (2009) and European Association of South Asian Studies (2010). See also Benjamin Zachariah, *Playing the Nation Game: The Ambiguities of Nationalism in India* (Yoda Press, 2012); and Maia Ramnath, *Haj to Utopia: How the Ghadar Movement Charted Global Radicalism and Attempted to Overthrow the British Empire* (University of California Press, 2011).

[8] For a history of India, along with China, Korea, and Egypt, during the Paris Peace meetings in 1919, see Erez Manela, *The Wilsonian Moment: Self-determination and the International Origins of Anti-colonial Nationalism* (Oxford: Oxford University Press, 2007). Although by 1927, Wilson hardly figured into the deep disappointment in the broader failures of the LON and imperialist powers to provide greater autonomy to the colonies.

By surveying the historical record of Nehru and the LAI, this essay considers the possibilities and problems inherent in the special blend of the League's internationalism with Indian nationalism. First, it examines the encounters, networks, and discursive practices that Nehru engaged within the League when he lived in Europe in 1927 and served on the executive council of the institution, as well as once he returned to India and worked on the anti-imperialist cause from home. These moments in Europe and India were formative to his lifelong commitment to anti-imperialist internationalism. Second, the essay considers the tensions within the anti-imperialist movement that led Nehru to break with the LAI in 1930. By the conclusion of the 1920s, the League shifted away from an inclusive anti-imperialist platform to a more rigid and exclusive communist apparatus. Forces external and internal to the League worked to break apart the solidarities built in 1927, and signaled a new moment in the internationalist anti-imperialism of the 1930s. Nehru's refusal to confront the changing environment of the LAI demonstrates not only the tensions inherent in the movement, but also the powerful and lasting inspiration anti-imperialism would continue to have on him even after he broke formal ties with the institution. As the essay concludes, anti-imperialist internationalism as a political approach, outside the institutional framework of the League, continued to play a preeminent role in his ideas about India and the world into the 1930s and beyond.

Roots of the Brussels Congress and LAI

Historians have long considered Nehru an "internationalist," but few have fleshed out the precise dimensions of his internationalism in the context of his earliest experiences in Brussels and through the League.[9] The few studies that do consider his connections to the LAI focus

[9] Most specialists of Nehru focus on his local and all-India activities. See, for example, Judith Brown, *Nehru: A Political Life* (New Haven: Yale University Press, 2003). While S. Gopal, *Jawaharlal Nehru: A Biography* (Oxford: Oxford University Press, 1989) and Benjamin Zachariah's *Nehru* (London: Routledge Press, 2004) attempt to situate Nehru in the international context of the colonial and postcolonial periods, the broad scope of biography has not allowed for a more detailed examination of the Nehru and LAI story beyond the Brussels

exclusively on the inaugural meeting in Brussels. Sarvepalli Gopal's oft-cited biography contributes a chapter to the Brussels Congress. He argues that it was transformative for Nehru, but

> it is significant that the change was wrought not by the revolutionary situation in India but by what he saw and heard and read in Europe. Jawaharlal was always a radical in the European tradition, seeking to apply and adapt its doctrine to his own country.[10]

However, as this essay demonstrates, the LAI was not simply a European enterprise. It evolved from the complex internationalist currents of the 1920s world, and while the meetings may have taken place in Europe, most of the key architects and contributors, such as Nehru, were not European. The recent biographical research on Nehru by Benjamin Zachariah more accurately characterizes his encounters at Brussels as the "the beginning of his close relationship with the international left."[11] This essay offers a more detailed reading of this burgeoning relationship than sweeping biographies allow.

Beyond the Brussels Congress, historians neglect the broad range of Nehru's experiences in the LAI after the moment of encounter. He served on the executive council from 1927 to 1930 and oversaw the establishment of the League's headquarters and drafting of its bylaws. After months of League work in Europe, Nehru returned to India and spent several years forging greater contacts between the INC and the League. In 1930, however, Nehru broke formal ties between India and the League's Berlin secretariat. The rupture is most often attributed to the shift in leadership within the League's international secretariat, which was increasingly under the directives of the Communist

Congress moment. This paper takes the Brussels Congress as a starting point for a more detailed history of Nehru and the League.

[10] Gopal, *Jawaharlal Nehru*, 58. For a key work on Nehru's ideas as a derivative of colonial discourse, see Partha Chatterjee, *Nationalist Thought and the Colonial World: A Derivative Discourse?* (Minneapolis: University of Minnesota Press, 1986).

[11] Zachariah, *Nehru*, 60.

International (Comintern).[12] Nevertheless, Nehru continued to cultivate a lifelong correspondence with many of the anti-imperialist comrades he met through the League. In 1935, he even reconnected with the League, then headquartered in London after a Nazi raid of the Berlin center destroyed the organizational archive and sent the secretaries into exile. In London, Nehru attended League meetings in 1935 and 1936 where he met with old comrades and new ones, most notably Pan-Africanists such as Jomo Kenyatta. In 1937, the doors of the LAI closed for good. Although no longer an official member, Nehru developed anti-imperialist partnerships through League meetings and networks for over a decade.

The institutional history of the LAI is not especially well studied either.[13] It certainly does not have the same presence in scholarly and

[12] For more nuanced reasons for the split, see Michele L. Louro, "'Where National Revolutionary Ends and Communist Begins': The League Against Imperialism and the Meerut Conspiracy Case," *Comparative Studies of South Asia, Africa, and the Middle East*, 33, 3 (December 2013): 331–44.

[13] The LAI archival record is scarce and scattered. The Nazi raid of the Berlin headquarters of the League in 1933 destroyed much of the institutional archive. Existing sources have been collected at the International Institution of Social History (IISH), or preserved in the personal papers of individual members, the colonial intelligence records, or the Communist International files. The papers of the post-1933 London-based LAI are held in the in the Papers of Reginald Orlando Bridgeman (1884–1968), Hull University Archives, United Kingdom (hereafter cited as ROB Papers). Historiography on the organization is also thin. The most extensive history of the LAI based solely on Comintern sources is Fredrik Petersson, *Willi Münzenberg, the League against Imperialism, and the Comintern, 1925–1933* (Lewiston: Queenston Press, 2013). For the relationship between LAI delegates from Ireland and India, see Kate O'Malley, *Ireland, India and Empire: Indo-Irish Radical Connections, 1919–64* (Manchester: Manchester University Press, 2008). Also more recently, one chapter is dedicated to the Brussels Congress against Colonial Oppression and Imperialism in Vijay Prashad, *The Darker Nations: A People's History of the Third World* (New York: New Press : Distributed by W.W. Norton, 2007). For the most detailed and cited account, see *Dictionary of Labour Biography*, Vol. VII, eds Joyce M. Bellamy and John Saville (London: Macmillan Press, 1984): 40–49. For very brief accounts, see also Jean Jones, *The League Against Imperialism* as part of the Socialist History Occasional Pamphlet Series (Lancashire: The Socialist History Society and the Lancashire Community Press, 1996).

pedagogical literature as interwar institutions such as the LON and Comintern. The origins of the League began as collaboration between communists and a number of expatriates from the colonies living in Berlin.[14] For Indians in particular, Berlin for much of the 1920s offered an important place for anticolonial and revolutionary activities. A contemporary American observer visiting Berlin in 1927 characterized the city as the European "centre for political activity of Oriental peoples, chiefly against English Imperialism."[15] Germany during the First World War had been a haven for political exiles from the colonies, and the German Foreign Office employed Indian expatriates in schemes to incite revolts among Indian soldiers in the Middle East and ship weapons to India to disrupt the British war effort. The alliance worked well in wartime; however, Indian expatriates found themselves in a peculiar place after the war as the Weimar state saw these communities less as anti-British allies and more as undesirable residents without clearly defined citizenship within Germany or the British Empire.[16] Still, before the rise to power of Hitler and the Nazi regime in the 1930s, Berlin expatriates continued to operate with some degree of autonomy. In this context of uncertainty during the 1920s, Indian exiles began to seek political alliances and solidarities with communists in Berlin, and out of this came several projects that culminated in the advent of the Brussels Congress and the LAI.

The opportunity to entice Nehru to attend the Brussels Congress arose when he traveled to Berlin in November 1926. Already in Europe

[14] Willi Muenzenberg is credited with founding the movement. He was the Communist International's chief propagandist in Europe, member of the Communist Party of Germany and the Reichstag. Petersson, *Willi Münzenberg, the League against Imperialism and the Comintern*; and See Sean Mc Meekin, *The Red Millionaire: A Political Biography of Willi Münzenberg, Moscow's Secret Propaganda Tsar in the West* (New Haven: Yale University Press, 2005); and Stephen Koch, *Double Lives: Stalin, Willi Münzenberg, and the Seduction of the Intellectuals* (New York: Enigma Books, 2004).

[15] Report written by Roger Nash Baldwin for the International Committee for Political Prisoners dated February 13, 1927, Box 11, Folder 9, Roger Nash Baldwin Papers, Seeley G. Mudd Manuscript Library, Princeton University, Princeton, NJ (hereafter cited as RNB Papers).

[16] Nirode K. Barooah, *Chatto: The Life and Time of an Indian Anti-imperialist in Europe* (New Delhi: Oxford University Press, 2004).

since March of that year, Nehru had stayed primarily in Switzerland to attend to his wife who suffered from chronic tuberculosis. As her health began to improve, Nehru ventured beyond Switzerland to Germany, France, and Britain. The Berlin trip in the fall had offered him an opportunity to meet some of the expatriates from India including Brussels organizer, Virendranath Chattopadhyaya. Slightly senior to Nehru, Chatto, as his colleagues called him, came from a wealthy Bengali family living in Hyderabad that included his sister, Sarojini Naidu, an influential Gandhian nationalist and poetess. Chatto came to Berlin after he fled London in 1910 on charges he had been involved in the assassination of a British official in the metropole. He settled first in Paris, 1910–14, then permanently in Berlin with a brief interlude in Stockholm, 1917–21.[17] Of the Indian expatriates Nehru encountered throughout his nearly two-year European sojourn, he most enjoyed the company of Chatto and admired his work and vision.[18] It was Chatto who extended to Nehru an invitation for the INC to send a delegate to the Brussels Congress. Enthusiastic and intrigued, Nehru wrote to the INC and requested a large Indian delegation attend Brussels. After consideration, however, the INC Working Committee sent a mandate to Nehru to be the sole spokesman for the Indian anticolonial nationalist movement.[19] The appointment letter had little else in terms of instructions, but Nehru packed his bags and headed to Brussels to step onto the world's anti-imperialist stage.

Over 170 delegates attended the League's inaugural meeting in Brussels representing 134 organizations from 37 countries. Seventy of those delegates came from colonies, mandates and dependencies traveling great

[17] Ibid. Archival sources on Chatto's life are scattered across many archives, and only one biography of him exists.

[18] Jawaharlal Nehru, *Autobiography*, 162.

[19] Nehru first wrote about the Brussels Congress to his father, Motilal Nehru, and he asked that Motilal persuade the INC Working Committee to appoint a delegation to the meeting. See, Jawaharlal Nehru to his father, November 16, 1926, *SWJN*, Vol. 2, 250–51. After the elder Nehru proposed the INC send a delegation, the AICC Secretary sent the official appointment to Nehru on January 6, 1927. The appointment letter to Nehru also included a draft for 50 pounds sterling for Nehru's expenses to attend the Brussels Congress on behalf of the INC. For INC deliberations on this see, File G21-1926, AICC Papers.

distances, often illegally, to Brussels.[20] Here, Nehru encountered for the first time anti-imperialist colleagues from places such as China, the Dutch East Indies, Indo-China, Persia, South Africa, Morocco, Algeria, Tunis, Egypt, Mexico, Argentina, Palestine, and the Philippines, as well as a cohort of influential leftists, trade unionists, socialists, communists, pacifists, parliamentarian legislators, and civil liberties reformers from the United States, Soviet Russia, Britain, Continental Europe, and Japan. As the "jewel in Britain's crown," India took center stage, and Nehru played a key role in drafting several resolutions and chairing sessions.

Nehru's encounters during and after Brussels produced not only a new working knowledge of imperialism and capitalism in other regions of the world once thought to be distant, but also an arsenal of contacts and partners that Nehru could draw upon for moral, intellectual, and sometimes financial support. For Nehru, anti-imperialism meant the collaboration among these myriad individuals, organizations, and places resisting the symbiotic forces of capitalism–imperialism. India, of course, played the central role in his anti-imperialist worldview, while other anticolonial nationalists, socialists, communists, and sympathetic leftists became his comrades against imperialism. Nehru came to be captivated especially by his fellow comrades from China, Egypt, and Indonesia; and he came to envision the Soviet Union as a bastion of anti-imperialism for its challenge to the capitalist classes in imperialist countries.

Nehru and the LAI in Europe, 1927

His travels and work for the executive council provided rich opportunities for Nehru's anti-imperialist worldview to expand and crystallize. Few anticolonial nationalists had the opportunity to contribute as much time and energy to developing the LAI as Nehru could in the nine months

[20] Sources vary on the exact numbers, approximately 170 delegates attended representing 134 organizations from 37 countries. For the most comprehensive collection of documents issued by the LAI including propaganda, manifestos, and resolutions see the LAI Archive (1927–31), International Institution of Social History (IISH), Amsterdam, Netherlands (Hereafter IISH).

between the February Brussels Congress and his departure for India in December 1927. His wife's health improved, but the Nehru family stayed in Europe through the end of the year. As an executive council member, Nehru was a key architect of the LAI during the nascent stages of the institution's history. He took part in two executive council meetings in Amsterdam (March) and Cologne (August), and several informal visits to the provisional secretariats in Berlin and Paris to oversee the organization of the headquarters. Late in 1927, the LAI facilitated Nehru's trip to Moscow for the celebrations of the tenth anniversary of the Bolshevik Revolution. His activities and encounters afforded by the League in these various places—Brussels, Berlin, Paris, Amsterdam, Cologne, and Moscow—were formative ones.

At the first executive council meeting in Amsterdam, Nehru joined a diverse cohort of colleagues in the hopes of hammering out a concrete plan for the structure and work of the LAI. The executive council had been elected at the Brussels Congress, and it was responsible for making the decisions for the structure and statutes of the League.[21] Members included Edo Fimmen of the Amsterdam International Federation of Trade Unions; Willi Muenzenberg of German Communist Party; George Lansbury and Reginald Bridgeman of the British Labour Party; Henri Barbusse of French Communist Party; Manuel Ugarte of the Argentine nationalist movement; Mohamed Hatta of Perhimpunan Indonesia; Liau Hansin of the Executive of the KMT; Chan Kuen of Chinese Trade Union Association; and Roger Baldwin of the American Civil Liberties Union. The international secretaries, appointed by the executive council, carried out the council decisions and also the League's daily functions. A larger general council (GC) also existed of mainly delegates from the Brussels Congress that committed to the League program and agreed to meet on an annual basis.

Nehru's, and by extension the Congress', financial and organizational support made India a powerful partner within the anti-imperialist coalition of the League during its first months of institutional uncertainty. Funds for the League were sparse, and the Brussels Congress expenditure nearly wiped out the treasury. Edo Fimmen and the Amsterdam

[21] LAI Statutes, Jawaharlal Nehru Papers at the Nehru Memorial Museum and Library (Hereafter cited as JN Papers), Political Files, Serial Number 123.

International Federation of Trade Unions loaned money for the first executive meeting, and the council members, including Nehru, promised significant contributions to keep the League afloat in the first months.[22] To this end, Nehru ensured that the INC made financial contributions to the League in the sum of 100 pounds sterling in both 1927 and 1928, a hefty donation for the time. Beyond institutional contributions, Nehru also convinced the INC to pay his European travel expenses in connection with the LAI.[23]

One of the most significant and early debates within the League focused on membership rules, a point that laid the groundwork for the institution to structure the international connections between anti-imperialists of national and social mobilizations. Because the League brought together activists, revolutionaries, and intellectuals from a wide spectrum of political affiliations—some sympathetic to anticolonial nationalist resistance but by no means active in the struggle—the institution had to be accommodative and flexible in its membership. No one on the executive council knew this better than Nehru. He thought that the INC might welcome the League's anti-imperialist message, but it would not accept the socialist and communist inspired agenda. To confront the issue, Nehru advocated a two-tiered structure for membership based on *affiliation* or *association*. Affiliated organizations or individuals were bound by all of the League programs and policies including both the socialist and anticolonial nationalist creed, while associated members were linked to the League to a lesser extent and could profess cooperation without towing the official League line. Nehru explained in a report to the INC: "I pressed for this rule chiefly in the interests of the Indian Congress and I feel that the Congress can take advantage of it without

[22] Donations came from the United States (Baldwin), Latin America (Ugarte), and Germany (Muenzenberg). Substantial contributions were promised from Egyptian and KMT members. See Nehru, "Note for the Working Committee," April 4, 1927, *SWJN*, Vol. 2, 316–23.

[23] Nehru relied on the INC to reimburse him for expenditures related to travel, cables, and postal services in connection with the LAI. See his correspondence with the INC general secretary Rangaswami Iyengar, AICC Papers, File 127(ii) 1927.

in any way committing itself to anything it does not approve of."[24] Here, we see Nehru's active work in thinking through the possibilities and tensions between the nationalist and internationalist fronts.

Nehru also devoted much of his time in Europe in 1927 toward creating a strong institutional center capable of forging anti-imperialist connections internationally. Responsibility fell on the secretariat to collect and translate information coming in from League members across the world, while also redistributing and recasting such vernacular pieces as part of a cohesive, anti-imperialist discourse. The power to construct the meaning of anti-imperialism often rested in the hands of those in the League center. If functioning properly, the League press service reached some of the most influential movements of the interwar period, notably the INC, but also Perhimpunan Indonesia (Indonesian National Independence Party), the Kuomintang Party in China, the Wafd Party in Egypt, the Egyptian Nationalist Party, the Sinn Fein Irish Republican movement, the American Civil Liberties Union, the National Association for the Advancement of Colored Peoples, and labor organizations such as the Confederation Generale du Travail Unitaire (CGTU) in France, South African Trade Union Congress, and the All-India Trade Union Congress. Already in 1927, self-funded national sections of the League began work in distant places like Argentina, Brazil, China, Cuba, Ecuador, France, Germany, Great Britain, Holland, Ireland, Japan, Mexico, Nicaragua, Palestine, Philippines, Puerto Rico, San Salvador, South Africa, the United States, and Uruguay.[25]

Location for the secretariat was the preeminent concern of Nehru and his comrades. The provisional center was located in Berlin, where the organizers of the Brussels Congress resided, but it was the executive council's intention to relocate the main office to Paris. Paris had been an epicenter for anti-imperialist activities before the Brussels Congress, and French communists, socialists, trade unionists, and revolutionaries from the colonies had worked in close alliance before 1927.[26] At the first

[24] Nehru, "Note for the Working Committee," April 4, 1927, *SWJN*, Vol. 2, 322.

[25] For a comprehensive list of LAI members and national branches, see File 2, IISH, LAI Archive.

[26] A history of anti-imperial activities is given in the "Report of the Activities of the French League Against Imperialism, Colonialism and for National

executive meeting in March, however, the relocation was impossible because French authorities cracked down on Brussels Congress participants including delegate Lamine Senghor, a Senegalese nationalist and brother of the more famous Léopold Sédar Senghor, later the president of postcolonial Senegal. Lamine Senghor founded the Paris-based Comité de Défense de la Race Nègre and its journal, *La voix des nègres*.[27] Immediately after the Brussels Congress and the wide circulation of Senghor's speech there, the French authorities imprisoned him. Harsh prison conditions coupled with lasting injuries from his service in First World War led to his premature death in November 1927 at the early age of 38. The atmosphere in Paris forced the League center to remain in Berlin until other alternatives could be explored.

Nehru worked on the development of the secretariat closely with an American executive council member, Roger Baldwin. Baldwin was the founder of the American Civil Liberties Union (ACLU), an organization that provided legal counsel to defendants in some of the most high profile court cases in the United States including the Scopes Trial (1925) over the right to teach evolution in schools. During the 1920s, Baldwin had international interests as well, and he chaired the International Committee for Political Prisoners, an international affiliate of the ACLU. In fact, he represented this committee, not the ACLU, in Brussels. Baldwin's keen interest in India's independence movement began during the First World War when he was imprisoned as a conscientious objector. While in prison, Baldwin met Indians serving sentences for seditious activities against the U.S. wartime ally, Britain. From 1920 onwards, after his release, Baldwin worked with Indian organizations in New York, and his later encounter with Nehru at the Brussels Congress in 1927 strengthened his commitment to India's independence struggle.

Independence." LAI circular to all executive council and general council members sent by LAI secretary, Louis Gibarti (Paris), July 20, 1927, File 542/1/21/8, Communist International Papers, Digital Copies in the Library of Congress, Washington DC, (hereafter CI Papers).

[27] For a history of Senghor in Paris, see Brent Hayes Edwards, *The Practice of Diaspora: Literature, Translation, and the Rise of Black Internationalism* (Cambridge: Harvard University Press, 2003).

Through the League meetings and correspondence, Nehru and Baldwin began cultivating a professional partnership that endured throughout the interwar years and beyond.[28] When Nehru considered his time at Brussels, Baldwin stood out as his "Anglo-American" colleague sharing "a certain similarity in our outlook."[29] Beyond the general concern of anti-imperialism, the two delegates considered the issue of political prisoners in India and what Baldwin and the ACLU might do to help. From Brussels on February 11, 1927, Nehru wrote a letter to the INC general secretary to introduce Baldwin as "one of the most courageous and effective workers in the United States." Nehru asked that the INC facilitate a process in which Baldwin and the ACLU could contribute funds to protect the civil liberties of political prisoners in India. He added in conclusion, "I have no doubt that you and the Congress will cordially welcome American help, not merely because of its monetary value but specially [sic] because it is an expression of the goodwill of friends in America."[30]

In April, Nehru and Baldwin met privately in Switzerland to discuss the state of the Berlin office and formulate a comprehensive plan for improving the secretariat. Out of his talks with Baldwin, Nehru produced a scathing twenty-two-point critique of the existing headquarters sent on May 3 to both League secretaries as well as Edo Fimmen in Amsterdam. Baldwin remarked that Nehru's report was a "more patient and thorough job than I would have done," but "between us I think we have said all there is to say."[31] The Nehru–Baldwin critique ranged from the fine details of the reports on Brussels being circulated by the secretariat to the larger issues of general focus and direction of League work. The letter opened by announcing that he and Baldwin agreed that, "all is not well with the League and we ought to wake up to this fact and take speedy action to put matters right."[32] However, Nehru wrote:

[28] For a history of this relationship over time, see Michele Louro, "Rethinking Nehru's Internationalism: The League Against Imperialism and Anti-imperial Networks, 1929–1939," *Third Frame: Literature, Culture, Society*, 2, 3 (2009): 79–94.

[29] Nehru, *Autobiography*, 172.

[30] Nehru to Rangaswami Iyengar, February 11, 1927, *SWJN*, Vol. 2, 277.

[31] Baldwin to Nehru, May 7, 1927, Box 8, Folder 2, RNB Papers.

[32] Nehru to Gibarti, May 2, 1927, Box 8, Folder 2, RNB Papers.

> I feel strongly that the League supplies a real want and it can develop into
> a powerful organization…. [Nevertheless] no number of pious resolutions,
> fervent appeals and exaggerated statements will do us much good or bring
> helpers and associates if the substance behind them is lacking.[33]

Nehru made clear that a well-functioning League secretariat was essential to serve as a nucleus for the anti-imperialist movement. To this end, the letter once again suggested the secretariat should be moved permanently and immediately to Paris. By May, it seemed possible again to resume anti-imperialist activities in France. Nehru thought Paris "is far the greatest international centre and has a tradition and atmosphere which no other city possesses."[34] Most importantly, both Nehru and Baldwin were staying in Paris throughout the entire month of May. The two intended to personally oversee the relocation and the implementation of executive orders within the secretariat. In response to Nehru's letter, Baldwin reiterated to Nehru: "I only hope the office will be moved while you are there, to get some of the benefit of yours."[35] The move to Paris never transpired; however, the organizational work helped Nehru consider the processes necessary to build internationalist institutions and alliances collaboratively with a wide array of comrades.

Overall, the letter demonstrated not only Nehru's commitment to the League's development, but also the ways the Indian leader came to identify himself as a member of a broader anti-imperialist community even in relation to the INC. This is most evident when Nehru addressed the reluctance of several INC leaders to respond to letters sent to India from the LAI. Nehru was keenly aware that the INC would not determine a clear policy and course for its relationship to the League until the all-India annual meeting later in December of that year. But, Nehru also recognized the skepticism many in India would have toward outside organizations such as the League. Nehru explained in this letter to the League secretary:

[33] Nehru to Gibarti, May 2, 1927, RNB Papers.

[34] Nehru to Fimmen, May 3, 1927, with enclosed copy of letter to Gibarti cited above. Box 8, Folder 2, RNB Papers.

[35] Baldwin to Nehru, May 7, 1927, Box 8, Folder 2, RNB Papers.

The difficulty is that *we* fail to realize that the outlook of *these* people in India is different from *our* [League] outlook. The only thing to do is to change *their* outlook and I am sure it can be done but it takes a little time and effort."[36] (author's emphasis)

The use of "*we*" to define Nehru's subject position in the letter situates himself as an anti-imperialist of the League in relation to "*these* people in India and *their* outlook." This distinction should not be overstressed, but it should be used as a lens to see the ways Nehru identified himself as an active member of both the Indian nationalist and the League's anti-imperialist communities in this moment.[37]

By the time of the second executive council meeting in Cologne in August 1927, Nehru boasted a high profile within the League, and his personal work on the secretariat paved the way for a more professional and organized center for anti-imperialist collaboration. Nehru's agency had been essential in the initial formulations for the center and its general direction. While the League's meeting spaces and secretariat were in Europe, those engaged in the process of making the institution—such as Nehru and even Baldwin—were often not European. Nehru's executive work, too, provided more opportunities to interact with some of his comrades in the executive council like Baldwin. In Cologne, Baldwin introduced Nehru to the American Red Scare and the anxieties over the threat of communist expansion into the United States by taking him to a rally against the Sacco-Vanzetti Case (1927), a controversial U.S. trial against two suspected of being communists and anarchists. Immediately following the executive meeting, Nehru and Baldwin traveled together to Dusseldorf for the political rally. Here, Nehru received further education on criticism of the U.S. government made by the international left in the 1920s.

The Cologne meetings were instrumental in expanding Nehru's contacts and understanding of the Dutch East Indies as well. One of the principal discussions at the second executive meeting in Cologne had concerned the LAI commission to be sent to Java for three months to

[36] Nehru to Gibarti, May 2, 1927, Box 8, Folder 2, RNB Papers.

[37] On the possibilities for multiple and compatible identities within the context of globalization, see Lynn Hollen Lees, "Being British in Malaya," *Journal of British Studies* 48 (January 2009): 76–101.

observe Dutch colonialism on the ground. In conjunction, P.J. Schmidt, vice president of the Dutch League, drafted a statement on the dire situation in the Dutch East Indies. A series of uprisings in 1926 and 1927 in Java and Sumatra resulted in a repressive crack down on anticolonial activists in Indonesia and Holland. Schmidt suggested that Dutch authorities were going to great lengths to link nationalists to communism as a means to further fuel the repressive measures of the colonial state. "The [Dutch] rulers may provoke and suppress, they may kill and murder to fill their prisons, but they will never succeed in killing the spirit of revolt of the Indonesian workers and intellectuals."[38] Nehru was moved by the plight of the Indonesian nationalists and workers, and he would later write a foreword for Schmidt's book on imperialism.[39] Nehru also had more opportunities to discuss the shared experience of European imperialism and anticolonialism with Mohamed Hatta, fellow executive member from the Dutch East Indies and later vice president of Sukarno's Indonesia, 1945–56.[40]

Nehru's experiences with the LAI inspired him to make his first comprehensive statement for Indian audiences in 1927 on the relationship between anticolonial nationalist struggle and internationalism.[41] Few statements so eloquently demonstrated the impact on him of the League's internationalist ethos and expanded geography of anti-imperialism.

[38] P.J. Schmidt, Statement on Dutch Java and Sumatra, November 1927, 542/1/5/138–39, CI Papers.

[39] This article was originally written for P.J. Schmidt's *The Imperialist Danger* in May 1928, however, published in the INC publication, *The Tribune* on July 24, 1929, repr. in *SWJN*, Vol.3, 151–58.

[40] Mohamed Hatta befriended Nehru at the Brussels Congress. The two kept in touch during the interwar years and worked together after 1947, most notably on the 1955 Bandung Conference. Hatta recalls the importance of the Brussels Congress as the preeminent inspiration for Indonesian leaders in suggesting the Bandung Conference at the Colombo power meeting in December 1954. See Mohammed Hatta, interviewed by B.R. Nanda, September 1972, interview transcript 121, Nehru Memorial Museum and Library (NMML) Oral History Collection, NMML, New Delhi, India.

[41] Nehru, "A Foreign Policy for India," September 13, 1927, *SWJN*, Vol. 2, 348–64.

Much of the statement is worth citing in detail here. Nehru argued that no country is isolated from the world:

> a shooting in London is followed by a murder in Warsaw and many executions in Moscow, and has its reverberations on the North-West Frontier in India. France, the most intensely national of countries, cannot have a minister who interferes too much with the plans of high finance of New York.[42]

He went on to characterize this interconnected world as one linked by powerful capitalists and imperialists: "We talk of labour and socialist internationals but the greatest and most powerful international organizations today are those of capital and finance which control the governments of even so-called democratic countries and bring about war and peace."[43] Nehru also demonstrated his heightened knowledge of other regions of the world and the links between capitalism and imperialist expansion: "The American marines take possession of Nicaragua because Messrs. Brown Brothers of New York have money invested there." Meanwhile, "China cannot be free because too much British and Japanese capital is locked up there."[44] In this world context, Nehru argued "India cannot keep apart from this tangled web, and her refusing to take heed of it may indeed lead her to disaster."[45]

What is India to do then? According to Nehru, India's connections abroad were the only solutions to contest the global flows of capitalism and imperialism, and the LAI specifically offered the means to collaborate with anti-imperialists internationally. He reminded his Indian audience that the INC abandoned foreign propaganda in 1923 because it did little to foster sympathy in the metropole. He argued that international connections should not seek out sympathy or help from Britain, but rather establish contact with other places and "take part in international joint action when this is to our advantage."[46] Nehru added:

[42] Nehru, "A Foreign Policy for India," 352.
[43] Ibid., 353.
[44] Ibid.
[45] Ibid.
[46] Ibid.

Let us remember that there are many countries and many peoples who suffer as India does today. They have to face the same problems as ours and it must be to the advantage of both of us to know more of each other and to cooperate where possible.[47]

For Nehru, the INC involvement in the Brussels Congress and LAI were steps in the right direction.

The LAI was also responsible for Nehru's first trip to the Soviet Union in late 1927. A group called the Society for Cultural Relations with the Soviet Union extended the formal invitation, but this was facilitated through League channels and the Berlin secretariat arranged the trip.[48] Nehru traveled by train from Berlin with his entire family including his father, Motilal, who arrived in Europe in October. The three-day stay was hardly long enough to justify the lengthy passage. Nevertheless, Nehru had enough time to observe Soviet Russia, and he was impressed. He wrote a myriad of articles for the Indian press on the theories, histories, and observations of Soviet Russia that were eventually collected and published in a book in India.[49] His initial impression was clear: "The picture I carry away from Russia is one of admiration for the men who accomplished so much within a few years in spite of all the disadvantages that one can imagine."[50]

The Soviet Union piqued Nehru's interest, but this intrigue was tempered by anti-imperialism rather than an allegiance to strict communist ideology. Nehru came to regard Soviet Russia as a haven for anti-imperialism and a stalwart against the British Empire in particular. Indeed, Nehru argued in his reminiscences of his trip that Soviet Russia and India were ideal partners against imperialism:

Ordinarily Russia and India should live as the best of neighbors with the fewest points of friction. The continual friction that we see today is between England and Russia, not between India and Russia. Is there any reason

[47] Ibid.

[48] "Information Bulletin for the Executive Committee, No. 3," LAI Secretariat, November 3, 1927, 542/1/5/82, CI Papers.

[49] Nehru, *Soviet Russia*, repr. in *SWJN*, Vol. 2, 379–451.

[50] Nehru to his sister, Vijayalakshmi Pandit, November 12, 1927, *SWJN*, Vol. 2, 371.

why we in India should inherit the age-long rivalry of England and Russia? That is based on the greed and covetousness of British imperialism and our interests surely lie in ending this imperialism and not in supporting and strengthening it.... India has nothing to fear from Russia ... we shall not permit ourselves to be used as pawns in England's imperial game to be moved hither and tither for her benefit.[51]

The timing of Nehru's visit to the Soviet Union was critical too. He came to Moscow at a moment of flux and fluidity. The invitation was extended on the occasion of the ten-year anniversary of the Bolshevik Revolution. Celebrations and ceremonies congratulated the success of the revolution and commemorated Lenin. Stalin had not yet emerged as the clear successor to the Soviet state or the ruthless dictator he would become in years ahead. The tenuous "united front" alliances still existed as late as November 1927, although the split in China between national-ist and communist forces had already foreshadowed the later ruptures between communists and noncommunists worldwide.[52] Nevertheless, Nehru encountered a robust and welcoming Soviet Union in November 1927 that inspired his longstanding admiration even after and despite of the collapse of the united front and the new direction of Stalin's regime.

By the closing months of 1927, as Nehru prepared to leave Europe for India, his political vision and activities straddled two spheres—the discourse and circuits of an internationalist world of anti-imperialism, as well as the local politics of anticolonial struggle against the raj. For Nehru, the distinction between national and international, or India and world, was blurred, while the anticolonial mission was to be "blended" with the internationalist struggle against empires. This had been a dynamic process in which Nehru emerged as a contributor and partner of anti-imperialism in places as diverse as Brussels, Amsterdam, Paris, Berlin, Cologne, and Moscow. Through the people he met, contacts he forged, and discourse he encountered, Nehru envisioned Indian independence

[51] Nehru "Russia and India," repr. in *SWJN*, Vol. 2, 450–51.

[52] On April 12, 1927, Chiang Kai-shek marched his military into Shanghai where strikes and communist activities against foreign imperialists had paralyzed the city for nearly a year. Rather than honor the his alliance with communists, Chiang defected from the united front and massacred thousands of suspected communists, trade unionists, workers, and peasants.

as the catalyst for the end of the British Empire, but India's struggle was only part of a larger anti-imperialist project. This special blend of nationalism and internationalism inspired by the League moment retained a consistent and enduring place in Nehru's view of India and the world well beyond his months in Europe.

Nehru and the LAI in India: Connections, Ruptures, and Continuities

On December 4, 1927, Nehru boarded the S.S. Angers in Marseilles, France, and bid farewell to the European continent that had been home for nearly two years. Nehru knew the distance between India and the LAI headquarters would hinder his internationalist activities, but he remained a committed comrade against imperialism. His return to India was an occasion for network building among anti-imperialists on the local, national, and international political terrains. He worked prodigiously to connect anti-imperialist forces of nationalism with socialism, communism and trade unionism within India. To this end, Nehru joined the All-Indian Trade Union Congress for the first time and found himself elected to preside over the 1929 annual sessions. Meanwhile he continued his role as general secretary of the INC. At the 1927 INC annual sessions, Nehru spearheaded the passage of several resolutions inspired by anti-imperialism including a formal authorization for the INC to affiliate with the League. Overall, his focus on internationalizing the nationalist struggle became a key component of his activities in India, a point overlooked in histories focusing only on his local and nationalist politics.

Even at a great distance from Europe, Nehru remained closely connected to the anti-imperialist struggle through the League's correspondence and propaganda networks. The archival record reveals a robust correspondence between Nehru and Chatto, the LAI's chief secretary in Berlin. Chatto also launched the League's flagship publication, the *Anti-Imperialist Review*, in July 1928. While earlier bulletins and newsletters provided snippets of information on anti-imperialist events and news, the quarterly journal provided a well-circulated forum for article-length discussions on imperialism and anti-imperialist resistance worldwide. The first volume opened with a foreword from the League's newly

elected chairman, James Maxton.[53] He reminded his audience of the link between the struggles of the working class and the colonized:

> Life under capitalism is bad enough for the Working Class in the highly developed industrial countries of Europe, but it is infinitely worse for the subject peoples, and particularly the coloured races, subjected as they are, to the double tyranny of foreign government and foreign capitalism.

The League, Maxton argued, was the first ever organization to offer a "common ground" to "pursue in the common task of emancipation."[54] The League's information and propaganda also provided rich material for recirculation in the Indian publications such as the *Forward,* the *Bombay Chronicle,* the *Hindu,* and the *Hindustan Times.* It also frequented the pages of INC bulletins as a constant reminder that India's struggle was part of broader anti-imperialist campaign.

Aside from propaganda, Nehru took concrete steps to build institutions in India capable of linking the nationalist struggle to the international community of anti-imperialism. He piloted the creation of the Independence for India League. It served as the cornerstone of connections between India and the international LAI on the one hand, as well as a meeting space for Indian nationalists, socialists, communists, and trade unionists to work together to challenge British capitalism and imperialism on the local and national levels. After three meetings and the drafting of a constitution, however, the Independence League failed to garner enough Indian support and dissolved in December 1929, just ahead of the Civil Disobedience Campaign.[55] Still, the ideas for the Independence League reflected Nehru's embrace and focus on anti-imperialist internationalism from India.

[53] Maxton was a key figure of Britain's Independent Labour Party and Member of Parliament from Glasgow.

[54] *Anti-imperial Review* 1, no. 1 (July 1928), File 37, LAI Papers.

[55] There are two explanations for the League's short existence. First, the members comprised of INC members who did not want to work with members outside the INC fold. Second, by late 1929, the INC demand for independence and ramping up for the Civil Disobedience campaign took precedence for most Congressmen.

Nehru also began a more enduring project to establish the first ever Foreign Department within the INC. Emblematic of his anti-imperialist internationalism, he argued for an INC Foreign Department on the grounds that:

> This Congress, being of opinion that the struggle of the Indian people for freedom is a part of the general world struggle against imperialism and its manifestations, considers it desirable that India should develop contacts with other countries and peoples who also suffer under imperialism and desire to combat it.[56]

The INC Working Committee nominated Nehru to oversee the Foreign Department because of his experiences abroad.[57] Of course, Chatto and the League supplied the new INC Foreign Department with all of its contacts, while Nehru began circulating official Congress Foreign Department Bulletins throughout the League networks. This connection linked nationalism and internationalism effectively, albeit temporarily.[58]

Nehru hardly could have foreseen the drastic and cataclysmic changes on the horizon in the later months of 1929 that brought his relationship with the LAI to a sudden crisis point. Again, timing is critical here. The emergence of Joseph Stalin in 1928, after a contentious power struggle for leadership in the wake of Lenin's death, opened a new era of rigid conformity to party lines within and outside the Soviet Union. This precluded the possibility of communist collaboration with either socialists or anticolonial nationalists. For the LAI, this initiated a series of institutional transformations. Until mid-1929, the League operated with a degree of flexibility and autonomy from the Communist International.[59]

[56] "Congress Bulletin: Issued by the Office of the All India Congress Committee," January 15, 1929, File 41-1929, AICC Papers.

[57] "Congress Bulletin," January 20, 1929, AICC Papers.

[58] The Foreign Department fell into inactivity during the Civil Disobedience campaign, 1930–34. Nehru took over its reconstitution in 1935 when it functioned until the British colonial government raided its headquarters and preemptively imprisoned the secretary in 1939 ahead of Second World War.

[59] U.S. League member, Roger Baldwin, remarked on the financial documents of the League in a letter to Nehru dated December 12, 1927. It warned that while the colonial countries funded a significant portion of the budget, the financial

However, as early as January 1929, the Comintern poured money into the League and sent Soviet advisors from Moscow to supervise the work of the Berlin secretariat.[60] The change in management, coupled with a more rigid vision for internationalist collaboration among only communist members, resulted in the ousting of many noncommunists from the LAI by 1930.

The shift within the League took obvious precedence at the Second World Congress of the LAI in Frankfurt in July 1929. Nehru did not attend, but the INC sent Shiva Prasad Gupta, a Congressman who happened to be in Europe at the time. Cast as a follow-up to the Brussels Congress, the Frankfurt Congress reflected less of the inclusive platform of 1927 and more the rigid realignment of anti-imperialist forces taking place in the League. Emblematic of this shift was the difference in the Brussels Manifesto (1927) call for the "oppressed peoples and oppressed nations, [to] unite!" and the slogan of the Frankfurt Manifesto (1929):

> The Second World Congress of the League Against Imperialism calls upon the colonial peoples and the toiling masses throughout the world to close their ranks, strengthen their organization and confidently carry on the fight for complete national independence, for defense of the Soviet Union, and against imperialism and imperialist war.[61]

One of Nehru's comrades from the Brussels days, Edo Fimmen of the Amsterdam Trade Union Federation, sent two distressed letters to Nehru in October characterizing the Frankfurt Congress as a

> wild heresy hunt by the dominant left wing section of the CI against everybody who was not absolutely trustworthy from their point of view. The congress was in no way a demonstration of unity, but a kind of ecclesiastical

necessities were forcing the League to seek more and more funds from communist and Russian trade unions. Volume 6, Correspondence Files, JN Papers.

[60] The Comintern alone contributed $5000 for the Frankfurt Congress and it secured an additional $16,000 from ancillary organizations of the CI. This was a substantial amount of money in 1929. See letter from A. Brittleman (Executive Committee of the Communist International in Moscow) to Willi Muenzenberg, May 22, 1929, 542/1/30/47, CI Papers.

[61] "Manifesto," Frankfurt World Congress, 1929, Printed by the LAI and for National Independence, File 78, LAI Papers, IISH Papers.

court for the arraignment and execution of comrades showing any signs of not being strictly orthodox.[62]

Nehru's American comrade, Baldwin, called the Frankfurt Congress a meeting of "political one-sidedness" that elected a general council "without much influence or particular interest in anti-imperialism."[63]

Within months, the fractures among anti-imperialists in Frankfurt spread to India. Even with evidence from Frankfurt and hostile letters from Berlin, Nehru continued to work on behalf of the League throughout the year. As late as November 1929, Nehru tried to revive the Indian Independence League and its collaborative work with the League's international community.[64] However, Nehru was growing concerned and wrote to the League secretary in late November:

> You will remember that in the early stages of the League we discussed repeatedly what the position of the communists and non-communists should be in the League. It is clear that the League was not a purely communist organization as you have yourself rejected. It was an organization which brought together all anti-imperialist elements whether communists or not. It appears however that the non-communist elements have been driven out of the League. This seems to me a very unfortunate policy which is bound to end in the collapse of the League.[65]

Nevertheless, Nehru clung to the League for another six months, finally ending the relationship in April 1930. His final letter to the League requested that the secretariat remove his name from the executive council list after news reached him of his excommunication from the League, a detail that had been published in Europe even before the Berlin secretariat contacted him.[66]

[62] Fimmen to Nehru, October 31, 1929 and Fimmen to Nehru November 12, File 7, LAI Papers.

[63] Baldwin to Chatto, August 26, 1929, Box 8, Folder 3, Baldwin Papers.

[64] Nehru to Independence League Members, November 15, 1929, File 7-1928, AICC Papers.

[65] Nehru to Chatto, "Selected Works of Jawaharlal Nehru" Vol. 3, November 26, 1929, 312–13.

[66] Nehru to LAI Secretariat, April 9, 1930, File 10, LAI Papers.

At the crux of this shift was a breakdown in the possibility for a "special blend" of nationalism and internationalism so important to the Brussels Congress and League moment in 1927. By 1930, the possibility for collaboration and active overlooking of differences among anti-imperialists was ending within the LAI and other international leftist organizations. The split between Nehru and the League was emblematic of a growing schism worldwide within the international left and between the ultra leftwing and communists on the one hand, and the more moderate leftists on the other. There may have been little Nehru could have done to avert the break with other internationalists in the League. The split also signaled a change in the more inclusive and fluid internationalist milieu of the late 1920s to the hardening and rigid categories of nationalism, socialism, and communism developing in the 1930s.

Despite new contingencies at the turn of the decade, the League rupture did not produce a longstanding change in Nehru's construction of anti-imperialism as a collaborative project between anticolonial nationalism and internationalism. In fact, Nehru took personal responsibility for his split with the LAI. He recalled in his 1935 autobiography that because of his decisions to support Dominion Status in the Delhi Manifesto rather than complete independence from the British Empire, the League "grew exceedingly angry with me, and excommunicated me with bell, book, and candle- or to be more accurate, it expelled me by some kind of resolution."[67] He added, "I must confess that it had great provocation, but it might have given me some chance of explaining my position."[68] Nehru's response reflected his failure to see clear cleavages within the anti-imperialist internationalism he imagined in Brussels and through the early months of the League. In turn, the resistance to new realities demonstrated the formative impact of the Brussels moment on his ideas about India and its place in the world.

The strongest evidence of the continuity of Nehru's anti-imperialism in spite of the fractures of 1930 can be found in his first substantial book, *Glimpses of World History*. Written immediately after the League split and while he sat in prison from 1930 to 1933, *Glimpses* totaled nearly a thousand pages on world history in the form of letters to his daughter

[67] Nehru, *Autobiography*, rev. ed., 174.
[68] Ibid., 174–75.

beginning with ancient history and running up to its publication in 1934. A second edition of *Glimpses* brought the magnum opus up to 1939, and a third U.S. edition enjoyed wide circulation in 1942.[69] A quick glance at the table of contents for the postwar years provides ample evidence that Nehru based *Glimpses* on international anti-imperialism and the comrades he met through the LAI. It was primarily attentive to the story of India set against the backdrop of events and forces at work in Europe, Russia, China, Egypt, and the United States. The detailed history of the years between 1919 and 1933 totaled a disproportionate one-third of the original 950-page manuscript. Writing this final third in the summer of 1933, Nehru was no longer drafting a distant history but instead an appraisal of current events as he saw them from his prison cell.

The post-Great War years—ones most formative to Nehru's personal formulations of nationalism and internationalism—provided a clear statement on his anti-imperialist worldview. It was a story of a world divided along the fault lines of capitalism and imperialism on one hand, and anticapitalism and anti-imperialism on the other. According to Nehru, the Great War

> shook the whole system of ideas on which we had grown up and made us begin to doubt the very basis of modern society and civilization.... It was an age of doubt and questioning which always come in a period of transition and rapid change.[70]

This produced two contentious forces. On the one hand, European capitalist-imperialist remained the antagonists of his story, but the postwar rise of the United States—the "money lender to the world"—represented the most powerful capitalist–imperialist force in the postwar era.[71] As Nehru wrote from jail, he also considered new forces at work in the 1930s such as fascism, but he did so within the familiar logic of his 1920s internationalism. He argued that fascism was only another

[69] Jawaharlal Nehru, *Glimpses of World History: Being Further Letters to His Daughter Written in Prison, and Containing a Rambling Account of History for Young People.* U.S. ed. (New York: The John Day Company, 1942). (Citations from this edition).

[70] Ibid., 685.

[71] Nehru, *Glimpses,* 686.

manifestation of the symbiotic forces of capitalism–imperialism. In other words, the world struggle of the 1930s was one against capitalism–imperialism–fascism. On the other hand, the heroes of Nehru's postwar world in *Glimpses* mirrored the anti-imperialist elements from Brussels and the League—nationalists from the colonies, socialists, and communists. He especially underscored the significant roles of India, China, Egypt, and the Soviet Union in the international struggle against imperialism. Brought to its logical conclusion, Nehru hoped for a better future with the resurgence and cooperation of the anti-imperialist forces to usher in a new era of progress.

Hardly reflective of his tensions with communists in the League in 1930, Nehru cast the Soviet Union and international communism as the beacon of hope for anti-imperialism in the postwar struggle laid out in *Glimpses*. Nehru wrote, "while trade depression and slump and unemployment and repeated crises paralyse capitalism, and the old order gasps for breath, the Soviet Union is a land full of hope and energy and enthusiasm, feverishly building away and establishing the socialist order." It was "attracting thinking people all over the world."[72] Lenin was "the embodiment of an idea" and he lives on "in the mighty work he did, and in the hearts of hundreds of millions of workers today who find inspiration in his example, and the hope of a better day."[73] He also romanticized Stalin as the leader of a new Soviet Union. Rather than recognize the great cost of human lives and suffering in the Five Year Plans under Stalin, Nehru argued that the people of the Soviet Union "tightened their belts" and "sacrificed the present for the great future that seemed to beckon to them and of which they were the proud and privileged builders."[74] For Nehru, the Soviet Union's transition from agricultural country to industrialized powerhouse was a lesson for India's and the world's future, one that enabled him to overlook both the crimes against humanity committed by Stalin, as well as the frigid relations that Soviet leadership developed with Nehru and the INC after 1930.

The reading of *Glimpses* as an international anti-imperialist narrative suggests two important points. First, despite Nehru's falling out with

[72] Ibid., 940.
[73] Ibid., 660.
[74] Ibid., 855.

the LAI and the new context of the 1930s, his formulations for Indian nationalism in relation to anti-imperialist internationalism continued after his institutional connection with the League ended. The formative moments in Brussels and through the League inspired Nehru to construct a vision of Indian nationalism tempered by internationalism and an expanded geography of anti-imperialism. This persisted even when the institutional networks did not. It also signals a failure to recognize that the basis for nationalist and internationalist collaboration was shifting in the 1930s. An era of more rigid and exclusive politics—emblematic in the rise of figures like Stalin, Mussolini, and Hitler—ushered in changes in the 1930s that complicated anti-imperialist imaginings and networks. Despite these transitions, Nehru came to identify nationalism and internationalism as the same project, and this logic underpinned his historical writings about India and the world even as this view began running counter to the shifts within the League's institutional platform from the inclusive internationalist "special blend," to the rigid and more exclusive categories of national and social mobilizations.

Nehru continued to pursue anti-imperialist internationalism long after the split with the League and the publication of *Glimpses*. Of course, his return to the LAI in London during his trips to Europe in 1935 and 1936 further demonstrate the loss of animosity toward the organization. Even his speech in 1936 as the INC president offered a clear statement on India and international anti-imperialism. The speech is emblematic of both his previous experiences with the League and his later, postcolonial vision for India and Asian-African solidarity. The body of Nehru's speech appealed to his nationalist colleagues to envision—as he did—the "organic bond" between India and the world.[75] Of India's independence movement, Nehru argued:

> Our struggle was but part of a far wider struggle for freedom, and the forces that moved us were moving millions of people all over the world and driving them to action. All Asia was astir from the Mediterranean to the Far East, from the Islamic West to the Buddhist East; Africa responded to the new spirit.

[75] Nehru, INC Presidential Address in Lahore, April 1936, repr., in *India and the World: Essays by Jawaharlal Nehru* (London: George Allen and Unwin Ltd., 1936), 68.

This spirit, according to Nehru, moved Asian, African, and even Soviet territories toward a "new conception of human freedom and social equality."[76]

Conclusions

What would become of Nehru's special blend of nationalism and internationalism as the interwar years closed and a Second World War ushered in an era of decolonization and new super power rivals, the United States and Soviet Union? Although beyond the scope of this essay, the anti-imperialist internationalism of the interwar years continued to inform Nehru beyond 1947, although sometimes in problematic ways. The afterlives of the international anti-imperialist moment of the interwar years were many.[77] As Minister of External Affairs, Nehru's foreign policy for India opposed European imperialist ambitions to reclaim colonial territories in Asia after the Second World War, and he emerged as a key partner for anticolonial struggles in Africa. Nehru's most coveted postcolonial partners mirrored the critical nodes of his interwar anti-imperialist geography. For example, Indonesia, China, and Egypt remained important even if interstate rather than international relations guided diplomatic ties between India and the world.

Although Nehru adhered to the neutral and nonaligned position in the Cold War, he also continued to admire the Soviet Union from afar and defended it against critics who characterized international communism as a neo-imperialist force in the world. Nehru argued frequently and adamantly that the Soviet Union was not imperialist. In 1955, he spelled out his position in a report to the Indian parliament: "Whatever views might be held of the relationships that might exist between the Soviet Union and them [Eastern European countries], they could in no way be called colonies nor could their alleged problems come under the

[76] Ibid.

[77] See, for example, Vijay Prashad, *The Darker Nations: A People's History of the Third World* (New Press, 2007).

classification of colonialism."[78] Based on his historical understandings of the Soviet Union, Nehru could not imagine the country as a colonial power. The argument was entirely anathema to his conception of imperialism and anti-imperialism born out of his interwar worldview and despite his own turbulent experiences with the post-1929 communist-run League. The chilled relations between Nehru and the Soviet Union after 1947, then, stemmed more from Stalin's antagonism toward India for its nonaligned position. In fact, Stalin refused to receive an Indian ambassador to the U.S.S.R. for two years, and until his death in 1953 Indo-Soviet relations were contentious. As the Indian ambassador to the Soviet Union K.P.S. Menon (position held 1952–61) remarked, "All one could do was, to put it bluntly, to wait in patience for Stalin to pass."[79]

Ultimately, it was the capture of the nation-state that created problems and obstacles to Nehru's anti-imperialist internationalism stemming from his interwar days. Inherent in the "special blend" of nationalism and internationalism was a tension that was never fully reconciled by Nehru and his interwar comrades against imperialism. The aspirations of many of the nationalists from the colonies were the capture of the colonial state and establishment of the nation-state, thereby creating the fundamental borders that anti-imperialist internationalism sought to break down. In other words, the fulfillment of the anticolonial nationalist agenda—the creation of the Indian nation-state in 1947—changed the ways in which Nehru could connect and collaborate with anti-imperialist comrades abroad. With India's independence, interstate relations would emerge as the primary structure of meetings and diplomacy. The rapid demise of European colonialism and the rise of platforms such as the United Nations only reinforced the primacy of nation-state and a world of interstate relations, which necessitated different connections, networks, and imaginings than the internationalism that inspired Nehru in the 1920s. This shift created discord among comrades he once imagined as India's natural allies, most notably China.

[78] Nehru, Speech to Lok Sabha, New Delhi, April 30, 1955 (New Delhi: Publications Division, Government of India, 1955), 17.

[79] K.P.S. Menon, "India and the Soviet Union," in *Indian Foreign Policy: The Nehru Years*, ed. B.R. Nanda (Honolulu: University Press of Hawaii, 1976), 136.

The legacy of Brussels and the League after 1947, then, was mixed. Still, the internationalist moment of the interwar years remain a formative and critical dimension of Nehru's biographical history and the development of Indian anticolonial nationalism more broadly. The history of Nehru and the LAI demonstrates the significant relationship between anti-imperialist internationalism and Nehru's nationalist imaginings for India. Beyond this essay, the study might also encourage a rethinking of postindependence studies of Nehru, India, and the Cold War by digging deeper into the archive to break the colonial–postcolonial divide in attempting to understand the histories of international and interstate connections between India and what eventually became the third world. There is much to be gained, for example, by analyzing in more detail the earlier, interwar histories in relation to the later developments in third world activism.

Beyond Nehru's personal history, this essay also uses his sources and perspectives as a prism for exploring larger questions about Indian history and colonial historiography in general. To insist on framing colonial resistance as an isolated and local project is to neglect what was possible for colonial reformers and activists such as Nehru who traveled the international world. The LAI offered alternative and unique tools, forums, and networks for Nehru and the INC, which opened up new possibilities and alignments that transcended imperial, national and colonial boundaries. Indeed, the League connections were one of many critical links that intertwined Indian nationalism, and its leaders, with other internationalist currents of anti-imperialism during the interwar and late colonial years.

3

Uniting the Oppressed Peoples of the East: Revolutionary Internationalism in an Asian Inflection

Carolien Stolte

Introduction

> If India determines to become the centre for the support and protection of the labouring classes and regards socialist Russia amongst the Eastern countries, we are certain there will be no failure. The committee is of the opinion that an Asiatic Federation will never fail, provided Asia does not absorb Russia. The Russians in the eyes of the Asiatic, are a semi-Asiatic nation and half of Asia is under their influence. By abandoning the old Imperial Russian ideas, Russia is now fighting for a principle, for which the standard bearer should have been Asia.[1]

[1] APAC, IOR, L/P&J/12/241: Secret Report, 1925, regarding a proposal by Obeidullah Sindhi to unite "the oppressed Asiatic Nations."

This contribution considers interwar internationalism in a particular political and geographical inflection, which is best termed as "revolutionary Asianism." It considers Indian revolutionaries, who, as trade unionists in India or (self)exiled revolutionaries elsewhere in Asia, looked toward the Soviet Union in general, and Soviet Asia in particular, as the most crucial building block for an Asian anti-imperialist movement held together by anticolonial and working-class solidarity. In this way, this paper seeks to add to the recent scholarly interest in Asianism, which has largely bypassed South Asia and focuses strongly on East Asian regionalism.[2] Notable exceptions are studies of Tagore's Asianism, which accorded Asia a world-historical role as a spiritual teacher to the materialist West; or the pseudo-imperialistic cartographies of the Greater India Society, which saw an Asia that had been civilized by India in ages past.[3] However, it is often overlooked that, especially when viewed from India, Asianism need not focus on East and Southeast Asia, but could and did engage with Central and Western Asia. It must be noted in this context that Tagore himself was no exception, as his Asianist writings on Persia may attest.[4]

Similarly, this paper seeks to contribute to the increasingly voluminous scholarship on interwar internationalism by locating a series of internationalist expressions in this period in less likely physical and mental locales. The movements, groups, and people in this essay drew inspiration from the Bolshevik revolution rather than from Wilsonian internationalism.[5]

[2] Among many others, C. Aydin, *The Politics of Anti-Westernism in Asia: Visions of World Order in Pan-Islamic and Pan-Asian Thought* (New York: Columbia University Press, 2007); E. Hotta, *Pan-Asianism and Japan's War 1931–1945* (New York: Palgrave Macmillan, 2007); S. Saaler and C.W. Szpilman (eds), *Pan Asianism: A Documentary History*, Vol. 1, 1850–1920 and Vol. 2, 1920–present (Lanham MD: Rowman and Littlefield, 2011).

[3] For an overview, see C. Stolte and H. Fischer-Tine, "Imagining Asia in India: Nationalism and Internationalism, ca. 1905–1940," *Comparative Studies in Society and History*, 54, 1 (2012): 65–92.

[4] R. Tagore, *Journey to Persia and Iraq, 1932* (Santiniketan: Visva Bharati Publication Department, 2003).

[5] See E. Manela, *The Wilsonian Moment: Self-determination and the International Origins of Anti-colonial Nationalism* (New York: Oxford University Press, 2007).

Like most internationalist movements of the interwar years, they envisioned an interconnected world of greater justice and equality. However, rather than working toward a decolonized world in which formerly subordinated peoples participated fully in the existing international system, they sought to overthrow that system, its constituent parts, and the ideas on which it was built. Their vision of a decolonized world included a world that had overcome the imbalance of power inherent in the League of Nations, its mandate system, and organizations such as the International Labour Organization (ILO) and the International Federation of Trade Unions (IFTU). Here, this paper follows Manu Goswami's point that the temporal referent of radical politics is the future, and that its anti-imperial expressions cannot be reduced to nationalism.[6] Rather, they formulated their plans in an explicitly internationalist, in this case Asianist, idiom. This idiom was geared toward forging an anti-imperial alliance based on Asian commonalities, and working toward an interconnected Asia that could take up a role in the world that befitted its size and population.

It has long since become a commonplace to state that regions, continents, "worlds" and other geographic concepts are discursive constructs, which have no meaning other than those projected on it by particular cultural, religious, or political agendas.[7] The groups described here shared an agenda which vocally contested the existing political and economic hegemonies of late-colonial Asia. But what was the "Asia" of these revolutionary Asianists? Their understanding of Asia was a space based not on geography, race, or culture, but on solidarity: The belief that the problems of the Asian working class—which they understood to encompass 90 percent of all Asians—were the result of Western imperialism. Therefore, "the oppressed peoples of the East" had an anti-imperialist struggle in common which was best waged collectively. In this way, these revolutionaries escaped what John Steadman has termed the "tyranny

[6] M. Goswami, "Imaginary Futures and Colonial Internationalisms," *American Historical Review* 117, 5 (2012): 1461–85, 1461–62.

[7] R. Karl, "Creating Asia: China and the World at the Beginning of the Twentieth Century" *AHR* 103, 4 (1998): 1096–1118; M. Lewis and K. Wigen, *The Myth of Continents: A Critique of Metageography* (Berkeley: University of California Press, 1997), 9.

of the word and the concept" of Asia.[8] Their Asia was a much more flexible space.

It is nevertheless worth "mapping" what this revolutionary Asia included and excluded, for it is a vocal expression of the intentions of its proponents. First and foremost, it was a space with shifting borders. It did not exist on a map. But despite its lack of formal cartographic expression, this analysis of revolutionary Asianism is informed by Sumathi Ramswamy's use of the concept of the "geo-body."[9] Taken as an expression which is "ephemeral unless hard and regular work is undertaken to produce and maintain its materiality," the geo-body is inherently fragile, yet capable of producing powerful reverence and affinity.[10] Her views on the cartographic "peninsularization" of India, moreover, help visualize Asia as seen from India.[11] Rather than the more intensively studied East-Asian regionalisms, which looked west, the revolutionary Asianists described here looked north. It is no surprise that the Himalayas, and in particular the Pamirs, played an important role in their Asianist thinking—not as a barrier, but as a route, which was hard to police and connected them to Kabul, Tashkent, and other centers. In addition, even if their Asia was not a bounded territory, these Asianists still expressed themselves using geographical terms, and understood "Asia" as those areas that were or had been physically occupied by European powers. In the understanding of the latter, as may also be seen from Obeidullah Sindhi's words above, Russia was an ambiguous space. Czarist Russia had definitely been European, but Soviet Moscow, insofar as it had adopted the cause of the "oppressed peoples of the East," could be co-opted as Asian. The revolutionaries described below were of the latter persuasion. The Asianist platforms they built in the 1920s, mainly in the form of revolutionary parties and trade union bodies, conceived of an Asia which included parts of, if not the whole, Soviet Union.

This essay consists of three parts. First, the development of this Asian geo-body and its most important centers will be examined through

[8] J. Steadman, *The Myth of Asia* (New York: Simon & Schuster, 1969), 14–15.

[9] S. Ramaswamy, "Visualising India's Geo-body: Globes, Maps, Bodyscapes," *Contributions to Indian Sociology*, 36 (2002): 151–89.

[10] Ramaswamy, *Visualising India's Geo-body*, 152–53.

[11] Ibid., 166.

Indian revolutionaries who traveled to Soviet Asia and the activities they employed during their time there. These revolutionaries, and the platforms they built, stood in direct conversation with revolutionaries in India, many of whom had organized themselves in trade unions—particularly in Bombay and Calcutta. The second and third parts consist of the Asianist projects of the latter: their participation in the League Against Imperialism (LAI) and the Pan-Pacific Trade Union Secretariat (PPTUS), respectively. Finally, it will be shown that for Indian revolutionary Asianists, the collapse of Soviet support for Asian trade unionism and in particular the disbanding of Profintern (the Red International of Trade Unions) in the Third Period (1928–33), coincided with a British clampdown on revolutionary trade unionism, which spelled the end for this particular type of interwar internationalism in an Asian inflection.

The Geo-body of Asia: The Soviet Union, Traveling Revolutionaries Asian Affinities

Despite the fact that most of its territory lies in Asia, the lands of the Soviet Union play at best a peripheral role in most Asian cartographies.[12] However, the Soviet Union, and especially its Central Asian Republics, occupied an important place in many Indian imaginaries of the region. To those who sought to project shared religious identity markers onto Asia, Central Asia invoked images of itinerant monks who had spread Buddhism across the continent. To those who imagined a Muslim Asia stretching from Indonesia to Turkey, Tashkent, Samarkand, and Bokhara were indispensable stops on pilgrimage routes. Yet others sought to incorporate India in a mythical "Turan," the imagined homeland of the martial and nomadic peoples of Central Asia.[13] But from the

[12] This point is elaborated upon in M. Bassin, "Russia between Europe and Asia: The Ideological Construction of Geographical Space," *Slavic Review* 50, 1 (1991): 1–17.

[13] In India, revolutionary-in-exile Mahendra Pratap identified with Turan as a masculine, independent space, as opposed to a colonialized space. Sultan Galiev, the "Red Tartar" saw a socialist Turan as a banner around which Central Asia might rally. M. Hauner, "Russia's Geopolitical and Ideological Dilemmas

early 1920s and throughout the interwar years, Soviet Asia became crucial in a set of anti-imperialist engagements which centered on Tashkent, Baku, and later also Moscow. In Tashkent, Indian Comintern leader Manabendranath Roy and his associates had created a revolutionary nucleus of Indians in Tashkent in the later summer of 1920. Baku was the site of the Congress of the Peoples of the East in September of that year, which had two Indian members in the organizing committee. Moscow, finally, increased in importance with the opening of the University of the Toilers of the East, which was attended by several Indian revolutionaries from the Tashkent circle.

Central Asia had become incorporated into the geo-imaginary of Indian revolutionaries in various ways. The revolutionary exile and Ghadarite Mohamed Barkatullah had written an anti-imperialist pamphlet in Persian at Tashkent, entitled "Bolshevism and the Islamic Nations."[14] Downplaying the antireligious tenets of the Soviet project and instead stressing the similarities of the Quranic precepts of *zakat* (alms-giving) and *bait-ul-mal* (distribution of revenue) to communism, he focused on the imperialist threat to Asia. He considered a program of aggressive modernization on the Soviet model as a "divine cry" to liberty, equality, and brotherhood.[15]

> British imperialism holds Asiatic nations in a state of eternal thraldom. It has moved troops into Turkestan with a view to felling the young tree of perfect human liberty just as it is beginning to take root and strength. Time has come for ... Asiatic nations to understand the noble principles of Russian socialism and to embrace it seriously and enthusiastically. They should fathom and realize the cardinal virtues taught by this new system....

in Central Asia," in *Turko-Persia in Historical Perspective*, ed. R. Canfield (Cambridge: Cambridge University Press, 1991), 189–216, 202; A.A. Bennigsen, *Muslim National Communism in the Soviet Union* (Chicago: University of Chicago Press), 66–68.

[14] On Barkatullah and the Ghadar movement, see M. Ramnath, *The Haj to Utopia: How the Ghadar Movement Charted Global Radicalism and Attempted to Overthrow the British Empire* (Berkeley: University of California Press, 2011), 47–49.

[15] G. Adhikari, *Documents on the History of the Communist Party of India*, Vol. 1, 1917–22 (New Delhi: People's Publishing House 1971), 126.

They should, without loss of time, send their children to Russian schools to learn modern sciences, noble arts, practical physics.[16]

Barkatullah's pamphlet was not the only Indian manifesto written in Tashkent. A sizeable group of revolutionaries had gathered there, one of whom, Abdul Majid, edited the Urdu-Persian paper *Zamindar* on behalf of the group. They too framed their activism in terms of an all-Asia project. In their inaugural issue, they declared their intent to "keep all Eastern revolutionary organizations under one centre."[17] One of Majid's associates, Muhammad Shafiq, later to be sentenced to three years of imprisonment in the Peshawar Conspiracy Case, wrote an "Appeal to the Oppressed Peoples of the East." This appeal echoed a sentiment shared by many Indian revolutionaries: If Asia stood united against the imperial powers, Indian independence would emerge naturally as a by-product of that unity. Shafiq wrote:

> Respectful greetings from the organization of Indian residents in Tashkent. India with heart and soul hopes for the fulfillment of your desires. India is so sick of the oppressive repression that it is determined to plunge into the battle. Oh, sufferers of the East dreaming of freedom from iron chains, it is your duty to follow the example of India! ... Brethren of Bukhara, is not your Amir a pawn of British greed? ... Oh, Iranian brothers, is not your Shah busy touring Europe? ... Oh, leading members of Soviet Russia, is your country really secure? ... Never! It is only when you understand this that you will heed the call.[18]

Both Barkatullah and Shafiq drew from Islamic and communist idiom in their writings, combining it into an Asianist call to arms. This discourse catered to their audience of Indians and other Asians in Central Asia. While some had been drawn to Soviet Asia soon after the Bolshevik Revolution for the sake of collaborating with the new regime, the majority had ended up in Tashkent for very different reasons. They had left after the 1920 Khilafat Congress, responding to the call for *hijrat* (migration to Islamic lands) after the fall of the Ottoman Empire: disillusion

[16] M. Barkatullah, "Bolshevism and the Islamic Nations," quoted in Adhikari, *Documents*, Vol. I, 126–28.

[17] Adhikari, *Documents*, Vol. I, 137.

[18] Adhikari, *Documents*, Vol. I, 137–39.

over broken British promises with regard to the caliphate and the holy places of Islam had sparked the movement. The *muhajirs* (migrants) had thus been on their way to Anatolia rather than to Soviet-controlled Asia.[19] Eyewitness accounts survive of their arduous journeys—they had been promised asylum by the Amir of Afghanistan, whose invitation was retracted when their numbers became too great—and many had to turn back.[20] Others, however, were convinced by Abdur Rab, an Indian diplomat-turned-revolutionary already present in the Soviet Union, to continue on to Soviet-controlled Central Asia, for "revolution had taken place and if they went there they could see and learn many things."[21] They agreed to proceed with Rab, but for many it was initially merely a ticket to get closer to their goal of reaching Anatolia. A few got as far as Baku, but were distrusted by Turkish representation there and refused permission to continue.[22] However, even there, at the western-most fringes of Soviet Asia, there was no escaping the euphoric moment of solidarity with the oppressed peoples of Asia that was pervading the region: At least two of the *muhajirs*, Akbar Shah and Masood Ali Shah, ended up at the Baku Congress of the Oppressed Peoples of the East, which opened on September 1, 1920.[23] They heard the following speech on the opening session:

[19] For the transformation of several of these *muhajirs* into revolutionaries, see K.H. Ansari, "Pan-Islam and the Making of Early Muslim Socialists," *Modern Asian Studies*, 20, 3 (1986): 509–37.

[20] See Shaukat Usmani, *Leaves from an Indian Muhajireen's Diary* (Varanasi: Swarajy Publishing House, 1927); Shaukat Usmani, *Historic Trips of a Revolutionary: Sojourn in the Soviet Union* (New Delhi: Sterling Publishers, 1977); and the account of Rafiq Ahmad, in M. Ahmad, *The Communist Party of India and its Formation Abroad* (Calcutta: National Book Agency, 1962), 37–42.

[21] From the account of Rafiq Ahmad, quoted in M. Ahmad, *The Communist Party of India*, 15. For rare biographic information on Abdur Rab, see M. Ahmad, *Myself and the Communist Party of India: 1920–1929* (Calcutta: National Book Agency, 1970), 50–51.

[22] Adhikari, *Documents*, vol. I, 27.

[23] Adhikari I, 52. On the Baku Congress, see J. Riddell (ed.), *To See the Dawn: Baku, 1920: First Congress of the Peoples of the East* (New York: Pathfinder, 1993); S. White, "Communism and the East: Baku, 1920," in *Slavic Review*, 33, 3 (1974), 492–514.

Comrades! The grey-haired East, which gave us our first notion of morality and culture, will today shed tears, telling of her sorrow, of the grievous wounds inflicted upon her by capital of the bourgeois countries. [...] We must at last slam shut this book of the accursed past, so that it may never return. We must open a new page of history, when the oppressed peoples of the East will no longer be slaves, when they will not allow British offices to shamelessly plunder the Indians and the Persians, killing, insulting and mocking at everyone.[24]

After Tashkent, Baku formed an important second site where Asian solidarity was expressed by a group of (temporarily) exiled revolutionaries of various backgrounds, and which was subsequently drawn into the revolutionary geo-imaginary of Asia. The Congress of the Oppressed Peoples of the East convened twenty-two Asian nationalities to hammer out a common policy against imperialism in Asia.[25] Fourteen Indian delegates attended, roughly half of whom belonged to the Indian Revolutionary Association which had been formed at Tashkent (and soon to be merged with the Communist Party of India).[26] M.P.T. Acharya and Abani Mukherjee represented the small group of "card-carrying" Indians. Acharya had been a member of the Indian group that had visited Lenin in 1918, and an associate of Abdur Rab.[27] But Mukherjee in particular was a revolutionary with a long pedigree in Pan-Asianist activism, whose travels had taken him to almost all Asianist centers of the interwar period. Having met exiled Pan-Asianist Rashbehari Bose[28] as early as 1914, his revolutionary activities led him to Japan, Singapore, and

[24] Congress proceedings: First Session—September 1, 1920, in Riddell, *To See the Dawn*, 60–77.

[25] Riddell, *To See the Dawn*, 11.

[26] S. Roy, *M.N. Roy: A Political Biography* (New Delhi: Orient Blackswan, 1997), 58.

[27] Acharya had left India in 1907. With a permanent British warrant for his arrest, he spent the whole interwar period abroad. M.P.T. Acharya, *Reminiscences of an Indian Revolutionary*, ed. B.D. Yadav (New Delhi: Anmol Publications, 1991), vi (Preface).

[28] On Rashbehari Bose, see U. Mukherjee, *Two Great Indian Revolutionaries: Rash Behari Bose and Jyotindra Nath Mukherjee* (Calcutta 1966); P.S. Ramu, *Rashbehari Bose: A Revolutionary Unwept, Unhonoured and Unsung* (New Delhi 1998).

the Dutch East Indies. His Indonesian and Dutch contacts acquainted him with communism, and through the offices of Dutch communist S.J. Rutgers, he traveled to the Soviet Union and at the Second Congress of the Communist International. During a clandestine return to India, he was briefly engaged in trade union activities, collaborating with, among others, S.A. Dange, who is treated below.[29]

As yet, the Baku conference has not been recognized as a moment of importance to the Indian anti-imperialist struggle, let alone as a site of Asianist significance to India.[30] This is partly due to the fact that Baku was not attended by any of the "figureheads" of the revolutionary struggle whose travels brought them to the Soviet Union, such as Barkatullah, M.N. Roy, and Virendranath Chattopadhyaya. However, the strong Indian presence at the congress caused India to become a Profintern priority. Abdur Rab had sent a letter to the Baku Congress on behalf of the Indian Revolutionary Association in Tashkent, urging the delegates, and the Soviet Government in particular, to come to the aid of the oppressed peoples of the East. It is indicative of the Tashkent circle's particular brand of Asianism, that in the letter they both vow not only to work with all the Baku delegates to resolve the "Eastern Question," but also hope that "help may be given without religious interference."[31]

[29] Mukherjee's aliases included Trailokovich Mukherdzhi (added Russian patronymic) and Dar Shaheer (alias used in Southeast Asia). He stayed in the Soviet Union primarily as an Indologist for the Soviet Council of Sciences, but was purged and executed in 1937. See also the rather hagiographic biography by G. Chattopadhyaya, *Abani Mukherji: A Dauntless Revolutionary and Pioneering Communist* (New Delhi: People's Publishing House, 1976).

[30] In stark opposition to the recognition of its significance to the Middle East and Persia. J. Pennar, "The Arabs, Marxism and Moscow: A Historical Survey," *Middle East Journal* 22, 4 (1968), 433–47; S. Blank, "Soviet Politics and the Iranian Revolution of 1919–1921," *Cahier du monde russe et soviétique* 21, 2 (1980), 173–94; S. Yilmaz, "An Ottoman Warrior Abroad: Enver Pasha as an Expatriate," *Middle Eastern Studies* 35, 4 (1999), 40–69.

[31] Russian Centre for Conservation and Study of Records for Modern History (RCCSRMH) 495-68-9: Mohammad Abdur Rabb Barq to the Comrades of the Third International, Second Congress, Baku, 10/8/1920. Published in: P. Roy, S.D. Gupta, and H. Vasudevan (eds), *Indo-Russian Relations: 1917–1947: Select Documents from the Archives of the Russian Federation* (Calcutta: Asiatic Society, 2000), 25–26.

After the Baku Congress, plans arose to organize a large Indian Revolutionary Congress in Central Asia with Soviet help. M.N. Roy tried to get word of this initiative to Indian trade unions.[32] M.P.T. Acharya, in the meantime, moved to Kashgar to coordinate Indian activities through a Kashgar Union with local activists, although he admitted to difficulties in locating "workmen's revolutionary unions" there.[33] Mukherjee took yet another approach, and worked toward getting Indian trade union-ists to the Congress of International Trade and Industrial Unions in Moscow, and toward getting "about three dozen Indian working men and peasants" to Moscow to be trained in trade unionism.[34] This transla-tion from the revolutionary internationalism from the Indian exiles in Central Asia, into trade unionism in India, was not without its effect. This would become clear when Profintern's Asia Bureau was founded, and particularly in the years of the short-lived PPTUS in which sev-eral Indian revolutionary trade unionists were involved. Conversely, it put the Soviet policy of the 1920s toward Asia firmly on the map of the Indian anti-imperialist struggle. As can be glimpsed from the above let-ters, Mukherjee and Abani both had large revolutionary networks within and outside of India, which included the leaders of revolutionary trade unions. Baku delegate Masood Ali Shah, moreover, was in close touch with M.N. Roy, and through him, with revolutionary trade union leaders such as Muzaffar Ahmed.[35]

Meanwhile in Tashkent, revolutionary training became more coordi-nated with the return of the Baku delegates. In October 1920, a political and military training school for Indian revolutionaries was established. The nucleus was formed by forty-odd *muhajirs*.[36] They were put up in the

[32] RCCSRMH 459-68-2, M.N. Roy to Ya. Z. Suritz, October 4, 1920. *Indo-Russian Relations*, 31–34: 33.

[33] RCCSRMH 544-1-11, M.P.B.T. Acharya to M.N. Roy, November 17, 1920. *Indo-Russian Relations*, 36–37.

[34] RCCSRMH 495-68-5, Abanui Mukherjee to S.P. Gupta, December 30, 1920. *Indo-Russian Relations*, 44–50: 50.

[35] S. Roy, *M.N. Roy: A Political Biography*, 61. On Muzaffar Ahmed's contacts in this period, see further: S. Chattopadhyay, *An Early Communist: Muzaffar Ahmad in Calcutta, 1913–1929* (New Delhi: Tulika Books, 2011).

[36] Adhikari mentions forty students in Vol. II, and fifty in Vol. I. Given that only twenty-six of the *muhajirs* actually joined the Tashkent school, the former

Indusky Doma (India House).[37] By April 1921, their numbers had risen to 110.[38] The short-lived school was referred to as *Indusky Kurs*, which suggests exclusive Indian involvement, but according to M.N. Roy, it was an "international brigade" of Indian, Persian, and Russian revolutionaries acting as an auxiliary to the Red Army.[39] The reality was probably less glamorous. The few existing accounts of the Tashkent School note general disappointment in the revolutionary zeal of its students—possibly because of their greatly varying educational backgrounds.[40] However, attempts were made to disseminate propaganda throughout Asia generated at the Tashkent School; Shaukat Usmani and Rafiq Ahmad were sent to the tribal areas of Turkestan, away from watchful British eyes, to set up printing presses.[41] Such equipment was both expensive and hard to move—M.P.T. Acharya, too, was entrusted with the care of a typewriter which was first moved to the Kashgar Union, and later to Tashkent.[42]

The Tashkent School left many unimpressed, Indians and Soviets alike, and after eight months the school was disbanded. However, the attempt to train revolutionaries from Soviet and colonial Asia together in order to form a united Asian anti-imperialist front had not lost its attraction to either the Tashkent circle or to the Soviet leadership: the school was moved to Moscow and merged with the Communist University for the Toilers of the East (KUTV).[43] This was an addition to the International

number is more likely. It is also closer to Rafiq Ahmad's account, who notes that from an initial group of sixty, a sizeable group never proceeded to Tashkent. M. Ahmad, *The Communist Party of India*, 27.

[37] Adhikari, *Documents*, Vol. II, 27.

[38] K. Manjapra, *M.N. Roy*, 45.

[39] M.N. Roy, *Memoirs* (New Delhi: Allied, 1964), 437.

[40] M.N Roy's own account not excepted. Roy, *Memoirs*, 464. For the British perspective, who noted that "from Roy downwards" Indian communists in Central Asia were largely incompetent, see R.J. Popplewell, *Intelligence and Imperial Defence: British Intelligence and the Defence of the Indian Empire, 1904–1924* (London: Frank Cass, 1995), 311.

[41] Ahmad, *The Communist Party of India*, 30.

[42] RCCSRMH 544-1-11, Acharya to Roy, October 27, 1920. *Indo-Russian Relations*, 34–36: 35.

[43] The university was expanded soon after to include branches in Tashkent and Irkutsk.

Lenin School, where European and American students were taught. The two universities were kept separated, with the University of the Toilers of the East geared exclusively toward Asian anti-imperialist efforts. Most of the Tashkent students joined the KUTV. A.C. Freeman, who was allowed to inspect the university on behalf of the New York-based Friends of Soviet Russia Society, reports that the school was a colorful mix of illiterate Muslim peasants and Chinese, Japanese, and Indian political refugees with degrees from Oxford and Heidelberg.[44] Indeed, the "Turkomans in high black wool hats, Sarts from Bukhara with brightly embroidered caps and almond-eyed Tartars from the Volga"[45] were joined by educated revolutionaries who would soon become important leaders in Asian anti-imperialist networks. Among them were Tan Malaka of the Indonesian Communist Party (KUTV 1922), Ho Chi Min (KUTV 1923), and Liu Shaoqi (KUTV 1921). Masood Ali Shah, Rafiq Ahmad, and Shaukat Usmani also attended.[46]

In this way, the university created an Asianist network of revolutionaries who not only remained in conversation with each other, but whose paths also crossed with revolutionaries at home. It made Moscow into a centre of Asianist enthusiasm in the first half of the 1920s, causing a variety of Pan-Asianists to include the city in their itineraries. The second anniversary of the KUTV was celebrated with speeches from all colonial territories in many languages, accompanied by a series of Asian dance performances.[47] At the third anniversary, Trotsky delivered a rousing speech. By this time, the school was under surveillance from British Intelligence, who dismissed Trotsky's words as a self-congratulatory "dwelling upon the world importance of the University:"[48]

[44] A.C. Freeman, "Russia's University of Oriental Communists," reproduced in Adhikari, *Documents*, Vol. I, 243–45: 244.

[45] Freeman, "*Russia's University of Oriental Communists*," 243.

[46] Maharastra State Archives (MSA), Home Special file 543(2) Bolshevism—Note by the India Office London on the Indian Communist movement for the period December 21, 1922 to May 10, 1923.

[47] As noted by former *muhajir* Fazl Ilahi Qurban, "Revolutionary Training Schools," *Vanguard of Indian Independence*, 1 (1923).

[48] National Archives of India, HP 220 (1924): The Communist University for Workers of the East.

You must know how to couple the uprising of the Indus peasants, the strike of coolies in the ports of China, the political propaganda of Kuomintang bourgeois democracy, the struggle of the Koreans for independence, the bourgeois-democratic rebirth of Turkey and the economic and cultural and educational work in the Soviet republic of Transcaucasia.... At the moment of these decisive events the students of the Communist University of the East will say: "We are here.... We know not only how to translate the ideas of Marxism and Leninism into the language of China, India, Turkey and Korea; but we have also learnt how to translate the sufferings, passions, demands and hopes of the toiling masses of the East into the language of Marxism." "Who has taught you that?" they will be asked. "The Communist University for Toilers of the East taught us that."[49]

The fourth anniversary was celebrated no less festively, with Stalin himself speaking on the "Political Tasks of the University of the Peoples of the East."[50] However, his speech suggests that the university was already losing the official backing it had enjoyed under Lenin.[51] His speech opened with the statement that although all students at the university were "Sons of the East," the differences between students from the Soviet East and from the Colonial East were too large to teach the two groups in one educational body. His speech showed the first signs that a large Asian front, of which all constituent parts fought against imperialism and for their own self-determination (an atmosphere which had prevailed at Baku and Tashkent, and during the early years of the KUTV), was not on Moscow's list of priorities. In hindsight, the speech reads more like a closing ceremony. This was confirmed in the early 1930s as the university was purged, along with its leadership.

During the 1920s however, Moscow remained at an important artery in the Indian revolutionaries' Asian geo-body. This was not limited to

[49] L. Trotsky, *Perspectives and Tasks in the East: Speech on the Third Anniversary of the Communist University for Toilers of the East*, April 21, 1924 (London: New Park Publications, 1973), 14–15.

[50] Published as "The Political Tasks of the University of the Toilers of the East," *Pravda* 115 (May 22, 1925).

[51] Lenin had died in 1924. The power struggle between Stalin and Trotsky was in full swing by 1925, and the university may have suffered from Trotsky's enthusiasm for it. Karl Radek, who headed the university in its early years, was expelled from the party in 1927. He was readmitted in 1930, but sentenced to hard labor in a show trial soon after.

the presence of Indian revolutionaries in Moscow and their activities, but also from attempts—with varying degrees of success—from various non-Indian organizations based in Moscow to give concrete expression to their solidarity with the "oppressed peoples of the East." Among organizations that sent funds directly to India's trade unionists were the Society of Cultural Relations with Foreign Countries, the Red International of Trade Unions, and the Colonial Bureau of the Comintern. Individual unions or groups of unions also sent funds: the All Russian Textile Workers' Federation, the Central Council of Trade Unions, the Central Committee Municipal Workers, and the Central Committee for Textile Workers were all flagged by British intelligence as communicating with India's revolutionary trade unionists.[52] The networks thus established, along with frequent Comintern telegrams of "fraternal greetings" to the yearly All-India Trade Union Congress (AITUC), helped to integrate the region into a perceived revolutionary Asia.[53]

The next section will be devoted to concrete expressions of this particular Asianism by revolutionaries in India. Their Asianism was institutionalized through the trade union involvement in larger internationalist platforms. That their Asianism was largely organized around trade union activity was shaped in no small part returning revolutionaries such as Shaukat Usmani and Nalini Gupta. Both engaged in active propaganda among Indian trade unions, and even British intelligence had to concede that they were not unsuccessful.[54] Their trade union networks were further strengthened through an event of British making: In March 1924, S.A. Dange, Muzaffar Ahmed, Nalini Gupta, and Shaukat Usmani were charged with seeking "to deprive the King Emperor of his sovereignty of British India," the same charge that would be brought in the Meerut

[52] Flows of funds, especially when attempted clandestinely, are notoriously hard to track down in the archive. The organizations mentioned here were flagged in the following files: MSA, Home Special Files 543(18) E/I, 1929–33 Bolshevism funds. Arrangements for interception and control of funds from Communist sources abroad.

[53] At the 1929 Congress, for instance, telegrams were sent by the Russian Council of Trade Unions and the Pan-Pacific Trade Union Secretariat at Vladivostok. See *Trade Union Record*, May 1929, 65.

[54] Cecil Kaye, Director of Intelligence, quoted in Popplewell, *Intelligence and Imperial Defence*, 312.

Conspiracy Case five years later. Kanpur had two unintended results: The first was a broad-based discussion of communists ideas and aspirations in the Indian public sphere.[55] The second was a linking of Asian and local networks through the contacts of the accused, which became instrumental in the establishment of the Workers and Peasants Parties from 1925. These links would be further cemented in the second half of the 1920s.

Asian Solidarity: Indian Trade Unionists and the LAI

The period from 1927 to 1929 marked a crucial phase in the trade unionists' Asian activities. This was largely due to the existence of two organizations: the LAI and the Asian Bureau of the Profintern, later known as the PPTUS, which will be treated in the following section. The LAI itself is discussed in greater detail by Michele Louro elsewhere in this volume. The present concern is with the specific impact of the League as a platform for Indian trade unionists to further develop their Asianist ideas and activities, which were marked both by an admiration of the Soviet Asian project, and by the invocation of Asian anti-imperialist solidarities based on the shared experience of foreign domination. In the sparse historiography of the LAI, Asianism as a theme has been conspicuous by its absence.[56] This is remarkable, considering that the very foundations of the LAI were Pan-Asian in character: a group of students from several colonial and semicolonial areas had come together in a Pan-Asiatic League in Berlin prior to the Brussels Congress, and were involved in its preparations.[57] The intent to have the Brussels Congress

[55] L. Hutchinson, *Conspiracy at Meerut* (London: Allen & Unwin, 1935), 76.

[56] Though mentioned by Micheal Brecher, *Nehru: A Political Biography* (London: Oxford UP, 1959). On the LAI, see further: M. Louro, *At Home and in the World* (Dissertation, Temple University, 2010); and V. Prasad, *The Darker Nations: A People's History of the Third World* (New York: The New Press, 2007), 16–30; J. Jones, *The League Against Imperialism* (Fulwood: Socialist History Society, 1996).

[57] N.K. Barooah, *Chatto: The Life and Times of an Indian Anti-imperialist in Europe* (New Delhi: Oxford University Press, 2004), 248.

function as a platform for Asian delegates to meet and to organize ways of coordinating anti-imperialist activities was clear from the outset. But although co-operation between the Chinese and Indian delegations at the Congress itself has been noted, the scale at which Asian delegations conferred with each other has so far not been touched.

A separate meeting of several Asian delegates also took place in Brussels, at which the possibility of founding a more permanent Pan-Asian organization involving trade union activists, was among the issues discussed.[58] It is worth mentioning that the resolutions arrived at in Brussels demonstrate Asianism at two levels. On the one hand, the Asian contacts fostered at this congress served specific political ends: China and India arrived at a joint statement denouncing the use of Indian troops and resources in the British suppression of China. Their resolution read: "Ever since the unholy Opium War from 1840 to 1842, Indian troops have been sent to China time and again, in order to secure the power of British Imperialism in that country. Eighty-seven years have Indian troops been abused in this way, and thousands of Indians were stationed as police officers today in Hong Kong, Shanghai, etc. They were later used to shoot Chinese workers, which has caused Chinese hostilities against the Indian people to grow.[59] This resolution was part of a larger Asian anti-imperialist protest against the engagement of Asian troops against other Asians.[60]

On the other hand, the resolution demonstrates the popular topos of "ancient bonds" between Asian lands, which had longer antecedents and was actively disseminated by the Greater India Society and related scholarly organizations in the 1920s. This discourse emphasized historical intra-Asian connections in the realm of religion, art and trade as constitutive of a particular "Asian" identity.[61] This too was part of a wider

[58] M. Brecher, *Nehru*, 109–10.

[59] International Institute for Social History (IISH), *League Against Imperialism*, File 26: Joint Sino-Indian resolution.

[60] For details on the "Indian face" of the British imperial police, see Isabella Jackson's account of Shanghai: I. Jackson, "The Raj on Nanjing Road: Sikh Policemen in Treaty Port Shanghai," *Modern Asian Studies* 46, 6 (2012): 1672–704.

[61] For an exposition of this discourse's main arguments, see its founding document: Kalidas Nag, *Greater India: A Study in Indian Internationalism* (Calcutta: Greater India Society, 1926).

Asian anti-imperialist idiom, for it was argued that these historical con-
nections had been severed by the incorporation of Asia into European
empires. The use of this discourse at a revolutionary gathering demon-
strates the wide currency of the notion of historical Asian connections:

> For more than 3000 years, the people of India and China were united by close
> cultural relations. From the days of the Buddha to the end of the Mughal
> period and the start of British rule, these friendly ties were ever-present....
> British Imperialism, which has kept us in isolation from one another in the
> past and has brought so much injustice, is now the very power that unites
> us in our struggle against it.[62]

The Sino-Indian resolution was one of very few bilateral resolutions
in Brussels. Most resolutions were either based on a particular grievance
of one single delegation, or collective stances against imperialist exploi-
tation. Another exception to this rule was a resolution arrived at by the
Asian delegations collectively. This was not a small group. "Asia" in
Brussels consisted of twenty-eight delegates from China, fourteen from
India, four from Indonesia, three each from Korea and Indo-China, and
two from the Philippines.[63] Their joint statement professed the features
they had in common. It is reminiscent of the style of the Sino-Indian
resolution, in that it emphasized Asian cultural and political heritage and
focused on anti-imperialist solidarity:

> The International Congress against Colonial Oppression and Imperialism,
> considering, that there are no areas in Asia free from colonial imperial-
> ism; considering, that all Asian lands have been the heritage of indigenous
> nations since centuries; considering, that these nations themselves have
> built states; considering, that these Oriental nations, who possess an old
> civilization, have a right, as much as the Western peoples, to determine the
> course of their own history; considering that political independence is an
> *absolute requirement* for a people, and that no nation may be subjected to
> a power it rejects, *demands*, that all groups participating in this Congress
> as well as the current organization, which must be built on these decisions,
> must undertake all necessary action, to free Asia from Imperialism and
> Colonial Oppression.[64]

[62] IISH, *LAI,* file 26. Resolution proposed by India and China.
[63] IISH, *LAI,* file 2. List of organizations and delegates.
[64] IISH, *LAI,* file 28: Joint Resolution by the Asian Delegations. Emphasis in
original.

The first LAI Congress had consisted mainly of unions and inter-
est groups already present in Europe. The Examples are the *Perhimpoenan
Indonesia*, the successor of the *Indonesische Vereeniging* (Indonesian
Association), which had been founded by Indonesian students in the
Netherlands in 1922; the Federation of Chinese Students in Europe;
and the Hindoo Unions of Oxford and Cambridge. There were various
reasons for this, the most important one being that with the Bolshevik
threat looming large, metropolitan governments had tightened con-
trol over who was allowed to travel and for what reason—and the LAI
was not a gathering to which a passport was easily obtained. As a con-
sequence, colonial territories were represented primarily by interest
groups already in Europe. This was not at all a new phenomenon. The
fact that public intracolonial gatherings were all but impossible to
achieve in Asia, in combination with the fact that an increasing number
of students received their education in Europe as the opening decades of
the twentieth century progressed, had made cities such as London, Paris,
Berlin, and Amsterdam to become the primary meeting ground for anti-
imperialists of various persuasions.[65]

At the Second Congress of the League Against Imperialism, held in
Frankfurt from July 20 to July 31, 1929, the make-up of Asian delega-
tions had shifted, convening more participants directly from colonial
territories, and in particular more Indian trade unions: Among the
unions and union federations represented were the AITUC, the All-
India Workers and Peasants Party, the Municipal Workers' Union of
Bombay, the Bombay Trade Council Union, the Bank Peon's Union, and
the GIP Railwaymen's Union. This shift in participation had everything
to do with the success of Brussels, and representatives of India's revo-
lutionary trade unions had gone to great lengths to travel despite tight-
ened monitoring of leftist organizations by the Government of India.
The findings of British Intelligence did indeed suggest that the Eastern
Bureau was involved in order to support anti-imperialist connections

[65] Among many others, B.H. Edwards, "The Shadow of Shadows," *Positions:
East Asia Cultures Critique* 11, 1 (2003), 11–49; H. Fischer-Tiné, "Indian
Nationalism and the World Forces: Transnational and Diasporic Dimensions of
the Indian Freedom Movement on the Eve of the First World War," *Journal of
Global History*, 2, 3 (2007), 325–44.

across Asia. This was exacerbated by a report that all delegates coming directly from Asia had been subsidized to attend the Brussels Congress with funds emanating from the Soviet Union.[66] This suggests that they were seen as a particular focus group.

Aside from the close cooperation between Indian and Chinese delegates—who met again at Dutch trade union leader Edo Fimmen's house in March—the prospect of a "Pan-Pacific trade union gathering" in China later that year was closely watched.[67] Intercepted correspondence from Nehru revealed "a big Pan-Pacific conference at Hankou in June to which representatives from India, Indonesia and other Eastern countries are being invited."[68] The Executive Committee of the LAI was to send a delegation to this gathering. This conference was indeed the PPTUC, which was in the process of being founded as the official Asian branch of Profintern.

At Frankfurt, the increased participation from the colonies was also reflected in the agenda for the Congress. Not only was the majority of the Indian delegation made up of trade union representatives; the plenary agenda for the Congress even read "the All India National Congress, the All India Trade Union Congress and their role in the National-Revolutionary Struggle" as a separate issue.[69] This is not altogether surprising in view of the fact that the LAI's impact on the Indian trade union movement itself had also been considerable. The AITUC, despite its absence at the first gathering, had been meticulous in discussing the League's resolutions. Pressure by the revolutionary faction of the Congress, led by S.A. Dange (treated above), led to AITUC's official affiliation to the League and the nomination of delegates to the next conference. K.N. Joglekar, the organizing secretary of the Railwaymen's Union, and D.R. Thengdi of the AITUC Executive Council, both close

[66] APAC, *IOR*, L/P&J/12/266, New Scotland Yard to India Office, September 15, 1927.

[67] APAC, *IOR*, L/P&J/12/266, Telegram: Viceroy to Secretary of State, Shimla, May 6, 1927.

[68] APAC, *IOR*, L/P&J/12/266, Note for the working committee by Nehru, April 4, 1927.

[69] Seeley Mudd Manuscript Library, Princeton: Roger Nash Baldwin Papers, box 8 folder 3: International League Against Imperialism 1928–1929; invitation to the Second Congress.

associates of S.A. Dange and Muzaffar Ahmed, were selected to be AITUC representatives at the next conference of the League.[70] Both, however, had been refused passports to travel to the Frankfurt conference, and their involvement with the League would later be brought as grounds for arrest in the Meerut Conspiracy Case.[71] AITUC was forced to nominate a representative already present in Europe.

However, the Indian delegation's active networking with the other Asian delegations, as well as AITUC's proactive attitude to the League had paid off in terms of interest for the Indian case. At Frankfurt, the League expressed solidarity with the Indian struggle for freedom.[72] But this was a two-way street. Nehru had been drawn into the League by Virendranath Chattopadhyaya, a revolutionary exile in Berlin and the League's secretary there.[73] Together, they worked hard to enlist more anti-imperialists. They kept track of editorial comments on the League in dailies in several languages[74] to see who would be willing to affiliate. Chattopadhyaya wrote triumphantly to Nehru just before the Second Congress, "There is every reason to believe that we shall succeed in drawing the parties into active cooperation with the League. If that is attained, we shall have the satisfaction of recording the affiliation of all the national movements from Morocco to Indonesia."[75]

The LAI would increasingly fragment into more explicitly communist local branches, losing its broad anti-imperialist signature, until its quiet demise in the 1930s. To the Indian revolutionaries, however, it had served as an important Asianist platform. The contacts forged in the League played no small part in the increased communications—including the flow of funds—between AITUC, the All-China Labour

[70] P.C. Joshi Archives of Contemporary History, Meerut Conspiracy Case file 33: Statement of K.N. Joglekar, 2038.

[71] Ibid.

[72] IISH, *LAI,* file 113: Resolution on India.

[73] And, incidentally, also the brother of Sarojini Naidu, who played a prominent role in the Asian Relations Conference in Delhi in March 1947, elaborated upon in Part V.

[74] Mostly European languages, but the Malay press was also monitored. P.C. Joshi Archives, *LAI Papers,* file 6.

[75] P.C. Joshi Archives, *LAI Papers,* file 6: Chattopadhyay to Nehru, March 3, 1929.

Federation, and the Chinese Information Bureau.[76] Finally, the contacts forged in the League served as a stepping stone toward the establishment of the PPTUS. This was an important step because it was the first subsidiary of the Red International of Trade Unions which was located and coordinated outside of Soviet Asia, and inside what had been known since Baku as the "Oppressed East."

Asia Unites at Hankou: The PPTUS

The establishment of Profintern in 1921 had been a direct challenge to the Second International, the social-democratic IFTU at Amsterdam. The struggle between both was waged, in part, on the Asian front. Amsterdam had never paid much attention to Asia, leaving a large area with a fast increasing number of trade union movements open to Profintern to sign up. This untapped source of unaffiliated trade unions was perceived to have great revolutionary potential. As Stalin noted in 1925, the revolutionary movement in China, India, Persia, Egypt, and other Eastern countries was growing, and the Western powers would soon have to lie "in the grave they have dug for themselves in the East."[77]

The Asian activities of the Profintern, and in particular the PPTUS, form another theme that has not received much attention to date.[78] If Profintern is mentioned at all, it is usually to dismiss it as irrelevant, "it never amounted to much, and for nearly half its active life its dissolution was under serious consideration."[79] But this view fails to take into

[76] MSA, Home Special Files 543(18) E/I, 1929–33 Bolshevism—funds.

[77] J. Stalin, *Works*, Vol. 7 (Moscow: Foreign Languages Publishing House, 1954), 235.

[78] No studies of India's involvement with the Pan-Pacific Trade Union Secretariat have been carried out as yet, but on the Secretariat, the most informative studies are: J. Fowler, "From East to West and West to East: Ties of Solidarity in the Pan-Pacific Revolutionary Trade Union Movement, 1923–1934," *International Labour and Working Class History* 66 (2004): 99–117; F. Farrell, "Australian Labour and the Profintern," *International Review of Social History* 24, 1 (1979): 34–54.

[79] G. Swain, "Was the Profintern Really Necessary?" *European History Quarterly* 17 (1987): 73.

account Profintern's activities in Asia, where it played a major role in linking the anti-imperialist activities of various Asian groups. It was here that the network of revolutionary trade unionists was extended from Central Asia to East Asia. Moreover, the importance that was attached to the Secretariat by its Asian members, rather than the Soviet leadership, should be taken into account.

At the first Profintern Congress in 1921, the assembly had expressed its interest in the Eastern question, and in early 1922 the Congress participated in the First Congress of the Toilers of the East.[80] In 1923, this interest was made official by the establishment of Profintern's Far Eastern Bureau. Its main focal areas were trade union activities in India, Indonesia, and China, but the Bureau would in time include those in the Philippines, Indochina, and other areas. This attempt to form a united front in Asia generated much discussion in Profintern itself, since the trade union federations of these countries were often closely integrated in their respective struggles for independence, and therefore consisted of multi-class parties. To some, including Trotsky, the idea of multi-class parties was reprehensible, "In China, India, and Japan, this idea is mortally hostile to … the hegemony of the proletariat and … can only serve as a base, a screen, and a springboard for the bourgeoisie."[81] Others, however, saw ample opportunity for bringing together in Profintern only those trade union groups from Asian colonial territories who were genuinely revolutionary. In the Indian case, this included contacts (after 1925) with the Workers and Peasants parties via Muzaffar Ahmed, later League delegates K.N. Joglekar, D.R. Thengdi, and other revolutionary internationalists.[82]

For most of the 1920s, such connections to Profintern and the Eastern Bureau could be maintained without alienating nationalist and reformist trade union leaders. Especially the latter were themselves actively engaged in building Asian connections which had important anti-imperialist overtones.[83] This situation changed with the establishment of the PPTUS

[80] R. McVey, *The Rise of Indonesian Communism* (Equinox: 2006), 82.

[81] Trotsky, *The Third International after Lenin* (New York, 1926), 223.

[82] P.C. Joshi Archives, Meerut Conspiracy Case, File 48: Prosecution Witnesses PW 1-104 (July 18, 1929 to August 16, 1929): 3301.

[83] C. Stolte, "Bringing Asia to the World: Indian Trade Unionism and the Long road Towards the Asiatic Labour Congress, 1919-37," *Journal of Global History* 7, 2 (2012): 257-78.

which, if AITUC would have affiliated to it, would have drawn India much more explicitly into the ambit of Profintern's Asian plans. A preliminary conference had been organized for October 1926 in Sydney. Initially, AITUC endorsed the plans, promising to send delegates.[84] However, it turned out to be too difficult to reach Sydney for most Asian delegates, so the founding of the PPTUS was postponed and its next conference scheduled for 1927 in Hankou, China. The invitation read:

> The stormy growth of the trade union movement in the Far East, following the world-changing rise of the national movement in the colonial and semi-colonial *countries* ... the pressing economic problems of the working class in this sphere, which are more sharply acute than anywhere else in the world; and the absence hitherto of any organized relationship between the organized workers of the lands most effected—all combine to make the proposed Congress of the utmost importance to the whole working class.[85]

By March 1927, the left-wing factions of AITUC had started to collaborate. When the invitation to the Hankou Congress of the PPTUS arrived, they decided to send two AITUC delegates. D.R. Thengdi and S.V. Ghate, both already firmly entrenched in the Asian networks of revolutionary trade unionism, were selected for the purpose. However, they were refused a passport.[86] With regard to revolutionary trade unionism, the Government of India was shifting its policy of increased surveillance to one of active intervention. This ensured that no Indian delegation was present at this first Pan-Pacific Labour Congress, but the refusal of passports had had no effect whatsoever: The Congress interpreted, correctly, that the British Indian government had not allowed Indian trade unionists to attend, and passed a resolution condemning the government's intervention. In response, India was treated as a full member anyway and was awarded a seat on the Bureau of Transport Workers for the Pacific.[87]

[84] WBSA, *Police Files*, Serial no. 49, file 248/36: Draft Propaganda Thesis on the Pan-Pacific Labour Conference.

[85] WBSA, *Police Files*, Serial no. 49, file 248/36: Invitation from the head of the Preparatory Bureau of the Pan-Pacific Labour Congress.

[86] P.S. Gupta, *A Short History of the All India Trade Union Congress (1920-1947)* (New Delhi: AITUC 1980), 112.

[87] X.J. Eudin and R.C. North, *Soviet Russia and the East, 1920-1927: A Documentary Survey* (Stanford, 1957), 268.

At this juncture, the revolutionaries in AITUC came to blows with the reformists. The latter preferred to address Asian workers' rights through the machinery of the ILO and IFTU. And though a majority of the AITUC, as noted above, had affiliated to the LAI, this was not the Asianist path the reformist faction desired. The reformists drew hope from the fact that IFTU had, after years of deliberation, finally reserved a council seat for "one of the Asiatic countries," and they wanted to have it.[88] At this juncture, they were creating their own Asianist momentum with an Asian Labour Congress, intended to present "Asia" more forcefully at the ILO. The PPTUS could only compete with, and not complement, their plans for an Asian labor front in Geneva.

It was clear that the AITUC faced a choice. For the reformists, the Asian seat in IFTU, the Asian group at the ILO, and the Asiatic Labour Congress were on the line and for the revolutionaries, their revolutionary Asianist networks, platforms, and funds through the Comintern and Profintern. From the first days of the PPTUS, Profintern laid claim to AITUC's Asianist sentiments, and to the network that had been created and maintained by revolutionary exiles in Soviet Asia. Profintern made it known to the eighth AITUC session that

> the struggle against imperialism and colonial oppression begun by the workers and peasants in the USSR, China and Indonesia, can be successfully accomplished only by the efforts … of the proletariat in the colonial countries. The role of the Indian proletariat in this struggle must be particularly great.[89]

As time progressed, their claim to AITUC's Asian allegiance became more forceful. The invitation next invitation to the PPTUS conference, sent in 1928, warned the AITUC against the reformist Asiatic Labour Congress, and urged the revolutionaries to formally oppose it.[90] Furthermore, the Secretariat sent a representative to the 1928 session of AITUC, John Ryan, who reiterated PPTUS opposition to the reformists'

[88] WBSA, *Police Files*, Serial no. 49, file 248/36, Extract from the report on the political situation and labor unrest for the week ending the January 31, 1924.

[89] "The RILU to the Eighth All India Congress of Trade Unions," in Adhikari, *Documents*, Vol. III-B, 276–78: 277.

[90] Gupta, *A Short History*, 130.

Asianist plans, and their concern that the Asiatic Labour Congress might grow into a rival body. He urged AITUC to choose a side in order to not fragment its Asianist activities. In the end, this Asianist competition fragmented AITUC itself: It split into a reformist and a revolutionary federation, of which the latter continued as AITUC.

AITUC now entered a period of factional fighting, in which the issue of Asian affiliation figured prominently. Newly elected leader S.V. Deshpande represented the most militant wing of the Congress. A mere six days after the split, one of Deshpande's first actions was to move for official affiliation to both the LAI and the PPTUS. It was quite clear in which direction he wished to move:

> The great Russian Revolution of 1917 had opened up a new horizon for the workers of the whole world. The Indian worker must study closely the history of the Russian Revolution. They must of course entertain no thoughts of violent revolution, but it is unnecessary to make an undue fetish of non-violence.[91]

Although passport refusals would ensure that no direct AITUC representative could travel to the 1929 PPTUS Congress either, the revolutionaries within AITUC maintained their connections to the Secretariat in writing—texts were, after all, easier moved than people. The official organ of the PPTUS, the *Pan-Pacific Worker*, came to rely on Indian contributions to fill its pages. Importantly, these continued to address Asian anti-imperialist solidarities rather than focus on the plight of organized labor in India. The Asianist rhetoric of the journal echoed that of the LAI half a world away: Asian lands that had been united in pre-imperialist times now stood united against the imperialist powers which had kept them apart:

> Because the Moroccans, Indonesians, Hindus and Chinese are struggling to liberate themselves from the double yoke of militarism and imperialism, they are branded as cruel and blood-thirsty. But if they submit without resistance to the modern forms of robbery and exploitation, the capitalist writers and "ideologists" are sure to laud the grandeur and beauty of the old civilizations.[92]

[91] WBSA, *Police Files*, file 98/1926 on AITUC, session report 1931.

[92] *Pan-Pacific Worker*, 1, 1 (1927), 11.

AITUC remained in touch with the PPTUS throughout the next year and a half. It was a profitable relationship, for the PPTUS also sent funds to help continue AITUC strikes.[93] AITUC's focus in this period was to forge links with other revolutionary trade union movements in Asia, and it succeeded in connecting to Indonesian and Chinese trade unions. Their engagement with those PPTUS members who were not from colonial Asia was negligible.[94] Australian trade unionists for instance, long one of the PPTUS' driving forces, are rarely encountered in AITUC correspondence on the PPTUS. AITUC's cartography of Asia, by this time, was still primarily based on an Asia marked by lagging development and industrialization, an Asia unable to operate on equal footing in the global system. Australia did not fit the rubric of "oppressed Asia."

In this sense, the geo-body of AITUC's Asia remained constant, and it continued to regard the PPTUS as an Asian umbrella organization for revolutionary trade unionists, through which Asian solidarities could continue to be expressed. However, as the Soviet Union entered its Third Period (1928–33), it moved away from its former Asia policies. The Soviet Union increasingly courted closer cooperation with the Europe-based IFTU.[95] Profintern's Asian wing became collateral damage in the resulting negotiations, since it worked against the interests of the Federation.[96] Its funding from Moscow was first cut, and finally withdrawn. The PPTUS lingered on, but its link to Central Asia, and through it, to India, was severed. This caused other members of the Secretariat to take its "Pan-Pacific" connotations more seriously than its status as Profintern's Asian Bureau. By 1936, the Profintern had dwindled to a few members, and later that year its publications ceased. The PPTUS, by this time, had broken with its Soviet parent and was hijacked by Chinese

[93] MSA, *Home Special File 543(18) E Pt I, 1929-1933* Bolshevism—funds. Arrangements for interception and control of funds from Communist sources abroad.

[94] Documents to this effect were found in searches of both private and trade union premises when the Meerut case got underway. See P.C. Joshi Archives, Meerut Conspiracy Case, file 1: Prosecution Exhibits P447-500, 1929–33.

[95] R. Tossdorff, "Moscow versus Amsterdam: Reflections on the history of the Profintern," *Labour History Review* 68, 1 (2003): 92.

[96] Indeed, IFTU refused to hold negotiations on international unity as long as the RILU existed.

and Japanese immigrant workers across the Pacific in San Francisco.[97] Now more transpacific than Pan-Pacific or Asian, the PPTUS itself looked toward the sea, not the Asian landmass.

Eclipse

As noted in the introduction to this volume, the interwar period was marked by a high degree of mobility and ideological flexibility in the 1920s, and a hardening of physical and mental borders in the 1930s. The Asianism of Indian revolutionary internationalists in this period was no exception. The Asianist euphoria which had united the "oppressed peoples of the East" in networks of solidarity which stretched across Asia from Baku to Hankou, did not survive far into the 1930s. This was due both to international changes, and to circumstances on the ground in India. Firstly, most Indian revolutionaries in the Soviet Union left, or were purged. Virendranath Chattopadhyaya was among the latter. Secondly, the Soviet leadership brought its international engagements under tighter control in the Third Period, causing the LAI to lose its function as a meeting ground for a broad cross-section of Asian anti-imperialists, and the PPTUS to be severed from the Profintern. Thirdly, these changes stood in conversation with the global economic crisis and the Manchurian invasion in 1931, which put a strain on Asian anti-imperialist networks. Finally, the Government of India responded to these changes with tighter restrictions on movements, networks, and organizations that could, justifiably or not, be construed as communist.

The Government of India's anti-communist offensive resulted in the Meerut Conspiracy Case.[98] This case effectively cut short the Asian

[97] J. Fowler, "From East to West and West to East: Ties of Solidarity in the Pan-Pacific Revolutionary Trade Union Movement, 1923–1934," *International Labour and Working-Class History* 66 (2004): 114.

[98] A.G. Noorani, *Indian Political Trials, 1775–1947* (New York: Oxford University Press, 2007): 238–64; S. Pennybacker, *From Scottsboro to Munich: Race and Political Culture in 1930s Britain* (Princeton University Press, 2009); P. Ghosh, *The Meerut Conspiracy case and the left-wing in India* (Calcutta: Papyrus, 1978); for a contemporary account, see L. Hutchinson, *Conspiracy at Meerut* (London: Allen & Unwin, 1935).

networks of India's revolutionary trade unionists, by imprisoning all trade union leaders who had maintained Asian contacts through the Soviet Union. The list of Meerut accused reads as a list of those involved in 1920s Asian anti-imperialist activism. Former *muhajir* Shaukat Usmani was arrested, who had run a Central Asian printing press, attended the University of the Toilers of the East and returned to rise in the AITUC ranks as vice-president of the reception committee of the infamous 1927 session.[99] S.A. Dange was arrested, the former associate of Asianist activist Abani Mukherjee, author of *Gandhi vs. Lenin* and AITUC stalwart.[100] Thengdi and Ghate, who had been nominated Pan-Pacific Trade Union Conference delegates in 1927 and continued to remain involved with the PPTUS, were arrested. LAI delegate K.N. Joglekar was also imprisoned. Finally, the arrest of Muzaffar Ahmad severed several Asian anti-imperialist links: He had been a contact for several of the former *muhajirs* who had remained in Asia, not least former Baku delegate Masood Ali Shah. He was also one of the main contacts for the PPTUS, and had met PPTUS representative Jack Ryan only months before his arrest.[101]

The Meerut case exacerbated reformist-revolutionary tensions in AITUC, and the final split and subsequent fragmentation of AITUC occurred less than a year after the start of the case. The collapse of the revolutionaries' Asian platforms, due to the changes in Soviet policy toward colonial Asia, did the rest: the mid-1930s marked the end of a decade and a half of Asianist anti-imperialist solidarity. The outbreak of the Sino-Japanese war in 1937, finally, heralded the end of the inter-war period in Asia and ended any possibility of a broad-based Asian movement. Although the militant faction within AITUC maintained its contacts with the Soviet Union throughout most of the 1930s, the relationship had changed. Consistent with the contemporary hardening of ideological lines, the engagement was strictly and exclusively communist, and lost its internationalist Asian inflection.

[99] For details on Usmani's activities after his return, see Nehru Memorial Museum and Library, Oral history project, Shaukat Usmani (interviewee) recorded by Dr Hari Dev Sharma (interviewer), December 20, 1976.

[100] S.A. Dange, *Gandhi vs. Lenin* (Bombay: Liberty Literature, 1921).

[101] P.C. Joshi Archives, Meerut Conspiracy Case, file 9: Prosecution exhibits (MCC 1929-33/1), 2132.

It is the earlier, more inclusive revolutionary Asianism which this paper has sought to emphasize, viewing it as part of the internationalist moment of the interwar years. The flexible use of complementary and conflicting Asian idioms in this period has been highlighted, for, as Rebecca Karl reminds us, it should caution the historian against essentializing Asia as a stable unit of analysis.[102] The Asia of interwar internationalists was not a geo-body with marked borders and clear characteristics. Rather, it was a set of definitions which served particular internationalist agendas, and created particular internationalist networks. Through their activities and contacts, the Indian revolutionary internationalists of the 1920s had created an Asian geo-body defined by anti-imperial solidarity with "the oppressed peoples of the East." Their Asianist platforms constructed an Asia of which the Soviet Union was an important part, and which radiated from Central Asia outwards. This focus on Central Asia, along with the inclusion of the Soviet Union, was one of the features which set this form of interwar Asianism apart from others. In this, it should be considered as an integral part of the internationalist momentum of the interwar years, but expressed in an Asian inflection.

[102] Karl, *Creating Asia*, 1118.

4

Straddling the International and the Regional: The Punjabi Left in the Interwar Period

Ali Raza

Assuming he read it, one can well imagine the Governor of Massachusetts, Alvan T. Fuller, feeling a little bemused at receiving a cable in early August 1927 from Amritsar, a town in central Punjab. The cable had been sent from the proprietors of the *Kirti*, the flagship journal of the Kirti Kisan Party (Workers and Peasants Party, KKP). The *Kirti* magazine condemned the sham trial and the impending execution of Nicola Sacco and Bartolomeo Vanzetti and "most emphatically" urged their release.[1]

Sacco and Vanzetti were two Italian-Americans anarchists who were arrested, tried, convicted, and executed over a murder they almost

[1] Meerut Conspiracy Case (MCC), Microfilm Collection (Zentrum Moderner Orient), 1929, (English Translations), *The Kirti* (Gurmukhi Edition), "Socco (sic) and Vanzetti."

definitely did not commit. Their arrest in 1920 came at the height of the "Red Scare" that gripped the United States and other countries in the aftermath of the Bolshevik revolution. The lengthy trial that ensued was closely followed around the world and in the days leading up to their execution, protests broke out in cities across the globe. Following their execution on August 23, 1927, in Massachusetts, there were:

> protests, there were riots. The people threw—uprooted lampposts in Paris, threw them through plate-glass windows. They attacked embassies. The Moulin Rouge was damaged. In Geneva, people took it out on American targets. They targeted stores selling Lucky Strike cigarettes and theaters showing Douglas Fairbanks films. There were strikes all over South America, shut down transportation. The American flag was burned on the steps of the American embassy in Johannesburg. The riots went on. Three people were killed in riots in Germany. The riots went on for a few days, and then finally they stopped.
> And Sacco and Vanzetti—the funeral in Boston attracted 200,000 people that marched through the streets of Boston to the cemetery where they were cremated.[2]

In India too, these executions were vociferously condemned. But how were the executions of two ordinary workers in the United States linked to politics in British India? A clue could be found in the "communist" journal *Kranti*, which declared that "Workers have no country and this was exemplified in the agitation that was carried on all over the world for those two Communist workers (Sacco and Vanzetti)."[3]

In many ways, this extract speaks for itself. Yet, it would be pertinent to make the obvious point that this emphatic declaration was emblematic of the politics of internationalism in the interwar period. Needless to

[2] Interview of Bruce Watson by Amy Goodman of *Democracy Now*, dated August 22, 2007. The interview can be accessed at: http://www.democracynow. org/2007/8/22/sacco_and_vanzetti_80_years_after. Watson is the author of *Sacco and Vanzetti: The Men, the Murders and the Judgment of Mankind* (Viking Publishers, 2007).

[3] MCC 1929 P-1375 T. *Kranti* "At Last Capitalists Book Victims: What Had Sacco and Vanzetti Done? Policy of the Bengal Police. Similarity of Capitalist Civilization All the World Over (August 27, 1927) 4. The *Kranti* was a Marathi paper published from Bombay.

suggest, in South Asia too, this politics attracted its fair share of adherents. What was remarkable about this brand of politics was how the "local" was imaginatively woven in with the "global." Thus, the Punjabi proprietors of the *Kirti* imagined themselves as part of a global movement that promised a glorious future for humanity as a whole. Their politics demonstrates how provincial politics, and the region itself, was tied to and profoundly affected by the global arena in various respects. This underscores the need for imagining the Punjab (and British India by extension) not as a bounded space, but rather as a region with an amorphous boundary that constantly shifted according to time, space and context. Viewed this way, the region and its politics extended to diasporic communities as well as itinerant groups such as traders, students, intellectuals, and political exiles. British Punjab, then, was part of a global *network of exchanges*, in which it was profoundly affected by the to and fro movement of goods, ideas and individuals. This was also true for political events that occurred far beyond its shores, of which the two world wars are but an obvious example.

But my concern here is to show how Punjabi radicalism was, in some ways, both born in and intimately tied to the global arena. To start with, there were of course a variety of networks that engaged with radical politics. These can also be understood as distinct trajectories to political radicalism. Some led through organizations formed by dissident intellectuals and activists who explicitly chose to settle outside British India in order to advance their anticolonial agendas. Another important route went through political movements that initially had little to do with anticolonial politics, let alone the leftist variant of it. This was true for political activists who emerged from localized struggles as well as those who circulated within the wider global arena in pursuance of their specific political aims. Moreover, political choices which led to radicalism were also available to those individuals who traveled beyond British India on account of their occupations. And last but not the least, the most important trajectory to political radicalism went through diasporic communities scattered across the globe. Together, the lived experiences of individuals within these networks and their encounters with a global intellectual and political milieu attracted them to a variety of ideologies, not least of which was the project of anti-imperialism and "communism." All these trajectories fed into the development of the Left within the

Punjab as well as British India in general. In what follows therefore, I will mainly focus on three networks that either emerged from the diaspora or circulated through the globe in an attempt to highlight how the "global" interacted with the "local."

Diaspora

My own attempt at exploring the linkages between the two begins, predictably enough, with a story of migration. Indeed, this has been a standard way in which connections between the Punjab and the wider global arena have been analyzed. Generally though, migration has been a very significant part of modern South Asian history.[4] But perhaps, nowhere was this trend quite as ubiquitous as in the Punjab. In the British period, a crucial aspect of this movement was militaristic. Countless Punjabis were deployed overseas as soldiers in the British Indian Army or as ex-servicemen employed in local police forces that geographically ranged from East Africa to South East Asia.[5] Indeed, the earliest recorded instance of this movement dates back to 1867 when a hundred Sikh emigrants went to Hong Kong to bolster the colony's nascent police force.[6] This movement, however, was not merely restricted to serving or retired military personnel, as thousands of Punjabi laborers, peasants, small traders, and students also ventured beyond South Asia to far flung territories. The vast majority of these migrants were driven by hopes of improving their economic conditions. This was particularly the case in central Punjab where fragmented landholdings and rural indebtedness, combined with the highest population densities in the region, worked as "push" factors for many migrants.[7] As a result, untold numbers traveled to the Far East,

[4] Sugata Bose in *A Hundred Horizons* suggests a figure of thirty million from the 1830s to the 1930s. Of these, nearly twenty four million returned to India, p. 73. See also Judith M. Brown, *Global South Asians* (Brown: Cambridge, 2006).

[5] See, for instance, Thomas Metcalf, *Forging the Raj: Essays on British India in the Heyday of Empire* (Oxford and New York: Oxford University Press, 2005).

[6] Darshan Singh Tatla, *The Sikh Diaspora: The Search for Statehood* (London: U.C.L. Press, 1999), 48.

[7] See, for instance, Harish Puri, *Ghadar Movement: Ideology, Organisation and Strategy* (Amritsar: Guru Nanak Dev University Press, 1983), 11–15. These

East Africa, and North America in search of better opportunities. These regions later proved to be cultivating grounds for disenchanted nationalists and committed revolutionaries alike.

The most important amongst these destinations was North America. Initially dating back to the 1890s, Punjabi immigration to Canada and the United States gathered pace during the first decade of the twentieth century.[8] This movement, though, came with its own set of problems. In both countries, Indians were gradually subjected to discriminatory official policies that were designed to discourage their immigration and settlement. This was manifested most starkly in the notorious *Komagata Maru* affair.[9] Matters were further worsened by prevailing racial attitudes. This inevitably increased the resentment felt by Indians for their host societies. Moreover, in Canada, this resentment was also fed

factors are mentioned in virtually all official and unofficial accounts on Punjabi migration and the settlement and radicalization of Indians in North America. For a personalized account, see the biographical accounts of Sohan Singh Bhakna, one of the founders and leading lights of the Ghadar movement. See Sohan Singh Josh, *Baba Sohan Singh Bhakna: Life of the Founder of the Ghadar Party* (New Delhi: Peoples Publishing House, 1970) and the CPI pamphlet that was based on interviews with Bhakna, Randhir Singh "Ghadar Heroes: Forgotten Story of the Punjab Revolutionaries 1914–1915" (Bombay, Peoples Publishing House, 1945).

[8] Tatla, *The Sikh Diaspora*, 51–52.

[9] The catalyst for this incident was a decision by the Canadian government to restrict the immigration of Indians into the country. Outraged at this unfair treatment, the ship *Komagata Maru* was especially hired to transport Punjabi immigrants to Canada. Designed to exploit a loophole in the law barring Indian immigration, the ship docked at Vancouver in 1914 but the passengers were not allowed to disembark. Instead the ship was forced to sail back to Calcutta where the furious passengers got into a violent confrontation with the police which led to a number of deaths. This incident inflamed nationalist passions in India and North America alike. Its impact can be gauged from the fact that this incident has been the subject of some academic and numerous popular works. It is also the subject of at least one movie. See, for instance, Hugh Johnston, *The Voyage of the Komagata Maru: The Sikh Challenge to Canada's Colour Bar* (Delhi: Oxford University Press, 1979) and Malwinderjit Singh Waraich and Gurdev Singh Sidhu (eds) *Komagata Maru, A Challenge to Colonialism: Key Documents* (Chandigarh: Unistar Books, 2005).

by a palpable sense of disillusionment with the rhetoric of the British Empire which claimed that all its subjects were equal within its dominions and colonies.[10] This feeling was further exacerbated by the perceived favorable treatment accorded to other Asiatic races, such as Chinese and Japanese immigrants. The favorable treatment accorded to the latter led many Indians to attribute their persecution to their status as an "enslaved nation."[11] In many cases, the disenchantment with Empire was also fed by the gradual dissipation of racial stereotypes that had been carefully constructed by the British. Living in these societies had afforded Indian immigrants with a far more intimate view of "white society" than had been possible back home. Viewed from up close, the "white man" was no longer superior to Indians, both in moral and physical terms, and was in fact "addicted to all sorts of vices."[12]

Owing to the rapid crumbling of superior racial stereotypes and the daily experiences of ritual humiliation and official discrimination that one encountered in the diaspora, a loosely fashioned sense of an "Indian" identity was formed, which soon channeled its way into an organized and radical anti-imperialist sentiment. This nascent anti-imperialist politics gathered momentum owing to engagements with leading Indian

[10] F.C. Isemonger and J. Slattery, *An Account of the Ghadar Conspiracy* (Lahore: Punjab Government, 1919), 12–14.

[11] Sohan Singh Josh, *Hindustan Ghadar Party: A Short History Vol. 1* (New Delhi: People's Publishing House, 1977), 67–68. It is tempting to treat these explanations as simplistic, but the issue of race and discrimination stands out in virtually all accounts, official and otherwise, focusing on the inception of the Ghadar Party. There have been accounts that focus on class and intellectual borrowings but the issue of race is by far the most popular explanation. This is particularly the case for accounts authored by former Ghadarites themselves. This theme also runs prominently in an anthology of poems penned by Ghadar activists in *Ghadar di Gunj* (Echoes of Mutiny) available at, along with other Ghadar documents, the South Asian American Digital Archive (SAADA) which accessible at http://www.saadigitalarchive.org/. For a relatively alternative, if unconvincing, account see, Harjot Oberoi, "Ghadar Movement and its Anarchist Genealogy," *Economic and Political Weekly* 44, 50 (2009): 40–46.

[12] Ibid., 69. Also interesting as a comparison are the similar sentiments of Indian soldiers fighting in the trenches on the Western Front during the First World War.

dissidents such as Lala Hardayal.[13] The result was the launch of the weekly *Ghadar* in San Francisco that was soon followed by the inauguration of a political party by the same name in 1914. Far more radical in its aims than the mainstream nationalist movement, which at the time was petitioning the British government for greater constitutional liberties; the Ghadar Party advocated nothing less than the complete independence of India from British rule. Subscriptions and donations to the party were obtained from immigrants in the United States and Canada while the *Ghadar* was sent to Indian communities around the world. Needless to say, in India itself the paper was quickly proscribed by the British authorities.

Rather than the party itself—which has in any case been examined in depth by a number of studies[14]—what is more important for the purposes of this essay are certain individuals who typify, in a sense, the journey to radicalism which for them began in the diaspora. One such individual was Santokh Singh. A son of an orderly of a colonel in the British Indian Army, Santokh Singh was born in Singapore in 1893. His family though, returned to their ancestral village in the Punjab following his father's retirement in 1903. After being schooled there, he made his way to North America to pursue his higher education. Soon after reaching the United States, he got involved in the brewing discontent

[13] A prominent intellectual, Hardayal was a lecturer in Indian Philosophy at Stanford University for a few years. He was renowned for his anti-imperial radicalism and his contacts with other radicals such as Shyamji Khrishnavarma, Madame Cama, and revolutionaries from other regions. In California he was instrumental in mobilizing Indian workers, students and farmers. Together with Sohan Singh Bhakna he was also one of the co-founders of the *Ghadar* paper and party. See, Harjot Oberoi, "Ghadar Movement and its Anarchist Genealogy," *Economic and Political Weekly*, 41. Also see Emily C. Brown, *Har Dayal: Hindu Revolutionary and Rationalist* (Arizona: University of Arizona Press, 1975).

[14] There have been numerous academic and (especially) popular works produced over the years on the Ghadar Party. Their list is so vast that the Ghadar Party could well be a sub field in its own right within South Asian Historiography. These accounts have been published by academics as well as former Ghadarites themselves. For the most useful, see the upcoming work by Maia Ramnath. For earlier works, see Harish K. Puri, *Ghadar Movement*, and *Ghadar Party: Its Role in India's Struggle for Freedom* (New Delhi: Communist Party of India, 1997), and S.S. Josh, *Hindustan Ghadar Party*.

within the Indian community, and joined the Ghadar Party in San Francisco. Elected as the party's secretary, Santokh Singh was at the forefront of organizing a rebellion against British rule by thousands of returning Ghadar activists who traveled from North America to India for the purpose.[15] Meanwhile, Santokh Singh himself proceeded to South East Asia in 1914 where he was entrusted with the duty of mobilizing Indian communities toward lending their support for rebellion against British rule in India. This endeavor however, like its counterpart in the Punjab, met with failure, especially since the German government was unable to deliver on its assurance of supplying the rebels with arms and ammunition. Consequently, Santokh Singh was compelled to return to the United States in 1916, where he was soon arrested and convicted in the famous San Francisco Conspiracy Case on the charge of conspiring with the German government.[16] He was released from prison in 1919

[15] Most of these returned emigrants were arrested or incarcerated in their ancestral villages under an "ingress ordinance" on account of their open rebellion against British rule. See for example, the Report on the Police Administration in the Punjab (henceforth referred to as RPAP) for the year 1914, 1915, 1916 (Lahore: Printed by the Superintendent, Government Printing, Punjab, 1915, 1916, and 1917) located in the Indian Institute Library at the Bodleian Library. But for a significant period of time, they were the most potent threat faced by the Punjab government during the war years. Returned emigrants were behind gang robberies, killings of government loyalists and servicemen, and most worryingly for the government, attempts to instigate a mutiny within regiments stationed in the Punjab and the United Provinces. And according to some claims, they even succeeded in instigating a mutiny in Singapore. A number of military servicemen were sentenced to death for their participation in the coup. See for instance the account of the serving governor at the time, Michael O'Dwyer, *India as I Knew It*, 190–209.

[16] Nine German subjects, four "German-Americans," five Americans, and seventeen Indians were prosecuted during this case, and all bar one, were found guilty. Ever since the launch of the *Ghadar* and the founding of the party, the British Consul under directions from the Foreign Office, had repeatedly urged the United States authorities to act against Ghadarites, censor their letters and prevent their publications from wider dissemination. They were frustrated in their attempts by what they perceived to be an inexplicable reluctance of the U.S. authorities to act against the party. All that changed however with the entry of the United States in the First World War. The San Francisco Conspiracy case was

and set himself to reorganizing the Ghadar Party, though by this time he was a committed Bolshevik, having been inspired and introduced to Marxism and the ideals of the October Revolution by fellow inmates, some of whom were professed communists, during his stint in jail.[17] The reorientation of Ghadarites toward Moscow led Santokh Singh to lead a two-men delegation to the Fourth Congress of the Communist International in 1922. He stayed in Russia for a few months where it was claimed he also attended the Communist University of the Toilers of the East (KUTV). Sufficiently inspired by his stay in Moscow, Santokh Singh then proceeded to India through Central Asia, determined to start a vernacular journal that would be aimed at organizing workers and peasants in the cause of revolution. While attempting to infiltrate British India through the northwest frontier of the subcontinent, he was arrested and incarcerated in his village for a period of one year.[18] Released in 1925 he continued from where he had left off and together with likeminded radicals, succeeded in bringing out the monthly *Kirti* (worker) in February 1926. Santokh Singh, however, did not live long enough to see his cherished dream reach fruition, for he died soon after in 1927—a victim of tuberculosis that he contracted during his detention— a few months shy of the founding of the KKP.[19] The party he helped to organize, though, maintained its links with the Ghadar Party and continued to be the primary destination for returning radicals and Ghadarites from the Punjabi diaspora.

So how do we understand Santokh Singh then? While he was instrumental in the founding of Punjabi radicalism and later "communism,"

an outcome of this changed policy. The party returned to business as usual after hostilities ended and the United States resumed its ostensibly indifferent attitude. For details into these discussions see IOR/L/P&J/12/148 (Anglo Soviet Relations: Communist Propaganda in India; Relationship between the Comintern and the Ghadar Party July 1933–January 1935) Indian Seditious Activities in the U.S. (P&J (S) 299 1934), 63.

[17] Sohan Singh Josh, *My Meetings with Bhagat Singh and on Other Early Revolutionaries* (New Delhi: Communist Party of India, 1976), 69.

[18] IOR/V/27/262/3, D. Petrie, *Communism in India 1924–1927* (Calcutta: Government of India Press, 1927), 150–57.

[19] IOR/L/P&J/12/300, Note on the Kirti-Kisan Sabha, File P&J (S) 1013 (1932), 1.

both in the diaspora and in India, he was hardly untypical. For the typi-fied in a sense, the political trajectory to radicalism that for many Indians began in diasporic communities spread across the Far East and North America. Radicalized by their lived experiences in the diaspora and adrift from colonial systems of policing and control, individuals such as Santokh Singh, adopted a politics, that while reflexive at the outset, soon assumed an uncompromising and radical character. A key part of these experiences was proximity to prevailing intellectual and political cur-rents which included engagements with revolutionaries from other con-texts as well as heady doses of anarchist and socialist thought.[20] Indeed, a number of Ghadar Party members started their political careers as members of the Industrial Workers of the World, otherwise termed the "Wobblies," before they joined militant anticolonial politics. Clearly, the diaspora had spatial advantages as compared to the subcontinent itself. Radical activists who emerged from such communities therefore, were very much a product of a particular moment and a political context where such ideologies were rapidly gaining currency. These individuals also benefited from engagements with other anticolonial radicals and espe-cially leading Indian dissidents who played a seminal role in politiciz-ing and radicalizing Indians settled in diasporic communities. Crucially, however, these migrants were typically nonelite in terms of their socio-economic background. In a sense then, the diaspora, unlike the subcon-tinent, offered a more level political field in which elite and (far more) nonelite alike could be politically active according to their respective ideological inclinations. Divorced from the courteous and polite politi-cal culture of the nationalist elite in India, these individuals had far more space to adopt a more radical line of political activism which, on account of their modest sociopolitical background, could also have been influ-enced by their inaccessibility to imperial patronage. Driven by a radical anticolonial sentiment, then, these individuals actively solicited support from the enemies of the Empire for the furtherance of their political and militant objectives. Before the Bolshevik Revolution, the German gov-ernment was a key, if ineffective, sponsor of anticolonial radicalism in British India. With the Bolshevik rhetoric of national self-determination

[20] Josh, *My Meetings with Bhagat Singh*, 47.

however, Punjabi radicals found a new center of power that could assist them in the furtherance of their political aims.

The Ghadar Party, though, was not the only movement that operated within diasporic communities. Indeed, there were other networks of Indian radicals that were dispersed across the globe. Some of them even predated the Ghadar Party while others worked in conjunction with it. For instance, one of the first spaces for Indian radicals was founded in 1905 in London by the renowned revolutionary, Shyamji Khrishnavarma. Krishnavarma was both the founder of the *Indian Sociologist* and the "India House," which was a "hostel" intended for Indian students. It was also a cultivating ground for many revolutionaries.[21] Similarly, in Berlin, another group of Indian radicals led by Virendranath Chattopadhyaya (also the brother of Sarojini Naidu) founded an organization that became known as the "Berlin India Committee."[22] In Kabul, a "Provisional Government of India" was formed by Raja Mahendra Pratap, Maulvi Barkatullah, and Obeidullah Sindhi.[23] Again, these networks were in addition to those that periodically operated in places like Paris, Geneva, Tokyo, and others, up until the end of the British Raj. Perhaps the most famous of these was the one run by Manabendra Nath Roy who operated from various centers and earned the distinction of founding the "first" Communist Party of India in 1920.[24] He also founded the Communist Party of Mexico which was ostensibly also the first Communist Party formed outside Russia.[25] The wider global arena, then, offered numerous opportunities for anticolonial radicalism to thrive.

[21] For more details, see Harald Fischer-Tiné, *Sanskrit, Sociology and Anti-Imperial Struggle: The Life of Shyamji Krishnavarma (1857–1930)* (Delhi: Routledge India, 2014).

[22] See, for instance, Nirode K. Barooah, *Chatto: The Life and Times of an Indian Anti-Imperialist in Europe* (Oxford: Oxford University Press, 2004).

[23] For a brief account of this experiment as well as the "Silk Letter Conspiracy," see Michael O'Dwyer, *India as I Knew It*, 172–82.

[24] There is a dispute between the CPI and CPI (Marxist) on whether the party was "first" formed in Tashkent in 1920 or in Kanpur in 1925.

[25] While there are numerous works available on M.N. Roy, there are a few that are particularly useful. See, for instance, the most recent biography on Roy by Kris Manjapra. Also see the writings of Roy, most of which are available at http://www.marxists.org/archive/roy/index.htm. Conversely, see Sibnarayan Ray (ed.),

Traveling

This was equally true for individuals who traveled beyond the shores of British India. In other words, the trajectory to radical politics was not merely restricted to those settled in diasporic communities. It goes without saying of course that mobile groups have been an essential part of South Asia throughout its history. In the colonial period though, opportunities for traveling grew rapidly owing to rapid industrialization and improvement in the means of mobility and communication.[26] These changes, however, also had the unintended consequence of providing many Indians with opportunities to engage with contemporary intellectual and political trends, both within the subcontinent and beyond it. This was true for all sorts of circulating networks that ranged from students and intellectuals to pilgrims and traders.[27] For the Punjab Left though, two networks in particular were of great importance. Both produced prominent leftists who remained engaged with the leftist movement in British Punjab as well as the postcolonial states that succeeded it.

The first of these was the Hijrat Movement.[28] Formed by Muslim youths, this movement grew from the Khilafat agitation in 1919. This agitation, along with the Non-Cooperation Movement, was the first mass agitation against the British Raj. Its aims were the protection and restoration of the Turkish caliphate—of great symbolic significance to Muslims worldwide—that was under threat of being dismantled following the victory of the allied powers in the First World War. Unsure of their position as subjects of a colonially administered territory that was deemed to be "hostile" to Islam, thousands of Indian Muslims—mostly from the United Provinces (UP), Punjab and the North Western Frontier Province (NWFP)—chose to respond to religious calls which called for

Selected Works of M.N. Roy, 4 Vols (Delhi: Oxford University Press, 1987, 1988, 1990, 1997). Also important are the memoirs of Roy himself: *M.N. Roy's Memoirs* (Bombay: Allied Publishers Private, 1964).

[26] See, for instance, Judith Brown, *Global South Asians*, 11–23.

[27] For students, see in particular, S. Mukherjee. "The Experience of the 'England Returned': The Education of Indians in Britain in the Early Twentieth Century and its Long Term Impact" (University of Oxford, DPhil thesis, 2007).

[28] Derived from Arabic, the term means "migration."

an en masse migration from India. Aside from protecting their religious autonomy that was perceived to be under threat, many also migrated with the hope of making their way to Turkey to bolster the faltering caliphate. Others aimed to agitate and fight against the British Raj. However, their traveling experiences were anything but pleasant. While initially welcomed by Amir Amanallah of Afghanistan, who intended to use this movement as a bargaining chip against the British, the *muhajireen*[29] soon overstayed their welcome. Thrown out of Afghanistan by the Amir they stumbled, half starved, cold and miserable, across Central Asia in their futile attempt of reaching Turkey. Along the way they were continually harassed and persecuted by "Turkomans" who they had always imagined as their "Muslim brothers." During their journeys they also encountered a nascent Soviet Union which, at the time, was extending its power and influence in Central Asia against the counter revolutionary forces.[30] Together, these encounters and experiences compelled many to reassess their political and ideological inclinations as well as their cultural and religious imaginations.

While these experiences obviously varied from one individual to the next, a glimpse into how they were interpreted by some is provided by an excerpt from Shaukat Usmani's memoirs. Reminiscing about his first encounter with a Soviet representative in Central Asia, Usmani wrote:

[29] Translated as "migrants."

[30] There are a number of useful accounts on the Hijrat movement and the journeys of the *muhajireen*. For a brief account, see K.H. Ansari, "Pan Islam and the Making of the Early Muslim Socialists," *Modern Asian Studies*, 20, 3 (1986): 509–37. For a more extended treatment, see K.H. Ansari, *The Emergence of Socialist Thought among North Indian Muslims* (Lahore: Book Traders, 1990). Also see Dietrich Reetz, *Hijrat: The Flight of the Faithful. A British File on the Exodus of Muslim Peasants from North India to Afghanistan in 1920* (Berlin: Das Arabische Buch, 1995). Especially important are accounts of the *muhajireen* themselves. See the works of Shaukat Usmani, the famous communist from the UP. He was also a co-accused in the Meerut Conspiracy Case and previous Conspiracy Cases. See Shaukat Usmani, *Historic Trips of a Revolutionary: Sojourn in the Soviet Union* (Sterling Publishers Pvt. Ltd: New Delhi, 1977), *Peshawar to Moscow: Leaves from an Indian Muhajireen's Diary* (Swaraj Publishing House, Benares, 1927), and *I Met Stalin Twice* (Bombay: K. Kurian, 1953).

A young man of 25 greeted us in English and shook hands with us. He was wearing the Bolshevik helmet, long boots and a military uniform. Some of us took him for a page, some took him for a soldier.

One of us said "Sir, we want to see His Excellency the Consul." He at once replied. "Comrades, do not say 'Sir' but 'Comrade'. I am the man you seek for. I represent the RSFSR and I greet you on behalf of the workers and peasants of Russia."

We were lost in amazement. How could he be a consul! How could he address the slaves thus? He is a white man like our white masters in India. We could not recover soon from our amazement.[31]

Here, then, was a fascinating glimpse into how these encounters shaped the understanding and world views of these individuals. Similar to many Ghadar activists, these experiences imaginatively inverted the racial hierarchies which many had grown accustomed to within the subcontinent. That said, these particular interpretations were far from uniform. This event for instance was viewed by some of Usmani's compatriots through different lenses. Far from being inspired, these men were irritated by the Bolsheviks and viewed them as a hindrance in their single minded determination to reach Turkey.[32] In other words, this was a powerful reminder of the contradictory possibilities that were latent in any encounter. Each had the potential to veer off in completely different trajectories.

For Usmani and his likeminded comrades, these and other encounters inspired them toward "communism," which varied according to each individual's interpretation. Thus, some of them actually ended up fighting for the Bolsheviks in the ongoing civil war. A significant number also went to Moscow to acquire political training. And these were the *muhajir* youths who, along with M.N. Roy, formed the "first" (though short-lived) Communist Party of India (CPI) in Tashkent in 1920. This was therefore the first in a series of prolonged engagements between prominent leftists who emerged from the Hijrat network and the Soviet Union. In doing so, many explicitly made a connection between the egalitarian "principles" of "Islam" and "communism." Indeed, this connection has been termed a "paradox" and has partially been explained

[31] Shaukat Usmani, *Peshawar to Moscow*, 39.
[32] Ibid., 40–41.

by branding the Muhajirs "understanding of socialism" as "limited."[33] But this categorization raises more questions than it answers. For one, it assumes that there was an "authentic" version of "socialism" or "communism" that was incompatible with "Islam." Far from extraordinary, these linkages were frequently made by "Muslim" and "non-Muslim" activists alike. Indeed there were a number of pamphlets issued by the CPI which explicitly associated the early history of Islam and its "revolutionary" invocations of socioeconomic justice with "socialist" principles. M.N. Roy himself made these correlations in his famous essay on the "historical role of Islam."[34] An intimate engagement with "communism" therefore, was eminently possible for those who emerged from an ostensibly contradictory sociopolitical context.

Similarly, these prospects were also on offer for labor networks that stretched across the British Empire. Among these, the networks of sailors or lascars[35] were particularly well placed for intellectual and political encounters. In particular, from the turn of the century onwards, tens and thousands of Indian seamen constituted a dynamically mobile group that was present in most of the important shipping ports in the world, and particularly those in North America, the Far East and Western Europe. To a significant extent this was owing to their status as casual labor. Thus, lascars were sometimes employed for the duration of a single trip and were left to fend for themselves in ports spread across

[33] K.H. Ansari, "Pan-Islam and the Making of the Early Muslim Socialists," 537.

[34] M.N. Roy, "Historical Role of Islam: An Essay on Islamic Culture" (1939), at http://www.marxists.org/archive/roy/1939/historical-role-islam/index.htm

[35] The term was derived from the Persian word *lashkar,* which can be translated as "army." From the eighteenth century onwards, the word was used by the British and other European shipping companies as a generic term for South Asian sailors. Another term, and one that was preferred by the sailors themselves, was *jehazis* (ship people). See Ravi Ahuja, "Subaltern Networks under British Imperialism. Exploring the Case of South Asian Maritime Labour (c. 1890–47)" in *Space on the Move: Transformations of the Indian Ocean Seascape in the Nineteenth and Twentieth Century,* eds Jan-Georg Deutsch and Brigitte Reinwald, Arbeitshefte 20 (Berlin: Klaus Schwarz Verlag, date unknown), 40. See also Ali Raza and Benjamin Zachariah, "To Take Arms Across a Sea of Trouble: The 'Lascar system,' Politics and Agency in the 1920s" (with Ali Raza), *Itinerario* 36, 3 (December 2012), 19–38.

the world until they could find work onboard another merchant vessel.[36] These ports offered numerous opportunities for political engagement, especially after the turn of century, as union activity, often quite violent, increased rapidly. After the Bolshevik revolution and with the activities of the Comintern, some of the seamen unions were also suspected of being involved with communist "intrigues."[37] Thus, through labor activism and encounters with ideas and individuals on their travels, lascars had the opportunity to engage with radical politics.

An excellent example of this was the case of "Dada" Amir Haider Khan, who later became one of the most prominent communist leaders in Pakistan. Born in a small village in the Potohar valley in Northern Punjab, Khan dropped out from his local school and made his way to Bombay where he found work on board a shipping vessel. Thereafter, he spent the next decade of his life visiting regions throughout the world and even spent a considerable amount of time in the United States employed as a worker in a car factory. Again the breakdown of imagined racial hierarchies was important in his experiences. In his case, this partly came through sexual liaisons with white women in brothels at various seaports.[38] Moreover,

[36] For an excellent introduction into lascar networks see Ravi Ahuja, above. Also see Gopalan Balachandran, "Searching for the *Sardar*: The State, Pre-Capitalist Institutions and Human Agency in the Maritime Labour Market in Calcutta, 1880–1935," in *Institutions and Economic Change in South Asia*, eds Burton Stein and Sanjay Subrahmanyam (Delhi: Oxford University Press, 1999), 206–306. In particular see, Frank Broeze, "The Muscles of Empire: Indian Seamen and the Raj, 1919–1939," *Indian Economic and Social History Review* 18, 1 (1981): 43–67.

[37] A prominent example of this was the umbrella organization, the Red International Labour Union (RILU), otherwise known as the Profintern. Moreover, organizations like the Indian Seamen's Union in London were also suspected of being affiliated or controlled by the Comintern. See, for example, Punjab Police Secret Abstract of Intelligence (PPSAI) 1927, Departmental Notice No. 56, October 8, No. 39, 437.

[38] See, for instance, Hasan N. Gardezi (ed.), *Chains to Lose: Life and Struggles of a Revolutionary Memoirs of Dada Amir Haider Khan*, 2 Vols (Delhi: Patriot Publishers, 1988), 189–91. It should be added that the imperial government was well aware of how white prostitutes would be viewed by their subjects. Thus, "foreign prostitution" was banned in 1912 in Indian cantonments for an "Imperial and very urgent reason." It was held that the degradation of a white

through his connections with the labor union at the factory and the New York port, where he was registered as a seaman looking for work onboard shipping vessels, he soon got in touch with the Communist Party of the USA, which, in collaboration with the Ghadar Party, made arrangements for Khan and five other Ghadarites to travel to Moscow for political training. After his stay in Moscow, he returned to India as a committed communist and frequently visited Russia in disguise as a sailor, and continued his work with the CPI in various capacities. Lascars like Khan, then, became the conduits through which alternative and crucially nonelite sociopolitical visions came into the subcontinent.[39] Additionally, this network could also be utilized by other radicalized Indians for political purposes. In this regard, the following excerpt from a police report in 1926 is worth quoting extensively:

One Kanshi Ram, son of Devi Chand, of Jalal village, Gujranwala district, arrived in Bombay from Liverpool on the December 31, 1925, by the SS *Trafford Hall*, on which he served as a seaman. The Shipping Master, Bombay, described him as a seaman of an unusual type who had given a certain amount of trouble on board, and he was found by the Customs Authorities at Bombay to be in possession of literature of a decidedly anti-British nature.

According to his own statement Kanshi Ram matriculated at the Punjab University in 1916 and after doing various odd jobs ... proceeded to America.... There he claims to have earned sufficient funds to keep himself while obtaining degrees in Law and Oratory, as well as his M.A.

Reports received from abroad show that in March 1925 this man signed on at New York as a member of the crew of the SS *City of Shanghai* by which ship he travelled to Liverpool via Australia, under the assumed name of Abdul Rashid. He informed a fellow seaman that he had gone to America about 5 years before to work for the independence of India, but that, in view of the failure of the movements started by Messrs. Gandhi and Das, he had

woman was tantamount to the degradation of the "ruling and paramount power in India." See Janaki Nair, "Imperial Reason, National Honour and New Patriarchal Compacts in Early Twentieth-Century India," *History Workshop Journal* 66, 1 (2008), 208–26.

[39] The imperial authorities of course were well aware of the dangers posed by this network. They, thus, liaised closely with shipping companies as well as port authorities. See, for instance, the file IOR/L/P&J/12/52 (Conveyance of Seditious Literature to India—Correspondence with Shipping Companies).

decided to return to India to start a new agitation. He is further alleged to have displayed two revolvers and to have claimed that he could arrange for the dispatch of arms and ammunition from America.[40]

As far as the British were concerned, these incidents only reaffirmed their suspicion that traveling groups, whether Indian or otherwise, from Bukharan carpet traders to foreign circus performers,[41] were the primary means through which proscribed material, "seditious" ideas and, of greater concern, arms and ammunition could be brought into India. This concern was driven by the perceived threat of a worldwide communist network that had the ability to engage and recruit Indians or foreigners traveling to India. In part, this fear was also grounded in reality, as the visits and activism of individuals such as Philip Spratt suggested.[42] But at times, this suspicion also extended to ostensibly innocuous traveling networks. Thus, it was mentioned in an official report from 1926, that the Soviet Union had established a consulate at Jeddah with the purpose of disseminating communist propaganda amongst pilgrims arriving for the annual pilgrimage of Hajj.[43] It was suspected that the Soviet consulate "was using the *mutawwifs*[44] and their agents or *wakils* as one of the channels through which subversive propaganda (was) passed into India."[45]

Notwithstanding the veracity of these claims, what is clear is the extent to which the imperial government was wary of the threats posed by a wider world in which individuals, ideas, and materials seemingly flowed more easily than under the watchful gaze of the intelligence services in India itself. The "corrupting" influences of distant shores that opened a world replete with possibilities and ideas had the potential to attract traveling groups of Indians to a brand of politics that was anathema to

[40] PPSAI, Look Out Notice, March 27, 1926, No. 26, 119.

[41] See the various "Departmental Notices" in PPSAI 1926 and 1927 files.

[42] A Member of the Communist Party of Great Britain, Philip Spratt was sent to India in his capacity as a Comintern agent in order to reform and organize Indian communists. See for example, Overstreet and Windmiller, 82–100.

[43] PPSAI, Department Notice No. 14, April 17, 1926, No. 16, 149.

[44] *Mutawwifs* are agents who assist pilgrims in their logistical arrangements and performance of religious duties.

[45] PPSAI, Look Out Notice, January 8, 1927, No. 1, 15.

British officialdom. Thus, "networks of subalternity"[46] or networks of subordination could also be converted into *networks of subversion*. Thus, it was to this end that a panoptical web of surveillance was laid across the land and maritime borders of the subcontinent so as to ensure that all materials and individuals coming into British India were suitably vetted before they were allowed in. This attempt at controlling the spread of ideas, however, did not completely succeed in achieving its intended effect, as the very *act* of traveling could constitute a political action that, aside from harming the interests of Empire, held out the, albeit remote, prospect of undermining the Empire in India itself.

Zones of Engagement

For migrant communities and traveling groups, intellectual and political exchanges took place in spaces which could appropriately be termed as "zones of engagement." These localities provided unique opportunities which were either unavailable, or strictly policed by the British in South Asia. These spaces acted as conduits for the safe passage of individuals and proscribed materials while also providing refuge to those attempting to evade the imperial security services. What was more remarkable was how these zones, which were as spatially distant as San Francisco, Paris, Berlin, Tashkent, and Kabul, among others, were together tied through a unique geographical imagination which viewed them as connected centers of anticolonial radicalism and revolutionary activism. In short, it was a novel way of perceiving the world and of contesting the political boundaries that cut across it. With the Bolshevik Revolution in 1917, the city of Moscow not only joined the group of localities where expatriate anticolonial activists converged but also emerged as the new and undisputed center for political radicalism.

It is perhaps impossible to understate the impact that the October Revolution had on virtually all movements that sought to end colonial rule in the subcontinent. According to Harikishen Singh Surjeet, the formal general secretary of CPI (M), the October Revolution "awakened

[46] Term used by Ahuja, 55.

the oppressed peoples of the East."[47] In the words of another Indian radical, Bejoy Kumar Sinha, it marked the "triumph of a people heralding a new social order" and had the "deepest impact" in "the evolution of ideas."[48] This event opened the doors to limitless possibilities for radicals around the world and provided a successful blueprint which could be emulated in their own sociopolitical contexts. More crucially, it also provided some much needed inspiration to anticolonial activists who interpreted the revolution as the first definitive blow to European imperialism. Their optimism was not only driven by the seemingly rapid decline of the old world order, but was also predicated on Lenin's declaration of firm support to national liberation struggles around the world. This promise was most clearly articulated through the founding of the Communist International, or Comintern, in 1919. Hardly surprising, then, that and in addition to aspiring revolutionaries and diehard radicals alike, this singular event also had a profound effect on the politics and thinking of constitutionally inclined nationalists as well as individuals long associated with parochial politics.[49] Hardly surprising, then, that the paths of leading Indian exiles and activists such as M.N. Roy, Maulvi Barkatullah, V. Chattopadhyaya, and others, frequently crossed through Moscow.

These figures were joined by hundreds of individuals from the Ghadar, Hijrat, Lascar, and other networks who traveled to Moscow

[47] Jyoti Basu (ed.), *Documents of the Communist Party of India (1917–28) Vol. 1* (Calcutta: National Book Agency, 1997), 27.

[48] Shaukat Usmani, *Historic Trips of a Revolutionary*, 87–88.

[49] Madan Mohan Malaviya was but one among many noteworthy individuals. According to Shaukat Usmani who met him in connection with a campaign for the release of a political prisoner, "Malaviyaji was very enthusiastic about the Soviet Union, and said that he would do anything for the people suffering for the sake of their ideology. Further, he exclaimed in glee, 'I would like to go to receive the Bolshevik Army at Peshawar if they came to liberate us.'" Ibid., 90. There was thus, a vast spectrum of political opinion that was influenced in varying ways by the Bolshevik Revolution. And as Kris Manjapra has viewed it, "communism" was an "ecumene"; "a field of symbols that was open to lively interpretations by disparate Indian actors, from different sites worldwide." Kris Manjapra, "Communist Internationalism and Transcolonial Recognition," *Cosmopolitan Thought Zones: South Asia and the Global Circulation of Ideas*, in eds Sugata Bose and Kris Manjapra, (Palgrave Macmillan, 2010), 160.

from the 1920s to the 1940s. From the Ghadar network, for instance, aspiring revolutionaries came from cells which had been established in Punjabi dominated communities spread across the globe. An idea of the sheer expanse of this network can be gauged from an intelligence report issued in 1933. According to the report, an estimated thirty five cadres of the Ghadar Party were undergoing doctrinal and military training at Moscow that year. More than the numbers however, what was remarkable was the fact that aside from California and India, Ghadar activists had come from regions as distant as "Argentine," Panama, Fiji, New Zealand, and Kenya.[50] There were of course a variety of ways through which these individuals reached the Soviet Union. Most involved arriving at Western European ports, and in particular Hamburg, from where the cadres of local communist parties, in liaison with the nearest Soviet missions, made arrangements for their travel onwards to Moscow. These arrangements were more complicated for activists coming from India. Such individuals either obtained employment as lascars on board shipping vessels bound for Western European ports or managed to smuggle themselves across the British Indian border into Central Asia from where they made their way to Moscow.

Once in the Soviet Union, the first point of contact for these individuals was the Comintern. Theoretically, the Comintern was a global organization for communist parties from across the world which was independent from the Soviet government. In practice, though, it often functioned as a very effective arm of Soviet foreign policy. That said, the founding principles of autonomy often proved to be a convenient excuse as the Soviets pled helplessness when confronted by other governments irritated at the Comintern's activities within their territories.[51] For the British too, the intervention of the Comintern in India and other colonies was a source of perpetual anxiety. Conversely, for Indian and other anticolonial radicals, this institution was invaluable for the support it

[50] IOR/L/P&J/12/148, (Anglo Soviet Relations) Secret Letter to H. Williamson August 22, 1933, P&J (S), 1–2.

[51] IOR/L/P&J/12/412, (Communist training schools for Indians in Moscow and Tashkent) Letter from Sir E. Ovey to Mr A. Henderson (Received July 7) dated Moscow, July 1, 1930 (Russia, confidential) P&J 1396 1930 July 7, 1930, 2.

promised and lent to liberation struggles in colonies around the world.[52] Moreover, it was the only powerful body willing and able to support anti-colonial activism after the defeat of Germany in the First World War. It was in this context, then, that radical networks maintained contacts with the Comintern with the latter providing material support and political training to party activists.

A key part of this political training was the enrolment of party activists and other Indian radicals at the famous KUTV. The "university" was run under the direct auspices of the Central Committee of the Communist Party of the Soviet Union. Before enrolling, aspiring students were interviewed to ensure that they had an acceptable class background and political potential. Their educational qualifications were apparently of little concern to the administrators as highly qualified students were accepted along with the completely illiterate. Generally, students from the ages of 16 to 50 were accepted for enrolment and housed in communal quarters. They were also divided into two distinct classifications. The majority belonged to the Soviet Union whose main task was to "consolidate the power of the Soviets and to build socialism." The second group was "primarily from the colonial and semicolonial east." Among other countries, these included activists from Japan, Turkey, Greece, Egypt, Morocco, Tunisia, and "a few Negroes from the United States." The largest group among foreign students came from China. These "students" were tasked with working for national liberation movements and organizing communist parties in their regions. With the diversity of this institution and others like it, these activists benefited from political and intellectual exchanges with radicals from other contexts while being involved in the euphoria of what seemed to be an exciting, and truly global, project.

For their political training, students were required to learn Russian and keep themselves abreast with the latest political developments. Thus, a key part of their course was the daily reading of newspapers which, in the case of Indian students, were translated and discussed by their Indian interlocutors at the university. Additionally, students were taught

[52] See, for instance, Odd Arne Westad, *The Global Cold War: Third World Interventions and the Making of Our Times* (Cambridge: Cambridge University Press, 2007), 51–55.

political and economic geography, anthropology, Marxist philosophy, history—with a focus on the history of the Bolshevik Revolution and the First, Second, and Third Internationals—and provided information about the Soviet State and the Communist Party of the Soviet Union's structure. Students were also taken for educational "excursions" and camping trips during the summer where group discussions on politics and training in military tactics took place. Confirming the worst fears of the colonial authorities, these activists were regularly trained by Red Army officers in the use and maintenance of various rifles, heavy machine guns, pistols, revolvers, and hand grenades. They were also required to draw topographical maps and demonstrate their familiarity with military science and warfare.[53]

The University of Toilers, however, was but one of many institutions on offer in Moscow for anticolonial radicals. Among the more important ones was the Lenin University for Marxian and Leninist Studies which was said to specialize in "advanced theoretical studies" and, predictably enough, "agitation." Also on offer were specialized institutes such as the Chinese University for the Toilers of China, also known as the Sun Yat Sen University, which catered primarily for Chinese and Korean students. Additionally, there were other organizations such as the "International Society for Assistance to Fighters for the Revolution." This organization was founded in 1922 by the Comintern. It had branches in "nearly all countries" and was concerned with "agitation and propaganda, especially by means of journals, and pamphlets." Lest its original purpose be forgotten, the Society also assisted political prisoners in other countries and provided their families with financial assistance and legal advice. All these institutions were of course in addition to other branches of the Comintern such as the Profintern (International of Syndicates chiefly devoted to the Pacific, India, China, Australia, and Polynesia), KEM (Communist International of Youth), Krestintern (Peasants International), Sportintern (Sport International), and others.[54]

Moscow, then, had the necessary infrastructure for being the center of a world revolution that was predicated on the freedom of colonies from

[53] Gardezi, *Chains to Lose*, 538–98.

[54] IOR/L/P&J/12/412, (Communist training schools for Indians in Moscow and Tashkent) Letter from Sir E. Ovey to Mr A. Henderson, 2–4.

imperialist subjugation. No wonder then, that aspiring Indian revolutionaries from a variety of networks either stayed at or crossed through Moscow. In most cases, Indian activists attempted to infiltrate British India after undergoing their training in Moscow where they had been equipped to explain the world to themselves and others. As a precaution to prevent their detection by the imperial security services, they were all given false names and were not allowed to disclose their identities to each other. Much to their misfortune however, the imperial intelligence services, through the rigorous interception of correspondences and reporting from spies, were mostly aware of their identities, and even on occasion their false names.[55] As far as infiltration into British India was concerned, there were three possible routes that could be taken. The first two were land routes through Central Asia either into the mountainous passes in the northwest or through the Persian border with British India. The third was a riskier sea route through steamers bound from Western European ports to India.

If they were lucky enough to avoid being arrested and promptly tried, these revolutionaries joined the various communist groups which proliferated in British India during the 1920s and 1930s. Not only did they act as emissaries of the Comintern which regularly issued instructions and advice to committed communists but they also their brought their "expertise" to bear in bolstering the fledgling Indian communist movement. It was an entirely different matter, however, whether this "expertise" was of any use at all. Ever since its inception, the Indian communist movement had been plagued by "sectarianism" and split along regional lines in parties working with a range of peasant associations and trade unions. Other questions of dispute centered on the extent to which the communists should work with the mainstream nationalist movement. That was in addition to the fact that most communist and radical parties molded their politics in accordance with the specific sociopolitical circumstances they operated in. That often meant that politics was conducted with considerations other than the latest Comintern dictates. To complicate matters further, and much to the frustration of their interlocutors in Moscow, most individuals who identified

[55] IOR/L/P&J/12/148, (Anglo Soviet Relations) Secret Letter to H. Williamson, 1.

themselves as communists were not orthodox Marxist–Leninists.[56] This was true even for individuals who had graduated as trained cadres from Moscow. On occasions, therefore, the Comintern was so disappointed with the "quality" of students sent from India as compared to those from North America that it ordered the cessation of recruitment in the subcontinent until prospective candidates could be vetted properly.[57]

Despite the tendency of Indian communists to chart an autonomous course, the Comintern still played a crucial role in the Indian communist movement. At one level, its influence came down to the issue of what passed for a language of legitimation in communist political discourse. Thus, individuals who had the backing of the Comintern or those who had passed through Moscow commanded considerable influence within radical political circles. In part, this was owing to the reverence accorded to the Soviet Union's undisputed position as the progenitor of the perpetually impending world revolution. As a result, all self-styled communist organizations ensured that they maintained their contacts with the Comintern. This often boiled down to correspondences with lengthy diatribes on topics ranging from the suitability of aligning with the Indian National Congress in its struggle against the British Raj to the womanizing habits of members from an opposing faction.[58] Often, these correspondences also included detailed reports of peasant agitations, workers' strikes, local politics, and sensitive information relating to the location of military installations.[59] This was in addition to regularly sending party pamphlets, newsletters, and other publications to Moscow. On a more practical note, however, maintaining relations with the Comintern, irrespective of whether its dictates were followed to the letter or not, was important for ensuring that Indian radicals continued to receive its

[56] This was particularly evident in the repeated use of religious idioms coupled with the notions of martyrdom and resistance in their writings. Many in fact were religious figures in their own right who emerged from Sikh and Muslim communitarian movements.

[57] IOR/L/P&J/12/148, (Anglo Soviet Relations), Extract from Weekly Report, No. 24, dated June 22, 1933, Shimla. Serial 6, Foreign Intelligence, P&J (S) 834 1933.

[58] See, for instance, Comintern Archives (CA), Library of Congress (LOC), F. 495, Inv. 16 File 50, 168–73.

[59] See, for instance, CA, F. 495, Inv. 16, File 57a.

support. A key part of this support was financial. Indeed, what the British dubbed as "Moscow gold," was crucial in sustaining the leftist movement that was constantly persecuted by a hostile colonial state. It was for this reason why a Ghadar Party leader cautioned his comrades against criticizing Russian officials and impressed upon them the necessity for maintaining good relations with the Comintern "in spite of the fact that the latter had made promises which they had not kept."[60]

Notwithstanding this mixed relationship and the varied understandings of "Communism," Indian radicals had the same broad objectives as their interlocutors in Moscow. At the core of their struggle was an aspiration for the complete independence of India from foreign subjugation. In this demand, Indian leftists were often ahead of the mainstream nationalist movement, which only settled on the demand for complete independence in 1929–30. But independence for the Left also meant the freedom from various internal systems of exploitation such as class, religion, ethnicity, and gender. Crucially, however, these political objectives were intrinsically tied in with the global project of "communist internationalism." In this however, the Left was part of a wider political culture which was eloquently summed up by Jawaharlal Nehru's call for the "spirit of internationalism to replace the spirit of nationalism."[61] Within the context of Indian and international politics, this spirit was very much evident in the early interwar period which was burdened by the expectation of the impending world revolution. Internationally, however, the dream of communist internationalism petered off during the late 1930s with the Stalinist purges and came to its lowest point with the dissolution of the Comintern in 1943; though it continued in other forms in the postwar period. In the Indian context, with the Second World War and the colonial end game, the Indian communist movement was compelled to choose between internationalism and nationalism, as defined by the inheritors of the British Raj.

Moscow therefore, offered opportunities for political and intellectual exchanges for Punjabi and Indian radicals that were unparalleled in the rest of the world. More than a mere locality however, Moscow also

[60] IOR/L/P&J/12/148, (Anglo Soviet Relations), Extract from the Weekly Report.

[61] PPSAI 1928, Lahore, February 18, 1928, No. 7, 71.

embodied many meanings, but none more important than the inspiring ideal of communist internationalism. In another sense, Moscow symbolized the potential that certain spaces across the world held for Indian radicals. Whether welcoming individuals from diasporic communities or from networks of subordination, these zones of engagements offered a space beyond the subcontinent from where Empire could be subverted, not just in India, but globally as well.

Contesting Empire Globally

Subverting Empire however, required a profound understanding of its distinctive features. In this respect, there were two main aspects of resistance that were formulated by Punjabi radicals. Firstly, given the global expanse of the British Empire, radicalized individuals could work for the liberation of India from spaces beyond the subcontinent itself. In part, this is the function that certain zones of engagements played. There was however another element to the equation. It was understood by these activists that Indians, and particularly, Punjabis, were complicit in sustaining and perpetuating the Imperial project. As part of the British Indian Army, they were involved in pacifying and conquering regions from East Africa to South East Asia and beyond. Moreover, they were also employed in defending the British Empire as the numerous Punjabi and Indian casualties in the First World War—sustained from the trenches of the Western front to the deserts of the Middle East—testified. Given the seminal contribution of Punjab in these campaigns, this issue struck a particular chord for Punjabi radicals. Time and again, their pronouncements and writings reflected a sense of embarrassment at the collusion of their fellow Punjabis in the project of Empire. Indeed, the very project of Empire would not have been possible without the active collaboration of Indians within it. At the same time, they also actively encouraged and called upon their compatriots to desist from offering their services in the cause of British imperialism.

It is for this reason that spreading disaffection within the Army and the police forces was a key element of the wider political strategy employed by Punjabi radicals, whether in the subcontinent or beyond

it. Given the wide deployment of Indian personnel around the globe in the service of Empire, the latter was not particularly hard to accomplish. Moreover, this approach was also driven by more pragmatic concerns, since many of these radicals could not possibly return to India without being arrested or incarcerated in their villages. In this respect, the activities of a few Ghadarites in Shanghai provide an excellent example of this strategy. The most prominent amongst these activists, Dasaundha Singh, joined the Ghadar Party as a student in the United States. He deserted his studies in 1925 to join Mahendra Pratap who intended to lead a foray into British India through Tibet. Following the abject failure of this mission, Dasaundha Singh headed to Peking, Hankow, and lastly in 1927, Shanghai, where he was entrusted with "spreading sedition and disaffection among the Indian troops in China, tamper(ing) with their loyalty and promot(ing) strikes among the Indian Police."[62] Accordingly, he issued calls for the Sikhs "to rise, unsheathe the sword and kill the English everywhere."[63] In between, he also edited the *Hindustan Ghadar Dhandora*, which was published in Gurumukhi and typically described as "highly seditious." Predictably enough, his activities soon attracted the attention of the British, and he was duly arrested and sentenced to one year's rigorous imprisonment with deportation to India on the expiration of his sentence. Nevertheless, the activities of Dasaundha Singh and other revolutionaries did not fail to have an impact. Thus, for instance, a factional dispute within the ranks of prison warders, in which "well-known seditionists" were fully involved, resulted in the decision of the Shanghai Municipal Council to cease recruitment of Indians in the police force. As far as the council was concerned, it was "a bad policy to recruit from a country which is as restless as India … where disobedience has been elevated into a political creed."[64]

[62] IOR/V/27/262/6, Intelligence Bureau, *The Ghadar Directory* (New Delhi: Government of India Press, 1934), 64–65. It should be also mentioned that Indian troops and police were in Shanghai to guard the commercial interests of the British from the advancing forces of the Kuomintang and generally from the ravages of the Chinese Civil War.

[63] PPSAI, June 22, 1929, Shimla-E, No. 25, 325.

[64] PPSAI, November 8, 1930, Lahore, No. 43, 785.

Additionally, there were other considerations in play over and above this strategy, which point toward the second aspect related to the understanding of Empire. For many Indian radicals, Empire was a profoundly global phenomenon and it thus had to be combated in its wider global manifestation, whereby the focus of struggle would not merely be restricted to the liberation of India from British rule. To better illustrate this sentiment, an excerpt from a proclamation of the Ghadar Party in response to British actions in China is worth quoting at length[65]:

> India's nationalists, all over the world, in co-operation with the oppressed humanity, are interested in the destruction of British Imperialism. They know full well that unless it is destroyed, there can be no peace on the face of this earth; there can be no freedom for India and other enslaved countries. It was Lincoln who said that there cannot be such a thing as a nation half free and half slave. *What was true of one country then, is true of all humanity today. Due to modern means of communication, mankind is functioning as one organism. Any one part of this organism cannot grow healthy while other parts are paralysed and diseased.*[66] A large part of humanity is suffering under the bondage of slavery on account of British Imperialism.[67] It was therefore "in the interest of humanity at large that British Imperialism (was) destroyed at all costs."[68]

This view perhaps reflected a more profound understanding of the empire than that which existed in mainstream nationalist circles within India. While in practical terms, such rhetoric may have remained just that, the references to humanity as an organic whole indicated that at the heart of such sentiments was a universalism founded on solidarity with the oppressed nations and peoples of the world. In fact, this internationalism also expressed solidarity with the Englishman who was "conscripted against his will." After all, it was only "a small number of Englishmen (who) have constituted themselves into the so-called British

[65] Also important to this pamphlet was an impassioned appeal asking their fellow Punjabis not to fire upon the Chinese.

[66] My emphasis.

[67] PPSAI 1927, Departmental Notice No. 43, Shimla, A Protest Against British Imperialism in China by the Hindustan Ghadr (India's National) Party, August 13, 1927, 320.

[68] PPSAI 1927, Shimla-E, July 22, 1927, No. 25, 246.

Empire" and destroyed the "best element in England" and "extracted the very life of the people in subjected countries." Resistance to imperialism therefore, had to be undertaken on all fronts, and not least from within British society itself. It was in this sense then, that the Empire was contested beyond the shores of the subcontinent, not simply to liberate India from British rule, but to rid humanity as a whole of the "curse" of imperialism.[69]

Funding

A crucial element in liberating India from beyond related to the flow of funds from diasporic communities in support of resistance movements in the Punjab and the wider subcontinent. Indeed, aside from Moscow, foreign remittances from the Ghadar Party and migrant communities were crucial in sustaining the Punjabi Left. These sums enabled the Left to function despite numerous proscriptions, fines, and security bonds. In this respect, the main beneficiary of foreign remittances was generally assumed to be the KKP. Notwithstanding the certitude of these claims, what is fairly clear is that the Punjabi Left and the KKP, in particular, benefitted from substantial remittances from North America and other regions with a large Punjabi, and especially Sikh, diaspora. Indeed it was primarily for this reason that the KKP was generally assumed to be the "Punjab branch of the Ghadar Party."[70]

The Kirti Party though, was not the only political body receiving financial support from abroad. In the 1920s, a number of Punjabi, and primarily Sikh, bodies were founded in North America and elsewhere, with the explicit purpose of supporting political struggles in India. These were mostly formed during the Akali movement and the leaders of this struggle were quick to tap into a source of financial assistance that was

[69] The British were all too aware of this potential. Thus for China they routinely expressed the fear that "the Indian revolutionary element will find a footing in a disordered China, and the Ghadar plotter and the Soviet emissary will join forces" to subvert the British Empire, IOR/V/27/262/5, Intelligence Bureau, India and Communism (Home Department, Government of India, 1933 Reprinted 1935), 12.

[70] PPSAI, Shimla-E, September 12, 1931, No. 36, 547.

clearly forthcoming owing to enmity with British imperialism or communitarian sympathies. One of the best means in which money was subscribed was the founding of societies aimed at securing the welfare of the dependents of those who had been imprisoned during the Akali struggle. One of the most prominent of such societies was then appropriately named the Desh Bhagat Qaidi Parwar Sahaik (Welfare for Families of Patriotic Prisoners) Committee.[71] At the other end, a cursory examination of the societies in North America alone provides an idea of how extensive this funding network was. For instance, aside from the Hindustan Ghadar Party, there were the Pacific Coast Khalsa Diwan Society, the Malwa Sudharak Society, the Sikh American Doaba Educational Society, and the Sons of Bharat, each of which were founded or had a branch in California, mostly in Stockton city. In Vancouver alone there were three societies by the name of: Canadian American Press Society of the Doaba, the Khalsa Diwan Society, and the Hindustani Young Men's Association. While most of these societies liberally subscribed to funds set up for the dependents of the Babbar Akali prisoners, they also had their own objectives. For example, the Malwa Sudharak Society had as one of its aims, "the collection of funds with a view to starting a newspaper in India for the purpose of antigovernment propaganda." To that end it financed the *Asli Qaumi Dard*[72] newspaper of Amritsar, which was labeled a "consistently antigovernment production."[73]

The Kirti Party therefore was also a beneficiary of "the underwriting of political revolution." The extent of this can be gauged from the fact that in 1927, it was estimated that its flagship journal, the *Kirti* had to its credit a sum of 40,000 rupees.[74] While the credibility of this figure may be suspect, what is certain is that there were repeated instances when money was reported to come from the diaspora. A number of small subscriptions to the *Kirti* newspaper and donations to the KKP kept pouring in, even sums as relatively substantial as 50 pounds, from diverse and distant regions such as Fiji,[75] Hong Kong, Java, Uganda, and

[71] PPSAI 1926, Lahore, November 27, No. 46, 569.

[72] Meaning, "Real/Genuine/True National Pain."

[73] PPSAI 1927, Shimla-E, July 2, No. 25, 245–47.

[74] Ibid., 245.

[75] IOR/V/27/262/5, India and Communism 1935, 277.

Panama.[76] Typically, this support was in response to news or propaganda material received from India. Thus, the *Kirti*, for example, was regularly smuggled to diasporic communities who in turn expressed their approval of it through their remittances.[77] These were typically delivered through returning migrants in order to prevent its confiscation by the British authorities. In some cases, returning migrants arrived with the explicit purpose of overseeing whether foreign remittances were being disbursed appropriately or not.[78] As far as the British were concerned however, Moscow remained the most prominent source of funding for the party. Reports, mostly unverified according to the British themselves, kept coming in of the transfer of significant sums of money, which on one occasion was estimated to be 8000 rupees.[79] Nonetheless, whether received from Moscow or from the substantial diasporic communities across the world, the flow of funds clearly indicated that radical politics in the Punjab was firmly tied to the wider global arena and was part of a relationship that extended to the movement of individuals, propaganda materials, and, not least, ideas.

From the Regional to the International

It was the flow and exchange of ideas between Punjab and the wider world that in many ways cemented the ties between the regional and the international. It was thus perfectly possible to be in touch with global developments and be engaged with a wider internationalist struggle without necessarily being physically located or having to travel in the global arena. In this sense, the flow of ideas and the imaginative reworking of the regional or the national as part of the international, provides a necessary corrective to a trend in transnational history which has tended to focus more on diasporic communities and the flow of individuals or goods across (retrospectively reified) borders. It also demonstrates how

[76] PPSAI 1927, Lahore, December 3, No. 47, 611–13.

[77] PPSAI 1928, Supplement 1, Lahore, May 5, No. 18, 200.

[78] PPSAI 1927, Lahore, December 3, No. 47, 612.

[79] IOR/L/P&J/12/300, No. 3/Soc/32, Intelligence Bureau, Home Department, GoI, Delhi, November 1, 1932.

the connections between the regional and the international were often more embedded than the flows from the national to the international or vice versa. This imbalance may probably derive from an underestimation relating to the flexibility and adaptability of ideas in contexts far different from the ones from which they "originated" from. In this sense, Punjab provides a fascinating insight into the reworking and development of ideas, ranging from communism to fascism, which were both a part of and fed into wider intellectual and political networks that did not observe the sanctity of geographical demarcations.

The case of the KKP, for instance, provides, to a certain extent, the applicability of this framework to the Punjab.[80] This organization drew on political networks that were founded in the international arena, either through Ghadarite or Hijrat connections, but more crucially, it grew on and appealed to a constituency which emerged from a localized political context in which the idioms of anticolonial resistance were largely developed and perfected during the recently concluded Akali movement which in turn drew on various struggles in the past such as the 1907 agrarian agitation.[81] The "genealogy of radicalism"[82] was thus tied in with emerging political and intellectual networks, not just in India but beyond it as well, that significantly influenced its eventual trajectory. A clue to this political and intellectual milieu can be found in the statement to the press announcing the launch of the *Kirti*:

[80] For more details on the on the KKP as well as the Leftist movement in the Punjab in general, see Bhagwan Josh, *Communist Movement in Punjab, 1926–47* (Delhi: Anupama Publications, 1979); Gurharpal Singh, *Communism in Punjab: A Study of the Movement up to 1967* (Delhi: Ajanta Publications 1994); Ali Raza, "Interrogating Provincial Politics: The Leftist Movement in Punjab, c. 1914–1950," (Ph.D. diss., University of Oxford, 2012).

[81] From its inception as an agitation against the raising of canal water rates, this movement quickly became antigovernment in nature. See, for instance, N. Gerald Barrier, "The Punjab Disturbances of 1907: The Response of the British Government in India to Agrarian Unrest," *Modern Asian Studies*, 1, 4 (1967): 353–83.

[82] Shalini Sharma, "The Radical Response to Colonialism: The Organized Left in Punjab 1920–47," (School of Oriental and African Studies (SOAS), Ph.D. thesis, 2005), 12.

The journal will be the voice of Indian workers living in American and Canada and will be dedicated to the sacred memory of those heroes and martyrs who awakened sleeping India and whose ideal was regarded by our own people as well as by outsiders as the dream of Alnaschar[83] ... at a time when the price of service and sacrifice was much higher than it is now. The journal will work for all the workers throughout the world, the entire female sex, the subjugated, weak and oppressed nations and subjugated India.[84]

Here, then, was a fusion of broadly two varying political strands. At the one end, this announcement and the paper itself drew on and glorified the ideals of its Ghadarite precursors, most notably in the 1914–15 rebellion, and the sacrifices of the Babbar Akalis.[85] Indeed, not only did many of its activists emerge from the Akali movement itself, but some remained actively involved in organizations such as Desh Bhagat Qaidi Parwar Sahaik Committee, formed for the explicit purpose of supporting the dependents of Akali prisoners.[86] At the other end of the spectrum, the Kirti movement also derived its inspiration from the success of the Bolshevik revolution and its accompanying emancipatory ideals that espoused internationalism founded on the solidarity of the working classes and the oppressed around the world which, significantly, also included "the entire female sex." Moreover, on a more practical note, the journal was also intended for its primary support base of Punjabi migrants living in North America (perhaps as a means for soliciting further subscriptions and funding) and claimed to express and represent their solidarity and, albeit tenuous, linkages with movements against injustice and oppression. In this respect, tangible indications to such universalist ideals and linkages came at a Kirti conference held in 1927 which began its proceedings with a message of solidarity from the "laborers of Berlin."[87] Far from being unusual, expressions of this sort

[83] IOR/V/27/262/3, Communism in India 1924–27, 157. Also, the part about the dream of Alnaschar is a reference to a fable in the Arabian Nights. The phrase itself, as used in this passage, refers to an impossible dream or a fantasy.

[84] S.S. Josh, *My Meetings with Bhagat Singh*, 73.

[85] PPSAI 1928, Supplement 1, Lahore, May 5, No. 18, 200.

[86] Baba Wasakha Singh and Baba Sohan Singh Bhakna are examples of this. See, for instance, PPSAI 1931–32.

[87] PPSAI 1927, Lahore, October 15, No. 40, 447.

of international solidarity were replete in Kirti publications and public meetings which routinely glorified the Bolshevik revolution and other nationalist struggles, such as the movements in China and Ireland, and repeatedly called for strengthening alliances with organizations such as the League Against Imperialism. The KKP however, was hardly unique in this stance as these sentiments were routinely expressed by other Leftist parties as well as a section of the nationalist movement.

Sustaining and feeding this internationalist sentiment was the regular flow, both to and from the Punjab, of information relating to political developments and prevailing intellectual currents. Aside from the standard journalistic outlets and a thriving print culture, the flow of information was made possible through the regular movements of individuals connected with diasporic communities and radical networks. Important too was the transfer of propaganda materials, such as party publications, books, radical newssheets, and much more. Most of this outgoing and incoming material was proscribed and intercepted respectively at the very outset, a fact to which numerous police and intelligence reports testify to. Thus, a regular week's report in 1929 stated that the following literature was intercepted by the Special Branch: *Daily Worker, Hindustan Ghadr, New Republic, League Against Imperialism, Sunday Worker, The Worker.*[88] This interception was also supplemented by a blanket prohibition of any communications emanating from black listed organizations, such as the Kuomintang, Pan-Asiatic League, Union of the Oppressed Peoples of the East,[89] Pan Pacific Trade Union Secretariat, Workers Welfare League of India, the Comintern and all organizations affiliated with it, and many others.[90] However, despite their efforts in trying to create a panoptical state, the British were unable to stem the flow of ideas. Thus Punjabi radicals continued to benefit from contemporary intellectual trends and literature which included seminal works such as *The State and Revolution, The Proletarian Revolution,* and so on.

It was therefore perfectly possible for radicals who had emerged from an "organic" political context to draw on global political and intellectual currents. Indeed, in this sense, the idea of politics, as inhabiting an arena

[88] PPSAI 1929, Lahore, December 21, No. 50, 769.

[89] PPSAI 1927, Departmental Notice, Lahore, April 2, No. 16, 119.

[90] PPSAI 1927, Departmental Notice, Lahore, No. 56, October 8, 437.

that was simultaneously regional as well as global in its spatial dimensions, was an unparalleled development in South Asian history that was already rife with instances of modern and premodern movements of individuals, materials and ideas. Viewed from another angle, the very nature of empire and its socialist nemesis, with both their global manifestations, had necessitated the emergence of such a politics. Viewed this way, the Empire was also an enabler of radical politics. The condition of traveling or belonging to a diasporic community therefore did not necessarily apply if one were to engage with this global political paradigm. Rather, it was perfectly possible to be international, or "transnational" as per modern historiography, by remaining firmly rooted in a particular political context. It is then sense then that the regional or the national was firmly tied in with the international.

Conclusions

In the final analysis, each of these narratives may appear disjointed if viewed in isolation from one another. And yet, once woven together, they reveal some important insights about the interwar "internationalist moment." For one, this period is remarkable for providing a space in which a distinct political trajectory to radicalism emerged and thrived. For an entire generation of Punjabi radicals, this journey began in locations far removed from the subcontinent. For many, this trajectory led through diasporic communities and the very *process* of traveling. For both cases, intellectual, political and personal encounters were instrumental in compelling potential radicals to reassess their place as subjects in a global empire, and to rework methods through which their sovereignty and, crucially, an amorphous, but very real, sense of dignity and self respect could be regained. For many, this entailed combating the empire, not only in a specific regional or national sense, but in the entirety of its global manifestation. At the other end of the spectrum, this method of combating the empire could just as well be adopted by individuals who emerged from a localized political struggle. For both types of radicals however, a unique form of universalism was adopted that, while being unprecedented in the Punjab and the wider subcontinent, was certainly typical of an internationalist moment that was global in

scope. Thus, in doing so, these individuals also defy the often unimaginatively used dichotomy of "elite" and "subaltern," for nonelites, at the margin of both the nation and empire, were often at the forefront of this political and intellectual milieu. In this reading, then, their experiences and activism also contest the narratives of subordination and oppression that tend to delimit the agency of these historical actors. And on a rather obvious note, the politics of these individuals also challenge the territorially bound narratives of Indian anticolonial struggles.

Secondly, it is worth bearing in mind that the internationalism to which many Punjabi radicals swore allegiance to was but one of many internationalisms that percolated during the interwar period. Among these were diverse movements, associated with national liberation, feminism, universal suffrage, self-determination and others, that in many cases converged and drew their inspiration and ideological formulations from each other. Thus, in a related sense, while not strictly internationalist in either spirit or practice, fascism too was part of the spectrum of ideologies that permeated the global political and intellectual landscape, and Punjab too was no exception to this trend. The Punjabi Left then, viewed within the regional political and intellectual space, was but one of many political impulses that ranged from openly communal and fascist trends, epitomized in organizations such as the Rashtriya Swayamsevak Sangh (RSS) or the Khaksar Tehreek, to ideas of revolutionary terrorism, which were articulated in both theory and practice by organizations such as the Hindustan Socialist Republican Army (HSRA). In between these extreme trends could be located an entire array of "loyalist," "nationalist," "leftist," and "communitarian" movements—each of whom came with a multiplicity of variations—which all competed with each other for political dominance. In doing so, these impulses also drew from and appropriated, not only from each other's political languages, but also from the wider global milieu of competing intellectual and political trends. The Punjabi Left therefore, in line with the prevailing zeitgeist, situated its politics simultaneously within the global and the regional, in which ideas of international working class solidarity and anti-imperialist struggle could easily be blended in with religiously inspired notions of martyrdom and resistance.

Normally these competing formulations are understood to be mutually contradictory. But the politics of Punjabi radicals showed how

these strands could come together in an apparently seamless manner. Similarly, it is owing to such conceptual determinism that the binaries of the "universal" and the "national," or even the "local," are rarely, if ever, bridged. The journeys of these individuals showed that the "global" and the "local" had an intimate relationship in terms of lived experiences. Moreover, in political and intellectual terms, it was perfectly possible for many to ascribe to a politics of internationalism that was at the same time rooted and directed toward a specific sociopolitical context. Indeed, that is precisely how Sacco and Vanzetti became part of Punjabi Leftist politics. Thus, far from being static and mutually exclusive categorizations, the politics of Punjabi radicals in the interwar period indicated that the impulses of "internationalism" and "nationalism" or even "regionalism" frequently overlapped, drew from, and fed into each other. In contemporaneous terms then, there were few, if any, reified conceptual and geographical boundaries that prevented Punjabi radicals from regularly transcending them. And it is partly in this sense that Punjab, and by extension, British India, ceases to be a territorially, and hence, conceptually bound unit of historical analysis.

5

Meeting the Rebel Girl: Anticolonial Solidarity and Interracial Romance

Maia Ramnath

When is love an act of liberation? Can the matter of whom one loves and how one loves them contribute to the work of anticolonial resistance? By putting Leela Gandhi's *Affective Communities: Anticolonial Thought, Fin-de-Siecle Radicalism and the Politics of Friendship* (2006) into retrospective conversation with the words of nationalist and feminist celebrity Madame Bhikaji Rustomji Cama in her Paris-based journal *Bande Mataram* (1912), and of Irish poet and patriot Brian Padraic O'Seasnain in New York's similar *Independent Hindustan* (1920), it is possible to sense these anticolonial activists' implicit responses to these questions. Embedded in their historical and political context they are quite different, of course, from those of a postcolonial theorist writing in the abstract nearly a century on, and I do not wish to do them the disservice of anachronistic interpretation. Nevertheless, for them too the notion of an anticolonial love depended upon where boundaries of self and other are drawn, and when crossed; on the rechanneling of

individualized libidinal energy into collective political action; and last but not the least, upon the status of women, both actual and iconic.

This essay emerged from the effort to address something that, rather to my own chagrin and not without a sense of irony, had become a persistent lacuna in my own work: namely, while I focused on weaving the "Revolutionary Movement Abroad" into a long-distance mesh of resistances whose concept of liberation far outstripped both the ideological and geographical boundaries of the nation, what fell from view again and again was the issue of gender. This was more than a matter of restoring women to a field of view that was often homosocial by default; it was also a matter of restoring a basic element in a framework of analysis. And it appeared to me that with regard to the latter, without neglecting the contextually specific conditions for Indian women's (lack of) participation in these transnational circuits, it was at least as important to follow the transpositions of libidinal energy, the conscious and unconscious political channeling of romantic desire, as it was to follow the footsteps of women. The perspectives expressed via these two documents, both addressing the issue of interracial relationships in the context of the Indian independence struggle overseas, offered an enticing stereoscopic opportunity.

In the early 1920s, *Independent Hindustan* served as official publication of the reconstituted Hindustan Ghadar Party, a movement of radical Indian immigrants then struggling to regroup after war-time repression.[1] For this both organization and journal drew upon the support of the Friends of Freedom for India, consisting of sympathetic allies among prominent U.S. progressives, anti-imperialists, and civil libertarians; but perhaps most of all upon the emigrant branch of the Irish republican movement. Taking a comprehensively progressive stance on social and economic issues both domestic and diasporic, *Independent Hindustan* under the editorship of Surendranath Kar furthermore demonstrated a consistently feminist perspective.[2] Along with the

[1] For a detailed treatment of this movement's trajectory, see Maia Ramnath, *The Haj to Utopia* (Berkeley: University of California Press, 2011).

[2] For this no little credit must surely go to Agnes Smedley, a white woman whose principled devotion to the cause was complicated by sexual/racial politics in general and by her romantic relationship with prominent left-national revolutionist Virendranath Chattopadhyaya in particular. This makes Smedley

usual installment of political analysis and global affairs, the November 1920 issue treated readers to a romantic tale of forbidden passion both doomed and ennobled by revolutionary idealism: In O'Seasnain's short story "Shane O'Neill Discovers India," an Irish soldier and a Calcutta student consummated their love only at the moment of death by British counterinsurgent bullets. Although couched as melodramatic fiction, the piece vividly dramatized the movement's motivations and desires.[3]

Indeed, the same motivations and desires were addressed in two companion pieces Cama had published eight years and one global conflagration before in the December 1912 edition of the *Bande Mataram*, this time with pragmatic recommendations toward their ultimate realization. In her open letter "To Young Orientals," and her transcribed address to the Egyptian National Congress in Brussels (an event that Indians in Paris had attended and helped to plan two years prior),[4] she weighed in on the issue of modern partnership, arguing that the proliferation of interracial couplings in the movement abroad was doing damage to the task of national self-strengthening by hindering Indian women's opportunities for progress at home.[5]

something very close to Naidu's sister-in-(common) law. An example of her contribution to the magazine is the article "Women and New India" by A. Smedley "An Interview with Mrs. [Lila] Singh, a Suffragist of India," and the first female student at an all-male school. Smedley quoted Singh, "The women of India are part and parcel of Hindustan; they retain the traditions and customs of India and they are the greatest potential forces in the struggle for freedom through which India must and is passing." *Independent Hindustan* 1:1 (September 1920), 10. Nehru Memorial Museum and Library microfilm collection.

[3] *Independent Hindustan*, 1, 3 (November 1920): 55–58, 70. O'Seasnain is perhaps best remembered for his 1917 volume of poetry *Star Drift*. His poems also appeared in *The Catholic World*, including "The Silences" (August 1919), and "Alone" (July 1920).

[4] *Bande Mataram* 4, 4 (December 1912): 2–3. Home Political file 37–39 B, 1913. National Archives of India.

[5] See, for example, Kumari Jayawardena, *The White Woman's Other Burden: Western Women and South Asia during British Colonial Rule* (Routledge: New York, 1995). Such relationships and dynamics can also be recognized in biographies of figures such as M.N. Roy, Virendranath Chattopadhyaya, Agnes Smedley, Har Dayal, Pandurang Khankhoje, and others.

What had these to do with each other? O'Seasnain's educated, militant heroine, the feminine embodiment of a liberated nation portrayed no longer as enslaved queen-mother but as active revolutionary, did not yet exist except as an ideal of the type of the new woman Cama hoped would emerge in reality. Only when she did would Cama see fit to dismantle the strategic—not essential—east–west barrier. In the case of Ireland, however, the issue was functionally moot; if the defining factor was political location as opposed to cultural attribute, then both Indians and Irish, unlike other Europeans, occupied the same side of the colonial divide. Moreover in O'Seasnain's story the pairing was of an Irish man and an Indian woman, whereas Cama's concerns were for the more frequent pairing of Indian men with western women. Could a partnership that in theory equalized the power gradients of gender and culture generate a substantively anticolonial love?

La Cama Urges the Discovery of India (a Reality)[6]

Madame Cama, as she was known, was perhaps in her day one of the most prominent "expatriate patriots" in the world. Cama left her native Bombay in 1901 at the age of forty, never to return until shortly before her death in 1935. Wife and daughter of affluent Parsi lawyers, deeply inspired by Krishnavarma's London India House, co-founded the Paris Indian Society in her new hometown in 1905 to become the financial patron and inspirational motivator to the Indian radicals who congregated there. As firebrand speaker known well beyond radical nationalist circles on the world stages of socialism and feminism—the zenith of her celebrity followed her unfurling of an Indian independence flag before the 1907 International Socialist Conference in Stuttgart—she was

[6] Radha Kumar provides a good feminist history of the independence struggle in *The History of Doing* (Verso: New York, 1993). For a masterful interweaving of Indian feminism with both nationalism and the changing geopolitical circumstances and imperial social formations of the 1920s, see Mrinalini Sinha, *Specters of Mother India: The Global Restructuring of an Empire* (Durham: Duke University Press 2006).

consistently militant in her provocative rhetoric. The cover of the *Bande Mataram* circa 1912 showed a powerful female figure superimposed onto the silhouette of British India, clad in a sari and drawing a sword, surrounded by bundles of shields, axes, banners on spears, and cherubs blowing trumpets. This iconography was familiar among the expatriate communities of London and Paris, for whom the Rani of Jhansi, heroine of the 1857 war of independence killed while leading her troops in battle, was as revered as she was ubiquitous in magic lantern slide presentations and commemorative journal covers. Later the cover of the *Independent Hindustan* also bore an image of the subcontinent in the shape of a woman, similarly accoutered with sari and sword, and stern as Liberty or Justice. Cama herself was poetically referred to as an incarnation of Durga, the female manifestation of avenging wrath riding on a tiger.[7]

Cama was an exception. Even assuming the requisite caste and class privilege, without an entree through a prominent father or husband, few Indian women were offered a doorway into public life, or the chance to travel to the cosmopolitan environments in which not only the hierarchies of the colonial order but traditional gender expectations were being challenged on the grounds of liberal, socialist, and radical-democratic political thought. The flow of students and radical exiles to the metropoles of Japan and Europe was almost all of young single men—although some had left wives and children behind, sometimes apparently without a backward glance—as were the flows of soldiers and police throughout the various colonial outposts and military theaters of the British Empire. Therefore, participants in this largely homosocial environment had the luxury of expressing daring support for female emancipation in relation to the task of national emancipation, without necessarily having to confront the daunting reality of that unprecedented prospect. When they did, their behavior sometimes revealed their unreadiness to measure up to their own avowed rhetoric.

Female laborers and families had joined the migration of the indentured to Caribbean and Pacific settlements since the 1830s, but due

[7] Kumar makes a distinction between the Mother India and the Kali-Durga images; the latter fighting and the former fought for. In addition to the maternal Cathleen, Irish mythography contained plenty of formidable female warrior images as well.

to a combination of immigration restrictions in North America and social conditions back home, few non-indentured laborers traveling there brought wives and children. A significant number of Punjabi farm workers in early twentieth century California intermarried with Mexican women—in that context functioning as their racial, social, and economic equals—since they could do so without violating the existing miscegenation laws. As for high caste and/or highly educated emigrants in North America, exotic cultural cachet sometimes won them a class-based racial pass to engage in relationships and even to marry white women who themselves tended to be highly educated and politically progressive individuals. This was true of most of the prominent revolutionaries who through a combination of inclination and necessity made long-term lives overseas. For example, both Agnes Smedley and Evelyn Roy played substantial roles in the intellectual and organizational evolution of the national revolutionary movement leftward. However, both were subject to some degree of resentment and suspicion on the part of their adopted colleagues for their influence both as women and as westerners. Nevertheless on the eve of First World War, such interracial partnerships were perhaps the closest approximation any had yet found of the companionate ideal so important to a particular sort of influential middle class nationalism exemplified by Tagore's alter ego in the novel *Home and the World*.[8]

But Madame Cama had concerns about the practice. She began her open letter by explaining that she wanted to respond to the many inquiries she regularly received from "young compatriots and also from my Persian and Egyptian camarades [sic], on the question of marrying foreign wives." Her simple answer: don't do it. "Brothers!" she exhorted (her conflation of Indians, Egyptians, and Persians here seems less a tribute to cosmopolitanism than a default acceptance of their membership in the category of the Oriental abroad in the West):

[8] Note that in Bengal and the rest of India the companionate relationship was a reenvisioning of the institution of marriage, whereas these overseas partnerships often (though not always) disregarded the formalities of the institution altogether. For some statistics on interracial relationships between British women and Indian emigrant men between the wars, and on the pervasive fear of miscegenation, see Rozina Visram, *Asians in Britain* (London: Pluto Press, 2002), 185–92, 273–76.

I do not wish to be too hard on you. I well understand your difficulties, and nearly the impossibility of finding educated and progressive wives in your countries; according to your *idee* of education and progress, which you have naturally formed during your stay in the Western World. Besides that, pure and ideal love between an oriental man and woman, or between an oriental man and an occidental woman, is the same thing. Ideal love is sacred. It is divine![9]

The difficulty, however, was that such a love was "a very very rare article." (Like any good Parisian woman of a certain age, it seemed, Mme C was wise in the ways of the world and the heart.) Rather the "International Unions" which her readers contracted in its name were, like all marriages, likely to be "more or less based upon a call of nature, desire or passion, and convenience, comfort, etc." In this it mattered little whether the bride was oriental or occidental, even if it were true that "the former is gentle and patient, by nature dignified and intelligent, while the latter is active and progressive, and by nature bright and of happy disposition."[10] Yet Cama did not essentialize this difference. If her "oriental sister is so much neglected and left behind," it was not her fault. On the contrary, boys, she suggested, think about this: Every time you marry a westerner, you in effect keep your own women back and hinder the process of national emergence. "The only way to bring up your fallen countries to a high pitch is the bringing out of your womankind, which is your half population!"[11]

The notion that in order to emerge as free and sovereign the nation had to modernize itself and its social institutions, including the key corollary that women had to be freed from patriarchal subjugation not only on liberal humanistic principle but in order to make the missing half of the national community's human resources available for its development, would have been quite familiar to her readers by this point.[12] Therefore, she reminded them, be patient and think of the future:

[9] Cama, 2.

[10] Ibid.

[11] Ibid.

[12] See, for example, Tanika Sarkar and Sumit Sarkar (eds) *Women and Social Reform in Modern India: A Reader* (Bangalore: Permanent Black, 2007); Tanika Sarkar, *Hindu Wife, Hindu Nation: Community, Religion, and Cultural*

You should rather suffer every day in your life in teaching the progressive ways to an oriental little wife, then [sic] getting a readymade article you get an easy home life, by marrying an occidental woman. If you agree to this principle; then it should be your faith; and Faith demands Action which means—try your best to marry oriental girls.... Bring them out with you, and let them see and learn the Forward Movements as therein lies the Salvation of the East.[13]

Cama had expressed a similar theme in her remarks to the Brussels conference in 1910. "Friends," she began, "I see only half the population of Egypt at these proceedings.... Sons of Egypt, where are the daughters of Egypt? Where are your mothers and sisters? Your wives and daughters?" Was it a misguided sense of chivalry that made them want to shelter the womenfolk? she wondered. When the country was in agony, did they think the women were safe at home blindly enjoying tranquility? No:

Friends, as a woman let me assure you, that we women feel as much as you feel for our oppressed countries, and let us take our rightful places at your sides. Work out the emancipation of Hind and Egypt through the joint efforts of men and women.[14]

This implied that she sought a place for women in the public, political sphere of struggle. However, it is plain she had not yet transcended the assumptions of the primacy of motherhood and domesticity as building blocks in the national edifice, for she then expanded upon the familiar theme of women's crucial role in shaping the nation's character through molding its children; the hand that rocked the cradle was a powerful hand. As such, if the young men were to seek love in Europe, "taking their partners in life from foreigners," they would in effect be colluding in "a foreign invasion! Egyptians and Hindis, you all know that you have had enough of foreign invasions."[15] Yet even while she seemed to echo the cultural nationalist's assumption that the ultimate violation was

Nationalism (Bloomington: Indiana University Press, 2001); Kumkum Sangari and Sudesh Vaid, *Recasting Women: Essays in Indian Colonial History* (New Brunswick: Rutgers University Press, 1990); among many others.

[13] Cama, 2.

[14] Cama, 3.

[15] Ibid.

that of the home's inner sanctum, for Cama the threat from these Trojan mares was not to tradition and cultural purity but rather to the process of self-strengthening and modernization itself. She took care to emphasize that she had nothing against her American and European sisters per se; she was, she declared, an internationalist who longed for the day when she could say that "the world is my country, and every human being is my relation." But it was not yet that day, and

> to establish Internationalism in the world, there must be Nations first. Now tell me what nation you can build out of such homes; where there is a French wife in one; a German in another; a third nationalist goes about with an Italian wife, and the fourth and the fifth settle down in England and America with and English and American wife?[16]

It would be consistent with her approach to consider this marital recommendation a temporary tactical measure necessary to attaining the desired stage in which the strict dichotomy between the public and the domestic might perhaps be eliminated as surely as that between the domestic and the foreign. In short, Cama's concern was that unless and until Indian and Egyptian women made progress towards modern education and full participation in civil society and became active in the movement for national self-realization, then cross-cultural relationships—though in an ideal world unproblematic—were within the actually existing situation detrimental to the mutually reinforcing emancipations of the nation and its women.

Some did try; for example, as a youthful idealist in 1907, Har Dayal had brought his wife Sundar to England for a year, but only by virtually abducting her against their families' will. Given the obstacles to accompaniment, in the end cross-racial couplings may have had more to do with simple loneliness and enforced distance than with a deliberate avoidance of this challenge. And for those who lived for many years abroad, the barrier of distance could work in the other direction as well. A series of Scotland Yard reports surveilling the London-dwelling anti-colonial activist Sasadhar Sinha noted in each entry over many years that Sinha was "still residing with his wife at [] Goldhurst Terrace." The woman recorded as Marthe Sinha, née Goldwyn, previously Goldberg,

[16] Ibid.

had married him in 1928 after cohabiting since 1924; for years she supported her penniless radical bookstore owner and part-time lecturer in history and politics on a schoolmistress's salary. The final report of 1945, marking Sinha's return to India to fulfill his expressed desire of connecting more directly with the struggle, notes with terse poignance, "his wife did not accompany him." It is impossible to know from this record what conversations passed between them leading up to his departure, what factored into her decision, or how things might have turned out if she had come.[17]

Shane O'Neill Discovers India (a Fantasy)

By 1920, when the *Independent Hindustan* was established, such a condition as Cama sketched could be imagined, if not yet fully realized. The journal, however, was optimistic. For example, monthly "News and Notes" and "Pulse of the Press" sections included items on women's educational progress in India or their contributions to the freedom struggle. Sarojini Naidu's speaking engagements were frequently reported in items such as "A Hindu Lady Demands Absolute Independence of India"[18] and "A Hindu Lady Speaks Her Mind,"[19] in January 1921.

Subsequent issues offered continuous coverage of the strike actions Mrs Manilal Doctor was then leading in Fiji. This was notable in that while her leftist lawyer husband was well-regarded as a social defender and freedom fighter in Mauritius and Fiji, it was Mrs Doctor whom the journal presented unequivocally as the true soul and strength behind the struggle for the rights of the indentured labor force. The content and political orientation of O'Seasnain's story, then, while creative in form, were very much in character for the journal.

[17] IOR/PJ/12/467. For a counter-example, see the biography of Pandurang Khankhoje written by his daughter, Savitri Sawhney, *I Shall Never Ask for Pardon* (Penguin: New Delhi, 2008). The Belgian-born Jeanne Sindic Khankhoje and their two daughters happily embraced Indianness when the family returned there after independence, once he no longer feared arrest upon arrival.

[18] *Independent Hindustan* (January 1921), 115.

[19] *Independent Hindustan* (January 1921), 115.

The protagonists meet cute. "God help me, look at the beauty of that girl!" exclaims one young soldier to another, pointing out a slender, sari-clad figure, reading at a bookstall in a Calcutta bazaar. The prosaic Englishman, who just wants to get back for mess and think about his sturdy "apple-cheeked" girl back home, "mockingly" reminds his poetic Irish cohort of the injunction against "illicit intercourse with the natives." But Shane O'Neill lingers, intrigued. "Damn supper! Damn the Impire! ... If I meet such a beauty as this during me first week's service in India, I'll surely learn to like the country."[20]

The girl remains absorbed in her book as Shane nerves himself to approach. He pretends to read nearby. She shifts aside. He shifts closer. Then with a start he sees what she's reading.

She turns and confronts him. "You were reading over my shoulder.... And now there are tears in your eyes. Why is that?"[21]

He's confused. He stammers, bows, removes his helmet, mumbles something about "dust in me eye and by a kind provision of nature, the tears came to sweep it out. Anyhow ... I'm Irish" (as if his music hall dialect hadn't made that clear); and so when he saw the book was "our own lad Yeats."[22]

Her interest is piqued. Had Shane ever seen the poet then? Yes, in Dublin at the Abbey Theatre. They bond a bit over shared appreciation of this "heartrending[ly] ... beautiful lament of Ireland's degradation."[23]

After a moment of embarrassed silence he blurts, "You're different from all the other girls here ... the right sort, I mean. And he's been 'famishing' to talk to a real girl, not you know."

"I know," she bestows a little smile. "I'll excuse you, big soldier, for trying to flirt with me ... because you have known Yeats. Only don't flirt anymore if you want us to be friends."[24]

That's great with him. They chat. A student at the University, she "believe[s] the Hindu woman deserves and needs the same freedom as men." Then rather abruptly she shifts her topic. "So, big soldier.... What

[20] O'Seasnain, 55.
[21] Ibid.
[22] Ibid.
[23] Ibid.
[24] Ibid.

do you think of Ireland? Will it be a republic?"[25] "I hope to God it will be," he says fervently.[26]

Interesting then that he's wearing that uniform, she observes. He explains that he comes from a long line of freedom fighters: great grand-father a rebel of 1798, grandfather involved in the 1848 conspiracy, dad a Fenian. He's the first of the family in the British service, "God help me." If he had only known when he signed up what he knew now.

So he is "a rebel at heart then, big soldier?"

"I'm afraid I am, but don't tell the Colonel."

"What do you think of this idea of freedom for India?" her question is deceptively casual.

Shane had no idea people there were asking for it. Even so, "Sure, why shouldn't ye have freedom if ye want it.... If freedom is good for Ireland, it ought to be good for India. I know we want freedom in Ireland. We've fought for it seven hundred years."

She's watching him closely but speaks with apparent nonchalance. "I know some people here.... They tell me that India too has fought for freedom thru [sic] the centuries. They tell me that freedom is coming. What do you think of that, big soldier?"

"Let it come, is what I think," he answers "gaily and carelessly."

"But you—when India calls for freedom—where will you be?"

"I'll be where freedom is, you may be sure." But that's far off, surely, since "whoever heard of a Hindu striking for freedom?"

Who indeed? "You are surely a stranger in India. There is much happening that you do not know."

So Ms Aparajita and Shane O'Neill of the 106th strike up a friendship. He asks if they can meet again. She demurs; it would be "bad for my work to be seen with a British soldier."[27]

He goes back to the base, and for the next month he's preoccupied, withdrawn, distracted. None of his teasing comrades guesses that he's been slipping off to "rendezvous with a dark-haired girl of the people," and although she had forbidden anything physical, "She had attained

[25] O'Seasnain, 56.

[26] Ibid.; as is the remainder of the following conversation.

[27] Ibid.

that rare ascendancy over him which overcomes the man of action who finds a woman who inspires his respect as well as his adoration."[28]

Finally one day as they stroll in Ballygunge he can contain his frustration no longer, declaring that though she has "the mind of a poet and the body of a fairy," she remains a mystery to him; he knows nothing of her home, her family, her work. He respects her secrecy, but fears she doesn't trust him. No, it's not that, she insists. "I would tell you all if I could, but don't you see–you are a British soldier, and I am a girl of the people."[29]

Oh, is that all? Easily fixed. He too will become one of the people, renouncing his uniform on the spot. Even so, she warns, there can be no romance until the work is done. "So be it," Shane says heatedly. He knows well what the work will be, and rebellion is in the blood of the O'Neills.[30] "I am now going to do something that would rejoice the heart of me ould mother. Can ye get me a native costume?"[31]

She lays her hand on his arm, "eyes shining," and asks him if he truly "know what it means–to live among an alien people–to be hunted and hated ... loneliness ... prison?"

"Ye needn't ask an Irishman that," he retorts. Nevertheless he anxiously reminds her that at least loneliness they needn't fear.

"I am yours.... Forever [...] But ... the claim of the motherland is first."

Here emotion overtakes both Shane and O'Seasnain: "'Enough,' he cried roughly. 'Little rebel, you are my motherland. The nation that produces the likes of you is good enough for me to serve.'" An hour later a tall Indian shadowed by a smaller silhouette melted away into the night as a uniform sinks to the bottom of the river, weighted with a stone.

Jump cut to General Dyer, grimly reading reports in his office. He receives an informer (loathesome, venal, servile vermin that O'Seasnain

[28] Ibid.

[29] O'Seasnain, 57.

[30] Neither name, one suspects, was chosen at random. The O'Neills were a fabled Ulster clan said to be descended from High Kings. Shane O'Neill was the son of the first Earl of Tyrone; though famous for rebelling against the Tudor conquest of Ireland, he was killed in a factional conflict in 1567. Aparajita means unvanquished; it was later the title of the 1932 sequel to 1929's *Pather Panchali* by Bengali novelist Bibhutibhushan Bandopadhyay, on which Satyajit Ray's famous Apu trilogy was based.

[31] O'Seasnain, 57: including the remainder of this conversation.

makes sure to emphasize he is), who announces the presence of an unidentified newcomer amongst the rebels, "tall and utterly without fear and very crafty."[32] The man is apparently "from one of the stalwart races from the north" (a Pathan, no doubt) and seems to be under a vow of silence. He also seems to know a surprising lot about the disposition of arms in the British arsenals, and probably had a hand in the recent series of barracks raids in which a significant quantity of weapons and ammunition went missing.

Get him dead or alive, says Dyer. "The insolence of the natives is getting beyond all bounds."[33]

Cut again, to a decrepit mansion by the river. Figures creep toward it in the dark trailed by twenty khaki-clad soldiers. In the garret, a rebel reads a report to his fellows by candlelight. "So here is the list, comrades: 15 rifles with 100 rounds, the military cipher for the month, one small case of anesthetics, the plans for the new service rifle, and the list of suspected persons" plus the "fruits of our most recent forced loans."[34]

Then he stops. His "cool, bantering tone" goes suddenly sharp and intense. Had they heard something?

"No, Shane ... what?"[35]

As a poacher in his youth, he recalls, he could hear the step of a rabbit at hundred feet and that of the gamekeeper a half mile away. "Well friends, I hear the step of the Imperial gamekeeper outside. Keep cool, all. Ram Dass, to the roof with these papers. The trees outside will be your road."[36] Oh, and take Miss Aparajita too, he adds. For indeed she too is among the guerrillas. But she digs in her heels and meets his gaze unflinching. He drops his eyes first. She stays.

To each of the remaining four he hands a rifle and a belt of ammunition. Go, comrades, "and God bless ye." They're to take positions in the hall and cover the stairwell with rifle fire to guard Ram Dass's escape. They wait in the dark, whispering comfort to one another in the face of impending death.

[32] Ibid.

[33] Ibid.

[34] O'Seasnain, 58.

[35] Ibid.

[36] Ibid.; the same applies to all quotations for the remainder of this scene.

Shane too addresses his brave beloved: "Little Aparajita."

"I am here, big comrade."

"This is the end."

"It is the end," she agrees. "For a moment she felt cold and lonely," O'Seasnain tells us. "Then courage came back in a rush. She tightened her small hands on the rifle."

"Then tonight, my dear," says Shane, "your work for the motherland will be finished, and mine will be ended too. Little Aparajita, you are most wonderful. Before I knew you, I didn't know how your people could be free. Now I understand. In the world we have left, you and I would be comrades ... in the way of other men and women."

"This is a better way," she says.

Time for one thing before the final parting: at last, they kiss for the first time.

"The first and the last," he said softly. [Then]"It is enough!" he cried. "It will do me forever. Surely life is a great wonder."

Glass breaks. The army bursts in. Gunfire flashes from the upper landings. Outside Ram Dass is sneaking away through the treetops to safety with the precious papers stashed in his turban, a Kipling-ready figure "whom the jungle had trained" for this very task.

A final cut: back to the sterile detachment of Dyer's office. The General hears the latest report, happier this time. The spy is sure it was the new fellow whom he saw in the encounter, conspicuous by his size. "He was greatly wounded before he died, and he fought with the soldiers from stair to stair using his rifle like a club. Also he shouted in English and used strange battle cries."[37]

The general is enjoying the ripping yarn. "Go on."

The insurgent's end was "the strangest thing of all. With ferocity he had driven the soldiers down the stairs again and again, while one rifle played on them from above."[38] Aparajita's? Then he went up into silence, followed by some soldiers with a searchlight. The big fellow was kneeling on the floor cradling the body of a "dead rebel girl," and speaking "wild words" to her until a soldier shot him in the head.[39]

[37] Ibid.

[38] Ibid.

[39] O'Seasnain, 70.

"Ah, were they lovers?" asks the general. "A strange tale."

"For a long time, he sat staring at the white paper in front of him. Then, with a frown, he shook off a strange mood and bent over to make his report."[40]

Other Discoveries (an Analysis)

On Self and Other

The story of O'Seasnain's lovers seems at first glance to evoke Leela Gandhi's vision of xenophilia, the cosmopolitanism of Kwame Anthony Appiah, or perhaps Derrida's politics of friendship: positing embrace of the Other, love of the stranger, and affinities of shared opposition as the key to anticolonial resistance.[41] But embedded in the context of interwar New York, the story conveyed something quite different. First, within the literary tradition of Irish Orientalism no less than the historical record of active political solidarity between the Irish and Indian freedom struggles, recognition between the two countries' rebels, artists, and visionaries was conceived not as an encounter between self and other but as a reunion of sundered kin.[42]

[40] Ibid.

[41] These ideas are developed in Leela Gandhi, *Affective Communities* (Durham: Duke University Press 2006); Kwame Anthony Appiah, *Cosmopolitanism: Ethics in a World of Strangers* (New York: W.W. Norton 2006); Bruce Robbins and Pheng Cheah, *Cosmopolitics: Thinking and Feeling Beyond the Nation* (Minneapolis: University of Minnesota Press 1998); Jacques Derrida, *Of Hospitality* (Stanford: Stanford University Press, 2000) and *Islam and the West* with Mustapha Cherif (Chicago: University of Chicago Press, 2008).

[42] For overviews of Indo-Irish anticolonial solidarity, see Tadhg Foley and Maureen O'Connor (eds), *Ireland and India: Colonies, Culture and Empire* (Dublin/Portland, OR: Irish Academic Press, 2006); Denis Holmes and Michael Holmes (eds), *Ireland and India: Connections, Comparisons, Contrasts* (Dublin: Folens, 1997); Kate O'Malley, *Ireland, India and Empire: Indo-Irish Radical Connections, 1919–64* (Manchester University Press, 2008); Matthew Plowman, "Irish Republicans and the Indo-German Conspiracy of World War I," *New Hibernia Review* 7, 3 (Autumn 2003): 80–105.

Gandhi's analysis of the politics of friendship is motivated by the task of revealing solidarities of affect between South Asian anticolonialists and fin-de-siécle radicals of various stripes, who she argues were situated in structurally analogous though qualitatively different locations counter to the dominant episteme of the British Empire. According to her summary of Hegel, the anticipated community that is

> outlined in the dialectic of the master and the slave, relies exclusively on the principle of reciprocal recognition, according to which I can only enter into intersubjective or communal alliance with another whom I recognize as myself. So too, my "interlocutor" cancels my alterity, seeing in me ... "another, but one that is not foreign, which is at one with himself."[43]

Just so Shane and Aparajita recognize one another as kindred spirits in the crowded bazaar. For Gandhi, this is a debilitating limitation. Her political ideal of relationality—what we might call an "'affective cosmopolitanism,' the ethico-political practice of a desiring self drawn toward difference"[44]—like Appiah's, is xenophilic. From this perspective, the scalar jump from a self-identical subject to a self-identical community is an existential dead-end; it matters little whether the boundary is scored along ascriptive or acquired lines. True friendship lies only beyond that closed loop in which "voluntary affiliations, still desperately seeking similitude (of sexual, intellectual, political, ethical, aesthetic orientation) endlessly replicate the deadlock of self-sufficient unity[.]"[45] It insists upon maintaining the difference that it loves as such. But Shane and Aparajita feel enraptured and inspired, not existentially trapped, by their discovery of commonality through their structural position in relation to the empire, as well as their ideological commitment to a free republic for all. In this case, the leap into empathy and identification occurs not between colonial and subaltern, but rather between two entities on functionally equal footing on the grid of imperial power (though not of gender). Shane has only been masquerading as a master; really he is a slave. On this self-recognition the plot turns.

[43] Gandhi, *Affective Communities*, 24–25.
[44] Gandhi, *Affective Communities*, 17.
[45] Gandhi, *Affective Communities*, 25.

Mutual recognition between the Indian and Irish situations had existed since the mid-nineteenth century, with active solidarities and working friendships developing between the respective emigrant communities in the United States since the early twentieth. Later, much as *Independent Hindustan* did, Irish papers such as *An Phoblacht* and *Saoirse* drew frequent parallels between their own situation and those of Afghans, Persians, Egyptians, and Chinese, locating themselves globally in contrast to the exceptionalism of a more right-wing cultural nationalism. But in the Indian case the "cross-colonial linkage,"[46] as literary scholar Joseph Lennon puts it, went beyond analogy to homology. The Fenian Brotherhood's *Gaelic American* had been sharing printing presses and trading texts with the Ghadar and proto-Ghadar publications since 1906, not to mention material support for one another's activists. By 1920, the overseas branches of the two national liberation movements regarded their respective struggles against British rule as more or less equivalent. Rather than a cosmopolitan xenophilia, then, O'Seasnain's story deployed the anticolonial internationalism typical not only of the *Independent Hindustan's* editorial leanings but of the socialist-republican, pro-India politics of Frank Ryan, Roger Casement, and James Connolly, crossed with the Irish Orientalism of the turn-of-the-century Celtic revival.[47]

Foremost among its exemplars was Yeats, whose cameo here as pretext for the lovers' first contact is significant. His work from the 1890s to

[46] Lennon, 268 and passim.

[47] At least two of these figures also had India connections. Casement was in Berlin at the same time as Chatto, Har Dayal and their fellows of the Berlin India Committee, many of whom were active in the United States Indo-Irish radical milieu before and/or after the war. He was pursuing virtually identical goals to theirs as well: The German Foreign Office was offering money and arms to potential insurgents in both countries in an attempt to strike at its British enemy from within. Neither effort was successful; both the mutiny attempt by the U.S.-based Ghadar movement in 1915 and the 1916 Rising in Dublin were crushed. Connolly (who like many Ghadarites was executed for his role in the Rising) wrote about the Indian situation in his journal *Harp*, but it was his son who was to have even closer ties to the Indian anticolonial left. After helping to form the Communist Party of Ireland in 1921, Roddy Connolly worked closely with M.N. Roy in Berlin to smuggle political literature into India. O'Malley, *Ireland*, 13–47.

the 1920s was stamped with a fascination for Asian spirituality gleaned from his reading of the Vedas, the Upanishads, the drama of Kalidasa and the poetry of Tagore. For Yeats, explains Lennon, Celticism and Orientalism (and English Romanticism for that matter) were virtually identical in their valorization of all that was antithetical to the drably positivistic, bureaucratic modernity of the British imperial metropole— traits which could then be mobilized into anticolonial as well as aesthetic movements.[48] This Celtic brand of Orientalism was just as selective as any other in its essentialized portrayal of a mystic, sensual, non-rational, rural, pre-industrial East, but with the key difference that the Celtic identified itself with the Oriental instead of casting the latter as the ultimate Other.

This is consistent with Shane's behavior in the story, wherein by adopting the ways and dress of the Indians he rediscovers his own truest self as an Irishman through struggle against British rule. True, O'Seasnain is hardly immune to racial exoticism in his clichéd depictions of Indian characters, or in his apparent presumption that once Shane joined the Indian guerrillas he would somehow automatically become their de facto leader. Nor is his white male point of view as narrator and protagonist fundamentally dislodged. Shane is always the "big soldier," Aparajita his "little rebel." Nevertheless within the story it is she who dictates the terms of the relationship, and she who prods him toward political action to match her own. Though O'Seasnain doesn't seem to have considered the possibility that she could have found in the movement an Indian male partner worthy of her, the omission is dramaturgically logical if his point is Indo-Irish solidarity.

Where Leela Gandhi argued that liberation lay in the ability to love the Other *as* other, and Cama had counseled that one must not love the Other until one could love the self as one loved the other, O'Seasnain

[48] Joseph Lennon, *Irish Orientalism: A Literary and Intellectual History* (Syracuse, NY: Syracuse University Press, 2004), 249, 287, 308–9. On Yeats' Celtic Orientalism, see also Kit Fryatt and Malcolm Sen in Foley and O'Connor; and Kelleher in Holmes; Gauri Vishwanathan, "Ireland, India and the Poetics of Internationalism," *Journal of World History* 15:1 (March 2004), 7–30. Sudipta Kaviraj shows another intertextual angle on Shane and Aparajita's tryst in "Tagore and Transformations in the Ideals of Love" in Francesca Orsini, *Love in South Asia* (Cambridge, 2006).

found liberation in discovering another self where he had thought to find simply an Other. What unites these differing interpretations is perhaps that the most significant divide is not the line between self and other per se, but the one between colonizer and colonized, as the categories wherein the substantive power imbalance lies.

On Eros and Thanatos

It so happened that in Paris, a city crawling with political exiles from around the world, Cama had met someone who might be considered in some ways her Irish counterpart: Maude Gonne MacBride, who lived there between 1903 and 1917.[49] Celebrated as feminist, radical nationalist, Yeats' muse and the object of his own frustrated love, Gonne had once portrayed the title character in the 1902 play *Cathleen ni Houlihan* by Yeats and Lady Augusta Gregory. The personification of an enslaved Ireland, Cathleen appeared on stage first as a fierce old woman demanding the blood of her sons for the redemption of her lost lands, and later as a young queen lauding her martyrs. Substitute Bharat Mata for Houlihan and one might be invoking the rhetoric of the Bengali Swadeshi movement, whose revolutionary acolytes fetishized self-sacrifice while adhering to the *brahmacharya* ideal of chastity.[50]

For Leela Gandhi, a deferral or sublimation of sexuality is one way into the kind of specifically anticolonial political friendship she is looking for.

[49] Gonne also met Subhash Chandra Bose for the first time (but not the last) in Paris, 1914. Her connections to India continued; she later served as president of the Indo-Irish Independence League in Dublin, which she co-founded in 1932 along with Mollie Woods, Charlotte Despard, Tripura Dey, I.K. Yajnik. R.C. Lotvala et al. Its aim was to join forces in anti-British collaboration on both political and economic levels. O'Malley, *Ireland*, 53–85; Bose and Ward in the Holmes volume.

[50] Incidentally the same issue of *Bande Mataram* as the above articles contained some material reprinted from the *Gaelic American*: an article addressed "To the Princes and Nobles of India," and a poem by J.K. Casey entitled "Thou Art Not Conquered Yet (Dear Land)." Built of couplets such as "Mother, thy heart beats proudly still: Thou Art Not Conquered Yet" and "Yet, darling, hold thy flagstaff firm: Thou Art Not Conquered Yet," the poem lamented the cruel snatching of the crown from her "fair head" and vowed to redeem her. *Bande Mataram* 4, 4 (December 1912): 1.

For example, she claims of Edward Carpenter, a faithful friend of India, the origin point of whose opposition to the dominant thought pattern of Victorian/British imperial society she locates in his homosexuality, that it was his socially required sexual "asceticism ... [that] equipped him for the complex affiliative demands of friendship."[51] Invoking Foucault's explanation of Greek askesis, she notes that such behavior expressed less a self-denying austerity than an affirmative ethical and aesthetic pathway to self-mastery, opening up the possibility of other forms of relationality by eliminating the distortions of desire.[52] Gandhi also takes from Foucault the possibility of seeing "sexual evasiveness as a judicious and purposive refusal to collude in the generative economy of power."[53] A certain type of sexual avoidance, she suggests, can then be recuperated as politics; namely as "the prelude for a radical reinvention and reimagining of community, kinship and sociality."[54] Again, at first glance it seems possible to read O'Seasnain in this light: Shane lusts for his dream girl but she forbids flirtation if he wants to be her *friend*, and later insists that their relationship must be that of comrades in anti-systemic struggle. But here too, inferring this type of askesis, while aesthetically tempting, would be something of a misplaced interpretation; context suggests a more tactical approach in practice.

Celibacy and renunciation were a recurrent pattern for Indian revolutionaries, including those of the Swadeshi era (circa 1905–12) contemporaneous with Cama's flowering. Once women began to join the militant ranks in the 1920s, sex between unmarried comrades was strictly forbidden; aside from any vestigial bourgeois prudery, total dedication to the cause no matter what one's gender meant abandoning all other desires. M.K. Gandhi of course was famous for his exercises in the restraint of various bodily appetites. For him as for his Swadeshi predecessors it was a rather yogic matter of channeling vital energies into a "higher" form, haunted by a horror of dissipating or squandering these forces through mere physical fulfillment. To return to Har Dayal: once back in India in 1908, he and the now-pregnant Sundar began living separately from one

[51] Gandhi, *Affective Communities*, 62.
[52] Gandhi, *Affective Communities*, 57–58.
[53] Gandhi, *Affective Communities*, 43.
[54] Ibid.

another, ostensibly because of his renunciation of conjugal and familial affection in favor of life as a political "mendicant agitator"; he claimed that both partners had been inspired by a "spirit of highest idealism" to dedicate their lives to the service of their people, which could most effectively be done apart.[55]

Later, the iconic martyr Bhagat Singh—whose political lineage can be traced directly through the influence of the Ghadar movement—gave a more materialist spin to the celibate's redirection of energy, fleeing marriage as a bourgeois trap to neutralize the revolutionary by binding him to the shackles of familial duty.[56] More charitably, one could see this as unwillingness to subject someone else to the pain and danger that his or her chosen life would bring. But could he not have imagined an Indian female partner who shared his views and commitments? (The question is intended as feminist, not as homophobic.) The auspiciously named Durga Bhabhi was a member of his inner circle, after all. Manmathnath Gupta recalled an incident in which Yashpal, another comrade, was threatened with death for being "more intimate with Prakashwati (not yet married) than the rules of the revolutionary party would allow." Yet it was the *sexual* and not merely the extramarital nature of the relations that was at issue.[57]

Moreover, asceticism and self-sacrifice had been promoted as the ideal for mother, wife and male patriot alike, miraculously recast now as the ultimate in virility prior to M.K. Gandhi's valorization of these traditionally feminized attributes as tools for struggle. Naidu's speech

[55] Emily Brown, *Har Dayal, Hindu Revolutionary and Rationalist* (Tucson: University of Arizona Press, 1975), 51. He never saw his daughter. Decades later, and decades after his last sight of India, he ended his life with a Swedish woman, Agda Erikson.

[56] Son and nephew of avid Ghadar supporters, had he read that group's publication *Rusi Bagion ke Dastaanen*, a hagiography of Russian Narodnik saints, in which many young radicals of both sexes either staged daring escapes or married comrades in arms for convenient show?

[57] Manmathnath Gupta, *Bhagat Singh and His Times* (Delhi: Lipi Prakashan, 1977), 123. Of this incident Radha Kumar (1993, 85) comments that apparently only Yashpal, not Prakashwati, was deemed in need of either punishment or protection from the hazards of sexuality. See also Shalini Sharma, *Radical Politics in Colonial Punjab* (London: Routledge, 2010), 1.

encouraging women's activism at the 1917 Calcutta Congress reminded her listeners of Padmini of Chittor, "one of the most brave and beautiful of Rajput satis" and a popular icon of Hindu women's heroism: "If you die, remember that [her] spirit ... is enshrined within the manhood of India."[58] But Naidu was equating Padmini's avoidance of anticipated rape through suicide to the preemption of invaders' seizing control of the homeland. The heroine's strength and physical courage could only be funnelled into a willed act of self-destruction. Although Aparajita too was ready to give her life, she was no sati; she went down fighting.

Moreover, Shane and Aparajita's deferral of sexual intimacy was not absolute; its projected expiration date would be the day when the task of liberation was realized. For O'Seasnain (as for E.M. Forster: not yet, not now) the deferral of connection was a tragic necessity of the condition of the world, but not in itself essentially enabling or heroic. With victory, all would be consummated: that would be liberation indeed, transposed from the political to the sexual. And yet it seemed that the consummation of this particular form of romanticism was to be found not in domestic bliss but in glorious annihilation. To die for the cause had intrinsic value, and victory for the individual (as opposed to the collective) lay in the immortality of martyrdom.[59] And that too perhaps would be liberation, transposed from the spiritual to the political. I must emphasize that this is not an argument about sublimation, cathexis, or any other such psychoanalytic notion that all displacement of sexuality into art, religion or revolutionary action must be a distorted mask, or a mere superstructure. I would suggest rather that we might see the translation of libidinal energy as manifest through any of these high-intensity modes without a hierarchy of ethical or psychological value. Within the

[58] Kumar, *The History of Doing*, 57.

[59] Compare Bhagat Singh's letter to his codefendant Sukhdev as both awaited execution in 1931: "We were ready to die. Do you mean to say that we were intending to commit suicide? No. Striving and sacrificing one's life for a superior ideal can never be called suicide ... the comrades among us, who believe that they will be awarded death, should await that day patiently when the sentence will be announced and they will be hanged. This death will also be beautiful, but committing suicide—to cut short the life just to avoid some pain—is cowardice." Here transcribed in Chaman Lal (ed.) *Bhagat Singh: The Jail Notebook and Other Writings* (New Delhi: LeftWord, 2007), 143.

"libidinal economy"[60] of this context, to use Leela Gandhi's term, the valuation was reversed.

Finally, while similar to Aparajita's moratorium on romantic love until political liberation was attained, Cama's own moratorium on inter-racial romance was urged on the grounds that it would forestall the emergence of just such college-educated radicals as Aparajita herself, an Indian woman capable of serving as her partner's political conscience and relationship pacesetter. To be together then, star-crossed or racially divided lovers needed not an escape but a systemic transformation.

Conclusions

I originally assumed that my encounter with these two documents—each expressing a similar aspiration in its own mode and moment—would involve restoring the presence of women to a narrative from which it seemed they were continually disappearing, along with an awareness of gender as an analytic; while simultaneously fleshing out some substantiation for theories of an emancipatory cosmopolitanism as manifested through relationships personal and political. But as with the India discovered by Shane O'Neill, what I found beneath the surface escaped this expectation. In O'Seasnain's specimen of Irish republican Orientalism written for an Indian internationalist magazine in New York (incidentally just three months after women had won the right to vote in the United States),[61] we see illustrated on the one hand the strong sense of

[60] Gandhi, *Affective Communities*, 35.

[61] There were also overlaps between the Indian independence movement and the British movement for women's suffrage. Living in England, Punjabi aristocrat Sophia Duleep Singh was dedicated to the suffrage struggle via the Women's Social and Political Union and Women's Tax Resistance League and Suffragette Fellowship from the early twentieth century until her death in 1948 (Vizram, 162–68). Gandhi was a supporter of the Pankhursts' feminist tactics, and Irish republican and suffragist Charlotte Despard collaborated with Indian revolutionists from the days of Krishnavarma's India House to the days of the interwar communist turn, the League Against Imperialism and the Indian-Independence League: see also note 49. (Visram, *Asians in Britain*, 151, 163, 308; O'Malley, *Ireland, India and Empire*, 26, 39–47, 63–76.)

Indo-Irish equivalence that furthered the practice of cosmopolitanism even while contradicting its philosophical underpinnings. On the other hand we can perceive the principled redirection of romantic love toward and through revolution; if love were to be an anticolonial act, it had to expand beyond individualized desire and gratification.

But such a channeling could serve a function of sexual liberation only insofar as both men and women were freely able to enact the transformation. In theory at least, if men under Gandhian influence could "feminize" their activism through transforming khadi-spinning and moral forbearance into radical acts, while at the same time women could become militants in the classical guerrilla mold, then the question would no longer be which of two differently gendered models of resistant subjectivity to valorize. Rather, the debate could shift into a *potentially* gender-neutral political register encompassing a range of tactical and ideological differences distributed among both men and women, as both modes became androgynous.[62]

This would require a change in women's real social conditions such as Cama demanded and worked for, as well as a change in emphasis within the nationalist iconography. Miss Aparajita portrayed the familiar trope of a woman as soul of the nation, its patron goddess, but not in the form of a passive yet insatiable mother demanding the sacrifice of her sons' blood, the old sow that eats her farrow. Here she was the warrior maiden who had renounced domesticity and motherhood, actively goading the male revolutionary to join her as an equal. Cama's own persona somewhat bridged the two. But while Aparajita did have real-life precedents and contemporaries who would have been known to those active in the revolutionary movement abroad,[63] a decade remained

[62] On Gandhi, gender, and sexuality, see Ashis Nandy, *The Intimate Enemy* (Delhi: Oxford University Press, 1983); Joseph Alter, *Gandhi's Body: Sex, Diet, and the Politics of Nationalism* (Philadelphia: University of Pennsylvania Press, 2000); Lloyd Rudolph and Susanne Hoeber Rudolph, *Postmodern Gandhi and Other Essays* (Chicago: University of Chicago Press, 2006).

[63] For example, there was Ms Perin Naoroji, granddaughter of the great Dadabhai, born in 1890 and educated in London and Paris. Since Perin's boarding house was down the street from chez Cama, intelligence guessed the girl had "no doubt learned politics from her." By March 1910 she was reported to be "working hard in the Extremist ranks" beside Cama, Chattopadhyaya,

before her younger sisters would appear under the banner of the Indian Republican Army, Chittagong Branch, timing their famous armory raid of 1930 to commemorate the Dublin Easter Rising. Guerrilla-trained Preetilata Wadedar later died in action; other female militants spent years in prison.[64] As active militants, they were explicitly portrayed as a new romantic ideal: P.C. Joshi said of these women in his preface to their published narratives, "to read them is to fall in love with them all, to deepen our own patriotism and get greater faith in the destiny of our ancient country."[65] Would Cama approve? And what story, I wonder, would O'Seasnain have spun from that?

Har Dayal and the rest, and even being tutored in bombmaking by W. Bromjevski, "a young Polish engineer, ... who visited her and her sister constantly at their flat for months." The sisters returned to India at the end of the year but remained in communication with Cama, via ciphered messages. History sheet in P.N. Chopra, *Indian Freedom Fighters Abroad: Secret British Intelligence Report* (New Delhi: Criterion Publications, 1988), 112.

[64] See Kumar, 85–91; Kalpana Dutt, *Chittagong Armoury Raiders: Reminiscences* (Bombay: People's Publishing House,1945); Manini Chatterji, "1930: Turning Point in Participation of Women in the Freedom Struggle," *Social Scientist* 29: 7, 8 (July/August 2001): 39–47. Wadedar died after taking cyanide to avoid capture while escaping from an ambush on a meeting of revolutionists. In 1922 Bina Das and her sister Kalpini started a revolutionary group and safe house at their mother's hostel and attempted to shoot the governor of Bengal. Shanti Ghosh and Suniti Chaudhri were transported for life for shooting a British official in 1931.

[65] Kalpana Dutt, *Chittagong Armoury Raiders: Reminiscences* (Bombay: People's Publishing House, 1945), 3.

6

International Utopia and National Discipline: Youth and Volunteer Movements in Interwar South Asia

Franziska Roy

In August 1928, a "World Youth Peace Congress" (WYPC) was held at Eerde in the Netherlands. The grounds at Eerde belonged to no other than Jidu Krishnamurti, the Indian boy proclaimed to be the next messiah by the Theosophical Society. The Congress took place just after Krishnamurti's "Star Camp" for youth (held under the auspices of his Order of the Star of the East), which the young messiah intended to be a true League of Nations as the members of the real League were naught but an "insincere and money grubbing lot of people."[1] The WYPC took

[1] See Roland Vernon, *Star in the East. Krishnamurti, the Invention of a Messiah* (New York: Palgrave, 2001), 100–1. On the background and history of the grounds at Eerde which were given to Krishnamurti as a gift see also ibid, 142–43, 176 ff., 180–84.

place with approximately 150 youth from 27 different youth organizations claiming to represent some 32 nations and more than 100,000 young people.[2] The WYPC traced its own origins to a mixture of the ideals of the romanticist back-to-nature *Wandervogel* movement that had been so prominent in Germany, the disillusionment with politics among youth following the Great War and the urgent need to establish a "world brotherhood" of man to ward off another world war in the future.[3]

A number of India delegates took part as well. One of them was the Bengali Congressmen Dr Nalinaksha Sanyal,[4] who was voted to be the spokesman of the oppressed peoples at this conference. In a detailed report sent back to the Indian National Congress (INC) he outlined his and the WYPC's engagements with the problems of peace, world brotherhood and the destiny of youth in building a more stable future with equality and justice for all. He also wrote with verve about the effortlessly innocent and physically healthy nature of European nudism.[5] His speech at the conference itself was an exposition on the horrendous plunder and poverty of India with the lesson that to ensure freedom and peace in the world, imperialism, and its underlying mechanism—capitalism—had to be abolished wholesale. Capitalism in the "west" destroyed the very fabric of society by denying the "social value of man." Sanyal called for the removal of any and all exploitation of the individual, a task to be accomplished by the youth of the world since the League of Nations—and here he echoed Krishnamurti's popular

[2] The Congress was organised by a conglomerate of groups, not least the British Federation of Youth. See Harold F. Bing, "British Youth and India," *The Young Liberator*, 1, 8 (April 1929), 276–80, see esp. 278.

[3] See "General report," World Youth Peace Congress, Eerde, August 16–26, 1928, by Nalinaksha Sanyal, in Nehru Memorial Museum and Library, New Delhi [NMML], All-India Congress Committee papers [AICC], F O-3, 1928, ff. 181–203.

[4] Sanyal was born 1898 and had studied at Presidency College, Calcutta and obtained a Ph.D. in Economics from LSE, London. While in London, he was a member of the foreign branch of the INC. He was a member of the Bengal Assembly and served as whip of the INC before the partition of Bengal.

[5] See "General report," World Youth Peace Congress, Eerde, August 16–26, 1928, by Nalinaksha Sanyal, NMML, AICC, F O-3, 1928, ff. 181–203.

sentiment—was nothing but a conference of "pirates."[6] Referring to the various political strands present and discussed at the WYPC from anarchists, anti-militarists, social democrats to "Physiocrats," he selected communism as the only practical and experimentally tested answer to the world's problems. But communism failed to inspire his heart as it had no place for family and love, and the dictatorship of the proletariat did not, to him, seem like a recipe for peace everlasting. Sanyal proclaimed that he was still holding on to Gandhism and non-violence by dint of his own stout-heartedness. But whether it would be Gandhism or communism for an India of the future depended on none but the youth of the world.

Less than two years later, the same Dr Sanyal gave a speech at the Murshidabad Youth Conference in Bengal in which he called on the youth movement to not join the INC as all the people of the land had not joined the latter. The youth movement should instead form

> into such a great and powerful association, where it would be possible for all to work unitedly. There would be no party faction or difference of opinion in it. Its object would be to create a new society and a new country. It is not only that before its force the British power would only bow down but before it all the political and economic inequalities would be removed. As destruction and construction would be the object of the youth movement, so its object would be to go against the "tradition."

The political movement of India was really an "all-world problem," and an intrinsic part of the "freedom movement that is going on all the world over." India's freedom struggle added to that colossal movement and in turn depended upon it. He stated further:

> Those who have youth in them, want to create[,] and this object is not to make them suitable to the present time. They are thought of as mad people and in a sense those who did some work for the world were all mad men. Among the examples he cited were Buddha, Sankaracharya, Shivaji, Lenin, Mussolini and Sun Yat-Sen. People called them mad men but due to the madness they gave to the world new things which were very much appreciated.[7]

[6] "India and the World Youth" (Speech of Dr Sanyal at the Eerde Conference, August 19, 1928), NMML, AICC, G-39, 1928, ff. 284–303.

[7] Dr Sanyal, review of speech given at Murshidabad Youth Conference, January 19, 1930, in West Bengal State Archives [WBSA], IB branch, file 271-C/ 28.

This short narrative highlights the intricately interwoven nature of nationalism and internationalism, references to which were ubiquitous at the time.[8] It also points to some of the contradictions of the international youth movement and the fluid nature of its actors' engagements—such as Sanyal citing the need for eternal peace while admiring Mussolini. This essay will provide a brief outline of important trends within the Indian youth movement(s) at the height of the "internationalist moment" and its connections with issues of mass mobilization during the anticolonial struggle by focusing on the "mainstream" and the orbit of the Congress' youth corps, the Hindustani Seva Dal (Indian Service army/organization), and point to other groups that, like the Dal, could be described as paramilitary organizations—a term that will be explored next.

The (albeit selective) international engagements of Indian nationalists points to what might be described as a common grammar of politics linked to a contemporaneous weltanschauung, which was shared by actors from a variety of backgrounds, and cuts across specific ideologies. This is not to negate in any way the important differences in political outlook. It is rather an attempt to examine deeper structures and an implicit consensus among actors with diverging (a)political opinions about the necessary structure of mobilization and organization to bring about progress—the"progress"of nation-states, but also of humanity by and large. It is worthwhile to engage with this sphere of ideas within their own contemporaneous horizon and highlight its fuzzy edges and fluid nature. Seen from a post-1939 perspective, some of its elements—namely eugenics, social Darwinism, and a romanticist and organicist rendering of the nation—can all too easily be seen as an intrinsic part of a process that culminated in fascism which has, understandably, become something like the black hole at the center of historiographical debates about this period. It is as important to analyze the pieces of the puzzle that fed into an emerging fascist nexus as it is to pay careful attention to the ruptures or elements that were shared by other -isms of the time.

[8] See, for instance, "Report of the secretary of the Student's Organising Committee" of the All Bengal Students' Association [established in 1928], dt September 9, 1928, in NMML, AICC, G-39, 1928, ff. 271–76, see esp. f. 272, and the programme at f. 276.

Youth and volunteer movements with paramilitary characteristics were—in South Asia as elsewhere at the time—spread across the political and social board. By "paramilitary" I mean groups whose internal organizations was clearly modeled on the armed forces, who highlighted the importance of physical fitness and practiced drill (including military drill) and who, propelled by a more or less explicit anticolonialism, sought to take over state functions such as keeping order and preserving the peace internally, or to defend the country against external foes. If we go by this definition, we find that in India at the time, virtually every organization—be it political party, social or religious body—cultivated a (semi-)paramilitary volunteer wing typically aimed at youth. With the dawn of mass politics, it became a necessity to have volunteers— and volunteers appeared in uniform, were described as *sepoys* or *sipahis* (soldiers) or *sainiks* (fighters), they were organized into battalions and companies, they had "commanders" and "dictators," they were almost always trained and drilled and often armed. That, at least, was the ideal, even though in practice these groups often fell short of the millenarian roles leaders claimed for them. Nevertheless, their practical importance should not be underestimated. More importantly, for the period under consideration, they served as objects to be mobilized by leaders as well as tools of mobilization for "the masses," and they functioned as laboratories to test out and implement visions of the nation and the perfect citizen on a small scale.

For one reason or the other, hardly any of these groups have been considered in any seriousness by historians (the notable exception being the Hindu-nationalist and revivalist Rashtriya Swayam Sevak Sangh [RSS]—though even here we find gaping holes beyond the level of ideology and the upper echelons of the organization).[9] Typically these movements were centered on urban areas and drew most of their members from there, but some groups managed to build a village network in urban hinterlands through training activities. This was especially true for the RSS which was seen as the youth group of the Hindu revivalist

[9] On the earlier history of the RSS, see especially Walter K. Andersen's 4-part series, "The Rashtriya Swayamsevak Sangh," *Economic and Political Weekly,* 7, 11 (1972), 589–97; 633–40; 673–82; 724–27.

Hindu Mahasabha, and to some degree the Khudai Khidmatgaran, better known as the "Red Shirts" of the North Western Frontier Province who were aligned with the INC managed to build a village network in urban hinterlands through training activities. Some of them recruited chiefly among a lower urban middle class that was entering the political arena[10] (a good example are the Khaksars who had a knack for staging martial spectacles drew those sections to themselves that were not represented by the rather elite Muslim League. But the latter started a youth group of its own, the Muslim National Guards, in the late 1930s).

Youth: Its Meaning(s) and Uses in British India

Youth as a relevant category entered the Indian arena around the same time as it did in the colonial metropole—an entangled development that became successively more important from just after the turn of the twentieth century.[11] An imagined "youth," national reinvigoration and "nation-building" were linked in many countries of the period. But "youth" and "young" in the stricter sense do not denote the same phenomenon. Biological notions of who could be a "youth" were intertwined with the sociopolitical functions of the category and remained so despite more concrete definitions available in the scientific or academic literature of the time.[12] Official correspondence shows

[10] See on this phenomenon Nandini Gooptu, *The Politics of the Urban Poor in Early Twentieth-century India*, Cambridge/New York: Cambridge University Press, 2001. Different groups, of course, had different recruitment pools depending on local socioeconomic circumstance, but we do not have time here to go into details.

[11] For details on this, see Franziska Roy, "The Torchbearers of Progress: Youth, Volunteer Organisations and National Discipline in India, c. 1918–47" (Ph.D., University of Warwick, 2013), see introduction and Chapter 1.

[12] The American philosopher-turned-psychologist, Stanley Hall, studied the effects of adolescence based on the entry into puberty and along with the outer markers—caused by physiological changes—he noted the peculiarities of this stage as craving excitement or "intense states" of mind and passion (see below).

just how interchangeable the idea of "youth" and volunteers became by the 1920s:

> The Government of India understands that its [youth movements] external manifestations are for the most part to be found in the activities of the volunteers. These devote special attention to physical culture, exhibition of feats of strength, *lathi* play, and so on.[13]

Youth as a particular phase in life is as yet unsettled, partly because it is at times defined as the phase prior to earning a livelihood and is (usually) not burdened by responsibilities for family maintenance etc.[14] Commonly, members of volunteer organizations were supposed to be between 16 (or 18) and 30 years of age with bachelorhood (or even *brahmacharaya* in the case of Congress and Hindu organzitaions) being the unspoken ideal. Widespread academic unemployment certainly was feeding into the prolonging of the youthful stage too.[15] In this respect, young people seemed clearly to have been the"ideal volunteer"as far as organizations were concerned. The Seva Dal is a prime example here. The obligatory pledge of the Congress volunteers stated that: "In the event of my imprisonment I shall not claim from the Congress any

Cf. Stanley G. Hall, *Adolescence: Its Psychology and its Relations to Physiology, Anthropology, Sociology, Sex, Crime, Religion and Education*, Vol. 2 (New York: D. Appleton and Co., 1904) 69–75.

[13] National Archives of India (NAI), Government of India (GoI), Home Dept., Political, 212/30, 1930, f.7

[14] A definition of youth that was and still is influential in the social science is the one epitomized in the definition of Charlotte Bühler from 1933: Youth is an in-between period beginning with the achievement of physiological maturity and ending with the acquisition of social maturity, that is with the assumption of the social, sexual, economic, and legal rights and duties of the adult. Charlotte Bühler, *Der menschliche Lebenslauf als psychologisches Problem*, second compl. rev. ed. 1959, Verlag f. Psych. Göttingen, quoted after Marie Jahoda and Neil Warren, "The Myths of Youth," *Sociology of Education* 38, 2 (Winter, 1965), 138.

[15] Cf. the competition for participating in the World Youth delegation in India was open to people up to 30 years of age, cf. Nehru Memorial Museum and Library [NMML], AICC papers, FD-10, I, f. 59.

support for my family or dependants."[16] As of 1931, volunteers were further asked to sign up for a number of years and they had to pledge their willingness to go traveling or take residence in any part of India that the Seva Dal might desire them to.[17] This was hardly an option for those with dependants, especially since such activities were honorary or came with a small stipend only.

As regards the normative horizon of "youth," the term functioned as a signifier, irrespective of the actual age of the individuals concerned, that referred to particular attributes which included energy, (physical) vigor, bravery, zeal, a broad outlook or "world-mindedness," desire for (national) renewal and change, purity of intent, but also passion, lack of self-control, a volatile temper, malleability, a tendency to violence and impatience. A number of actors proclaimed loudly that no "youth" could be considered truly "young" if he did not exhibit these characteristics.[18] Youth had already been associated with notions of virility and war in eighteenth-century France, and this proved to be a lasting association.[19] Thus, "youth" was a constructed, relational and metaphysical super-category for the active and politicized layers of society which departed from accepted, political frameworks.[20] Youth was to be feared and celebrated because it deviated from norms of social behavior demanded by the status quo. As such, youth and contemporaneous ideas of modernity

[16] Resolution I of 36th annual Congress session, Ahmedabad, December 31, 1921, cited from: NMML, AICC papers, F. No. 70 Pt I, 1946–47, f. 13.

[17] NMML, AICC papers, F.No. 8, 10/1931, f. 5.

[18] See, for instance, B.S. Moonje especially during his speech January 2 and 3, 1934 addressing the virtues and faults, merits and demerits of youth as a phase in life but more than that as a defined phase as a quality and outlook. See NMML, B.S. Moonje Papers, Subject File 41, see esp. ff. 49–50.

[19] See, for instance, Sabina Lorgia, "The Military Experience," in *A History of Young People, Vol. II: Stormy Evolution to Modern Times*, eds Giovanni Levi and Jean-Claude Schmitt (Cambridge, MA: Harvard University Press), 11–36, who traces the rise of notions of fitness and virility with regard to youth and its association with war in late eighteenth-century France and the Napoleonic Wars. See esp. ibid., 32–36.

[20] Partha Chatterjee, "Beyond the Nation or Within," *Social Text*, 36 (1989): 57–69.

(or with Lefebvre: modernism[21]) were closely linked with youth form-
ing the corporeal link between present and (possible) future(s),[22] utopia
or dystopia and progress in a unique way and thus it functioned also a
metaphor for the awareness of contingency that is one of the hallmarks
of the"modern"mindset.

The widely held dreams (and nightmares) of the period tapped into
desires for utopian change,[23] for a meaningful collective destined for
a preordained task in a world that looked increasingly uncertain. The
yearning for a (semi-)mythical apotheosis that would catapult the self
and the collective—or humanity itself—into a higher state aligned with
universal progress held sway. Appeals to history, science, and scientific
history were integral to the ideologies of the volunteer movements with
its striving for discipline and societal betterment. In the later nineteenth
and early twentieth century, utilitarian thought along with the positivist
scientism[24] were intermingled with symbols and beliefs of a millenarian

[21] See on the distinction between modernity and modernism, Henri Lefebvre,
Introduction to Modernity. Twelve Preludes, September 1959 to May 1961
(London/New York: Verso, 1995), 1–2, where modernism is described as an
awareness and fashion marked by a triumphant mindset and certainty; whereas
modernity is a social phenomenon characterised by uncertainty and reflexivity
accompanied by a certain mode of critique.

[22] See Joseph M. Hawes and N. Ray Hiner, "Hidden in Plain View: The
History of Children (and Childhood) in the Twenty-First Century," *The Journal
of the History of Childhood and Youth*, 1, 1 (2008): 43–49.

[23] Utopian change seemed not only possible but inevitable to many at this
juncture, see, for instance, Subhas Chandra Bose, Speech at the Uttar Pradesh
Naujawan Bharat Sabha, Mathura, May 23, 1931, [http://subhaschandrabose.
org/speechContent.php?id=YWJlcmFzaWJvKDQpZmlyZQ##, retrieved August
5, 2012].

[24] See Arendt's pertinent analysis of the rise and success of positivism in
the context of bourgeoisie notions of the state and society and what this meant
for the science of history, Hannah Arendt, *The Origins of Totalitarianism* (San
Diego/New York/London: Harcourt Brace & Co., 1979) 170–84. On positivism
in India, Geraldine Forbes, *Positivism in Bengal: A Case Study in the Transmis-
sion and Assimilation of an Ideology*, Calcutta: Papyrus, 1999 (Calcutta: Minerva,
1975) and Dhruv Raina and Irfan S. Habib, "The Moral Legitimation of Modern
Science: Bhadralok Reflections on Theories of Evolution," *Social Studies of Sci-
ence*, 26, 1 (1996), 9–42.

mysticism as well as an evolutionary determinism that pervaded percep-
tions of the linearity of history in India (and elsewhere).[25] The period
was, thus, marked by models of linear progress with Herbert Spencer
and Marx being two political poles within this discursive formation.

From the perspective of the meta-historical debates of the early
twentieth century, among ideologues and activists, both deterministic
(Darwinist and structuralist explanations) and voluntaristic (Lamarckian
and idealistic) ideas of societal and individual developments were articu-
lated and mixed up, resulting in a highly amorphous social Darwinism[26]
and ideals about a "new man" that eclectically combined elements of
positivist notions of science, utilitarianism, Spencer, the Nietzschean
superman,[27] Malthusianism, Theosophy (proposing an alternative self-
willed model to Darwinian evolutionary theory), spiritualism (sometimes

[25] The understanding of history as a science and the revelation of certain
structures and laws has of course, a much longer history. See Michael Bentley,
"The Turn Towards 'Science': Historians Delivering Untheorized Truth" in *The
Sage Handbook of Historical Theory*, eds Nancy Parker and Sarah Foot (London:
SAGE), 10–22; see also the classic R.G. Collingwood, *The Idea of History*
(London: OUP, 1956 (1st ed. 1946)) 126–33 on positivism and history, see Ibid.,
93–126 for the former "romantic" notions of history (from Fichte to Hegel).

[26] On a common sphere of ideas that was well developed in Victorian Britain
by the time Darwin and Russell made their discoveries about the principles of
evolution, see Gregory Claeys, "The Survival of the Fittest and the Origins of
Social Darwinism," *Journal of the History of Ideas* 61, 2 (2000): 223–40. There is
an abundance of writing on Social Darwinism and the underlying principles and
varied applications. See especially Mark Singleton "Yoga, Eugenics, and Spiritual
Darwinism in the Early Twentieth Century," *International Journal of Hindu
Studies*, 11, 2 (2007): 125–46. On the appreciation of Herbert Spencer by certain
nationalist leaders, see also Shruti Kapila, "Self, Spencer and Swaraj: Nationalist
Thought and Critiques of Liberalism, 1890–1920," *Modern Intellectual History*
4, 1 (2007):109–27.

[27] The most emotive evocation of the Superman is in Nietzsche's *Also Sprach
Zarathustra;* see also his *Menschliches, Allzumenschliches.* The Superman in
Nietzsche has a biological and a moral dimension he is a trans-humanly self-
evolved subject with capabilities beyond that of ordinary man. On other, including
biologistic and eugenic, notions of the development of the new "Herrenmensch,"
see Rüdiger Safranski, *Nietzsche: Biographie seines Denkens* (München/Wien:
Hanser, 2000), 266. See also Werner Ross, *Der ängstliche Adler: Friedrich
Nietzsches Leben* (München: DTV, 1999) (4th ed.), 657–729. On the question of

with a pacifist slant) more generally, and liberal humanism—to name some of the strands making for the remarkable array of ideas that constituted the"popular political imagination"[28] of the time and manifested itself as the political common sense—which does not constitute a different epistemological order as such but partakes of the contemporary discourse(s).

Some scholars have engaged with this nexus in recent years—from a "spiritual Darwinism" to what we might (with Nietzsche) call the "physiology of morality."[29] Starting from the notion that eugenics, Nietzscheanism and Darwinism formed a cluster of ideas that were "highly malleable cultural ideologies" that were "intertwined in popular thought and practice and called into the service of sharply divergent social and political enterprises,"[30] I would suggest that it was this nexus that informed not only the prevailing discourse but also, and much more tangibly, the practice of many of the youth movements in British India at the time.

Young Cosmopolitanism

It is now widely acknowledged that rhetoric and practices in the colonies (as elsewhere in the world) are to some extent derivative without simply

Nietzsche as Social Darwinist or anti-Darwinist, see Gregory Moore, *Nietzsche, Biology, and Metaphor* (Cambridge et al: CUP, 2002), see esp. 21–55.

[28] On a popular imagination of the Indian state and how to study such a phenomenon, see Sudipta Kaviraj, "On the Enchantment of the State: Indian Thought on the Role of the State in the Narrative of Modernity," *European Journal of Sociology*, 46, 2 (2005): 263–96, see esp. 263–64.

[29] See Singleton, *"Yoga, Eugenics, and Spiritual Darwinism,"* 125–46; Joseph Alter, *The Wrestler's Body. Identity and Ideology in North India* (Delhi: Manohar, 1992); Carey Watt, *Serving the Nation. Cult of Service, Association, and Citizenship in Colonial India* (New Delhi: OUP, 2005), and his earlier "Education for National Efficiency: Constructive Nationalism in North India," 1909–1916, *Modern Asian Studies* 31 (1997): 339–74. Bernd Markus Daechsel, "Faith, Unity, Discipline": The Making of a Socio-political Formation in Urban India—Lahore 1935–1953" [Ph.D. thesis, Royal Holloway, 2001]. See also the book based on the Ph.D., *The Politics of Self-Expression: The Urdu Middle-class Milieu in Mid-twentieth Century India and Pakistan* (London/New York: Routledge, 2006).

[30] Singleton, *Yoga, Eugenics and Social Darwinism,* 125.

mimicking those in the "metropole": the zeitgeist influences colonies and metropole, center and periphery alike but manifests itself differently in a particular locality, varying according to a specific context. This does not negate the power structures involved. Certain ideals and traditions were, indeed, heavily influenced by reactions to the British "civilizing mission" and, for instance, ideals of "manliness" drew heavily on Victorian values and "muscular Christianity." On the other hand, the very notions of a certain type of masculinity in Britain were linked to and took shape in the context of the imperial enterprise itself.[31]

The recent historiography, albeit acknowledging this mutual influence between metropole and colony, still tends to circle around engagements "in the shadow" of the Empire rather than seeing Empire as just one framework and mental map for actors to draw upon (though undoubtedly a compelling and immediate one). When looking at the world in the interbellum period of 1919–39 we are indeed looking at a period that some, keeping in line with the tides of historiographical fashion, might term "cosmopolitan." The problem with such a description is the overarching positive normative connotation that often forms the very basis of its definition. It is conceived of as an antidote and alternative to an aggressive (ethnic, cultural) nationalism or communitarianism on the one hand and "particularistic multiculturalism" on the other.[32] The paradox we are facing is that this kind of cosmopolitanism

[31] Mrinalini Sinha, *Colonial Masculinity: The "Manly Englishman" and the "Effeminate Bengali" in the Late Nineteenth Century* (Manchester: Manchester University Press, 1995). Donald E. Hall, *Muscular Christianity: Embodying the Victorian Age* (Cambridge/New York: CUP, 1994); John MacAloon, *Muscular Christianity in Colonial and Post-colonial World* (London/New York: Routledge, 2008); and Gerald Studdert-Kennedy, *Dog-Collar Democracy: The Industrial Christian Fellowship, 1919–1929* (London: Macmillan Press, 1982). For South Asia, also see Studdert-Kennedy's *British Christians, Indian Nationalists, and the Raj* (Delhi/New York: OUP, 1991); Charu Gupta, "Articulating Hindu Masculinity and Femininity: 'Shuddhi' and 'Sangathan' Movements in United Provinces in the 1920s," *Economic and Political Weekly* 33, 13 (1998), 727–35; Harald Fischer-Tiné, *Der Gurukul-Kangri oder die Erziehung der Arya-Nation* (Stuttgart: Steiner, 2003).

[32] Steven Vertovec and Robin Cohen, "Introduction: Conceiving Cosmopolitanism," in *Conceiving Cosmopolitanism. Theory, Context and Practice*, eds idem (Oxford: OUP, 2008).

cannot be analyzed in terms of social history or practice—the moment we attempt that, it becomes what David Harvey called "hyphenated cosmopolitanisms" or, in fact, modes that might not be easily brought in line with the idealistic notions of the proponents of cosmopolitanism.[33]

I here consciously overstretch the term "cosmopolitanism" by suggesting a framework of a "social Darwinistic cosmopolitanism" that was prevalent in the late nineteenth and early twentieth centuries. The practical engagements with this nebulous sphere of ideas as well as its universalist claim on the basis of a supposed "natural law" (in this case the law of the stronger) can be viewed as a dynamic link of various actors and movements. My point here is not that social Darwinism was a global phenomenon (which is obvious) but that we might be able to explain some of the seemingly contradictory ideological formations and trajectories of actors by locating a common grammar that was shared by various outlooks before and beyond their divergent political paths. An actually existing (positive) "cosmopolitanism" might be ascribed to actors who saw the interconnectedness of global developments in the period after the First World War as necessitating solidarity at a time when disarmament and preserving future peace by cross-cultural understanding and tolerance were immediate concerns. But these concerns often went hand in hand (even in the case of the very same actors) with concepts about national uplift and "regeneration" through social engineering of a eugenic type, the "struggle for existence" (dating back to Malthus), wherein groups deemed "fit" according to differing criteria would develop and progress, while the "unfit" ones would stagnate and ultimately perish, the goal being the successive progression to a more advanced social type.[34] This, again, went hand in hand with ethical conclusions from (social) Darwinism which stressed the need for individuals to sacrifice themselves for the sake of the collective (a type of co-operative social Darwinism that was closer to Darwin's own heart).[35]

[33] David Harvey, "Cosmopolitanism and the Banality of Geographical Evils," *Public Culture* 12, 2 (2000): 529–64, see esp. pp. 529–31.

[34] Claeys, *The Survival of the Fittest*, 223–40.

[35] For the distinction between Malthusianism and Darwinism, see, for instance, Gregory Moore, "Nietzsche, Spencer, and the Ethics of Evolution," *The Journal of Nietzsche Studies* 23 (2002): 1–20, esp. 1–2.

In the popular imagination in South Asia these notions mingled and formed the backdrop to a variety of discussions about the future of "young India."[36]

Why is it then important to identify an interwar "moment" when many of the ideas were currents in deeper intellectual structures dating back to the nineteenth century? The sphere of ideas talked about became more manifest around and after the time of the First World War. The postwar era witnessed the first serious attempts at mass mobilization in the South Asian context. Hence, questions about social set-up and organization, citizenship and the shape of the projected independent nation (after the rhetoric of the Montagu–Chelmsford Reforms) were of more immediate concern in the national arena. At the same time, the actual international engagements intensified.

Youth Will Build the Future[37]

The importance given to youth in a variety of contexts (and with a variety of motifs) can be gleaned exemplarily from a semi-official U.S. endeavor: in 1936, U.S. executives with an advisory committee prepared the "World Youth Tour," which was to have delegates from various countries to tour countries from Brazil to China and "study and discuss in public meetings pertinent economic problems." It went on: "The future belongs to the youth of to-day and they must bear the burden of the world."[38] The same

[36] Sarah Hodges had earlier noted that "most social and political debates in India were informed and energised by eugenic thinking," without this being in any way an indication of a particular political trend. See Sarah Hodges, "Indian Eugenics in an Age of Reform," in *Reproductive Health in India*, ed. idem (New Delhi: Orient Longman, 2006), 115–38.

[37] Proverb in the World Youth movement, cf. article on "The World Youth Congress, 1928" by Harold, F. Bing, in *Youth—The Magazine of the British Federation of Youth*, in NMML, AICC papers, F.No. O–3, 1928, f. 213.

[38] Leaflet: "World Youth Tour," in NMML, FD-10, Pt.I/ 1936, for the quote cf. f. 140. The United States of course faced export problem and slumps in the economic market, and the threat of war due to economic issues was perceived by many observers. One might see the whole endeavour as that of an early International Relations think tank. See NMML, FD-10, Pt.I/ 1936.

year, Jawaharlal Nehru announced to the"Canadian Youth Congress":
"It is right that youth, which is not hide-bound and tied down to the
ancient ruts, should consider the problems that encompass us and try
to find ways of solving them."[39] Nehru himself was perceived, mainly, as
a "youth leader,"and his focus of activity in the 1920s justifies this.[40] In
1928, he had proclaimed: "I believe in Youth Movements so much that I
am prepared to sacrifice all other work to the organisation of youths in
India."[41] The socialist Nehru, one of the few who criticized fascism early
on, still could call on youth to adapt what he called the "fascist motto"
of "live dangerously" while simultaneously evoking a "commonwealth of
empire of youths."[42]

"The youths" themselves seemed quite ready to accept the impor-
tance, avant-gardism and status accorded to them.[43] As we have already
seen in the example of Dr Sanyal at the WYPC, there was a marked
degree of generational conflict that played into the importance of youth
too—the notions of solidarity among youth for a better future was seam-
lessly connected to a turning away from the "old,"everything represent-
ing the stark boundaries, cynicism, and political maneuvering that had

[39] NMML, AICC papers, FD-10, Pt.I/ 1936, f. 211.

[40] Smedley, Agnes, *Battle Hymn of China* (London: Victor Gollancz Ltd.,
1944), 23. Nehru and SC Bose were very much perceived as the new generation
of leaders who built their strength on the discontent of a young, educated
generation with the Congress "talking club."

[41] Jawaharlal Nehru to K. Venkatachari, Genl Secy Indian Youth Congress,
and Secy, Young India Party, Madras, March 28, 1928, in NMML, AICC papers,
F.No. O – 3, 1928, f. 65. Later that year, Nehru became President of the All India
Youth Congress.

[42] Nehru, speech at Students' Conference at Shraddhanand Park, Calcutta,
September 22, 1928, in Durlab Singh (ed.), *To the Youth of my Country: Being
the Survey of the History of the Youth Movement in India as Expounded in their
Addresses by Subhas Chandra Bose, Jawaharlal Nehru, Sarat Chandra Bose, K.F.
Nariman, Kamla Devi Chattopadhya, T.L. Vaswani, Dr Raman, Mr Sanyal and
Other Youth Leaders* (Lahore: Hero Publications, 1946), 90.

[43] There are countless examples of the grandiloquence exhibited on student
and youth platforms in the 1920s and 30s. For some examples, see as follows.
See, for instance, Anila Das Gupta, Chair Woman's Address, All Bengal Students
Conference, 1936, in NMML, FD-10, Pt.II, ff. 350, 349, respectively.

led to the Great War, the Treaty of Versailles, the Depression and that would, if not overcome, lead to further wars.[44]

Generally, almost all youth and volunteer movements had some form of paramilitary organization, as mentioned above, and it was this feature that had the Government of India perpetually worried about adolescents parading on the streets in what looked like official police or military uniforms, and numerous bans and restrictions were implemented with regard to this. The surveillance, bans and restrictions imposed by local or central government contributed to organizations claiming that they were "purely social" or "purely religious" if there was no direct party affilia-tion (as the RSS and the Khaksars were wont to do). These claims should not lead one to think they did not on the ground engage with politics or parties.[45] But the free mixing of political engagement and "purely social" uplift has another dimension as well: Given the widespread concern about necessary inner reform before outward political reform could be achieved, politics and personal morals were collapsed into each other, and it is futile to try and distinguish the "political" from the "social" too closely.

Social uplift generally, and the youth movement(s) in particular, were envisioned by most of its apostles as something supra-political—again something that becomes clear from the speech by Dr Sanyal at Murshidabad. They were imagined as the materialized form of an eternal ideal of youth symbolizing the metaphysical forces of an onward march of progress as well as agents of destruction of everything that is. Various

[44] One of many example is the to be found in the magazine "Youth" (Magazine of the British Federation of Youth), whose organising secretary Harold F. Bing also helped to coordinate the World Youth Peace Congress in 1929: "We are all tired of our conventional leaders, and disgusted with so many of these fanat-ics, who in the name of religion are exploiting public sympathy." cf. "Youth," in NMML, AICC papers, F.No. O–3, 1928, f. 109.

[45] The Khaksars, or rather their leader Mashriqi claimed persistently the Khaksars were a social organization, in fact they participated in a number of political rallies, ML meetings, etc. and locally in politics and election campaigns, cf. NAI, GoI, Home Dept., Political, 74/6/1940-Poll(I), f. 57; and "Khaksar and Other Volunteer Organisations in Indian States: Policy to be Adopted Towards Them," in NAI, GoI, Political Dept., Political, 31(2)-P(S)/40, 1940.

Congress leaders emphasized that the youth movement was to be something above parties, above political allegiances, something even above the Congress, which was often equated with the nation by those same leaders.

How this new society was to come about and what it would look like were not really the questions to be answered directly—the central concerns of the advocates of youth movements circled more around the qualities that youth had to embody as a basis for building the nation. Given adequate levels of energy, efficiency, discipline, and unity, the desired new order and fulfillment of the destiny of India as a nation would but be a logical outcome. As one author who was closely connected with the Seva Dal declared:

> One strong will can set a thousand to dance in joy of self-less action, Awaken this central force in you, direct it towards the service of the Mother and you have done your duty. Because, all else will take care of itself and all other necessary actions will flow from you.[46]

The Hindustani Seva Dal (HSD) is a good example in this context: It subscribed to the standpoint that it was essential for an efficient volunteer body to be above party politics, to remain untainted by political compromises and maneuvering, and to serve as faithful soldiers whoever might lead the Congress. Narayan Subbarao Hardikar, the spiritus rector of the HSD, liked to sum this up in his oft-repeated credo "We belong to Congress but parties have we none."[47]

Numerically only a minor part of the overall "volunteer" or "youth" organizations were Congress or Congress-affiliated.[48] An India-wide

[46] R.R. Diwaker, "The Will To Serve", *The Volunteer*, November 1925. More information on the magazine is given later in this essay.

[47] N.S. Hardikar citing Hardikar, "Cawnpore Volunteers! Listen," *The Volunteer* (December 1925): 296.

[48] And even were they were Congress-affiliated, some provincial Congress Committees kept bodies that were not adhering to the official rules and guidelines of the "one and only" official Congress volunteer movement. See, for instance, "A Brief Report of the Hindustani Seva Dal from August 10 to the end of October, 1931. Submitted to the Central Board" by N.S. Hardikar, in NMML, AICC papers, F.No.- 9/1930.

intelligence surveillance of volunteer organizations in British India for 1940 gives the total membership of all known bodies as 194,247. Provinces with a particular high turnout were Bombay with 20,173 (of which 12,574 were "Hindu communal" organizations, and the RSS alone made for more than 10,000 members); the United Provinces with 73,284 (of which 30,710 were "Muslim" and 38,613 "miscellaneous"); Punjab with 29,265 (with "Hindu" and "Muslim" organizations showing both around 11,900); and the NWFP with 32,211 (of which 14,571 "Muslim" and approximately 17,000 "miscellaneous," the bulk of which were apparently Red Shirts).[49] In contrast, Madras Presidency had a mere total membership of 1,791 (of which 1,084 Muslim).[50] The overall figure of volunteers would rise sharply during the Second World War, and by 1946 it would have more than doubled making for close to half a million volunteers according to the official (and therefore conservative) count.[51]

Given the martial appeal, it is perhaps not surprising that the body of the ideal volunteer is that of the physically fit male. Beyond discussion on the effeminate India and the nationalist catch-up game with Victorian ideals of manliness arising out of the imperial project, one structural problem that especially applied to volunteering females would be the strong authority family or guardians would typically exercise. A good

[49] For an appreciation of the wider political engagements of the Red Shirts, see Sayed Wiqar Ali Shah, *Muslim Politics in the North-Western Frontier Provinces 1937–47* (Oxford: Oxford Pakistan Paperbacks, 2000); for the Red Shirts in particular, see also Mukulika Banerjee, *The Pathan Unarmed: Opposition and Memory in the North West Frontier* (New Delhi: OUP, 2001). See also Gandhi's secretary, Pyarelal, *Thrown to the Wolves: Abdul Gaffar Khan* (Calcutta: Eastlight Book House, 1966) and his *A Pilgrimage for Peace: Gandhi and the Frontier Gandhi among N.W.F. Pathans* (Ahmedabad: Navajivan, 1950).

[50] The Congress in these lists is generally listed as a "Hindu" body, since, as an Intelligence officer reasoned, whatever they said they consisted mostly of Hindus. Cf. "Volunteer Organisations in British India, Statement C. Provincial Figures at a Glance," in: NAI, GoI, Political Dept, Political, 31(2)-P(S)/40, 1940, no ff. nos. See also Statements A and B for detailed lists of organizations and their relative strength.

[51] "Distribution of Major Volunteer Organizations in Provinces," British Library, London, India Office Records [IOR], L/PJ/12/666. A study on the role of these movements before and during the partition of India in a broader perspective is being prepared by Ali Raza and the author.

example for this, and the notions "volunteering" might be linked to, is the story of Prema Kantak, a Sevika Sangha (the female volunteering wing) member who helped to organize the National Volunteer Corps which the Maharashtra Provincial Congress Committee (PCC) started.[52]

Prema Kantak was planning a camp for women, where notable nationalists such as Seth Jamnalal Bajaj and the socialist Gadgil were expected as speakers on themes such as "revolution in women's life" and "world politics." This caused a minor public scandal, notably driven by the moral outrage of the Democratic Party. Prema Kantak reported to Nehru what had transpired in a talk she had with them: The Democrats stated that the Congress was dominated by socialists and while they didn't mind socialist economics, they were afraid of Congress' stance on sex and gender norms. In Russia there was no respect for the holy bond of marriage and there were more divorces than marriages, they claimed. "[T]hey want licence not liberty." Socialist and communist young men held the same views and it was these same young men that were so much appreciated by leading Congress men.[53] For these reasons they were not willing "to send daughters and sisters and womenfolk to your corps or camp."[54] They perceived it as their moral duty to warn parents and guardians, as a result of which, Kantak reports, many women then stayed home "because they could not offend their guardians." In her letter to Nehru she goes on to say that she does not know a lot about Russia, that of course she appreciates how much they had done "for humanity" and tentatively enquires about Nehru's views about the state of affairs in Russia and whether he truly wants the "same state of affairs brought about in India." "I suppose you would better choose India to rise in a new form on the old basis of Aryan civilisation of ideal ancient times."[55]

There was usually not much ground for such sexual anxieties as male and female volunteers in India were strictly segregated; they had their own trainers (of the same sex wherever possible), their own wings in the movement, their separate camps and training regimes and different

[52] "'All India Womens' Conference," NMML, AICC papers, F. No. G–47, 48, 49/ 1936, f 11.

[53] Ibid, (p. 4 of letter–no individual ff. nos).

[54] Ibid (p. 5 of letter).

[55] Ibid, (p. 6 of letter).

functions at public venues, and until the communist movements of the 1930s, there seems to have been precious little overlap of social space.

Volunteer Movement and Notions of Citizenship

Looking at the range of volunteer and youth movement in existence during this period, there are not only certain structures that seem to pervade the differing political attitudes and social goals but also a common language, rhetoric and a common understanding of why organizing young people was of such paramount importance. A look at the constitution or published objectives of various bodies makes this clearer. Recurring items include the attainment of "unity" (Seva Dal, Naujawan Bharat Sabha) or an "Islamic brotherhood" (Muslim National Guards and Khaksars) and the fostering of a spirit of service and self-sacrifice for the higher goals and the sake of the community/motherland or nation, freedom or invincible power (Khaksars). The same stress is generally laid on fostering qualities such as discipline, simplicity, self-reliance, selflessness in *young* people who were still susceptible to the implementation of values. Discipline, physical drill and the "selfless" submitting to authority were then, on the one hand, *values* which everybody, irrespective of political outlook, had to foster in himself (and herself) and at the same time *tools* for the mobilization of a tier of the population that was to be integrated into the political arena. In that sense, such endeavors were not strictly limited to youth but youths were imagined to be the ideal recipients and the image of the perfect volunteer which is almost without fail that of the physically fit, selfless young male.[56]

[56] Discipline, physical prowess, and obedience were the buzzwords of the day employed by political leaders from left to right, see for instance, Jawaharlal Nehru in *The Volunteer*, January 1925 (first issue), 3, Moulana Shaukat Ali, *The Volunteer*, January 1925, 2, Lajpat Rai, Ibid, 2; Editor, "Need of Physical Training—Extracts from Pt. Madan Mohan Malaviya's speech delivered last month at the Physical Culture Institute at Bangalore," *The Volunteer* (August 1927), 208–10.

For a future India, the development of a body of citizens firmly imbued with all the necessary characteristics, moral as well as physical, was of utmost importance to overcome social injustice, "emasculation," "backwardness," and "superstition" and other social evils that were keeping "the nation" imprisoned and helping the colonial overlords to retain their grip on it. The notions discussed here were well summed up in the Rules of the Congress Seva Dal.[57] The objects of the Seva Dal were described in four points. First: "To instil qualities of self-discipline, self-sacrifice, self-reliance, simplicity, service, tolerance and aptitude for corporate and co-operative work and life in youths," so that they (a) become disciplined workers of national service and (b) "become *ideal citizens* of a Free India"(my emphasis). The second point relates to the promotion of national unity irrespective of caste and creed. The third again is worth quoting:"To improve the health and physique of the Indian people through physical culture and training."The fourth object is for the volunteers to act as a"peace and relief brigade"in times of emergency and"to protect the life, honour and property of the people."A later draft version of these rules read by the President (Nehru) and approved by the Congress Working Committee included as one main objective in paragraph 15 the"defence against anti-social elements."[58]

It may be pointed out here how gendered notions again found their entrance into the triad of fear regarding "life, property, and honor." Honor is, by default, the honor of women in the context of the fear of violation. By extension, however, this honor is not only representative of but *is* itself the honor of the whole community. The need for also training women in self-defense, as pioneered by organizations such as

[57] NMML, AICC papers, F. No. 8, 10/1931, f.1 and the later constitution under: NMML, F. No. 70 (I), 1946–47, f. 65 (2pp). The Seva Dal had been established as an official All India Congress Volunteer Organisation at the Cocanada Congress Session in 1923, with the main objective "that in order to train the people of India and make them effective instruments for the carrying out of National Work on the lines laid down by the Congress, it is necessary to have a trained and disciplined body of workers." Cf. WBSA, GoB, Office of DIG of Police, CID, IB Branch, file no. 343/23, f. 13 (12).

[58] This later version is the Draft Rules of 1946. NMML, F. No. 70 (I), 1946–47, for the quote cf. f. 61.

the Bengali Dipali Sangha in the first decade of the twentieth century, seems to have been heavily influenced by such notions. For instance, Inayatullah Khan better know under his honorific of Allama Mashriqi, who started the Khaksars in 1931 and asserted that it could never be "an organizations of women" gave orders in 1943 when—helped by the Second World War—communal tension assumed new feverish proportions that: "[Khaksars] should also make their women folk perform drill and exercise."[59] Mashriqi, like so many others, claimed that his Khaksars were only geared towards producing "useful citizens" even while their activities, martial displays, elaborate military sham fights and violent clashes with the police—preferably with sharpened spades that were part of their uniform—became notorious.[60] But social uplift by this time was an almost hegemonic discourse in all political quarters. The Oxford graduate Mashriqi, who was known for his claim of having inspired Adolf Hitler in the first place, evolved his own form of social Darwinism which he blended with a theism that reinvented Islam as an inherently military tradition. In his usual provocative way, he went so far as to claim that the best Muslims were those who were fittest and most dominant in the world—be they infidels or not.[61]

At the core of movements aiming at "social uplift" or the betterment "of the physique" (the official object of the RSS)[62] of this or that community is this drive to build a "homogeneous body" (that is a body that could aspire to be a nation or "community" in future). Thus, in all these notions of "usefulness," "brotherhood," and the "spirit of sacrifice" that was to be inculcated in the masses and particularly the young "future citizens" we can discover the outlines of an envisioned nation, where a "healthy," "disciplined," and "drilled" body of citizens is prepared or

[59] NAI, GoI, Home Dept., Political, 28/5/43-Poll(I), 1943, f. 24.

[60] Inayatullah Khan to the Viceroy, June 5, 1940, in NAI, GoI, Home Dept., Political, 74/6/1940-Poll(I), f. 57.

[61] On the ideology of Allama Mashriqi, see Markus Daechsel, "Scientism and Its Discontents: The Indo-Muslim 'Fascism' of Inayatullah Khan al-Mashriqi," *Modern Intellectual History*, 3, 3 (2006): 443–72.

[62] Cf. "Volunteer Organisations in British India, Statement C. Provincial Figures at a Glance," no ff. nos., in NAI, GoI, Political Dept, Political, 31(2)–P(S)/40, 1940.

expected to sacrifice their individual needs or even their lives for the greater common good. In other words, this is the idea of an organic nation-body, which is frequently ascribed to "communal" organizations like the RSS of today, but which can indeed be discovered in all organizations at the time—an expectation arguably carried over into the future independent Indian state.[63]

Education was another important sphere of nation-building, one into which I will not go here in detail. But reports about the deplorable physical degeneration of students were common and ascribed to the mindless habit of cramming without bodily activity to counterbalance its physically harmful effects, and the lack of appreciation in society, and especially among the middle classes, for anything but exam results within an anti-national education system aimed at keeping the population in subjugation. Shocking descriptions about the stereotypical college or university student made the rounds. The *Volunteer*, a monthly journal edited by the Seva Dal's organizing secretary, NS Hardikar, but regularly substituted by the INC, was among a number of publications centrally concerned with this theme, next to national regeneration, physical culture and its connection with volunteering. I will be using some examples from the *Volunteer*, as it represented a wide cross-section of opinion from staunch Gandhians to militarists, and the political left to right, while it was at the same time closely tied to mainstream opinion in its

[63] Most clearly in the Planning Committee which not only looked into the future economic to be implemented to solve social and economic problem but also at "spiritual" and cultural issues of human life, cf. K.T. Shah (ed.), *Report: National Planning Committee* (Bombay, June 1949), 10. The report implicitly took a somewhat organicist view of the nation as a bodily entity. The general education sub-committee not only prescribed Nehru's long nurtured plan of a compulsory year of "disciplined national service" of young men and women but the sub-committee on population prescribed norms of physical fitness for the population at large (pp. 207–8) and prescribed "self-control" as well as "birth control" and equated "eugenic" with "healthy" and "socially progressive" when talking about the removal of inter-marriage barriers "for eugenic reasons." Quoted after Benjamin Zachariah, *Developing India: An Intellectual and Social History, c. 1930–50* (New Delhi: OUP, 2005), 216, 247–48.

function as a semiofficial (and later official) publication of the Congress' Hindustani Seva Dal.[64]

What is interesting about the *Volunteer* in our context is the abiding if eclectic interest in international affairs it exhibited despite its claims to be purely concerned with the Indian volunteer movement. The *Volunteer* regularly carried articles from foreign correspondents such as Agnes Smedley or, for instance, members of the Czech Sokol movement, whose founder had been a great admirer of a physical program infused with social Darwinism to achieve a nationalist renewal.[65] Hardikar was very taken with the Sokols (as was Allama Mashriqi for that matter), but the *Volunteer* had as much time for the Russian pioneers (which Hardikar saw as a truer embodiment of the scout spirit since they were also nationalists)[66] or the Chinese struggle in the 1920s (where it had sided with Sun Yat Sen and the Kuomintang before the internal purges carried out under the leadership of Chiang Kai Shek in 1927—but authors of the *Volunteer* expressed some admiration for the "strong men" and warlords too). Hardikar, with the help of some INC notables including Nehru, even tried to launch a medical mission to China following the "Shanghai massacre"—to much acclaim and generous (also monetary) support from the public, but passports were ultimately denied to the members of

[64] The *Volunteer* was not the Seva Dal's official organ though money came regularly from the Seva Dal and INC for its upkeep. It counted among its contributors some of the who's who of the anticolonial movement. The *Volunteer* never achieved a subscription list that crossed 1,000 and hardly ever managed to be self-supporting. On the other hand, it was on the exchange list with almost all the big national daily and weekly papers and a number of monthly magazines in and outside of India, including *Amrita Bazar Patrika*, the *Bombay Chronicle*, *Madras Mail*, *Forward*, *Mahratta*, *Indian National Herald*, *Swarajya*, *Hindustan Times*, *Guardian*, *Lokamanya*, Palme Dutt's *Labour Monthly*, and others. A number of reading rooms and libraries were on the subscription list, including the New York Public Library and various Indian and non-Indian student organizations.

[65] See, for instance, the article by J.V. Klima, "The Great National Leaders of Czechoslovakia," *The Volunteer* (July 1927), 175–77, which traces the conversion of the Sokol Movement's founder, Miroslav Tyrš, from his earlier admiration for Schopenhauer to social Darwinism.

[66] See Hardikar, "Scouting in Russia," *The Volunteer* (April 1927): 93–97. On Hardikar's notion of a "true" scout movement, see, "Comparison and Contrast of the Scout and the Volunteer Movement," *The Volunteer* (August 1926): 175–76.

the mission by the British government who accused the group of having ulterior political motives.[67] Unfortunately, we do not have space here to go into the intricate web of the Seva Dal's international role models— suffice it to say that during this time, actors could perceive and engage with a variety of possible paths of development and progress on the plane of world history, and that those from the Indian subcontinent by no means limited themselves to the framework of the British Empire when exploring the intertwined nature of "world forces" and their own place in it. But instead of enumerating all the models held up for emulation by the *Volunteer*, let us look at the underlying motivation and weltanschauung that made it possible and even commonsensical to draw on such a heterogeneous set of examples.

Raghupati Sahai, under-secretary of the All-India Congress Committee (AICC), did not hold back when deploring the state of affairs in India with regard to individual and national fitness:

> There is all round degradation and misery in every [middle-class] family. Each family is breeding and bringing up only invalids, boys and girls who if they survive, are a disgrace to manhood and womanhood.... It is the *pariah* and not a well-bred human being that is visible in shrunken, stunted deformed, and weakened bodies ... of their children.... If these thousands of homes will be allowed to remain like so many plague spots how can a better social environment be possible. If in their homes vermin are bred how can

[67] On the Chinese struggle, see "Sun Yat Sen and New China," *The Volunteer* (October 1927): 267–72; A Nationalist, "The Indian Fist at [sic] Nationalist China," *The Volunteer,* January 1927; K.A. Venkataramaiya, B.A., Hubli, "The Youth Movement in China," *The Volunteer* (January 1927): 20–23; T.C. Goswami "The Voice of Humanity, China and the Powers," *The Volunteer* (Oct/Nov 1927): 259–61. See also Hardikar's message to General Seng, Southern Army, Peking (China): "Indian Nationalist Youth rejoice Your Victory," AICC papers, F. No. G–08, 1928, f. 259. For the deliberations of the government which ultimately rejected to give passports to the proposed participants of the medical mission as well as the overwhelming public response to the call see Maharashtra State Archives, Bombay [MSA], Home (Spcl), 355 (58) A, 1927. On the engagement of the international left with the Chinese struggle more generally, see Fredrik Petersson, "We are no Visionaries or Utopian Dreamers—The Network of the League Against Imperialism, Comintern, and the Anti-Imperialist Movement, 1925–1933" [Ph.D., Åbo Akademi University, 2013].

men and women be found to carry on or be benefitted by the schemes and measures so much advertised in every quarter?[68]

Another regular author of the *Volunteer*, after a similarly stark description of the sickly educated Indians from whom salvation could surely not be expected, summed up: "So we must beware betimes and care first for our bodies and then for everything else."[69] The state of physical fitness of students was reviewed in various university reports, and compulsory physical or military training was a perennial topic, which was discussed by most (nationalist) educational institutions, and various localities implemented schemes to this effect in the interwar period.

The editorial piece of *Science and Culture* of October 1938 on education, most probably penned by its editor and an avowed socialist Meghnad Saha, referred in its opening to the Chinese philosopher Liang Ch'i-Ch'ao who defined education as "the means by which the state nurtures its own kind of people, welding them together as a whole that they may be independent and struggle to strive in the world where victory goes to the *fit*, and defeat to the *unfit*. Against the Gandhian advocacy of a return to the village, Japan was cited as the model for industrialization without the horrors of class war. And India could achieve the same if "the Nation will [it] so."[70]

The widespread fascination with all things military went hand in hand with the fear of what happened to nations who failed to continuously evolve, those who (had) stagnated, according to the contemporaneous discourse. Thus, degeneration and the "struggle for existence" was a recurrent trope in publications concerned with physical culture and youth movements. In 1927, B.G. Lokare, the under-secretary of the HSD, wrote in the *Volunteer*:

> The whole human life is a continuous strain and struggle against the forces of opposition in the achievement of its goal. This struggle, therefore, has

[68] Raghupati Sahai, under-secy, AICC, Allahabad, "Some Matters of Importance," *The Volunteer* (August 1926): 184–86; for quote see p. 185–86.

[69] R.R. Diwaker, "Neglect of our Bodies," *The Volunteer* (September 1926): 204–6.

[70] "On a National Scheme of Education," *Science and Culture* 4, 4 (October 1938): 199–200, for quote see p. 199.

been described as "the battle of life." This holds good of the life of a nation as well. Countries there are many in the world. The struggle of one country for individual existence is a struggle pure and simple as against the opposition of all the other countries in the world.

Lokare went on to say that in politics, whether we preferred the role of the non-cooperators, the constitutionalists or the revolutionaries—it is "all the same. The struggle does exist there as everywhere else." It just may be more or less bloody.[71]

This was by no means an exceptional statement and we can find numerous instances of statements along the lines of "society has been rightly compared to an organism."[72] Human society, in such examples, is rendered analogous to plant-life, where every part of the plant exists only by virtue of being a member of the whole, or to the social organization of beehives.[73] Though less numerous, we also find explicit explorations of social Darwinism especially in their beneficial effects in other countries and movements.[74]

This is, of course, not to suggest that *everybody* was under the spell of models of society that favored the organic collective at the expense of individual freedom. Rather, a number of competing claims for ideal society were voiced at the time. But all of these shared the language in which these questions were negotiated and a common concern about a changing global environment, which seemed to favor strong nation-states with

[71] B.G. Lokare, "The First Step in Building a Nation," *The Volunteer* (June 1927): 149.

[72] Jagunathrao, Cawnpore, "Indvidualsm [sic] and Organisation," *The Volunteer* (June 1926): 128.

[73] See, for instance on the value of organization and references to analogies of bee hives and animal life, the Gandhian M.B. Dixit, a regular contributor to the *Volunteer* on village uplift, "Value of Discipline," *The Volunteer* (April 1926): 81. See also the curious piece "Drops of Nector" [sic], which is an assemblage of popular social Darwinistic words of wisdom in the form aphorisms, *The Volunteer* (August 1927), 212–13.

[74] See, for instance, the article by J.V. Klima, "The Great National Leaders of Czechoslovakia," *The Volunteer* (July 1927): 175–77, which traces an alternative, independent evolving of social Darwinism to the founder of the Sokol Movement, Miroslav Tyrs.

the well-known (nationalist) minimum of unity (language, culture, history and "fate"/ aspiration).

The above-mentioned Raghupati Sahai with his condemnation of the degenerate, life-unworthy "pariahs" developed in two articles an utopian vision of how the forces of natural progress would render all divisions of society on the basis of race, caste, gender, religion anachronistic, and would give way to "another world wide system of a single human organism brought about by similar conditions" of knowledge, universal civic law and governance. There would be a shift from religion and tradition at the center of social organization to economic well-being, personal dignity within a new worldwide system.

> It is consciousness defining and manifesting itself through a prosperous and happy worldly life, in an ever perfecting rhythm "the musical thought" of creation realising itself in more and more life-like forms till it reaches its crown and climax in man who is the embodyment [sic] of the perfect fusion of matter and spirit, thought and form, of the visible and the invisible. This is the great harmony, the cosmic yoga, the "one far off divine event," to which through the winding process of the suns the whole creation moves and avails. The great Brotherhood of the future will have only one creed—life—and not Hindu or Muslim, Budhist [sic] or Christian, Aryan, Semetic [sic] or Jewish. It will be predominantly human.[75]

The collective versus the individual was one of the central questions in these negotiations, and the two poles were demarcated by an outright anti-individualism and a more lenient, liberal approach in which individual development was to go hand in hand with the required "social nature" and responsibility of the individual for the collective (though not necessarily the other way round).

As an example of the first train of thought one might cite the prominent Seva Dal organizer and instructor, G.G. Jog, from Kanpur, who wrote, "individualism is an anachronism" and whoever talked in support

[75] Raghupati Sahai, B.A., Allahabad, "Orbiter Scripta I," *The Volunteer* (April 1927). The second part was published in a later issue and sounded even more ecstatic, according India a special place in the all-equal human brotherhood, predictably enough that of spiritual guide. This was the utopian *Aufhebung* rather than the negation of social Darwinism.

of it was "pathetically behind the times ... he is a madieval [sic] reborn."
These, he proclaimed, were the days of large aggregations and not small
communities. "This is not to say that individualism is a lost cause. It has
its place and value in philosophic thought. But it is a spent up force."
He explained, however, that there was room for *an* individual in every
society: "Every nation has its individual, its hero," and these heroes by
their actions and the merit gained for their respective nation

> justify themselves.... But the *common herd* is a different commodity. we [sic]
> cannot afford to let them go their way. We must devise certain broad rules
> by which they shall be guided. Thither we must allow them but let it not be
> too long. Let us leave them sufficient scope for the exercise of their limbs.
> But let them not tread their several paths, lest they work not in co-operation.

He explained that in society there could only be competition or co-
operation, and while competition might spur activity it "kills in the long
run." It was movements and not men who really moved the world. Only
an organization was efficient and "all powerful.... A man is but a unit.
And a unit by itself is nothing."[76]

Another line of argument purported to be "indigenous" or "spiritual"
and opposed to "western" models but was, in fact, embroiled in the very
same lines of argument and reasoning. This strand attempted to wed
the Kantian (or Mazzinian) credo that man was *also* an end in himself
to the national (or international) collective, in which the individual was
called upon to develop as long as this was not at the expense of his "social
nature."[77] Selfless service as the path for self-realization and thereby for
individual, voluntaristic self-perfection that was only to be found when
becoming an integral part of the organic, holistic group-body (Jesus,
Seneca or the Bhagavadgita were cited by way of authoritative argu-
ments) were philosophies employed towards the same end, especially by
the more religiously minded who saw communism, fascism, militarism
as the "symptoms of the wasting disease which is ruining human nature"

[76] See G.G. Jog, "Individualism vs. Organisation," *The Volunteer* (September
1926): 206–7.

[77] See Jagunathrao, "Individualsm [sic] and Organisation," *The Volunteer*
(June 1926): 128–29. See also N.H. Pandia, secretary of the HSD in Bombay,
"Team Work," *The Volunteer* (October 1926): 232–33.

and the worship of brute force as a sign of the Asura power that was ruling the world but could relate service, discipline, sacrifice, and the volunteer movement to Dharma.[78] Volunteers occupied a prominent place in such discussions, since a higher level of collectivism was naturally expected of them. As ideal citizens of tomorrow, they were depicted as individual quasi-ascetic renouncers and as obedient, yet thinking and creative soldiers. This position was summed up well by the famous nationalist Lajpat Rai, known as "the lion of the Punjab," who wrote a letter to Hardikar (who had been his secretary in the United States), which was later published under the title "I Wish I Was A Boy Again." In this, he said: "The most important element is to forget your personal elements in obeying orders in a superior cause."[79]

It was the importance and alleged immense energy of youth that was also the reason it needed to be reigned it and controlled tightly, especially in its phase of awakening. This was true for society at large but especially for the boundless energies of youth, since it was assumed, as a later observer stated, that "young people will tend to flock round any fanatical banner that is raised."[80]

For society to be protected from itself, to be purged of old and harmful traditions and weak national life, unity reached through efficiency and discipline was needed, but for such movements to be able to effect

[78] Cf. "Address of Shri K. Nageswara Rao Pantulu Guru," *The Volunteer* (January 1925): 8–11, for quote see p. 8. There were some sanyasins writing and joining the Seva Dal who had no such qualms about "brute force" but celebrated the ideals of manliness epitomized by the muscular heroes with the wonderful physical powers of the Mahabharata. For the references to Seneca etc. see K.B. Dixit "Religion of the Volunteer," *The Volunteer* (October 1926), and ibid., "Service Before Self," *The Volunteer* (July 1926): 154–55, 228–30; also R.R. Diwaker, "The Will to Serve," *The Volunteer* (November 1925): 267–69.

[79] Lala Lajpat Rai, "I Wish I Was a Boy Again," *The Volunteer* (March 1926): 52. This is echoed by most people as the most essential quality of the volunteer "to merge your personality in the cause of service," see the address of S.V. Kowjalgi [president of the Karnataka Congress Committee], Chairman of the Reception committee of HSD, Conference at Belgaum, in Hindustani Seva Dal Belgaum Conference Report, 1924, 7.

[80] William Cowley, *A Plan for Youth: A Handbook of Youth Organization for India and Pakistan* (Calcutta: OUP, 1949), 2–3.

the requisite changes, what was also required was precisely the type of strong leader who had already arisen in other countries. The canon of examples in this context almost invariably mentioned Atatürk and Mussolini, sometimes Lenin and Hitler, in the mid-1920s certainly Sun Yat-Sen, Chang Tso-Lin, the Manchurian warlord, and Chiang Kai Shek, and in other instances Primo de Rivera in Spain, Pilsudski in Poland, Raza Khan in Persia, and Amir Amanullah in Afghanistan.[81]

The influential Prof. Puntambekar, an MA from Oxford, bar-at-law, head of the Economy Department, and later the History Department of the Benares Hindu University, elucidated the advantages of dictatorship in Hardikar's *Volunteer*: he argued that though it was commonly stated that this was the age of democracy, a number of dictators had risen, and these were "engaged in strengthening the state and revolutionizing the old conditions" and that they "are actuated with strong desire of promoting the greatness of their nations." India alone seemed to suffer from the lack of such an "avatar" or dictator. He enumerated: "The value of dictatorship lies first in its national outlook, then in its rigorous work in arriving at decisions and carrying them out strenuously, and lastly in the discipline it spreads for revivifying [sic] and re-ordering society."

Echoing a common trope, he said in a certain phase of national life a dictatorship was needed so that beneficial change might be forced upon society—otherwise vested interest and minorities were allowed to hamper progress. Gandhi, he claimed, might revolutionize minds but was lacking in compulsion and discipline since there was no punishment for the breach of his code. Hence, Puntambekar stated, the mind loses its original vigor and the newly born creative force is eroded.[82] It seems that a widely shared opinion held that nation-states in their "adolescent phase" required a dictator to lead the nation to modernity and efficiency. Puntambekar, who also penned admiring articles on Mussolini (a great man, even though he repressed and silenced his opponents) and George Washington (a great military leader, who built a victorious army out

[81] See, for instance, speech by Dr Shastri at the Second Youth Conference, Madras, December 1927, printed in *The Volunteer*, December 1927, esp. 281–82.

[82] S.V. Puntambekar, "Democracy Dictatorship," *The Volunteer* (March 1927): 69–70.

of the rabble)[83] was certainly among the more outspoken advocates of such trends, but the references in this vein are recurrent on a number of platforms.

Let it not be said that the fascination with Mussolini was restricted to the orbit of Benares Hindu University and characters like B.S. Moonje or other prominent members of the Hindu Mahasabha.[84] To illuminate just how widespread this fascination with the big dictators of the time went, the following example might be apt. Mrs Datta, wife of Surendra Kumar Datta, national secretary of the Young Men's Christian Association (YMCA), former MLA and at the time principal of the Foreman Christian College, Lahore,[85] traveled to Europe in mid-1934 with some twenty female students. They visited the Pope and Mussolini, and later ventured into Germany. In the article written by one of the participants, the meeting with Mussolini and the impressions from Italy stand out with their glowing, admiring description. The group swooned over the Duce, the writer romanticised the *ballilas* and the blood these martyrs shed in the street fights preceding the fascist grab for power.

> Italy is now waking up to the present. One feels the pulse everywhere, through the narrow lanes, where the Ballila nation song is heard, over the golden corn in the fields that were once the unhealthy marshes of the Champagna [...], [in] the Youth of Italy with their impressive black uniforms, until it finds its culmination (on its source) in the stern, immobile face of Signor Mussolini. [...] We saw this sternness relax and Signor

[83] See Puntambeker, "Mussolini," *The Volunteer* (June 1927): 147–48; and his article on George Washington in *The Volunteer* (August 1927): 203 ff.

[84] Marzia Casolari, "Hindutva's Foreign Tie-Up in the 1930s: Archival Evidence," *EPW*, 35, 4 (January 22–28, 2000): 218–28. On the engagement of Hardikar with B.S. Moonje and Moonje's vision of physical fitness and a military academy, see Franziska Roy, "The Torchbearers of Progress," Chapter 4.

[85] S.K. Datta was the national secretary of the YMCA for India, Burma and Ceylon from 1919 to 1927. He had a long-standing association with the Foreman Christian College, where he had worked as a lecturer from 1909 and became its principal in 1932. He was an MLA in 1924–26 for the Christian constituency and participated in the Round Table Conference of 1931. Moreover, he was in close touch with Gandhi and Mahadev Desai over the village uplift schemes undertaken by the Congress, he functioned as one of the All-India Village Industries Association's "expert advisers" (see Zachariah, *Developing India*, 114).

Mussolini became quite human as he laughed and talked to us in his audience room. The preliminaries [...] rather awed us. We almost trembled in our shoes until a door opened at the farther end and somebody walked in quite informally. It wasn't till he stood in front us and gave us his Fascist salute that we realised it was the great Mussolini.[86]

Describing the exhibition devoted to the Fascist Revolution in Rome with a shrine to the "martyrs," the article says it is

a graphic and detailed commemoration of the great struggle [...] when Fascists had to strive to obtain ascendancy in the land [...] The Sanctuary of the Martyrs cannot fail to impress strangers. It is a circular room all draped in black. In the middle of the floor a huge black cross rises from a blood red pedestal, the blood of the martyrs. On it is written in large letters "Per La Patria Immortale"—and from all around the circular walls of the shrine comes the response in bright golden letters "Presente." [...] A Fascist soldier stands motionless on guard at the entrance. One comes away feeling most awed and stirred.[87]

Compare this breathless mythopoetic description to the narration of the day of the so-called "Röhm Putsch" in Germany:

Altogether our visit to Italy [...] forms the happiest part of our tour. We were in Munich on June 30, that terrible weekend of Herr Hitler's "clean-up," but those on the spot always see the least of the game. One of the victims, Herr Fritz Beck [...] was our host that day. A great personality whose life-motto was service, he endeared himself to us in the little time we spent with him. We said au-revoir on Saturday afternoon [...] It was really a farewell, for he disappeared that night and was found shot dead outside Munich two days later. We were a good deal shaken at the murder of this godly man.

The sterilized commemoration of the Fascist street-fight and brutal intimidation or murder of opponents here becomes an emulable Italian character-study to the group of visitors, who see in it the stirring example of a nation harnessing youths' energy and purifying itself, while the

[86] "Il Duce" Greets Indian Women—Party's Tour—in Munich on Day of Nazi "clean-up," by "a correspondent" [one of the participants], *The Statesman*, November 2, 1934. I am indebted to Carolien Stolte for sharing this source with me.

[87] Ibid.

actual experience of the political "clean-up" directed against political opponents, including opposing members of the stormtroopers and others under the leadership of Röhm—who suffered the fate of Beck[88]—has them shocked in its banal violence. Even the description of the events is in a cut-and-dried way and starkly opposed to the cadence when referring to Italy. I quote this passage in full to bring home the fascination with fascism which was seen by many as the embodiment of progress at the time.

The Will to "Self-defence"

The ability to defend one's own country was linked to natural rights and national honor and, at the same time, to realpolitik considerations of the rearmament of the world, especially of the United States in the interwar period.[89] At the same time, the distinction between internal and external self-defense became extremely blurred especially with the more frequent outbreaks of communal violence from the mid-1920s onwards, and National Militia or Civic Guard organizations (as the Seva Dal under Hardikar liked to style itself and was styled by the Congress high command) had the double task of defense against external aggression and internal disorder.[90]

[88] The writer does not comment further on Fritz Beck. Beck founded the student house and union in Munich and had seen to it that Röhm took over his student club, a branch of the world student federation (Weltstudentenwerk), to save it from the "Gleichschaltung." It is possible he was killed due to his involvement with Röhm or simply liquidated by opposing members within politicised student circles. See Jahresbericht 2010, Studentenwerk München. (http://www.studentenwerk-muenchen.de/fileadmin/studentenwerk-muenchen/publikationen/jahresbericht/stwm_jahrsbericht_2011_RZ_web_NEU.pdf)

[89] That carrying arms and waging wars was the birthright of a sovereign people was a commonly reiterated credo. See, for instance, "Inspiration of the Past: A Message of His Holiness Shri Shankaracharya (Dr Kurtakoti)," September 1926, 193. See on the impact of the perceived global rearmament N.S. Hardikar, "Let U.S. Protect Ourselves: Facts about Military Education in U.S. America," *The Volunteer*, March 1926, 49 ff.

[90] There are numerous examples for this haziness concerning the object of the ubiquitous "self-defence." See, for instance, the editorial piece "Mofussil

Sarojini Naidu, the famous poetess, during her term as Congress President, took an active stance on the question of compulsory military training, which she wanted to be an essential part of any national school's curriculum. In a speech she elaborated on the right to self-defense:

> Is it not the saddest of all shameful ironies that our children whose favourite lullabies are the battle-songs of Kuru-Kshetra and whose little feet march gaily to the stirring music of Rajput ballads should be condemned to depend for the safety of their homes ... on the fidelity and strength of foreign arms? The savage Massai ... may claim the inalienable right to defend the honour of their race but we alone have been defrauded of that privilege and have become cowards by compulsion, unfit to answer the world's challenge to our manhood, unable to maintain the sanctity of our homes and shrines.[91]

She therefore urged the Congress to form a National Militia, the core of which was to be the present volunteer organization. Motilal Nehru, who had earlier joined the Skeen Committee which was to work out schemes for the Indianization of the British-Indian Army,[92] appealed in 1927 to Congress volunteers that "[i]mmediate cultivation of 'esprit de corps'" was required for effective service and effective sacrifice, without which no country had ever achieved freedom: "Remember, you volunteers, you are the soldiers of unity. You must gird up your loins to restore unity. You are the future national army of India."[93]

Defence" regarding the appeal by Mr Sham Sunder Chakravarty, editor of the Servant, Calcutta, in *The Volunteer* (September 1926): 216. Others saw volunteers as a "second line of defence" in case of an attack on India. But the role of keeping internal order would have usually been the first association in this context.

[91] Sarojini Naidu, "Editorial Notes," *The Volunteer*, "editorial notes" (February 1926): 22–23.

[92] He was criticised for joining this committee by the Swarajists but had defended his position by stating that the addition of one more Indian being able to defend his country was worth more than the appointment of ten Indian governors and that all Indians, no matter what school of thought they belonged to, had as their duty to increase the number of those potential defendants of the country. Hardikar, editorial notes, "Pandit Motilal Nehru Joins" *The Volunteer* (August 1925): 164.

[93] Motilal Nehru, "Soldiers of Unity," *The Volunteer* (January 1927): title page.

For many Congressmen, and we can count Hardikar among them, nonviolence of an allegedly Gandhian variety was a credo that was chosen for pragmatic rather than ideological reasons. Many of the Seva Dal leaders thought that the organization "should be run on military lines."[94] Hardikar himself was sympathetic to such ideas. He professed "that he, personally, was in favor of military education, but of military education minus the inhuman and brute part of it."[95] Hardikar, Sarojini Naidu, and Jawaharlal Nehru, to name a few, made at various points statements to the effect that nonviolence was a strategically fitting method. Naidu stated for instance that the volunteer movement should "serve as the first steps to the [armed] National Militia. If we have not yet the arms to use, let us first train ourselves in other ways. Let us learn to obey and die in the service of the land."[96]

Conclusions

The most intriguing feature of the various youth/volunteer movements is the astonishing similarity in the structure of these organizations. This similarity, based on a common grammar that spanned the national and

[94] B.V. Inamdar (Dal organiser, Malad), "Suggestions on the Resolution of the Congress Working Committee on the Hindustan Seva Dal, in NMML, AICC papers, F. No. G–8, 10/1931, f. 85. See also Dr A. Laxmipathi (Madras), ibid., f. 87. Other voices already prepared for a "war council" which should have at least two Dal members ex-officio, see ibid., f. 89. S.S. Shastry, Pleader, Honavar objected to the Dal coming under direct Congress control because the "present policy of the Congress namely non-violence non-cooperation" would be a hindrance to the Dal's efficacy. The basis of the Dal was to have "an efficient body of workers, to be ready to take up work of a sort which may in many ways be inconsistent with the current policy of the Congress." (Ibid.)

[95] WBSA, IB Branch, file no. 354/26, f. 4.

[96] See editorial, "Congress President and defence," *The Volunteer* (February 1926): 23. See also Hardikar, editorial, "Is the Dal a Revolutionary Body?...," *The Volunteer* (June 1925): 97–99, esp. 97–98. See for comments on the necessity of violence and armed forces that reflect the actual Congress mainstream probably more closely, also the English professor of Presidency College, Calcutta, Nripendra Chandra Banerjee, in his article "A Review of the Wardha Scheme of Primary Education," *Science and Culture*, 4, 4 (October 1938): 201–4, esp. 203.

international context, allowed, among other things, for actors to perform political shifts in seemingly paradoxical ways, for members to change movements, and also for ordinarily rival organizations to communicate across political boundaries.[97]

The young men and women who joined organizations did not necessarily consider their politics first (or know much about them at the time when they joined, apart from the fact that they were "doing something for the country"), rather the personality of local leaders and the *form* of the organization seems to have drawn people, and so the quasi-military setup of many organizations must not only be considered a tool of mobilization and discipline from above but as a reality on the ground, an implicit consensus permeating party politics or social goals that this was "the way it was done." This leads to a wider historiographical question of "zeitgeist" or "style" arguments, mostly made in the context of identifying fascism and fascist tendencies in Europe between the wars, but crucially applicable to South Asia at the time.[98]

[97] One example of such an unlikely alliance is the story of the RSS and the Khaksars at a certain point whose leaders seriously considered a common protest against the ban placed on the Khaksars in the Punjab NMML, Delhi Police Records, V inst., F. No. 64, f. 89.

[98] For a "zeitgeist" argument: Zeev Sternhell, "How to Think about Fascism and its Ideology," *Constellations* 15, 3 (2008): 280–90. For an engagement with the question at what point we can identify "fascism" and whether it makes sense to assume a stable core of the idea at all, see Kevin Passmore, "The Ideological Origins of Fascism before 1914," in *The Oxford Handbook of Fascism*, ed. R.J.B. Bosworth (Oxford: OUP, 2009), 12–31. For more or less successful attempts at coming to a more generic concept of fascism, see for instance, Roger Griffin, *International Fascism* (London: Arnold, 1998) and his earlier *The Nature of Fascism* (London: Routledge, 1991); and Roger Eatwell, *Fascism: A history* (London: Vintage, 1996). Eatwell employs the description of a "holistic-national radical Third Way" that is neither conservative nor communist and aims at social rebirth (cf. Eatwell, *Fascism*, 1996, quote on p.11). Griffin puts more emphasis on the style of organizations and suggests that fascist movements are revolutionary in that they intend to overthrow the current order and revitalise an older "golden age" by means of permanent mobilization aimed at condensing the population into a nationalised and totalitarian society but arrives therefore at a rather flat typology. He endorses the notion of fascism as a quasi-religion with totalitarian means, which has been rightly criticized (cf. Bosworth in his introduction to the

I would argue that by using youth movements as a window we are be able to trace in greater detail certain tendencies that were central and inherent to the independence struggle in India insofar as it used physical culture as a commonly approbate means for regeneration of a corporeally imaged nation. Common to these movements was a belief, in an organicist nation-state, at times, conceived in eugenicist terms, that was as amorphous in India as internationally, and part of the same mixture of utopian or "progressive" ideas. The consensus across the political board with regard to the nexus between citizen–volunteer–soldier also needs to be explored with regard to post-independent realities. The still prevailing view of the Congress in pre- and postcolonial times as an organization based on a moral consensus entailing nonviolence breaks down quickly when exploring the practices and discourses on the ground.

Furthermore, there is an international context that needs to be seen as intricately linked to the national youth movement. Notions that were internationally of importance were deeply ingrained in these movements and helped shape their own outlook. This international engagement was true not only of self-consciously internationalist groups, but also of groups who specifically claimed to be indigenous and operated in the nationalist arena.

Handbook of Fascism). See also Benjamin Zachariah in his contribution to this volume.

7

Srečko Kosovel and Rabindranath Tagore: Universalist Hopes from the Margins of Europe

Ana Jelnikar

> The traveller has to knock on every alien door to come
> to his own, and one has to wander
> through all the outer worlds to reach
> the innermost shrine at the end.[1]
> —Rabindranath Tagore

> You have to wade through a sea
> of words to come
> to yourself. Then alone,
> forgetting all speech,
> go back to the world.[2]
> —Srečko Kosovel

[1] Rabindranath Tagore, poem no. 12, in *Gitanjali: Song Offerings*, tr. by the author (New Delhi: UBSP, 2004 [1912]), 25.

[2] Srečko Kosovel, "If You Cannot Speak," in *Look Back, Look Ahead; Selected Poems,* tr. by Ana Jelnikar and Barbara Siegel Carlson (New York: Ugly Duckling Press, 2010), 66.

Introduction: Frameworks of Comparison

In 2008, within a few months of each other, two new books of poetry in translation came out in England bearing the same title—*The Golden Boat*. One contained a selection from the extensive oeuvre of the world-renowned Indian writer Rabindranath Tagore (1861–1941), and the other the selected poems of the relatively unknown Slovenian poet Srečko Kosovel (1904–26).[3] Neither collection had anything to do with its authors' original publication nor the manuscript. *Sonar Tari* was a small collection of nineteen poems that Tagore published in 1894, while *Zlati čoln* was Kosovel's first manuscript, but one that never got published as intended, since the poet died before the manuscript made it into print and the manuscript was subsequently lost.[4] That the publication histories of these two poets, whose writings extend back in time by at least ninety years, with Tagore having a long and complicated English career to his name and Kosovel practically none, should have converged in such a way is of course a mere coincidence; beyond the mere fact that poetry in English translation has become richer by a contribution from the world of Bengali/Indian and Slovenian letters respectively, there would in fact be nothing obvious to link the two books, nor the two poets, were it not for the same title. Yet, it is this connection, with its potential symbolic resonances of the phrase "the golden boat" that has, at the most basic level, aroused my interest in this curious one-way encounter.

Tagore stands out as one of the most referred to writers in Kosovel's work: his poetry, prose pieces, essays, letters, and notes, and yet this topic has so far received no more than a mention or at best a few pages stating

[3] Rabindranath Tagore, *The Golden Boat: Selected Poems*, tr. by Joe Winter (London: Anvil Press Poetry, 2008); Srečko Kosovel, *The Golden Boat*, tr. and ed. by Bert Pribac and David Brooks, assisted by Teja Brooks Pribac, (Cambridge: Salt Publishing, 2008).

[4] The only surviving part of the original manuscript is the preface, fully reproduced in the first volume of Kosovel's Collected Works, Srečko Kosovel, *Zbrano delo 1* [Collected Works 1, henceforth referred to as CW1], 2nd edn, ed. by Anton Ocvirk (Ljubljana: DZS, 1964), 411–13. Without a definitive list of poems at hand, when a selected book of poems entitled *Zlati čoln* did come out in 1954, clearly to honor the poet's intended publication, the composition of it was inevitably an editorial construct.

the obvious.[5] It is true to say that the existing tools for analyzing the ways in which Tagore was appreciated in different parts of Europe, all too often simply blurred with the notion of "the West," can only take us so far in understanding this particular cross-cultural response. Coming from the so-called margins of Europe as opposed to the strong Western European imperial "centers" (particularly that of Britain), the response is inflected with preoccupations and concerns which cannot be subsumed under the power/knowledge nexus of the Saidian Orientalist paradigm, in which the motivations and perceptions of the "Orient" are inextricably linked to imperial interests (though, of course, the Anglophone responses to Tagore too were far from unanimous or unambiguous).[6] The question of a theoretical framework within which to make sense of responses that do not fall neatly (not that many do) within the dominant Said-inspired model of "Western" perceptions of "the East" presents itself forcefully when we come to the "subalterns" of Europe itself, those, who, like the once-colonized countries, have been delegated to "an imaginary waiting room of history," the "not-yet" of political modernity.[7] A differentiated view of Europe is certainly in order here, as is a consideration of the symbolic geographies of Europe that strive to separate the "insiders" from the "outsiders" through ideological constructions of "Easternness" and "Westernness."

[5] A cursory glance at the index pages of CWs reveals that Tagore gets a mention over fifty times. Leo Tolstoy, another figure Kosovel admired, is referred to thirty times and Romain Rolland fifteen, for example.

[6] For the most recent discussion of the complexities of Tagore's reception amongst the metropolitan and colonial elites in Britain, as well as his friendships with some key individuals from the Anglophone world, see Michael Collins, *Empire, Nationalism and the Postcolonial World; Rabindranath Tagore's Writings on History, Politics and Society* (London and New York: Routledge, Chapters 4 and 5), 101–43.

[7] Dipesh Chakraborty, *Provincializing Europe; Postcolonial Thought and Historical Difference* (Princeton: Princeton University Press, 2007), 8. Metaphors of belatedness and catching up with the modern "West" or simply "Europe," feature prominently in both Slovenia's popular and academic discourses, though less so now that the country has been accorded a place first within NATO and then the European Union.

So, in thinking about "different" responses to Tagore coming from the "margins" of Europe, we might ask: What of the fellow poets and like-minded individuals from within Europe who endorsed Tagore's literary and intellectual credentials outside the confines of an imposed or self-styled mystic identity? Or who looked to Tagore from a strongly felt sense of identification or sympathy derived from perceiving a common cause with the poet, rather than from a sense of having to assert an unbridgeable (cultural) difference and, ultimately, superiority. The notion of *situational identification* which I develop might be more appropriate here by way of theorizing these kinds of responses than the more conventional postcolonial models of cross-cultural encounters we are familiar with.

Furthermore, in contrast to Tagore's famous cross-cultural literary encounters, most notably, with W.B. Yeats, or Ezra Pound, or even André Gide, the case of Kosovel followed a one-way trajectory. The young poet died just months before Tagore traveled to former Yugoslavia in 1926, as part of his longest European tour, stopping for two days in Zagreb in present-day Croatia (a short distance away from Ljubljana, where Kosovel lived and worked for the most part of his short life), and then moving onto Belgrade, the capital of present-day Serbia. Tagore, we can safely assume, would not have heard of the Slovenian poet, who was then only just beginning to emerge as a literary figure (of a "national" reputation). Certainly, Kosovel wielded neither the influence nor the power of established poets à la Yeats, whose laudatory introduction to Tagore's English *Gitanjali* (1912) traveled far beyond the English-speaking environment, in many ways setting the tone to the chorus of worldwide adoration for the Indian poet. So perhaps the value of looking at his response then lies precisely in that Kosovel can be seen to be a representative of what Leela Gandhi, in her suggestively titled book *Affective Communities* (2006), has dubbed "western 'non-player[s]' in the drama of imperialism," but whose "minor" discourses are nevertheless a variation on the larger theme of anti-imperialism shared internationally by a small intellectual elite in the first decades of the twentieth century.[8]

[8] Leela Gandhi, *Affective Communities: Anticolonial Thought, Fin-de-Siècle Radicalism, and the Politics of Friendship* (Durham: Duke University Press, 2006), 1–2. Her context, however, are late Victorian radicals: vegetarian and

Albeit a small piece in the mosaic of Tagore's international reputa-
tion, I want to suggest that its significance extends beyond its arcane
historical value. Kosovel's response was in many ways representative of
the internationalist moment in which he participated whereby various
links and solidarities were being (imaginatively) forged across regions,
nations and continents to address the ills of modernity, of which imperi-
alism and nationalism, as both Tagore and Kosovel felt, were particularly
in need of addressing. While personal relationships and networks, real-
ized in practice through travel and correspondence, were indeed cru-
cial for creating worldwide platforms of solidarity in the early decades
of the twentieth century,[9] they were not, as Kosovel's example shows,
essential.

In other words, given the unilateral dimension of Kosovel–Tagore
"encounter" as well as the absence of direct historical links between the
two poets' respective countries, we are led to adjust the comparative
angle to consider correspondences and relations which are *not* primar-
ily guided by direct impact or exchange, but are the outcome rather of
negotiating a common (virtual) space of an emerging global modernity.[10]
Partha Mitter's concept of "virtual cosmopolis" to denote a shared
worldwide corpus of modern ideas, as well as ideas on modernity, with
which the metropolitan elites from both "center" and "periphery" of the
(pre-)industrialized world were grappling, sometimes through channels
of direct personal contact, but largely through the printed medium, will
therefore provide another relevant framework for linking the two writers

animal-rights campaigners, anti-vivisectionists, theosophists, homosexuals,
who, she argues, all articulated their singular programs as a variation on the
theme of anti-imperial politics. Her fresh perspective seeks "discursive and ethi-
cal continuities between the critic of the fox hunt and the critic of the empire"
on the grounds that the two are joined by opposition to the binarism of imperial
reason that insists on dichotomies between races, cultures, genders, sexualities,
etc. p.11.

[9] Elleke Boehmer has written pertinently on the subject in the context of
cross-colonial relations, see her book *Empire, the National, and the Postcolonial
1890–1920* (Oxford: Oxford University Press, 2002).

[10] It was only in the early 1960s, when Yugoslavia joined the Non-Aligned
movement that Slovenia, as one of the republics of the socialist federation, forged
direct political links with India.

across their vastly different cultural and geopolitical spaces, and take us beyond the more conventional model of direct influence.[11]

Two sets of questions present themselves here. On the one hand, we might ask, why did Kosovel feel drawn to the Indian poet in the first place? How did he incorporate and assimilate what he read into his own poetic and intellectual horizon? In what way did this serve his pre-occupations and interests? But on the other, it is the correspondences, or deeper unities that underlie the connections that Kosovel makes with Tagore—not merely through the historical and political but also through the quotidian, the mundane and the ahistorical—that offer a more unex-pected and therefore richer texture to what was an emerging "new 'world order'" not just in global politics and economics, but also in literature.[12]

Linn Cary Mehta has made an important point with reference to a number of poets of decolonization from Asia, Africa, Latin America, and the Caribbean that poetry of the early twentieth century "stands at the fulcrum of the world literary tradition," meaning that from that moment onwards "the world [could] no longer be divided into two literary hemi-spheres, into the European and non-European [...] or into first-world and third-world literature."[13] The sort of cross-fertilization and inter-nationalism that characterizes the poetry of decolonization would also seem to be consciously motivated by the idea that it was from within one's own "tradition" that one worked toward a "universal" tradition, opening up one's language, whether a vernacular or an adopted colonial tongue, for the experience of "the other." Kosovel's aspirations for an ideal "universal artist," as he noted in his journal, someone who in the style of writing would not be "patriotically local" but "*humanly universal*" can be productively related to his search for a poetic form that would capture the larger concerns of his age.[14] To align him with other thinkers and poets of resistance and decolonization is certainly one way in which his poetry can be opened up to fresh interpretations, an approach that

[11] Partha Mitter, *The Triumph of Modernism: India's Artists and the Avant-Garde, 1922–1947* (London: Reaktion Books, 2007), 11–12.

[12] Linn Cary Mehta, *Poetry and Decolonization: Tagore, Yeats, Senghor, Cesaire and Neruda, 1914–1950* (Ph.D. thesis, 2004, Columbia University), 15.

[13] Ibid., 2.

[14] Srečko Kosovel *Zbrano Delo [Collected Works] 3*, prvi del [part one], ed. by Anton Ocvirk (Ljubljana: DZS, 1977) (henceforth referred to as CW3), 750.

is largely validated through his reading of Tagore but also, as we shall see, through his frequent expressions of solidarity with the colonized the world over.

Many intellectuals and avant-garde artists of the 1920s, including Kosovel, today considered as the foremost Slovene avant-garde voice of the interwar period, raised a vocal protest against aspects of European civilization and some of its certainties. And it would seem that their protest is not unrelated to the emergence of new colonial writers and their presence in avant-garde circles in the West, whose own concerns posed a challenge to European cultural authority and contributed to the "volatile new cosmopolitan climate."[15] Cultural and aesthetic influences appear to have moved in multiple directions as nineteenth-century forms were being superseded by more revolutionary modernist aesthetics. That Kosovel's avant-garde poetics is visibly indebted to his reading of Tagore, himself a forerunner of postcolonial modernism, would be a case in point.

What links the two poets across the distance was therefore not just the fact that Kosovel read and took inspiration from the Bengali poet, but that they shared a remarkable set of preoccupations. I contend that these commonalities, the overarching expression of which is a creative ideal of universality, have a backdrop in *structurally* similar, if by no means identical, forces of political and cultural subjugation. As we consider the particulars of Kosovel's historical positioning, from which he sympathetically reached out to Tagore and took lessons from him, it will become clear that like Tagore, Kosovel too understood the pressures and dilemmas pertaining to a people dominated by another. Interestingly too, with regard to those pressures and dilemmas, he offered some remarkably "Tagorean" answers.

It is particularly the anti-nationalist theme and its resolve in a "universalism" that will guide the discussion on these pages, as we consider the various aspects of Kosovel's *identification* with Tagore. For what unites these two thinkers across their respective "colonized" margins (the term will be qualified in relation to Kosovel) is that at a time when—and from within a context in which—across the world, there was a "normalisation of the national principle as one that orders 'races'

[15] Elleke Boehmer, *Colonial and Postcolonial Literature* (Oxford: Oxford University Press, 1995), 123.

into states"[16]; when, in other words, the only way to claim a legitimate status to equality and independence or self-determination was through organizing yourself into a nation with a state—these two poets sounded a warning signal against the hegemony of this principle. Put differently; in an age of compulsory nationalisms, they refused to—drawing on Zachariah's provocative title—*Play the Nation Game*. Tagore did so quite literally when he pulled out of the Swadeshi movement, the first popular anticolonial movement in India sparked off by Lord Curzon's proposed partition of Bengal in 1905, and in which he had vigorously participated for a brief few months, and Kosovel by practically screaming from the rooftops that "nationalism is a lie." They were not sore losers, intent on spoiling the game, but wanted to subvert an ideology they considered dangerous and misguided.

Both wrote from an acute awareness of their region's subjugated status and both endorsed an anti-imperialist stance, but one that rejected nationalism as a viable means of liberation, embracing instead a *creative, universalist ideal*. Since the only way to be anti-imperial in those days was to be a nationalist, such anti-nationalist sentiments were deemed suspect.[17] What, in turn, was the "universal" they reached for by

[16] Benjamin Zachariah, *Playing the Nation Game; The Ambiguities of Nationalism in India* (New Delhi: Yoda Press, 2001), 182.

[17] The suspicion still hovers in the many attempts by scholars to mitigate, for example, Tagore's anti-nationalist sentiments or to qualify his "nationalism" as being poised only against certain "bad" forms of nationalism—the more extreme, aggressive, exclusionary, or top-down variants—while itself standing in for a nationalism that is good, desirable and necessary. A recent awkward attempt to redeem a form of progressive nationalism in relation to Tagore in particular and India more generally has come from the historian Sugata Bose, claiming that "the nationalisms in Asia have always been fused with universalism." See "Tagore fused Indian nationalism & Asian Universalism: Sugata Bose," in *Bengal Post*, Tuesday, December 18, 2012. (Supposedly that makes them better than nationalisms elsewhere in the world.) This welding together of "Indian nationalism" and "Asian universalism" obfuscates more than it helps to explain. It is unclear what exactly "Asian" and "Indian" are meant to signify in this case, and it also suggests the "universal" must always proceed through the "national." Tagore, however, rejected the "nation" both as a state and a people legitimized by the state. This false dichotomous view of nationality and universality in fact undermines the "true" emancipatory potential of a nonhegemonic universalism that proceeds

way of transcending categories of nation and ideologies of nationalism they found so problematic? Was this a category that supposedly already existed, or was it a category in the making—an open-ended concept? And if open rather than predetermined, descriptive rather than prescriptive, then how was it to be created?

Situational Identification: Limits of "Orientalism"

Tagore was a poet and thinker Kosovel read with great interest, at the same time urging other people to do so, convinced that here was someone who was able to show a new path out of the crisis Europe in general and the Slovenian people in particular were experiencing in the disillusionment years of First World War. There are a number of interrelated ways in which Kosovel's keen response to the Indian poet can be made sense of. The most obvious is to see in Tagore's attraction for Kosovel yet another predictable response coming from "the West" from within the romantic and "Orientalist" tradition of Europe's enchantment with "Eastern" thought and art. Some of the qualities Kosovel perceived in Tagore, notions such as "simplicity," "naturalness," "child-likeness," as also his comparing the power of Tagore's language to that of the gospels,[18] are indeed all part and parcel of the dominant tropes that guided the imaginations of Europeans when they turned toward "the East" in the early decades of the twentieth century. Kosovel's most explicit tribute to Tagore in his creative writing, the poem called "In Green India," which imagines the Indian poet dwelling "among silent trees" in a symbolist meditation on timelessness and life caught "like eternity [...] in a tree,"[19] is a case in point.

from a direct link between individuality and universality. In my analysis this is Tagore's contribution to the universalist debate, as he rejected, most forcefully, *all* forms of nationalism, including the Indian variants.

[18] Kosovel, CW 3, 56, 509, 558.

[19] Srečko Kosovel, *Look Back Look Ahead*, tr. by Ana Jelnikar and Barbara Siegel Carlson (New York: Ugly Duckling Presse, 2010), 96.

But to stop here would be to stop short of more fully appreciating why Tagore was so important to Kosovel or how even some of these same concepts might have actually contributed to the project of individual and collective emancipation both poets seem to have shared. For all the enthusiasm the young Srečko felt toward his older Indian contemporary, there was little of blind veneration in the way he perceived him. Rather Kosovel studied his philosophical writings and poetry seriously, taking "lessons" from him when they struck a chord, and urging others to do the same.[20] Significantly, when works were not yet available in Slovenian translation, as was the case with *Nationalism*, *Sadhana*, and *Personality*, he got hold of them in German and Serbo-Croatian (the languages he could read alongside French, Italian, and Russian).[21]

Furthermore, the "Orientalism" at work here (i.e. Western ideas about "the Orient") cannot be that of the Saidian mould, motivated by ambitions to dominate over "the East" or secure a sense of a positive, superior identity for itself. Or, argued differently, in as much as Kosovel's response to Tagore, in itself emblematic of a host of other similar European responses, known and unknown to us, is still seen to operate within the twentieth century "Orientalist" discourse of "Otherness," then it must be acknowledged, as J.J. Clarke has argued in his reassessment of "Orientalism" that there can be, as indeed there was, a counter-hegemonic cultural drive to this phenomenon. Without disputing the basic premise that when Western thinkers drew on Eastern thought—the religious and philosophical ideas of India, China and Japan—they did so

[20] From the exchange of letters that passed between him, his family, friends and associates, many of whom were at the time living abroad (in Munich, Paris, Prague, and Trieste), it becomes clear that there was in fact a whole group of young Slovenian writers, musicians, and artists who responded to Tagore from a deeply-felt creative need that went beyond mere fashion.

[21] From his letters and journals it can be established that he read *Sadhana* in German, as also *Personality* (*Persönlichkeit*, CW 3, 683), but *Nationalism* was available to him in German or Croatian (tr Antun Barac), both published in 1922. Poetry, however, he read in Alojz Gradnik's Slovenian translations. The first collection to come out in Slovenian (translated from English) was *The Crescent Moon* (1917), to be sold out within months and republished in 1921. It was followed by: *Stray Birds* (1921), *The Gardener* (1922), *Fruit Gathering* (1922), and finally *The Gitanjali: Song Offerings* (1924).

in line with their own goals and pursuits, Clarke rightly argues that these ideas were "often in the business not of reinforcing Europe's established role and identity, but rather of undermining it."[22] They provided a source that would serve as a "corrective mirror" to Europe, undermining some of its certainties and orthodoxies. Put differently:

> The perceived otherness of the Orient is not exclusively one of mutual antipathy, nor just a means of affirming Europe's triumphant superiority, but also provides a conceptual framework that allows much fertile cross-referencing, the discovery of similarities, analogies, and models.[23]

Indeed, a more open and reciprocal model of "otherness" and inter-cultural (-textual) encounters is needed, if we are to more fully understand some of the responses to the Indian poet coming from "the West." The talk of "crisis" or "sickness" besetting "Western civilization" and of the need to turn "Eastwards" for cure certainly offers another lens through which Kosovel's championing of Tagore can be made sense of.

Imre Bangha has pointed out with respect to Hungary how Tagore's greatest supporters were to be found among the readers and writers who were born or lived in regions "lost" after WWI, and how they would often sympathize with the Indian freedom struggle as opposed to the colonizer's viewpoint.[24] Something similar can be said of Kosovel whose hometown was "lost" to Italy following the collapse of the Austro-Hungarian Empire. Certainly, within Europe, there were many individuals and groups who celebrated Tagore from their own real or imagined position of "Otherness." Their cross-cultural response was framed by their perceived sense of commonality and joint purpose with the Indian poet and they genuinely looked to Tagore for moral sustenance as well as alternatives to some of the dualist thinking that drives hegemonic ideologies.

In that sense, a useful way of framing Kosovel's response to Tagore is to see it in terms of a *situational identification* where sympathies

[22] J.J. Clarke, *Oriental Enlightenment: The Encounter between Asian and Western Thought* (London: Routledge, 1997), 27.

[23] Ibid.

[24] Imre Bangha, *Hungry Tiger: Encounters between Hungarian and Bengali Literary Cultures* (New Delhi: Sahitya Akademi, 2008), 15.

are forged between individuals and inspirations derived from a sense of shared predicaments, or as Hogan puts it, "we develop an immediate sense of intimacy with someone as we intuit shared feelings, ideas, references, [and] expectations."[25] For Kosovel, reading Tagore meant encountering a voice that shared some of the age's deepest cultural and intellectual concerns, spanning nationalism, scientific and technological revolutions, environmentalism and feminism alike, and which helped him think through these pressing issues. It is therefore more in the spirit of parity that Kosovel approaches Tagore, as opposed to an "Eastern guru" at whose feet one should sit, or, following the colonial mindset, "an Oriental" who deserves to be patronized.[26] To press the notion of situational identification further, however, we need to understand Kosovel's own lived experience of nationalism (vis-à-vis his experiences of internationalism and cosmopolitanism). For it was the political circumstances of the early decades of the twentieth century, as Slovenes were caught in the cross-fire of a number of aggressive nationalisms (external and internal), that in large part galvanized the poet to grapple with the problematic of "nation," "nationalism," and "nationhood."

Cosmopolitan Background: Virtual or Real

Srečko Kosovel was born in 1904 in the town of Sežana not far from Trieste in what was then the Austro-Hungarian Empire. He was brought

[25] Patrick Colm Hogan, *Empire and Poetic Voice: Cognitive and Cultural Studies of Literary Tradition and Colonialism* (Albany: State University of New York Press, 2004), 26.

[26] In fact, Tagore's popularity in Slovenia, from its very beginning, was connected less with the romantic side of "Orientalism" that looked towards India for a redemptive spiritual injection and saw in Tagore above all an exotic and sage-like figure, than with a sense of identification with the poet and his people, derived from a perceived common goal of striving after political and cultural independence. I have written elsewhere on Tagore's reception amongst the Slovenes and in former Yugoslavia, so will not go over the subject again here. See Ana Jelnikar, "Turning 'East': Orientalist Variations on Tagore from the 'Eastern Corner of Europe,'" in *Rabindranath Tagore: A Timeless Mind* (London: The Tagore Centre UK, 2011), 165–78.

up in a well-established and respected family as the youngest of five children. His father Anton was a school teacher and headmaster who taught in the Slovene language. He belonged to the generation of teachers who still felt their vocation as a "national" mission to defend and cultivate a language and culture against assimilative pressures of foreign rule. Also a musician (a choirmaster and an organ player) with an avid interest in farming, he made sure that his children were given a broad education spanning cultural and economic matters. By the age of seven, they were learning French, Russian, and German. Anton's proud Slovenian stance, however, often got the family into trouble with the Austrian authorities. Soon after Srečko was born, they were made to move to the nearby town of Pliskovica. Two years later, they were forced to move again, this time to Tomaj, where they settled for good. Tomaj was a village of a slightly more than 600 inhabitants, predominantly wine and wheat producers, battling the harsh conditions of the wind-swept, arid landscape of the Karst region. If Srečko inherited some of Anton's passion for Slovenian matters (and notwithstanding the fact that he did not follow his father's wishes that he become a forester and help develop the region), he took from his mother, Katarina Stres, a defiant streak and a deep curiosity about the world. As a young girl with little formal education, Katarina had rebelled against her own parents, refusing to marry the man that they had chosen for her. She ran away from her native village of Sužid to the city of Trieste—the cosmopolitan hub of old Austria. There she had taken up with a Greek noble family, the Scaramagnas, as a nanny for their two daughters.

Srečko's childhood years were interrupted by the outbreak of the First World War. A new front opened up along the river Soča (Isonzo), not even fifteen miles to the west of Tomaj, where some of the fiercest fighting between the Austrians and Italians took place. His parents sent the twelve-year-old boy, together with his sister Anica, to Ljubljana (Laibach, as it was known then, was a provincial town of some 50,000 inhabitants at the Empire's southern extreme). By then he had already seen the horrors of war from up close, and his childhood innocence soon passed into knowledge of death. For the remaining decade of his short life, Kosovel lived in Ljubljana, returning home only for the summer and during term

breaks.[27] During these holidays, he often visited Trieste, which together with his native Karst, and adopted home of Ljubljana, was one of the three major locales defining the spatial geography of his life. A brief look at Trieste's turn-of-the-twentieth-century history, the shifting political designations of the city and its hinterland of what historians refer to as "the Adriatic boundary region,"[28] will help us situate Kosovel not just in relation to Slovenes and Europeans but also open up the broader logic behind his *identification* with Tagore.

Trieste was brought into the modern world in the eighteenth and nineteenth centuries by the Habsburgs who declared it a free port in 1719, and, not unlike Calcutta, was transformed from a small fishing village into an imperial city.[29] For generations, political antipathies between subjects and rulers notwithstanding, this contemporary of Calcutta thrived as a commercial and trading port, largely unperturbed by notions of ethnicity, race or religion. In his eloquent study *The Years of Bloom* (2000), John McCourt, describing James Joyce's long-standing relationship with the city, tells us that Trieste of the early twentieth century was "the third urban centre in the empire after Vienna and Prague [and] the world's seventh busiest port."[30] Located at the cross-roads of competing cultures, this "dynamic city characterized by commercial solidity and

[27] For biographical details, I draw on Aleš Berger, *Srečko Kosovel* (Ljubljana: Zbirka Obrazi, 1982); Mira Cenčič, "Življenjsko okolje Srečka Kosovela" [Living Environment of SK], *Primorska srečanja*, 277, 8 (2004): 8–12. Marija Ravbar Jelen, "Kosovelova domačija" [Kosovel's Homestead], *Primorska srečanja*, 273 (2004): 38–41; Nadja Mislej-Božič, "Pravili so mu Pilat; Pogovor z Dragico Sosič" [They Called him Pilate: In Conversation with Dragica Sosič], *Primorska srečanja* 273 (2004): 51–57.

[28] Glenda Sluga, *Difference, Identity, and Sovereignty in Twentieth-Century Europe: The Problem of Trieste and the Italo-Yugoslav Border* (New York: State University of New York Press, 2001), 13.

[29] This comparison occurred to me while reading Jan Morris's book on Trieste, where she mentions other "imperial cities" including Calcutta. Jan Morris, *Trieste and the Meaning of Nowhere* Cambridge (MA: Da Capo Press, 2001), 26.

[30] John McCourt, *The Years of Bloom: James Joyce in Trieste, 1904–1920* (Dublin: The Lilliput Press, 2001), 29.

also notable for its intellectual curiosity and openness" was a melting pot of nationalities, languages and cultures.[31] The diverse and hybrid character of its population in the wake of rapid urbanization encouraged by its status as a free port soon turned Trieste into a microcosm of Europe, bringing together Italians, Austrians, Germans, Slovenes as the largest ethnic Slav minority, alongside Croatians, Serbs, Bosnians, as well as Greeks, Armenians, Hungarians, Jews, English, and others. The mix of nationalities and cultures that came to participate in the region persistently frustrated attempts at neat classification based on absolutes of national difference, while at the same time inviting precisely such clean-cut categorizations. As cogently argued by Sluga, the history of Trieste (Triest for Austrians and Trst for Slovenes and Croats) was vitally bound up with the representation of cultural/ethnic/racial difference of its diverse populace, where models of heterogeneous identity clashed and competed with essentialist models grounded in homogeneity.[32]

Before the war, the Kosovel children would often go to Trieste to see a Strindberg or an Ibsen play at the popular Teatro Verdi or Teatro Rossetti, as well as performances at the Slovenian theatre house, founded in 1903 as the first Slovenian theatre.[33] One would like to imagine that they may have sat in the same audiences as James Joyce, or that Kosovel may have strolled along the stretch of coastline from Trieste to one of his favorite places, Duino (Devin), while Rilke was composing his *Duino Elegies* at the castle situated just above. While today the city is predominantly Italian, with Slovenes forming a small ethnic minority, the turn-of-the-century Trieste had a Slovenian population bigger than that of Ljubljana.[34] It was considered an important center of Slovenian culture, where cultural institutions were established soon after the revolutionary

[31] Ibid., 30.

[32] Sluga, 17; see also pp. 12–38 for a range of references to nineteenth-century anthropological and ethnographic studies, preoccupied with classifying cultural/national difference in the region.

[33] Pahor, Boris, "Srečko Kosovel v Trstu" [SK in Trieste], in Stano Kosovel et al. (eds), *Srečko Kosovel v Trstu* (Trst: Zaliv, 1971): 23–44 (25).

[34] According to 1910 Austrian census "the city of Trieste was 62 percent Italian, and 25 to 30 percent Slovene," Sluga, 30. Slovene historians have adopted these figures, invariably quoting 60,000 as the number for Triestine Slovenes and 52,000 for Ljubljana's Slovene population.

year of 1848, and the Slovene political party *Edinost* ("Unity") was founded as early as in 1874. At the same time—and importantly so for young Kosovel—it was a rich and vibrant cosmopolitan city.

In the course of the late nineteenth and early twentieth century, as different narratives of national identities were being constructed, Trieste and the boundary region were transformed from what was "imaginatively represented as mixed" into "an unproblematically 'Italian' space."[35] In the decades leading up to the collapse of the Empire, the city's multiethnic composition, thoroughly shaken through the consequences of war and further unsettled by revived old enmities between Italians and Slavs, crumbled into factions vying for their political dues: "Slavic propagandists championed the rights of the Slovene and Croat populations" and "Italian nationalists clamoured for the redemption of 'Trento and Trieste', seeking to unite all Italian populations under the flag of Italy."[36] Racial bigotry erupted, and with the political barometer decidedly pro-Italian, Slavs became the butt of persecution.

Kosovel referred to the year of 1918 as a "catastrophic defeat" in which "our destiny was decided by foreigners and not ourselves."[37] He must have been referring to the Secret Treaty of London (1915), in which Britain had promised Italy the possession of swathes of territory as an incentive to enter the war on the side of the Entente: not only Trieste, but also the whole of eastern Adriatic coastal region (excluding the port town of Rijeka/Fiume), the islands off the coast of Istria and Dalmatia, as well as African colonies.[38] After the war, when Slovenes joined the new South-Slavic Kingdom of Serbs, Croats, and Slovenes (renamed Yugoslavia in 1927), the disputed border area was settled— with vital input from the international mediators—in favor of the Italian claims, though not nearly to the extent promised by the London Treaty. With the signing of the Rapallo Treaty in November 1920, which established the Italo-Yugoslav border, some 350,000 Slovenes and Croats

[35] Sluga, 6–7.

[36] Maura Hametz, *Making Trieste Italian, 1918–1954* (Woodbridge: Boydell Press, 2005), 14.

[37] Kosovel, CW3, 34.

[38] Sluga, 26.

were left to Italy.[39] The whole of Istria and Primorska (Slovene Littoral), including the Karst region that centers on the port of Trieste and the Isonzo valley with its main urban center in Gorica/Gorizia, were ceded to Italy.[40] With additional territorial losses in Southern Carinthia along the north frontier with Austria, these border adjustments effectively resulted in one third of the Slovenian population remaining outside the newly-formed state. Kosovel did not mince his words as he reflected on the situation:

> Slovenes are not finding it easy to cope in the midst of this sick European secret diplomacy, which bargains off territories of small peoples, appeasing their dumbfounded looks with the League of Nations, where sit the very people who had sold these territories, the very people who now tyrannize them.[41]

The "catastrophic defeat" Kosovel refers to was lent force by the policies of assimilation adopted by Italians toward Slovenes and Croats now living within Italy's borders. In Trieste, as noted by the scholar of Triestine culture Katia Pizzi, "a straightjacket of Italian officialdom was imposed on the city's multiethnic and multicultural identity, notably through acts of violence and persecution directed towards the Slovene community."[42] In 1920, the seat of Slav cultural life, the *Narodni Dom* (National Home), which housed the oldest Slovene bank, theater, library, and leisure associations, was torched by a mob with the consent of the Triestine police and authorities. This signaled the beginning of enforced assimilation, a doctrine which gained broad legitimacy as fascists came into power in 1922. Policies adopted between 1924 and 1927 "transformed five hundred Slovene and Croatian primary schools into Italian-language schools, deported one thousand 'Slavic' teachers

[39] Mitja Velikonja, "Slovenia's Yugoslav Century," in *Yugoslavism: Histories of a Failed Idea 1918–1992*, ed. Dejan Djokić (London: Hurst & Company, 2003): 84–99 (87).

[40] Jože Pirjevec, "Italian Politics Towards the Slovenes from 1915 to 1994," *Slovene Studies*, 15: 1–2 (1994): 63–73 (63).

[41] Kosovel, CW3, 40.

[42] Katia Pizzi, *A City in Search of an Author: The Literary Identity of Trieste* (London, Sheffield Academic Press, 2001), 243.

(personified as 'the resistance of a foreign race') to other parts of Italy, and closed around five hundred Slav societies and a slightly smaller number of libraries."[43] Kosovel's father, on the other hand, was forced to retire for refusing to abide by the Italian-only language policy, and was replaced by the more pliant Slovene Ivan Kosmina.[44] This brought the family severe financial difficulties. They even lost the roof over their heads, since their accommodation was tied to his father's teaching post. By 1926 non-Italian names had to be Italianized. By 1927, soon after Kosovel's death, the use of Slovene was prohibited in public. Slovene newspapers were banned and Slovene political parties dissolved. Many intellectuals and artists were forced into exile.

Unlike Joyce, who left the city once it succumbed to bigotry, Kosovel retained his links with Trieste after the war. He was particularly drawn to the important current of international socialism there, mediated to him by his Triestine Slovene friend Vladimir Martelanc, who supplied him with Marxist literature. Seeing the city regress into crude nationalism, Kosovel deplored both Italian irredentism and Slavic nationalism. "The heart-Trieste is sick," he wrote in the poem "Almost Midnight," and the city's setting became the locale for the apocalyptic vision expressed in the nine-part poem "Tragedy on the Ocean."[45]

If Italian irredentism[46] was one source of concern for Kosovel, the other was Yugoslav unitarism, as the centralizing tendencies of Belgrade were becoming more prominent. While most Slovene intellectuals accepted the newly-formed state of Yugoslavia, within which, for the first time, Slovenes were able to set up their own educational and cultural institutions—the Ljubljana University in 1919, the Slovene radio in 1928, and the Slovene Academy of Arts and Sciences in 1938—they were at

[43] Sluga, 48.

[44] In many instances, criteria other than ethnic such as class or economic came into play, complicating issues of identity. Many upwardly-mobile ethnic Slovenes, for instance, adopted Italian as their first language, setting their class allegiance above their ethnic belonging. See Hametz, 6.

[45] Kosovel, *Look Back, Look Ahead*, 46, 154–67.

[46] From *irredentismo*, the condition of being unredeemed, Italian irredentists were nationalists who, following Garibaldi's motto "free from the Alps to the Adriatic" saw Trieste as a natural—and unredeemed—part of Italy's unified body politic.

the same time eager to preserve the distinct language and by implication culture.[47] Kosovel's own response to the above questions at a time when the Yugoslav state centralism was gaining the upper hand (to culminate in King Alexander's dictatorship in 1929) is worth looking at.

Against charges of separatism leveled against Slovene critics of Yugoslav integralism,[48] Kosovel wrote a short essay entitled "*Separatisti*" ("Separatists," 1925). Predictably, it would seem, he stated: "Are a people automatically separatist, if they want to live? If they want to evolve, following their own path, and to crystallize their own body in their own spirit?"[49] If this amounts to an espousal of a classical separatist cultural nationalism,[50] in the very next line Kosovel interrogates the whole notion of "separatism" as it was used in political discourse as he lodges it in the very human condition: "Man is by his nature a separatist." Morevoer, Kosovel's concern seems to be with the individual rather than a collective:

> Walking down the street, you run into a friend. The friend wants to talk to you or simply feel your friendship, but, as it is, you are not in the mood. You know perfectly well that, feeling as you do, whatever you would say would come across as hurtful. So, you just want to go off, sit by yourself in a café, read a newspaper, and be with your own thoughts. You are—what else?—a separatist. Or, say you get invited to a dance. Though you love watching people enjoy themselves [...], you yourself prefer to keep a distance. Again, you are a dangerous separatist.[51]

[47] Velikonja, 89.

[48] The term itself and related charges regained political currency after the Second World War at the birth of second Yugoslavia, as Slovene critics of Yugoslav integralism were criticized as "egoists," "traitors," "separatists," "destroyers of Socialist Yugoslavia," etc., see Velikonja, 28, 94.

[49] Kosovel, CW3, 59.

[50] "Separatist cultural nationalism" is the designation and description for the dominant strain of Slovene 'nationalism' essentially based on "the nation's linguistic and cultural uniqueness vis-à-vis other South Slavs, rather than on myths of a glorious past and lost medieval kingdoms," see Andrew B. Wachtel, *Making a Nation, Breaking a Nation: Literature and Cultural Politics in Yugoslavia* (Stanford: Stanford University Press, 1998): 246.

[51] Ibid.

This rather tongue-in-cheek exposition of the individual's right to "separatism" then finally gets reconciled in a philosophy that carries an undeniable Tagorean imprint:

> All of us are walking with different faces, with distinct motives; each one of us has our own way, our own goal, and yet only seemingly so; in the depth of our souls we all strive for one thing: harmony [...] Let us be one in spirit and love, but maintain our own faces.[52]

Though spatially confined to a very small geographical area, comprising his childhood town of Tomaj, the closest urban center Trieste, and then Ljubljana, Kosovel, who desired to travel but never got a chance, nonetheless felt himself to be participating in a much larger arena, not least because he could perceive similarities in concerns with other parts of the world. The already mentioned concept of "virtual cosmopolis" (Partha Mitter), which takes on from Benedict Anderson's idea of "imagined community" based on print culture to explain how, for example, artists and intellectuals worldwide may have found themselves united in a front against urban industrial capitalism, or discern clear parallels between their own resistance to a Western imperialist power and someone else's critique of (aspects of) European civilization, is apt here.[53]

When Kosovel thought of the troubles of Primorska (the Slovenian Littoral) under Italian rule, he would align them with the "unnatural act" he saw in the "colonisation of the non-European peoples."[54] It was from this particular historical juncture that he also gained his sense of intimacy and shared concerns with Tagore. But if what we have sketched so far can be called the political geography to Kosovel's short life, there's also the related mental geography that was just as instrumental in influencing political decisions and historic events.

[52] Ibid., 59.
[53] Mitter, 11–12.
[54] Kosovel, CW 3, 65–66.

Mental Geographies

Another important aspect to Kosovel's situational identification with Tagore stems from the fact that both writers were perceived as occupants of the large ideological constructs of "the East." This mental geography lent legitimacy to the often violent repression of cultural and linguistic difference in the Adriatic border region by drawing on historical perceptions—and representations—of the antithetical notions of "East" and "West" within Europe. In this representational framework, different nationalities were accorded a separate racial status in a hierarchical setup: "Germans and Italians were regarded as cultural equals: bourgeois, modern, nationally evolved, and essentially Western," and "Slavs were backward peasants, lacking national consciousness, and Eastern."[55] What helped justify and consolidate the Italian claim to authority over the disputed area was their alleged racial, cultural and linguistic superiority. According to an Italian irredentist Virgino Gayda, for example, whose prewar writings were published in English and circulated internationally, Slovenes did not have a language, but a dialect. The fact that most Slovene Triestines were bilingual was seen as proof of their cultural backwardness. It pointed to a lack of national consciousness, their meekness, and suggested an essentially assimilatory character that could easily be subsumed into the superior *italianità*.[56]

Such valorizations of Italian culture, however, were no irredentist or fascist novelty but were grounded in a tradition of representation going back to the Enlightenment.[57] A host of Western literary and academic writing has over the centuries explicitly generated this bi-polar view of Europe, in which "Eastern Europe" or "the Balkan East" is imagined as the Western half's lesser other. These perceptions influenced political decisions on a number of levels. In relation to the Adriatic question, for example, British diplomats, harboring notions of the Slav's "doubtful

[55] Sluga, 2.

[56] Ibid., 27.

[57] For the classical study of this phenomenon, Larry Wolff, *Inventing Eastern Europe: The Map of Civilization on the Mind of the Enlightenment* (Stanford: Stanford University Press, 1994).

capacity for self-government," readily assented to Italian claims to the territory on grounds of their "cultural and political precedence."[58]

Apart from the fact that in the days of its maritime glory, the city of Trieste was commonly referred to as *la porta d'oriente*—the gateway to the East, for its real contact with the Orient,[59] the category of "East" as popularly understood by Italian Triestines or Western Europeans more generally, resonated with associations of territories and peoples within much closer proximity than the far-off world the city traded with. Often "the East" would be no further away than the rocky escarpment extending above the city known as *Kras* (*Carso* in Italian, and *Karst* in German).The identification of "Eastern" and/or "Balkan Slavs" with a backward rural folk as opposed to the modern and urbanized Italians was lent force by the physical geography in which Trieste stood apart from the mainly Slovene-populated villages atop the barren limestone plateau overlooking the city. In the wake of political conflicts pre- and post- both world wars, it gave rise to popular anxieties of Slavic invasion from the "barbarous East"—their descent from the mountains, as it were—so that Trieste became seen as the "last bulwark of the West in the face of cultural and psychological anarchies perceived as predominant in an aggressive East."[60]

Jan Morris lends her vivid voice to these perceptions of the region: "The permanent element of dissent in Trieste [...] its immovable reminder of an alternative world of strangeness, harsh challenge, mystery and unconvention [...] the city's real zone of disorder is the Karst."[61] Savage, dangerous, and set beyond the pale of civilization, the landscape

[58] Sluga, 35, 37. Robert Seton-Watson, the founder of the University of London's School of Slavonic and East European Studies, a one-time advisor to the British Foreign Office, and editor of the review *The New Europe*, wrote in one of his articles dealing with the Adriatic question that the region was "a centre of Italian culture and sentiment", and should be assigned to Italy "on moral and spiritual grounds," Ibid., 31.

[59] "Trieste became Europe's chief point of contact with the Orient, especially after the cutting of the Suez Canal: even the British, when they wanted to reach their Indian empire in a hurry, sent their mail and couriers across the continent by rail to Trieste, to pick up a Lloyd Adriatico packet to the east," Morris, 175.

[60] Pizzi, 157.

[61] Morris, 145–46.

invited associations with places much further removed in geography, but which lent themselves to a similar kind of romanticization or demonization. For example, Elizabeth Burton, the wife and biographer of the British explorer, writer and linguist Sir Richard Burton saw "the wild Karst" as "stony Syria."[62] Today little known, but in the turn-of-the-twentieth-century-Trieste a highly influential Jewish writer and journalist, Haydée (Ida Finzi; 1867–1946) would make African colonies and the Karst into interchangeable settings for her novel *Allieve di Quarta: Il Cuore delle bambine* (1922).[63]

Such conflation of categories and settings is commonplace in imperialist attitudes toward their colonies. Certainly, the more entrenched the essentialized perceptions of difference between Italians and Slavs became, the more divisive was the border separating them.[64] The bipolar imaginary of "us" and "them," coupled with a blanket treatment of the "other," presented one of the most formidable challenges to what Tagore and Kosovel both felt was the mission of their age.

Against this background, informed jointly by concrete historical events and representational practice thereof, broad discursive similarities between Tagore's and Kosovel's respective positions can be discerned. Both, in a sense, were projected as members of an inferior and governable race, Indian and (Balkan) Slav respectively with their respective identities were rehearsed through the common stock of racial platitudes (irrational, infantile, incapable of self-rule, lacking national

[62] Cited in McCourt, 30. Richard Burton was British consul in Trieste between 1872 and his death in 1890. His most celebrated book, the translation of *The Arabian Nights* (1885), was completed in his study in the Opicina/Opčine on the Karstic rim just above the city.

[63] For further detail cf. Pizzi 2001: 141–47.

[64] For the history of the extended contact between the Slovenes and Italians in Trieste and the forging of mythologies of "Italian" Trieste and "Slovene" Trieste, see Marina Cattaruzza, "Slovenes and Italians in Trieste, 1850–1914," in *Comparative Studies on Government and Non-Dominant Ethnic Groups in Europe 1890–1940*, vol. VIII, eds Max Engman, F.W. Carter, A.C. Hepburn, and C.G. Podey (Darthmouth: New York University Press, 1992), 189–217 and Marta Verginella, (2005) "Mit o Slovenskem Trstu" [Myth about the Slovenian Trieste'], *Zbornik prispevkov v počastitev 75-letnice prog. Sergia Tavana*, Nova Gorica: Goriški muzej, 91–104, respectively.

consciousness, backward, and so on) employed to validate the colonial mission on the one hand while bolstering the colonizer's sense of superior self on the other.[65] Both were at the receiving end of what Raymond F. Betts has termed "the peculiar geography of imperialism", whereby Western Europe was the center of the world, "radiat[ing] outward" from its core "those attributes we describe today as 'modern.'"[66] Not wanting to oversimplify what is indeed more complex a topic, I merely wish to restate that it is from this positioning in which Kosovel and the Slovenes under Italian occupation are culturally and politically oppressed (and ideologically othered) that he sees himself as occupying the same space vis-à-vis the imperial West as Tagore:

> At a time when we are being lashed by European imperialisms, we are down on our knees, praying to God to grant us our rights and give us righteous masters. And these masters let us have our God but take away all the rights God has given to man.[67]

It is also from this positioning that he extends his hand to Tagore in what Boehmer has evoked as "anticolonial hand-holding"—the resistance that emerges between "others."[68] But if Kosovel could understand the violence of a colonial encounter based on the binaries of imperial imagination, he could also understand the opportunities that came with cross-cultural contact. His artistic temperament in the final instance celebrates the meeting of "the East" and "the West," and he extends the notion of "the East" to encompass Asia:

> We happen to be living at the crossroads of Western and Eastern Europe, on the battlefront of Eastern culture with Western, in an age which is the most exciting and the most interesting in its multiplicity of idioms and movements in politics, economics and art, because our age carries within itself

[65] Being an Indian "aristocrat" belonging to an ancient civilization made Tagore acceptable to the British colonizers. He was knighted and awarded the Nobel Prize through British support. Nonetheless, if he refused to toe the line, he was demoted to an Indian "babu."

[66] Raymond F. Betts, *Decolonization* (New York: Routledge, 1998), 7.

[67] Kosovel, CW3, 35.

[68] Boehmer, 2002, 30.

all the idioms of the cultural and political past of Europe and possibly the future of Asia.[69]

The reference to Asia is no doubt an allusion to Tagore's own under-standing of Asia's future relationship with the world, which Kosovel was familiar with from reading his book *Nationalism* (to be discussed shortly). And the fact that Kosovel saw his own position defined in terms of an "East–West" juncture—at once a point of division and contact—enabled him to relate to Tagore's own project of exploiting the divide for a creative encounter: the forging of a new emancipated individual—"new man" or Tagore's "universal man"—who would somehow be free of these divisions.

Nationalism: A Lie and a Menace

The postwar situation alerted Kosovel to the pathology of national-ism and the raising of barriers along ethnic lines, where being Italian, German, Slovene or other, overrode notions of a shared human iden-tity or precluded the possibility of hybrid or multiple identities. It was also the cosmopolitan city of Trieste, in many ways a city he felt more at home in than in Ljubljana, that sensitized him to models of subjective identification that could either accommodate difference (the city before the war was a place where diverse groups were able to share the same territory without too much conflict) or violently repress it (as was the case once the city and its environs were designated as exclu-sively Italian and assimilation became the order of the day). The shifting political geography of the Adriatic region at once corroborated a sense of national identity and undermined it. The multiple names Kosovel was obliged to adopt as governments changed hands (under Austrians, *Srečko* meaning "lucky" became Felix, under Italians, he was Felice), reflect the political and cultural pressures he was under. Similarly, adop-tion of three passports in so short a life must have thrown the notion of nationality as something organic to one's identity seriously into question.

[69] Kosovel, CW3, 178.

Lines such as "Nationalism is a lie"[70] in Kosovel's poetry and other writings echo Tagore's own proclamation, "Nationalism is a great menace."[71] It is well known that after a brief stint with the Swadeshi movement, Tagore, upon seeing the movement's close alignment with Hindu revivalism leading to communal violence, withdrew all his support and became the most vociferous critic of *all* nationalisms, be it for imperial or anticolonial ends.[72] But even as he rejected the antico-lonial variety of nationalism, seeing it as basically flawed in that it was top-down and elitist, riding roughshod over the weaker segments of society, particularly the Muslim and Hindu poor, he held onto—and this is often missed—an anti-imperialist or anticolonialist position.[73] Or, from the opposite end, if Tagore's anticolonialism/imperialism is taken seriously, then, it seems, this can only be at the expense of his anti-nationalist critique, which, rather than being taken wholesale, as a *total* rejection of the phenomenon in all its disguises, gets reconfigured into a "nationalism" that is somehow desirable and acceptable, because inclusive (rather than aggressive and exclusive), or inflected with "universalism" and therefore "post-nationalist,"[74] or simply supplanted with "patriotism."[75] Scholars' reluctance to delink Tagore from the

[70] Kosovel, CWII, 31. See also his poem "Spherical Mirror," in Kosovel *Look Back, Look Ahead,* 126.

[71] Tagore, *Nationalism* (London: Macmillan and Co., 1917), 111.

[72] See Sumit Sarkar, *The Swadeshi Movement in Bengal 1903–1908* (New Delhi: People's Publishing House, 1973).

[73] Michael Collins makes this same point in his book on Tagore, and it is encouraging to have Collins proclaim outright "Tagore was not a nationalist in any analytically useful sense of the term" (p. 15), a claim that allows for bringing Tagore into a fresh historical focus.

[74] In *Culture and Imperialism* Edward Said writes about intellectuals of decolonization from various parts of the globe committed to what he calls a larger search for liberation, and Tagore is included in the ranks of the likes of C.L.R. James, Neruda, Cabral, Yeats, Fanon, and others. For them he invents the paradoxical category of "post-nationalist nationalism" to suggest their nationalisms were inflected with a universalist theme. Edward Said, *Culture and Imperialism* (London: Vintage, 1994), 270.

[75] Ashis Nandy, who has contributed significantly to the debate on Tagore's nationalism, asserts that Tagore's was the ideology of "patriotism" rather than nationalism. It was the poet's undeniable *Bharatchinta* or *swadeshchinta* (literally

designation "nationalist" has of course something to do with the fact that Tagore has had, for over a century now, the status of a "national" icon and is therefore a pole on which to hoist a national flag (Kosovel, we should add, is burdened with a similarly iconic status within the Slovene republic of letters). His "nationalism" is obligatory, as it were. The tension or paradox seems clear: how do we explain the fact that Partha Chatterjee's *foremost builder of a national culture* over the past two centuries "was at the same time one of the most vociferous critics of nationalism?" Why do we presume that he was a builder of a *national* culture? Moreover, it is precisely the latter, the fact that Tagore came to repudiate the modern idea of the nation-state in no uncertain terms, that presents "a serious problem" for Chatterjee.[76]

Chatterjee's problem with Tagore's critique of the nation (state) is that it is at once too one-sided and too absolute, seen "from a rather narrow and limited angle," for surely there are aspects of nation building that cannot simply be dismissed as "mechanical" or "interest-driven," the point Tagore harps on in his critique of the nation-state. With an explicit nod to Benedict Anderson, Chatterjee contends: "It is striking how much of our personal and even intimate lives—our habits and desires—are shaped by the literature, art, music, or advertising produced within the imagined community of the nation."[77] Though he takes Tagore's "trenchant critique of nationalism" seriously, he fails to see how Tagore's political thinking could be relevant to the "purposes of contemporary postcolonial world,"[78] beyond it being an "attractive" *aesthetically* motivated intellectual critique of modernity, propelled by an "urge for universality."[79] It would be hard to disagree with Chatterjee

"thinking about India or one's own country," terms borrowed from Arabindo Poddar) that, Nandy argues, underpinned his version of "universalism" and can be seen to convey an "idea of patriotism without 'nationalism'." See his *The Illegitimacy of Nationalism; Rabindranath Tagore and the Politics of Self* (New Delhi: Oxford University Press, 2005), 80–85.

[76] Partha Chatterjee, *Lineages of Political Society; Studies in Postcolonial Democracy* (New York: Columbia University Press, 2011), "Tagore's Non-Nation," 116.

[77] Ibid., 109.

[78] Ibid., 122.

[79] Ibid., 108.

that Tagore's political thinking cannot be made sense of from within a Marxist framework of critical thinking, nor with the fact that Tagore's project for an alternative community in "two or three villages" premised on interpersonal bonds of cooperation and mutual help, could realistically offer a viable alternative to the large imagined community of the nation. Yet, while these might all be considered serious problems, the question remains, why would Tagore even have wanted an alternative to something he did *not* acknowledge as legitimate or desirable (at least not in his post-Swadeshi period). It seems to me that the problem lies elsewhere: in the difficulty to nowadays think of Tagore's "political thinking" from outside the limits of a "nationalist" framework or the dictates of the "nation game," which has become the meta-narrative of so much of academic and intellectual pursuit as well. For surely Tagore was not self-consciously, or intrinsically, a "builder of a *national* culture" (my emphasis), a culture he, for one, did not believe in, since India for him was emphatically a "no-nation." It was rather already through the insidious workings of obligatory "nationalism," insidious, because "naturalized," that he was retrospectively fashioned into one.[80]

Consider this statement from Tagore's address to his students in 1908 later published as "*Purba o paschim*" ("East and West"), a statement which cannot be tallied with any geopolitically circumscribed notion of "India" or one that would operate in a prescriptive manner of identity politics:

> Who are we to say that this country is ours alone? In fact, who is this "We"? Bengali, Marathi, or Punjabi, Hindu or Muslim? Only the larger "We" in whom all these—Hindu and Muslim and British and whoever else there be—must eventually unite, shall have the right to determine what is India and what is of the outside.[81]

[80] Benjamin Zachariah's notion of "residual nationalism" to suggest that nationalism has become so comfortable a garb it is worn without being noticed is highly apt in this context. See his paper, "Residual Nationalism and the Indian (Radical?) Intellectual on Indigenism, Authenticity and the Colonizer's Presents," in Debraj Bhattacharya, ed., *Of Matters Modern: The Experience of Modernity in Colonial and Post-colonial South Asia* (Calcutta: Seagull Books, 2008), 330–59.

[81] Tagore, "East and West," in *Towards Universal Man: Rabindranath Tagore*, ed. Bhattacharya Bhabani et al. (London: Asia Publishing House, 1961), 129–40 (133).

This quotation is interesting—in fact radical—not just because it explodes the idea of *ownership* of a particular territory, but also because it problematizes the imagined unity of the "nation" (if, for the sake of argument, we are to insist that India is a "nation") as something already out there, or achieved. It also raises the key question of boundaries. To evoke Homi Bhabha here might be apt. The "*inter*national dimension," that comes through Tagore's open-ended pluralist "We," is seen to fall as much within the "margins of the nation-space" as "in the boundaries *in-between* nations and peoples."[82] The unity Tagore speaks of cannot be a fantasy projection of a homogenizing oneness, but rather a basic acknowledgement of existing cultural heterogeneity from which it might then be possible to imagine an essentially deteritorrialized and open-ended notion of "India" (this was more easily imaginable *then* than it would be now). The diversity of peoples, languages and cultures that is India's reality, the "ambivalent nation-space" in Bhabha's language, is but "the crossroads to a new transnational culture" suggested by Tagore's "larger 'We'." Such a perspective, I wish to argue with Bhabha, is essentially "anti-nationalist,"[83] because it stands diametrically opposed to any bounded notion of "nation," not just with respect to the outside but also with respect to the inside. This fundamental acceptance of hybridity, which predates the arrival of the British, matched with a reluctance to re-purify oneself for strategic anticolonial or any other purposes, is what in my view gives Tagore's "political" thinking continued salience. It also brings both Tagore's and Kosovel's critiques of nationalisms grounded in their own respective experiences thereof close to Zachariah's over-arching point on the subject:

> [I]t is futile to search for a serviceable nationalism that is less than exclusion-ary or oppressive; nationalisms draw boundaries of inclusion and exclusion, impose belonging and non-belonging, and police these. Nationalism, even when it is a search for unifying factors, ends up squeezing or coercing iden-tities towards neat formulations that inevitably exclude.[84]

[82] Homi Bhabha, *Nation and Narration* (London: Routledge, 1990), 4.
[83] Ibid.
[84] Zachariah, *Playing the Nation Game*, 250–51.

Indeed, whether serving imperialist aggression or liberation movements, for Tagore nationalist ideologies resulted in social exclusion, entrenched hierarchies, and led to violence. As already mentioned, his most stringent critique of the cult of the nation came with the publication of *Nationalism* (1917), in which he also explicitly argued that imperialism and nationalism were two faces of the same monster.

For Tagore, "Nation" (capitalized to mean the nation-state and possibly to stress the dimensions of evil he came to associate with it) meant a population welded into a political and economic union for the purpose of commercial self-interest.[85] Its objectives were utilitarian and ignoble: efficiency and competition were placed in the service of material greed. The supreme ideals were "to gain and not to grow."[86] Nation-states generate wars and result in colonialism. Through the cult of nationalism and patriotism, they exploit mass psychology by legitimizing people's instincts of self-aggrandizement, imbuing them with an irrational pride in their race and hatred of others. Tagore warned that it was not the crowd but the individual who thinks, and pride tends to lead to moral blindness.[87]

Society on the other hand had no such ulterior motive but was based on natural regulation of individual ties and human relationships, so that ideals of life could be developed through mutual cooperation. [88] What allows for human perfection and prevents us from hurting each other are our higher moral ideals. And these own no geographical boundaries.[89] Tagore acknowledged that in human relations self-love and self-interest have a part to play, but as essentially baser traits, they remain dangerously incomplete if not balanced by nobler instincts of sympathy and mutual help. While self-respect is important, it should not be allowed to degenerate into egoism. [90]

[85] Tagore, "Nationalism," in *The English Writings of Rabindranath Tagore: Volume Two, Plays, Stories, Essays,* ed. Sisir Kumar Das (New Delhi: Sahitya Akademi, 1996), 421.

[86] Ibid., 448.

[87] Ibid., 428.

[88] Ibid., 422.

[89] Ibid., 442.

[90] Ibid., 446.

Professionalization versus socialization of a people, organized and mechanical versus natural and human—these are the poles between which Tagore's thinking moves, as he points out that Indian languages have no word for nation and that India should resist adopting this aspect of modernity.[91] Tagore was terrified of abstractions that ignored living reality and individual lives. "Nation" to him was such an abstraction. He compared it to a powerful anesthetic which dulled people's sense of moral responsibility and could lead them to terrible crimes.[92] The problem of nationalism, however, was not in it being a western ideology, but in it being an obstacle to the pursuit of greater human flourishing anywhere.

At the core of Tagore's moral philosophy was the belief that "men are so closely knit that when you strike others the blow comes back to yourself."[93] This led him to predict the eventual demise of nation-states and nationalisms. Given the falseness of Tagore's predictions, it is perhaps necessary to see his utopian construction of *samāj* in its proper place as "a politics of hope."[94]

Kosovel's thinking on this subject is directly indebted to Tagore, as evinced by an essay he wrote in 1923, and in which he drew substantially on Tagore's book *Nationalism*.[95] Entitled "Nationhood and Education,"[96] this essay, however, shows Kosovel to be grappling, in far more uncertain

[91] Ibid., 429.

[92] Ibid., 434.

[93] Ibid., 447.

[94] Rustom Bharucha, *Another Asia: Rabindranath Tagore and Okakura Tenshin* (New Delhi: Oxford University Press, 2006), 109. See also pp. 105–11 for Bharucha's retort to Partha Chatterjee's politically realist critique of Tagore's stance on the modern nation-state and nationalism.

[95] *Nationalism* became the book of the 1920s in Yugoslavia, cf. Svetozar Petrović, "Tagore in Yugoslavia," *Indian Literature*, 13, 2 (1992): 5–29. It is prescient that in 1990, with Yugoslavia on the brink of collapse into horrendous violence *Nationalism* was republished in Serbia in two thousand copies, and reprinted in 1992. But just as Tagore's anti-nationalist message went unheeded in his day, so it fell on deaf ears at the end of the twentieth century.

[96] "Narodnost in vzgoja" was published in *Učiteljski list* ("The Pedagogical Gazette"), a journal of the Association of Slavic pedagogical societies in Trieste, which gathered around it a group of socially committed Slovenian writers and publicists, with whom Kosovel collaborated.

terms than his Indian contemporary, with the problematic of "nation" (though Tagore's thinking on the subject is not without ambiguities either). Kosovel certainly decries nationalism, but at the same time he is trying to salvage the concept of *narod* (a people) from being hijacked by nationalism: "A *narod* for us can only ever mean a nation which has freed itself from nationalism."[97]

Drawing on Tagore's distinction between "Nation" and "society," Kosovel sets the negative "materialist" notion of Nation against a positive "spiritual" category of *narodnost* (nationhood), defined as "a sum total of all the elements of a people's spirituality."[98] So *narodnost* is meant to correspond with Tagore's definition of "society," and as a spiritual principle, while it can bind a particular people in unity, it rests on an assumption that cannot be delimited by geopolitical boundaries:

> "Nationhood" is a part of the human soul, and it is the basis from which culture emerges. But culture does not encompass the soul life of only one *narod*; it extends towards infinity [...] it is the outcome of man's striving to attain as closely as s/he can that spiritual beauty, goodness, that perfection which s/he intuits and knows exists. That goal is what defines human culture in general.[99]

Because this goal is generic of human culture per se, all peoples and individuals are "on their way towards perfection." Hard as it may be to define perfection—it can only be intuited—our contemplating it, in whatever shape or form, will safeguard us against egoistic impulses. "Perhaps the whole point of eternity," Kosovel's logic runs, "is in that it is there for us to tend toward."[100]

Driving a wedge between nationhood and nationalism meant for Kosovel demarcating the important sense of "national" selfhood from a self-indulgent celebration of one's own identity. Nationhood, in the final instance, was important, but it required a measure of selflessness, lest it should lead down "the wide road of national egoism."[101] Therefore,

[97] Kosovel, CW3, 624.
[98] Kosovel, CW 3, 66
[99] Ibid., 68.
[100] Ibid.
[101] Ibid., 67.

it remained vital to cultivate the perspective of "the soul." The problem with nationalism, however, was also in that it used nationhood to rally support for its essentially aggressive and expansionist goals. As urgent as the question of "Slovenianness" presented itself to Kosovel in this age of compulsory nationalisms, as recalcitrant, it seems, were his attempts to define it.

In a lesser-known poem, ironically titled "Italian Culture," Kosovel strives for a definition of "Slovenianness" that is worth looking at. The first stanza enumerates, line by line, the facts of fascist brutalities against Slovenes: the torching of the National House in Trieste in 1920, the burning of wheat fields, fascist threats during elections, Slovenian worker's homes on fire, etc. The next stanza, however, shifts dramatically in concern from "them" to "us" in these strange lines:

> Slovenianness is a Progressive Factor.
> Humanism is a Progressive Factor.
> A humanistic Slovenianness: synthesis of evolution.
> Gandhi, Gandhi, Gandhi![102]

Clearly Kosovel was searching for alternative models of resistance. As Slovenian cultural institutions were under attack in Trieste, Gandhi was launching his non-cooperation movement on the subcontinent in the attempt to oust the British. But it was not Gandhi the leader of non-cooperation that attracted Kosovel, but rather Gandhi who would not condone of violence as a means of reasserting one's identity. Slovenes, whatever they do, must not jeopardize human values.[103]

Both Kosovel and Tagore believed in the perfectibility of human beings, and "humanism" too, as the poem insists, is subject to evolution. Therefore, a possible way of out of the insoluble problematic of "nation" and "nationhood" was through an appeal to a *new* humanism. This is also what put "man" (i.e., human being; in Slovene the word *človek* is gender unmarked) at the heart of Kosovel's evocations in poetry, while

[102] Kosovel, *The Golden Boat*, tr. and ed. by Bert Pribac and David Brooks, assisted by Teja Brooks Pribac (Cambridge: Salt Publishing, 2008), 137.

[103] Kosovel, "A nation only becomes a nation when it becomes aware of its humanity," in a letter to his French teacher Dragan Šanda, dated September 15, 1925, CW 3, 323–24.

confronting art with a new set of questions, which effectively meant breaking with traditional representation in art. The shift from national to individual is also crucial here, as Kosovel insists that each and every person must go through "their own inner revolution [...] and have their coat of hypocrisy torn off". Only then, in the spirit of "truth" and "openness," will "*new* humanity" arise, and only "*new*" man will be able to create *new* art (original emphasis)."[104]

At the same time, Kosovel invoked solidarities of the downtrodden across the world, and not unlike Frantz Fanon—one of the more famous proponents of a "new humanism"—felt that humanity, somehow, belongs to the oppressed, and that it is now up to them/us to improve on the "universalist" claims of "Western civilization." [105] For, Europe, as Fanon famously proclaimed—and Kosovel would have agreed— produced "only a succession of negations of man, and an avalanche of murders."[106] The idea was to "try to create the whole man, whom Europe has been incapable of bringing to triumphant birth."[107] But ultimately, what this Martinique-born psychiatrist who joined the Algerian war of liberation, wanted, was to transcend the polarities between "us" and "them," "the colonizer" and "the colonized," and do away with, as he had put it, "the absurd drama others have staged round me" and "reach out for the universal [...] through one human being."[108] It is impossible here not to think of Kosovel's own evocation of such "one human being" in a manifesto he wrote in 1925 (but never published). Entitled "*Mehanikom*" ("To the Mechanics"), this is perhaps the most cogent expression of Kosovel's universalist aspirations. Here is but an excerpt:

> Dawn is breaking! Can you feel the shimmer? There are no more peoples [i.e. *narod*-s], no nation states, no humanity. There is one Man standing

[104] Kosovel, CW 3, 98–99.

[105] Kosovel: "Only those who are suppressed can feel and create new justice, a new world built for Man," and "only in a mighty phalanx of all who are suppressed lies our salvation," CW3, 49.

[106] Frantz Fanon, *The Wretched of the Earth*, tr. by Constance Farrington (New York: Grove Press, 1963), 236.

[107] Ibid., 252.

[108] Fanon, *Frantz, Black Skin, White Masks*, tr. by Charles Lam Markmann (London: Pluto Press, 1986), 197.

in the centre of the world [...] One Man, and everyone around him is his different faces. (Is he a miner, a tanner, a docker, a peasant, a functionary, a writer, an intellectual or a beggar, I cannot make out. Is he a Slovene, a German, a Russian or a Frenchman, I do not know, I know only that I am awfully fond of this Man, whoever s/he is, whatever s/he is.[109]

Kosovel's "one man" could very well be the Fanonian "whole man," healed of the Manichean split produced by racial imagination (imperialist or anti-imperialist).

Certainly, the question of Italian dominance or "culture," to come back to the poem, was not a straightforward affair for Kosovel. In the same way that Tagore, despite the violence and humiliation of foreign rule, refused to succumb to an outright dismissal of everything British or, in turn, an uncritical valorization of everything Bengali/Indian, Kosovel too made it a point to discriminate between imperialist forces that deserve all reprobation and forces he felt were (for the) good even if from the wrong quarters. Both writers strove to override politics in an open acceptance of what they felt was commendable in any given culture, laying themselves open to charges of collaboration with imperialists or denationalized surrender. For indeed, as Tagore wrote, thinking of the relationship between the British and the Indians: "It will not do to blame them alone. We have to be prepared to take the blame on ourselves."[110] It is precisely the ability to transform "passionate self-other" debates into a "self-self" debate,[111] that sets a universalist quest into motion. Thus, in line with some of the most imaginative anticolonial or anti-imperialist responses across the globe, Tagore's and Kosovel's anti-imperialist stances commanded a pull away from nationalism toward a larger search for liberation and a more integrative and pluralistic view of humanity.[112] What they sought was much more than the simple departure of the

[109] Kosovel, CW 3, 114.

[110] Tagore, "East and West" in *Towards Universal Man,* 138.

[111] Nandy, *The Illegitimacy of Nationalism,* 82.

[112] Besides Fanon, one can think here of Ngũgĩ wa Thiong'o, a self-designated "unrepentant universalist" in his book *Moving the Centre: The Struggle for Cultural Freedoms,* London: James Currey, 1993, 17.

colonizers: there had to be a complex transformation of the colonized, else alien hegemony would merely be replaced by a home-grown one.[113]

If Kosovel perceived in Tagore a kindred spirit, this was because, sensitized by Slovenian circumstances, he was able to identify with him and relate to his historical predicament of colonial subjugation. Tagore's universalist philosophy certainly struck a chord with him, who saw his native region affected by imperialist forces, perceived as similar to those that subjugated India. Furthermore, he understood the plight of his native region in the larger context of the plight of all who are—in his own vocabulary—beaten, downtrodden, and subjugated. If the suffering of his own people was a symptom of wider social forces—namely those of capitalist Europe with its imperial onslaught on the rest of the world, and an outlook promoting sharp distinctions between races and civilizations—then Kosovel felt the solution too had to be sought on a global scale, in the ascendance of a new social order. This brings us to our last point in Kosovel's identification with Tagore, in which the Indian poet is co-opted into the ranks of the proletariat, the connection Kosovel made in a lecture he delivered to the miners in the industrial town of Zagorje shortly before he died.

Enter "East" again

Certainly for those writers who resisted the civilizational crisis in anti-bourgeois and anti-capitalist terms, the Russian revolution of 1917, offered a realistic hope, however short-lasting, for the ideal of a new, non-exploitative, classless society. Moreover, it unleashed what Timothy Brennan has argued was "a full-blown *culture* of anti-imperialism for the first time (emphasis author's)."[114] In wanting to reinstitute interwar Marxism with the recognition it deserves as a precursor to postcolonial

[113] See Nigel C. Gibson, *Fanon: The Postcolonial Imagination* (Cambridge: Polity Press, 2003), 179–80.

[114] Timothy Brennan, "Postcolonial Studies between the European Wars: An Intellectual History," in *Marxism, Modernity and Postcolonial Studies*, eds Crystal Bartolovich and Neil Lazarus (Cambridge: Cambridge University Press, 2002), 185–203 (19).

studies—for the parents to reclaim their orphaned child, as it were—Brennan submits that "the Russian Revolution [...] was an anticolonial revolution." This he takes to mean in "its sponsorship of anticolonial rhetoric" which "thrived in the art columns of left newspapers, cabarets or the political underground, mainstream radio, the cultural groups of the Popular Front, Bolshevik theater troupes," meeting with responses and contributions from "the various avant-garde arts."[115] Referring to the more dissident wings of European thought, Brennan gives ample evidence to counter the claim that anti-imperialist theory arose only after the Second World War. Even activist writers such as Frantz Fanon and Amilcar Cabral, the most formidable anti-imperialist voices of the 1950s and 1960s, belong to the lineage that is, the author states, a "direct product of interwar Marxism." But it was

> especially (and significantly) the Marxism of the Eastern periphery of Europe that played the largest role in nudging intellectuals into a liberatory view of non-Western societies between 1905 and 1939 [...] It was not the Frankfurt school but cultural Bolshevism and the larger networks of fellow travellers it spawned that made possible the early twentieth-century sensitivities towards colonial oppression.[116]

Locating the epicenter of anticolonial sentiment in the Russian revolution, the aftershocks of which were felt throughout the world, Brennan cannot overstate the implications of the revolution for the "the idea of the West." It "delivered Europe," he says, "into a radical non-Western curiosity and sympathy that had not existed in quite this way before." It "altered European agendas and tastes by situating the European in a global relationship that was previously unimaginable."[117]

If we now think back to Kosovel's sympathetic gesturing toward the non-Western world and recall his staunch anti-imperialist stance, his fascination with Tagore assumes a logic and relevance that is part of a more general moment in history when "a distant, instinctive reaction to the colonies,"[118] was inscribed, as it were, into the very logic of the social,

[115] Ibid., 192.
[116] Ibid., 190.
[117] Ibid., 192–93.
[118] Ibid., 195.

political, and artistic forces fuelling that moment. What, more precisely, is the logic that connects the proletarian revolution with the anti-imperialist energies?

While historians have pointed out that the imperial enterprise of the interwar years seemed for the most part quite secure, and for most people of Western imperialist nations "it was just there" either as "a source of national pride [...] a source of entertainment [or] a source of tales of daring," there was now "a small but vocal number of individuals" who profoundly questioned the world order, challenged the conceits associated with the alleged civilizing mission of the colonizers, and cast in doubt the civilization that made it possible.[119] In this respect, the Russian revolution, together with the Third International or Comintern (1919), was a vital source from which the historical lesson in self-liberation appeared to flow. And the idea of social revolution was now combined with anti-imperialist thought. This was because an analogy was being made between the capitalist's exploitation of the worker and the imperialist's exploitation of the colonized. Within such a framework, anticolonial or anti-imperialist protest is but an extrapolation of the Marxist critique of capitalism, the twin logic of which was compellingly elucidated by Vladimir Lenin in his book *Imperialism: The Highest Stage of Capitalism* (1920). For indeed, in this treatise, "Lenin assumes the social standpoint of those whom modern capitalism as a world system most exploits and oppresses, even when they are not 'proletarian' in a conventional sense."[120] I would even stress that for Kosovel, who subscribed to this view but was no blind admirer of the Soviet experiment, the "proletariat" was more or less interchangeable with the suppressed and the downtrodden, suggesting a more universal human condition. Though the poet was not himself always above a dualistic view of the world that pitted suppressors against the suppressed, in the final instance he did not permit himself the luxury of thinking that the solution to the "world problem" lay in a simple reversal of these dichotomies and

[119] Raymond F. Betts, *Decolonization* (New York: Routledge, 1998), 10–17.

[120] Neil Larsen, "Imperialism, Colonialism, Postcolonialism," in *A Companion to Postcolonial Studies*, eds Schwarz, Henry and Sangeeta Ray (London: Blackwell Publishers, 2000), 28–52.

the power structures they entailed: "In our innermost being, there are no classes or nations."[121]

When Kosovel turned toward "the East" for inspiration, anticipating a "new morning," this morning, he said, would come "in a red mantle," hence its irradiating core was the Soviet Union and not primarily "the Orient" of Tagore.[122] And yet, of course, the two were closely related. Hence, for Kosovel, Tagore belonged to those "intellectuals, famous artists and scientists" who had "joined the proletarian movement."[123] At some non-literalist level, in co-opting Tagore into the ranks of the "proletariat," Kosovel was in fact not off the mark, for in the way that he himself took inspiration from Russia—skeptical of its emerging "political dictatorship of the Bolsheviks," but full of praise for its vast and consistent efforts to bring education and culture to the Russian people[124]—was not at all dissimilar to Tagore's response to Russia in 1930, when he visited the country, coming away impressed with the Soviet education system and the alleged self-respect it brought to the peasant and the worker, but doubtful about the political direction it was taking.[125]

In an important aspect of Kosovel's identification with Tagore, the anti-capitalist and anticolonial struggles converged, so "the East" became as much the promise of a new world order associated with the Bolshevik Revolution as it was evocative of the old romantic "Orient" that would help heal the deep spiritual "crisis" of the postwar European generation.

Conclusions

I have stressed the links and associations that Kosovel surmised between himself and Tagore and which extended his vision beyond the borders

[121] Kosovel, CW 3, 102.

[122] Kosovel, CW3, 93.

[123] Kosovel, CW 3, 27.

[124] Ibid.

[125] See Tagore's "Conversations in Russia," in *The English Writings of Rabindranath Tagore: Volume Three, Miscellany*, ed. Sisir Kumar Das (New Delhi: Sahitya Akademi, 1996), 916–39.

of Europe to show, on the one hand, the two contemporaries sharing an (anti-nationalist) outlook from their respective "margins," but also to suggest that Kosovel's poetry should be read as part of a more complex, global configuration of anti-imperial politics and ethics. Both poets were acutely aware of the historical realities of his time, where a handful of Western powers had brought an overwhelming segment of the globe under imperial control, and both deplored the fact that the meeting of cultures had come largely on the back of conquest and colonization, rather than in a spirit of free exchange, but argued, against the odds, for a non-hierarchical dialogue between cultures. How to resist foreign impositions and yet not bar oneself from the discoveries of the modern age, whether in science, technology, economics, politics, art, or litera-ture; how to adjust creatively and retain agency as opposed to imitate slavishly or conform unthinkingly, and what are the implications of global expansion for individual and collective identities—were questions that preoccupied both thinkers. And these shared concerns were at least in part a result of being exposed to the same globalizing forces such as capitalism and imperialism and of intuiting common goals arising out of the consciousness of inhabiting *one* world as opposed to separate cul-tural enclaves.

Since both thinkers sought to transform anticolonial dissent into a creative project of liberation, with emphasis on creativity rather than (national) authenticity, it remains to be asked, what, in the final instance, is the "universal" they reached out for so as to break the historical impasse of what they felt was an intolerable choice, overdetermined by the either/ or logic: either to assimilate an "alien" modernity (and conform) or return to the spurious "authenticity" of pre-colonial origins (shutting oneself off from the modern-day developments). For both thinkers, in a sense, "celebrated" the expanded international stage that came on the back of imperialism, immigration, technological advances, and wanted to move beyond the static and oppositional view of civilizations to stress the limitless potential for everyone—the colonizer and the colonized alike—to realize a new, more consummate identity. So, the "universal" could not have been something already out there as a given, or a fixture to be emulated or imposed across the world. But neither was it a lack, rather it had to be a category always and already in the making but never

quite achieved. Subject to a (self-)critical engagement between various protagonists variously placed, "universality" was, in the final instance, an aspirational category. Or, as Ernesto Laclau has dubbed the "new" universal: "the symbol of a missing fullness."[126] The *golden boat* perhaps?

[126] Ernesto Laclau, "Universalism, Particularism, and Question of Identity," *The Identity in Question*, 61, (1992): 83–90 (89).

8

Meghnad Saha's Two International Faces: Politics in Science and Science in Politics between the Wars*

Robert S. Anderson

Almost all Indian historians and scientists think they know who Meghnad Saha was, what he stood for, and what he did. A widely respected figure whose image still spans the West Bengal–Bangladesh boundary, he had both an all-India and international reputation, which grew after his death in 1956. Yet he was a much more curious and surprising figure than his stylized public image of "heroic socialist–nationalist–scientist" suggests. He contested issues which others had not thought to, and sometimes contended with (even confronted) public figures whom

* I am most grateful to Benjamin Zachariah for an invitation to discuss Meghnad Saha's life and work at the Department of History at Presidency University in Kolkata in March 2013, and for the excellent questions raised there. This essay is a continuation of those conversations. My research is supported by the Social Science and Humanities Research Council of Canada.

others thought were beyond criticism. When his scientific reputation and political reputation came together we see him meet his greatest tests, and see his internationalism flourish, bending his international reputation back to national purposes. In 1942, Saha was starting to build, at the height of the war, a nuclear institute independent of universities, using rare international equipment (a cyclotron); he had already begun to be an important communicator about science and planning, and was trying to persuade India and Indians to follow an independent nuclear and industrial path.

In view of his deep belief in the value of the systematic application of the sciences and new technologies, he was asked to make compromises of his firm principles along the way. His success lay in the realization that he could not achieve his goals *unless* he made these compromises in order to continue doing scientific work and training students at a high level. It was more a political challenge than a scientific dilemma and his genius lay in his ability to rise to it by at least occasionally astute handling of his political masters as well as his peers. In this formidable task, for which his scientific career had provided no training, he was greatly aided by his international reputation during the twenty-four years between 1918 and 1942, a reputation which gave him usable leverage across India (and thus also "locally" in Bengal), and enabled him to launch his own strategy, one that entailed risks, some of which were partly of his own construction.

In this essay, I focus on four episodes in the evolution of Saha's work and reputation, all underscoring the complexities of the unavoidable correlations he had to effect between international influences and national exigencies. The first episode is his work in Calcutta using the literature in German physics journals in 1918 and 1919, coupled with the first translation (done with collaborators) and publication in English of two of Einstein's seminal articles (1905 and 1916); this leads to Saha's sojourn in London (1920) and particularly Berlin (1921), where he had both scientific and political involvements, one of them concealed and surprising. The second episode is the Royal Society of London's consideration of Saha's nomination and his election to be a Fellow (1925–27). The third is Saha's role in the beginning of national economic and industrial planning (1936–39), and the fourth, a set of abrupt changes brought about by wars in Europe and Asia, changes which Saha faced personally in 1941

and 1942. These episodes do not flow smoothly from one to another but have a kind of stochastic quality, appearing as abrupt because we are looking at each complicated context through the experience of one person. He turns out to be an intermediary figure, crossing numerous boundaries, even though his fascinating postcolonial roles cannot figure here in the interwar moment. By selecting four key moments from Saha's international engagements, we will have to neglect many transitional threads, along with weighty evidence of the local effects of his international influence; those transitions unfortunately have to be reduced to one or two sentences.

Since the broader outlines of Saha's life are now well known, I shall be selective in my choice of citations of material for this essay. In particular, I do not wish to appear to ignore the work of others by passing over or not mentioning commonly cited material, for example, articles by David DeVorkin on Saha's work on selective radiation pressure in the solar atmosphere and astrophysics generally,[1] and Abha Sur's *Dispersed Radiance*, which is focused on Saha and C.V. Raman.[2] Soma Banerjee's recent dissertation examines Saha's relationship with physicist Satyen Bose and Bose's relationship with Einstein.[3] The works of Sur and Banerjee are important in that both have also read sources in the Bangla language. My own recent (comparative) biography involving Saha (and others such as Bhatnagar, who is mentioned here) contains a fairly complete bibliography up until 2010.[4] There are numerous studies about aspects of his life (e.g., political speeches, collected scientific works) and of course Saha himself wrote prolifically, particularly in his own monthly journal *Science & Culture*.

[1] David DeVorkin, "Quantum Physics and the Stars (IV): Meghnad Saha's Fate," *Journal for the History of Astronomy*, 25 (1994), 155–88.

[2] Abha Sur, *Dispersed Radiance: Caste, Gender and Modern Science in India* (Delhi, Navayana Publishers, 2011).

[3] Somaditya Banerjee, "*Bhadralok* Physics and the Making of Modern Science in Colonial India," unpublished dissertation, University of British Columbia, 2013. Conversations with Dr Banerjee have been most valuable in this work.

[4] Robert Anderson, *Nucleus and Nation: Scientists, International Networks, and Power in India* (University of Chicago Press, 2010). Of course this essay here builds on the work of historians of science and technology such as Dhruv Raina, S. Irfan Habib, Deepak Kumar, and David Arnold.

Saha, German Physics in Calcutta, and Berlin 1918–21

As a seventeen-year old, living in Dacca, Saha seized a chance to learn the German language from a chemist who had returned from studies in Vienna. He could hardly have expected to use that language in Bengal, and he was not yet "a scientist," but somehow he judged this effort as valuable in itself. German achievements were thus established in his mind before the 1914 war, at which point he had just turned twenty, an accomplishment that earned him the nickname "Eigenschaften" at college in Calcutta.[5] He said years later "I was a regular reader of German journals" just after the conclusion of the war. Then when physicist D.M. Bose arrived home in 1918, having been interned as an alien in Germany, he and Saha (and friend Satyen Bose) began to discuss the research under way in Germany. As is well known, they decided to translate and publish two of the key papers of Albert Einstein and one by Hermann Minkowski, then available only in German. Saha translated Einstein's "On the Electrodynamics of Moving Bodies" published in 1905 and Minkowski's "Principle of Relativity" published in 1909 (he had been Einstein's mathematics teacher). Called "*Principles of Relativity*," this "first" book was a sensation and sold out quickly.[6] Saha became known to Einstein (and so of course did his friend and fellow-translator

[5] I agree with Abha Sur that it is a curious nickname for a teenager, but his friends might have misunderstood the term (in German) and felt it stood for "qualities" and/or "properties" which, in their opinions were sufficiently well known that they could be implied for Saha. I think Sur would know that teenage nickname logic is impenetrable.

[6] When the three editors/translators in Calcutta were ready to publish they needed Einstein's agreement. Having given the rights to his work to Methuen publishers in London, he received a protest from that publisher, trying to stop the University of Calcutta Press. Einstein intervened by deciding that if the book was circulated in India only, there was no conflict. The first printing sold out rapidly. It was called "*The Principle of Relativity*," published by the University of Calcutta Press, 1920; it contained an introduction by P.C. Mahalanobis and (1) Einstein's "*On the Electrodynamics of Moving Bodies*" published in 1905, translated by Saha; (2) Minkowski's "*Principle of Relativity*" published in 1909, translated by Saha; (3) Einstein's "*The Foundation of the Generalized Theory of*

Satyendranath Bose, later known, for convenience, as S.N. Bose). When Saha met Einstein two years later in Europe, the relationship became more personal. Though there were German speakers in Calcutta at the time, Saha would have had little contact with them; however there was an Austrian teacher at the Bengal Engineering College who was generous with his books, lending them to Saha. Saha published eleven papers up until he was awarded the DSc by the University of Calcutta in 1919, one of them being his famous article on the ionization of the solar chromosphere. The completion of his doctoral studies was soon followed by two prestigious traveling scholarships. His knowledge of German enabled him to read an important paper by John Eggert in 1919—about which he said later:

> I saw at once the importance of introducing the value of ionization potential in the formula of Eggert, for calculating accurately the ionization, single or multiple, of any particular element under any combination of temperature or pressure. I thus arrived at the formula which now goes by my name.[7]

It was probably then that he realized that he could use his scholarships to go first to Britain and then possibly Germany, perhaps to test his theory of ionization of particular elements at very high temperatures in order to accurately interpret the stellar spectra. Treading across the space between these two enemy nations was a new, risky, and thrilling kind of internationalism, as we shall see from the reception he received in London and then Berlin.

Saha arrived at the University of London in 1920; twenty-six-year old, he came without a specific place or supervisor for research on his theory of solar ionization. He wanted to work in Cambridge but could not afford to live there and had no "place" to land. He therefore stayed in London, which had not been his first choice, but was guided by friendly intermediaries to the lab and office in the University of London where he eventually worked. He already had his doctoral degree, and had received

Relativity" published in 1916, translated by Bose. I thank Soma Banerjee for this personal communication on May 4, 2013.

[7] Meghnad Saha to H.H. Plaskett, undated probably December 21, 1948, quoted by DeVorkin, "Quantum Physics and the Stars" and based on Saha Papers in Saha Institute Calcutta.

a kind of postdoctoral scholarship, allowing for travel. This scholarship enabled him to travel to Berlin in 1921, where he waited outside the lab of Walther Nernst (along with a dozen other University of London students including his new friend the chemist Shanti Bhatnagar from Lahore), all bearing a letter of introduction from the famous London chemistry professor F.G. Donnan. Nernst's lab had played a key role in the initial stages of chemical warfare research in 1914, but those technologies were further developed, tested, and proved for the German Army by Nernst's rival colleague Fritz Haber during the later stages of the war. Nernst (already famous for his knowledge of heat) was awarded the Nobel Prize for Chemistry for 1920 "for thermochemistry," in fact just as Saha arrived. Saha was most keen to see Nernst's student John Eggert, a specialist on photochemistry who was two years older than Saha and moving up quickly in Berlin. In the Friedrich Wilhelm University, of which his teacher Nernst had just become the Rector, Eggert was on his way to become professor of physical chemistry in 1924. However, Nernst at first refused to invite the London students in to his laboratories in 1921 on the grounds that the German researchers were still too sensitive about the outcome of the war. "Later on a note came addressed to Saha saying ... [that] Nernst would allow him and his Indian colleague Bhatnagar to see the laboratories because the last blow to the British Empire would come from India."[8] Saha set up an experiment in Nernst's laboratory even though, as he said later, he still could not conclusively verify his theory of thermal ionization in the experimental sense.[9] During this time in Berlin, Meghnad made acquaintance with Albert Einstein, Max Planck, Arnold Sommerfeld, and other European physicists, and also encountered for the first time influential Indians (such as Rabindranath Tagore and Muhammad Ali Jinnah) who were visiting Germany.

[8] Nora Richards, *Life and Work of Sir S.S. Bhatnagar* (Delhi, New Book Society, 1948), 61.

[9] Saha's authorized biography published in 1954 [hereinafter "Saha Biography"], S.N. Sen (ed.) *Professor Meghnad Saha: His Life, Work, and Philosophy* (Calcutta: MN Saha Sixtieth Birthday Committee, 1954), 15. Saha was soon to begin work on a textbook for students called "Treatise on Heat," published in many editions through to the 1950s, and from which he derived a steady if modest income. Nernst's more famous work was in 1907 and called by others his "heat theorem."

Berlin was a revolutionary, artistic, and intellectual center at this time, rivaling Paris, even in those Indian imaginations which were all otherwise naturally so fixed upon London. It was a place free of British influence, with many Germans genuinely interested in India. But Germany had lost a war and was experiencing humiliation and resentment in the postwar settlement. Saha had sympathy for the underdog and probably experienced a kind of quiet thrill, contemplating this "transgression," this crossing of a frontier between two opposing countries and cultures, one of which, Britain, he would like to have removed from his "own" space "at home."[10] The idea of a British departure from India was gaining momentum in Bengal. Here in Berlin, he would find contacts that had already been made by militant Bengali revolutionaries whom he admired; here were a number of people sympathetic to the subordinate condition of India. Here were impressive large industries run by people with scientific degrees that supported and employed other scientists and engineers. Here was industrial innovation. Saha's year in Berlin resulted in his first paper published in German in the *Zeitschrift für Physik* on a physical theory of stellar temperatures (1921). Just then Sir Ashutosh Mukherji, who had just been reappointed as Vice-Chancellor of the University of Calcutta, telegraphed an offer of a new chair in physics at Calcutta, which Saha, who had already been awarded a DSc degree, accepted. He returned to Calcutta in late 1921, at age 28. His international reputation was good, and he showed great promise; ten years later he would be at the heart of the politics of the scientific community throughout India, and fifteen years later he was planning for the independence of the nation and a new role for the scientific community in it.

At the same time, according to DeVorkin, "the image Saha wished to project in his letters from Berlin to people such as Hale and later to Russell, was of a poor transient whose fate was to return to a distant and ill-equipped outpost in his native land."[11] For years he tried to overturn the assumption among foreigners and some Indians that his important

[10] Sur subtly analyzes Saha's progressive social outlook and readiness to struggle in light, among other factors, of the position of the Saha caste-group in a much larger group of castes called the "nama-sudra" group, low in the ritual hierarchy yet (in the Saha case) mobile on the socioeconomic scale. See *Dispersed Radiance*.

[11] DeVorkin, *Quantum Physics*, 161.

work on solar physics had been done in London in 1920. This assumption was reproduced over and over again for other Indian scientists; for example, foreigners usually thought the "Bose" of the Bose–Einstein statistics was a German physicist because it was, after all, also a German name. Even those who did know Satyen Bose thought his crucial work had been done while he worked in Europe in 1924–26, instead of earlier in Calcutta and Dacca in 1920–24. It was entirely consistent with most assumptions about the origins of the Saha equation that it must have occurred to him while working in London or Berlin during his 1920–21 sojourn.

Exciting political contacts in Berlin were indeed made through M.N. Roy, who in 1921 was oscillating between Moscow and Berlin as a member of the highest committee in the international Communist movement (the Presidium). Knowing of Saha's relationship with the Jugantar Party, M.N. Roy persuaded him to become the keeper of a secret code for communication in Bengal with Nalini Gupta who had experience with munitions manufacture in Britain, and who was part of an effort to persuade Germany to finance a revolution on a major scale in India (which the Germans did not do). "Bagha" Jatin Mukherjee had been leader of the Jugantar Party, planning armed struggle in Bengal using German small arms and finances; when he was killed in 1915, he was incorporating a younger colleague named M.N. Roy (a *nom de guerre*) in his work. Mukherjee frequently ate in the student mess at 110 College Street in Calcutta where Saha stayed. According to his authorized biography "Saha's revolutionary friend 'Bagha' Jatin advised him to keep away from politics; the task of building the country was no less urgent. Saha agreed. But the revolutionary embers continued to glow."[12] However, it appears that Saha did not really commit to Mukherjee's advice, and was in fact involved in an attempt to receive guns from a ship landing on the coast in June 1915, when Saha was almost twenty-two.[13]

[12] Santimay Chatterjee, "Meghnad Saha: Scientist with a Vision," *Science Today*, February 1968, 46. See "German Conspiracy: The Organization of the Revolutionaries," in *Bengal: The Nationalist Movement 1876–1940*, ed. Leonard Gordon (New York: Columbia University Press, 1974), 148–58.

[13] When Saha went to the seashore in the Sunderbans in 1915, he was not alone, he had with him some colleagues from Jugantar and Anusilan Samity who had three joint receiving centers along the shore of Bay of Bengal: Hatiya

East Bengal was home to a high proportion of Indian revolutionaries: Saha also knew Pulin Das, who organized a revolutionary Anusilan Samity (a rival of the Jugantar Party) more than 400 km away from Calcutta at Dacca, and Sailen Ghosh who was just beginning his revolutionary political work.[14] Saha appears to have favored Jugantar and Jatin Mukherjee's leadership, but Mukherjee was killed in a gunfight with police at Balasore in 1915. This is how Saha became connected with the international network of Bengali revolutionary parties who used Berlin as a base, and where and how he met M.N. Roy (who had already founded a Communist Party in Mexico in 1917–19). As code-keeper he remained in discreet contact with them after his return to Calcutta, particularly with Nalini Gupta, who came home to organize the Bengal Workers and Peasants Party. Communication codes were

in Noakhali district (East Bengal, headquarters for the Barishal branch of Jugantar), Baleshwar in Orissa (whose leader was Bagha Jatin), and Raymangal in Sunderbans in South 24 Pargannas (South Bengal) (where the people in charge were Jadu Gopal Mukherjee and Meghnad Saha). That was a huge sweep of territory. The weapons were mostly American manufactured and shipments were coordinated by Jugantar and the Indian Revolutionary Committee in Berlin in Germany. "Maverick" was one ship which could not arrive in India, and "Henry" was another ship coming from Manila via Singapore with guns. It was sailing toward the Sunderbans, but when "Henry" arrived in Shanghai on June 2 (under British and French occupation), all the arms were forfeited from "Henry" and the ship was returned on June 22, 1915. Though Jugantar and Anusilan intelligence was not poor, British surveillance and censorship was so effective that the telegram for Jugantar sent from Shanghai did not reach Jugantar's Calcutta base. Hence Saha had to reach Sunderbans before the ship "Henry" arrived and simply wait. Jugantar and Anusilan Samity initially worked together (during this period) but later split apart after 1921.

The source for this information in Bengali is "Biplobi Jugantorer Sankhipto Itihas" published by Jugantar Biplobi Sammiloni (Calcutta: Tathya Sonkolon Sakha, 1997) adapted from Police Archives, Intelligence Branch, Kolkata and Jugantar Party's leaders oral interviews and personal memoirs. The Saha Institute of Nuclear Physics folder 3403 mentions this incident but not at the level of detail mentioned in this Bengali source. I am most grateful to Soma Banerjee for this personal communication August 23, 2013.

[14] Saha Biography, 6. See Peter Heehs, *The Bomb in Bengal: The Rise of Revolutionary Terrorism in India 1900–1910* (Delhi: Oxford University Press, 1993).

essential because of the increasing government surveillance of political parties, and because of continuing conflicts between the revolutionary parties. Saha's role has been described in interviews by individuals engaged in politics at that time, particularly the interview of B.K. Dutta by Gautum Chattopadhyay. Dutta, and other members of Jugantar, organized the reception in Bengal for Nalini Gupta, Roy's emissary from Berlin. "Towards the end of 1921 or early 1922 ... M.N. Roy's courier [Nalini Gupta] reached Dr. Meghnad Saha, who was keeper of our secret code."[15] Chattopadhyay described the complex relations among the revolutionary groups in both Calcutta and Dacca in 1921–22, and among their young leaders; Nalini Gupta had learned how to make bombs while working in a munitions factory in Britain during the First World War, so was in demand among Bengali revolutionaries.[16] Saha and Gupta (and others) all met at the offices of a sympathetic dentist in Wellington Square. By now Saha had also already met Maulana Azad in Calcutta, an ally of the militant Jugantar party too, and a young leader of the Khilafat Movement in 1920–21 (when Saha was in Europe). Azad impressed Saha by becoming the youngest President of the Congress Party in 1923, with Gandhi's recommendation. Saha (a very secular scientist) and Azad (an *alim* and a *mufti* in Muslim law, and a journalist in Urdu) were destined to cooperate when Maulana Azad was appointed Minister of Education for India in 1947. Presumably when Saha left Calcutta for Allahabad in 1923 his secret role in the Jugantar party ended, particularly as it was being enfolded in the new Communist Party of India.[17]

[15] B.K. Dutta interview, July 7, 1968, cited in Gautam Chattopadhyay, *Communism and the Bengali Freedom Movement*, Vol. 1, 1917–29 (Delhi: Peoples Publishing House, 1970), 50–60. I am grateful to Sulagna Roy for providing this reference and to Subhas Ranjan Chakraborty and Benjamin Zachariah for arranging a meeting in Calcutta with Gautam Chattopadhyay for me in January 2005.

[16] Indian revolutionaries and German and Indian seamen worked together on this: the German Seamen's Union assisted the return to India from Moscow of the communist Nalini Gupta in 1921, along with some arms and ammunition. IB Sl. No. 73/22, File No. 68/22, West Bengal State Archives, Calcutta. I am grateful to Benjamin Zachariah for sharing this file, May 1, 2013.

[17] See David Laushey, *Bengal Terrorism and the Marxist Left*. Calcutta, Firma K.L. Mukhopadhyay, 1975.

On the eve of his departure from India for the first time in 1920 Saha already had an international reputation as a researcher though he had not yet worked outside the country, a fact that was contrary to popular assumptions for a long time. Not yet a "cosmopolitan," but like most other good scientists alert to insight and evidence from elsewhere, Saha had already become proficient in three languages, Bangla, English, and German (the latter two most influential in his field of physics). When he returned eighteen months later he had spent almost two years in the great centers of scientific research and had met the leading people in their fields.

Meghnad Saha and the Royal Society of London (1925–27)

In a chapter with a whimsical title drawn from Kipling's 1902 novel *Kim*, Ben Zachariah asks "why does Hurreebabu *want* to become a member of the Royal Society?"[18] The character Hurreebabu was a mid-level intelligence officer in the Raj, and the Royal Society of London did not ever elect such persons as Fellows, though doubtless some scientists who were Fellows also had roles in state intelligence later in their careers. But this rhetorical question was answered quickly among scientists, then as now, who countered "why not?" This recognition of a scientist's achievement, verified through voting by disciplinary peers already in the Society, had strong boosting effects on individual and institutional reputations and research budgets in other countries too. A trickle of Indian scientists had already passed through that charmed door into a huge terrace house overlooking The Mall, and had become Fellows. Though he might have hesitated to accept a knighthood in London (J.C. Bose received a knighthood in 1917, C.V. Raman became "Sir" in 1929), Saha would not have hesitated to join the very imperial Royal Society of London, notwithstanding his opposition to many aspects of the empire in India. People

[18] Benjamin Zachariah, "Hurreebabu and the Royal Society," in *Playing the Nation Game: The Ambiguities of Nationalism in India* (Delhi, Yoda Press, 2011), 117–52.

he admired greatly, and some of his perceived competitors or opponents in research, were already Fellows.[19]

London was not just a world scientific center, it was also a center for influential Indian scientists. For example, at the time of the colloquium where Saha's friend Shanti Bhatnagar defended his DSc dissertation in chemistry in early 1921, C.V. Raman, Sir J.C. Bose, and P.C. Ray (all professors at the University of Calcutta) were visiting the city. The new vice-chancellor of Benares Hindu University asked these three individuals for nominations to a new Chair in Chemistry at Benares. P.C. Ray already knew of Bhatnagar's abilities, and heard from F.G. Donnan of the University of London about his good performance at the thesis defense. J.C. Bose had just been elected as FRS in 1920, after five previously unsuccessful annual attempts. Bose's Institute was now receiving a Rs 75,000 annual grant from the Bengal and India governments for "pure science," and this was soon to be increased to Rs 100,000.[20] P.C. Ray had, like Bose, been nominated for the five previous years as FRS, but even after eight years was never elected. Raman, much younger than the other two, and on his first visit to Britain, was already nominated and was to be elected to the Royal Society in 1924. The trio of Raman, Ray, and Bose cabled from London their unanimous recommendation for Shanti Bhatnagar for the chair in Chemistry, so like Saha, Bhatnagar returned to India in 1921 to a new full professorship in the university at Benares at age 27, with the blessing of its most prestigious figures.[21] This is just one illustration of the importance of the Royal Society in a life of Indian scientists like Saha.

After arriving in Calcutta, Saha experienced dissatisfaction with the working conditions and decided to accept an offer to work at Allahabad in 1923. Taking stock of his situation so far displaced from Calcutta, Saha

[19] For a complete account of how Indian scientists were entered into the society's nominating and voting process by already-established Fellows, see Anderson, *Nucleus and Nation* (2010).

[20] Subrata Dasgupta, *Jagdis Chandra Bose and the Indian Response to Western Science* (Delhi: Oxford University Press, 1999), esp. Chapter 7 "Empire Building." It must be emphasized that this was a large amount of money for any scientist anywhere at the time, let alone a scientist in India.

[21] Nora Richards, *The Life and Work of Shanti Swarup Bhatnagar* (Delhi: New Book Society, 1948), 6; see also *Nucleus and Nation*, 37.

began to look for funds to support his research. But it turned out that to succeed in Allahabad, Saha's nomination to the Royal Society of London had to succeed too; however, there were local and foreign obstacles to this objective. In 1924, using his network of colleagues, he learned that Niels Bohr had received an £800 grant from the Rockefeller-supported International Education Board. Saha wrote to Henry Russell to ask him about an application for a £2000 grant. As DeVorkin has shown, Russell (of the Board) consulted Caltech's Robert Millikan, who was on important granting committees. Millikan replied to say that the grant to Bohr was an exception and that Saha should not expect it; American physicists would have priority before international applicants for the Rockefeller funds, he said, as this was an American foundation. This was a polite way to reject Saha, without mentioning that Millikan had already formed a poor opinion of Saha's abilities as an experimenter, based entirely on C.V. Raman's advice. Millikan and Raman had conversations about Saha at CalTech in 1924, and because Millikan and Russell both respected Raman's opinion (and perhaps also for reasons of precedence) the application was rejected. Henry Russell recalled having conversations with Ralph Fowler, who also raised doubts about Saha's abilities as an experimenter.[22]

Of course Saha was unaware how such opinions against him might have been formed, but he probably realized their consequences. (It should be remembered that Raman did not think *anyone* in India approached his own experimental abilities). Meanwhile Saha was nominated in 1925 to become a Fellow of the Royal Society by his teacher Alfred Fowler in London and by Gilbert Walker, mathematician and meteorologist who spent much of his life in India (and was now retired in England); both were Fellows themselves. Saha's rival C.V. Raman received his FRS in 1924. Citations to Saha's work were increasing, and there was already talk in the literature of "Saha's equation." Well informed about India, James Jeans, secretary of the Royal Society, asked the Viceroy's Office in 1925 "whether Saha's political record is likely to be embarrassing afterwards to the Royal Society." The official reply from the Viceroy's Office was that there were grounds for not recommending Saha for a Fellowship, and this reply caused a further investigation by a British intelligence officer in

[22] DeVorkin, Quantum Physics, 161–62.

India, who eventually reported that Saha was sympathetic to revolutionary aims and activities, though not an active participant in them.[23] The evidence available to us now confirms that Saha gave money to "political sufferers" (code word for those who were penalized, lost jobs, or were imprisoned due to political activity against the British administration). Moreover, the Viceroy's Office said that he probably had been a conduit for Indian revolutionaries in Germany and Switzerland, but it appears that Saha's role as code keeper for Jugantar had not leaked out.[24]

Though it is unknown whether the Viceroy's intelligence office uncovered Saha's role as code-keeper, the Royal Society was so alarmed by other evidence in the Viceroy's report that James Jeans asked Alfred Fowler whether or not he wished to continue to nominate a "rabid revolutionary," and suggested that Saha's name could be withdrawn. Provided with the intelligence report, says DeVorkin, "Gilbert Walker [who had previously offered Saha a job in India] remained solidly behind Saha" and Alfred Fowler replied that the nominees would sustain the recommendation for Saha.[25] By now, Saha was third overall in accumulated citations to his work among all physics candidates for FRS in 1925. But other factors were against his election in 1925 (historically, few Fellows have been elected in the first or second round). Saha's name came forward for election again in 1926. The nomination now needed and acquired further backing from the astronomy community of Fellows; Fowler and Walker "recruited" the signatures of F.A. Lindemann at Oxford, J. Evershed, F.W. Dyson, and others, as was common practice. This year too was a disappointment. But if Lindemann harbored antagonism to Saha at this stage he did not apply it to the vote in the

[23] Exchange of letters, James Jeans and Holland, May 1925, cited in DeVorkin, 163.

[24] I have read the intelligence files at the British Library in the L/PJ/12/395 and L/PJ/12/669 series and found no reference to Saha: his name does not appear in subsequent official publications on communism or terrorists up to 1940, such as *Communism in India*, Calcutta, Government of India Press, 1927; *The Politico-criminal Who's Who of Bengal Presidency*. [secret] Calcutta: Bengal Intelligence Branch of CID, 1930; *Review of the Terrorist Situation 1939–1940*. Calcutta: Intelligence Branch CID, 1940.

[25] It is unclear what the Royal Society thought was risky about this nomination: For a complete explanation see *Nucleus and Nation*, 67.

following year: with Lindemann's vote and the others, Saha was finally elected a Fellow in 1927 for "development of the theory of high temperature ionization."[26]

We do not know if or when Saha learned of the scrutiny to which his candidature had been subjected in 1925. We do know that Saha thought that his younger competitor E.A. Milne at Cambridge disregarded his work on selective radiation pressure, and thought Milne avoided giving him credit. Nevertheless, when Saha planned to go to Oxford ten years later, Milne himself wrote to Saha to warn him that Lindemann was jealous of his success, and said "he has never forgiven himself for not discovering the physical nature of the stellar spectral sequence himself, which we all recognize was due to you." Milne here seems to concede what Saha thought Milne himself had been withholding, namely due recognition. Milne also warned Saha that Lindemann appeared to be "not very well disposed to Indians."[27] Lindemann, an Oxford physicist, later became Winston Churchill's chief scientific advisor (nicknamed "The Prof") and was deeply involved in policy related to science and industry in India; he had no prior contact with India when he co-signed Saha's nomination in 1926.[28]

In this experience with the Royal Society, Saha encountered genuine recognition of the importance of his research, a surface of hospitality and assistance, but a deeper reservation, if not prejudice, about India: a familiar one that was used by some people in Britain to convince themselves that ruling India was both ethically and politically correct. This nomination process also made clear to Saha a distinction between the scientific reputation and the politics of the person behind it. Not only was Lindemann "not well disposed to Indians," but E.A. Milne himself was specifically opposed to the nationalist movement in India, according to astrophysicist S. Chandrasekhar a few years later, because Milne did

[26] Note that both Fowler and Walker played key roles in later nominations to the Royal Society of physicist K.S. Krishnan (1940), astrophysicist S. Chandrasekhar (1944), and physicist–statistician–physical anthropologist Prasanta Mahalanobis (1945).

[27] E.A. Milne to M. Saha, September 7, 1935, cited in DeVorkin, *Quantum Physics*, 171, 186.

[28] This soon changed when Lindemann first visited India in 1928 as member of a review committee of the Forest Institute Dehra Dun.

not think India could survive without British presence. While saying that British scientists had no reason to be ashamed of their positive role in helping India in science, Chandrasekhar said he experienced a different reaction (in Britain) about their politics in the mid-1930s: "it was quite obvious that the establishment at Cambridge was quite against the Indian movement. I mean, I could feel it very strongly as a Fellow.... I found it very difficult to talk politics with E.A. Milne or R.H. Fowler because they had opposite views."[29] This is relevant because Lindemann and Milne and Ralph Fowler were precisely the individuals in Britain with whom Saha interacted most before and after he became FRS in 1927, and from whom he wanted scientific recognition during his exile in Allahabad. They were pillars of the (conservative) British scientific establishment. Nevertheless, Lindemman had supported his election, and Alfred Fowler and Gilbert Walker had persisted with it in spite of adverse reports about Saha. They could have dropped their nomination near the beginning or not have sought Lindemann's influential assistance. Milne did vote for Saha and did eventually give due recognition to Saha's work, according to DeVorkin. This interplay of scientific reputation and politics "about" India was infinitely complex.

This success at the Royal Society of London suggests why Saha's authorized biography says "things began to change only after 1927," meaning that recognition in Allahabad, following the election to FRS, came from the Governor's Residence (and a substantial research grant), as well as from his colleagues at the university.[30] The image which Saha wished to project in his letters of a poor transient scientist in an ill-equipped outpost remained available to him when he wanted to use it. Confusion reigned about it in terms of the "local." For example, as mentioned earlier, some Europeans thought the "Bose" of the Bose–Einstein statistics was a German physicist who had developed his ideas (for the statistics) while in Europe in 1924–26. So now Saha could claim recognition "at home" in his exile in Allahabad. This all occurred in "the Nehru zone," and that rich and influential family based in Allahabad, always so close to "the news," would also have known about Saha's FRS. It was

[29] K.C. Wali, *Chandra: A biography of S. Chandrasekhar* (Delhi: Penguin, 1992), 259–60.

[30] Saha Biography, 19.

a ten-minute walk to the Nehru mansion from the university buildings where Saha had his office and lab. Though it might be a short physical distance, there was still a great social distance between them. We know little about any relationship at this time, but that was about to change. Their relationship proved difficult for both of them to manage over the long term, but it was essential for Saha's ambitions in national science and planning, and curiously important to Nehru too.[31]

It is important to address this question of "social distance"; by the early 1930s Saha was a full professor with as much job security as any other faculty member, albeit not in a major university like Calcutta. The distance between his office and his house and the Nehru mansion was not just one of income and assets, though that was definitely important. Just as importantly the Sahas had begun, in the nineteenth century an occupational shift far beyond their "traditional" assignment in the caste system, namely those who performed low status livelihoods such a liquor making. Sahas numbered in the millions, and were one of a cluster of caste groups which was/is called "nama-sudra." But with Sahas gradually becoming educated professionals, Meghnad was, in the 1930s, leading the way along one path. In contrast, the Nehru family was Brahmins, originally from Kashmir. So though both families were migrants to Allahabad, the Nehrus brought status and money with them (and had been there for over fifty years), and Saha, who did not have either, brought ambition, advanced training, and determination. He was thus a "transitional" figure in multiple senses, and his international face was crucial in this social mobility.

Saha as an Early Entrant to the Planning Game

In 1937–38 Saha became deeply involved in the politics of national planning, and in the National Planning Committee (NPC) set up by Congress. He had already declared himself opposed to what he considered the "retrograde" aspects of Gandhi's strategy, most particularly the focus on the

[31] Though it falls outside the scope of this essay, this issue is dealt with in *Nucleus and Nation* (2010).

village economy and the very limited role that large scale and capital intensive industry should play in rural change. Saha wanted industrial transformation, his own "great leap forward," and was prepared to cooperate (cautiously) with private capitalists and industrialists and foreign experts to achieve it. Though he might not have understood the implications of these commitments in 1935, they were sharpened for him in 1938–39 in his role in the NPC.[32] By that time far-sighted Indians, even those not convinced there would be the war in Europe, had concluded that Britain would inevitably have to let go of India sometime soon. One effect of the economic depression of the 1930s in India was that people looked far beyond Britain for insight into how economies should be reorganized and redirected, and this included some (though not all) government officials in India. The international flow of ideas and models increased so that beside the state-guided reconstruction of the American New Deal, there was a lot more attention paid to the U.S.S.R.: for example, in both America and the Soviet Union, promoting rural electrification was a cornerstone of securing state power in agrarian societies, and increasing rural productivity. These international projects were judged as the way to contribute to state revenues, which were then flat. Given the "failure of capitalism" in the global depression, a new fascination with Soviet progress was spreading among young people in the late 1930s, and Saha was in full sympathy with this trend. But the proximate cause of the creation of the NPC was the transfer of limited powers to the provincial governments in 1937, and this created a "minister of industry" in provincial governments—this was a start of Saha's dream and the start of his new role. He proposed a policy-strong institute in 1933 to study and then

[32] There is not space here to review the reasons why "national planning" was acceptable in 1937, and to so many different kinds of people; this is dealt with at length in *Nucleus and Nation* (2010). However, I do not wish to give the impression this was a *new* feature of the 1930s; it was well established—see Dhruv Raina and S. Irfan Habib, "The Unfolding of an Engagement; The *Dawn* on science, technical education and industrialization in India, 1896–1912" and "Bhadralok Perceptions of Science, Technology, and Cultural Nationalism" in *Domesticating Modern Science: A Social History of Science and Culture in Colonial India* (Delhi: Tulika Books, 2004). The broadest and most complete history of this planning process is Benjamin Zachariah, *Developing India: An Intellectual and Social History c. 1930–50* (Delhi, Oxford University Press, 2005).

control floods in Bengal (based on U.S. and German models), and began to write in 1934–35 about electricity production and delivery, and made an unfavorable electrical comparison between his own (dark at night) Allahabad and Portsmouth. This electrical orientation connected him with industrialists starved for electricity; here he spoke about rural electrification which he had seen while on study leave in the United States (in 1936–37, particularly the new Tennessee Valley Authority) and had read about in the U.S.S.R. For all this, he decided, "we need an effective state, a strong state." It was this outlook that he became involved in in "the national planning movement" when the committee was formed within the orbit of the Congress Party in 1938.[33]

I agree with Abha Sur who said, "Saha harbored a dogmatic scientism—that science and technology can solve all the problems of mankind regardless of the social and political context in which they are practiced."[34] What is equally important is that Saha, having returned from special studies during a year abroad in the United States, seized the opportunity in 1938 to return to Calcutta and to a now-available endowed chair in physics at the University of Calcutta; here he began to build a program and lab on nuclear physics.[35] Saha had always been ready to be mobile, and by age 20 in 1913 had moved semi-permanently to Calcutta from a village near Dacca. But by 1920, as a married adult with children, he had to be prepared to be mobile again, and so in 1923 moved to work in Allahabad (thereby joining the Bengali diaspora in the Hindustani-speaking north). Again, in 1938, he moved back to Calcutta to a more prestigious university position.

Thus it was that Saha came into frequent contact with politicians and industrialists who split off and eventually formulated the 1944 Bombay Plan which proposed a mixed public and private sector economy. However, there was another Saha involved, one who claimed to have persuaded Subhas Bose to set up the NPC in the first place, and who also become a member of the NPC. This was A.K. Shaha (of the same caste

[33] Saha Biography, 41, see footnote no. 10.

[34] Sur, ibid., 31.

[35] One of his first efforts was to send a student to the University of California who had moved with him to Calcutta from Allahabad; this was B.D. Nagchaudhuri who later directed Saha's research institute after the founder's death in 1956. *Nucleus and Nation*, 54.

as Meghnad Saha, but a different Russianized spelling), also from East Bengal, who was invited to Moscow as a "foreign specialist" in the early 1930s, married a Russian woman, and achieved the Russian equivalent of the DSc degree in engineering. He advocated for India the same rapid industrial approach which Stalin was taking (e.g., the Stakhanov movement), and (like Meghnad Saha) praised the role of science and scientists (and engineers) in industrialization.[36]

So influential did this other Shaha become that Subhas Bose wrote to Nehru, chairman of the NPC, to ask that AK Shaha be appointed as joint secretary of the whole committee: Nehru replied that Shaha "might have been appointed an honourary General Secretary but would have had to resign his (unpaid) position in the NPC if he accepted the (paid) position of Joint Secretary." Nehru wanted "to profit by his special experience in the sub-committees.... I have been trying hard to get a suitable place for him in some provincial government."[37]

Meghnad Saha had already discussed the issues of industrialization outside the NPC in 1938. He had recently founded a monthly journal in Calcutta dedicated to "science and culture," and had established an academy at Allahabad for scientists in "the United Provinces" but with pretensions to have national coverage; as president of the National Academy of Sciences in Allahabad, he chaired a session on power and electrical supply problems in 1938, and even proposed the use of nuclear power in 1939. Jawaharlal Nehru, whose home was in Allahabad, presided over that 1938 meeting, and was thanked by Saha thus:

> It was in the fitness of things that Pundit Jawaharlal Nehru has agreed to preside over this annual gathering of scientists in India. His position in this country can be described by a phrase which Americans use with respect to Abraham Lincoln,* 'first in war, first in peace'[sic]. Next to Mahatma Gandhi, he occupies the first place in the hearts of his three hundred million

[36] A.K. Shaha, *India on Planning: Planning for Liquidation of Unemployment and Illiteracy*. Calcutta 1948, for a fuller account of these circumstances, also see Benjamin Zachariah, "The Uses of Scientific Argument: The case of "development in India," *Economic and Political Weekly*, 29 (September 2001), 3699.

[37] J. Nehru to S.C. Bose, July 11, 1939, in Netaji Research Bureau, *The Alternative Leadership: Speeches, Articles, Statements, and Letters of Subhas Chandra Bose* (Delhi: Oxford University Press, 1998), Vol. 10, 156–57.

countrymen. The time has come for him to give a lead in peace-time work of reconstruction and consolidation of the country.[38]

(* George Washington, not Lincoln.)

Saha also invited Subhas Bose, then president of Congress, to preside over the third general meeting of the Indian Science News Association which published his journal *Science and Culture*. In August 1938, Bose came to its meeting and made his views on development clear:

> though I do not rule out cottage industry and though I hold that every attempt should be made to pressure and also revive cottage industries whenever possible, I maintain that economic planning for India should mean largely planning for the industrialization of India. And industrialization, as you will all agree, does not mean the promotion of industries for manufacturing of umbrella handles and bell-metal plates, as Sir John Anderson would have us believe.[39]

Like Bose, Saha was critical of Congress "high command" and their support of both cottage industry and the mixed economy proposed by prominent industrialists' in the discussions leading up to Bombay Plan (their first discussions occurred in 1938–39, and their final report, drafted by John Matthai, was published in December 1944).[40] He agreed with Bose's view that India was in need of a "forced march to progress" (Saha's words in his authorized biography)[41] like the U.S.S.R., and was critical of Gandhi's policy of *khadi* (home-spun cloth) which was strongly

[38] Saha Biography, 39.

[39] Bose's entire speech can be seen in Netaji Research Bureau, *The Alternative Leadership*. Ibid., 156–57; he had laid out a manifesto of sorts in Subhas Chandra Bose, *The Indian Struggle 1920–1934* (London: Wishart & Co., 1935)].

[40] Dr John Matthai was secretary to the group of industrialists which included many names who figure prominently in this book: J.R.D. Tata, G.D. Birla, Kasturbhai Lalbhai, A.D. Shroff, and "the Knights," Sir Ardeshir Dalal, Sir Puroshottamdas Thakurdas, and Sir Shri Ram. The plan was published in two slim volumes, and later published together as a Penguin Special: P. Thakurdas et al., *A Plan of Economic Development for India* (Harmondsworth: Penguin, 1944). John Matthai's career took off from this point, so that he became India's Minister of Finance until 1951. See also Zachariah, *Developing India*, 220–22.

[41] Saha Biography, various pages.

supported by one faction of the Congress—and by influential supporters, for example, by Saha's chemistry teacher, P.C. Ray: Saha went to lengths to explain he meant no disrespect to Ray, but that students could and should disagree with their teachers on matters of principle like this.[42] Striking out against Gandhians, he was angry when K.N. Katju, the Congress minister for industry in U.P., opened a match factory in 1938, saying it was heralded as the start of large-scale industrialization. Saha is cited as quoting Bose extensively in the 1954 authorized biography because, said Saha, "in contrast to other political leaders, Bose's mind was absolutely clear on the post Independence problems."[43] Here he was alluding to Nehru as "other political leaders," establishing for himself a problematic relationship with someone powerful on whom he would have to depend. Saha and Bose disparaged John Anderson's views about umbrella handles and bell-metal plates for another year, and this both irritated Gandhi and Nehru.[44] Anderson had articulated an authoritative and safe position for moderate conservatives such as K.N. Katju, a position which neither Gandhi nor Nehru could criticize very strongly, given their own interdependent relationships.[45] Disparaging Anderson's views meant simultaneously condemning the colonial government and

[42] M.N. Saha's statement in "Acharya Roy Birth Centenary Souvenir," supplement to the *Journal of the Indian Chemical Society*, August 1961.

[43] Saha Biography, 63.

[44] Anderson had been not only the Chancellor of the University of Calcutta, but also the patron of National Institute of Sciences of India (NISI) of which Saha was president in 1938. Broomfield describes him thus: "This appointment as Governor in 1932 of Sir John Anderson, a senior British Civil Servant with experience in counterinsurgency in Ireland, was followed by an overhaul of the government's intelligence system and the movement to Bengal of seven battalions of British infantry, who were deployed to hunt down the revolutionary bands and restore British rule in the countryside." J.H. Broomfield, *Elite Conflict in a Plural Society* (Berkeley: University of California Press, 1968), 303. Anderson's term ended in 1937; he was clearly an adversary of the political movement which Saha supported. But Saha was to meet Anderson again, in London, when Saha came there in 1944 as an important guest of the government of which Anderson was Home Minister.

[45] J. Nehru's letter of September 28, 1939, to K. Kripalani, in Jawaharlal Nehru, *A Bunch of Old Letters* (Bombay: Asia Publishing House), 1960.

dismissing a man who had, prior to leaving India in 1939, already been considered for the position of Viceroy (and would be so considered again, by Churchill, during the war).[46] It also meant condemning those in the Congress who agreed to serve under the Viceroy in the central or provincial governments (until they resigned when war was declared in September 1939), and those in business who profited from this situation. Subhas Bose also demanded thorough land reform which most of the Congress leaders did not dare to support.[47] Saha's promotion of complete industrialization, and his backing of Bose, exposed him to further suspicion, even though eventually in Bengal Subhas Bose was given heroic status: for *some* people Saha's support for Bose ultimately raised Saha's reputation, particularly among those Bengalis who had a mystical belief in Bose (including that he was still alive after his death in an accident in 1945).

In this context, Saha was invited by Subhas Bose to a meeting in October 1938 at Delhi, attended by Ministers of Industry in Congress-controlled provinces, "and certain other prominent men of India" among whom was K.N. Katju.[48] Saha arrived late to this meeting, intended to form the NPC, and discovered that Sir M. Visvesvaraya had already been asked to become the chairman of the committee. Mokshagundam Visvesvaraya, trained as a civil engineer, had been Dewan of the State of Mysore, and had supervised the building of hydro-electrical power dams, iron and steel mills, a university, and schools and libraries. But he was known here as the author of a 1934 book, *A Planned Economy for India*.[49] Given his prestige (engineer and activist dewan) he was a logical choice, but Saha said that he persuaded Visvesvaraya not to accept

[46] J.W. Wheeler-Bennett, *John Anderson* (London, Macmillan), 1962.

[47] Saha's authorized biography refers to Saha's satisfaction with Bose's commitment to land reform, p. 81.

[48] Saha Biography, 93. Katju was not prominent but was important in the Congress; Saha faced his authority in parliament when Katju became the powerful cabinet position of home minister in 1952.

[49] Little is written about Visvesvaraya; an exception is Dhruv Raina, "Visvesvaraya as engineer-sociologist and the evolution of his techno-economic vision," National Institute of Advanced Studies, Bangalore, 2001. (NIAS Lecture L1).

the position of chairman because *unless an important member of the Congress* was chairman, the Planning Committee would

> be regarded merely as academic and would have no value in the eyes of Congress. The grand old man saw the force of the argument and readily agreed. It was my suggestion that Nehru, then in Europe, be invited to take up the Chairmanship of the proposed committee.[50]

As a senior member of the NPC, Saha became Chairman of the Power and Fuel Sub-Committee, and a member of the River Transport and Irrigation Sub-Committee, two subjects on which he wrote regularly in *Science and Culture*.[51]

Following this organizational meeting in Delhi, Saha went to speak with Tagore at Santiniketan. They had first met in Germany in 1921 through the physicist Sommerfeld. Nehru had accepted the position of chairman of the Planning Committee when he returned to India, and on November 28, 1938, two letters were written to him from Santiniketan— one from Tagore and the other from Tagore's secretary, Anil K. Chanda. Tagore wrote supporting the idea of thorough planning, supporting Nehru in his role and urging him to be strong minded; Chanda wrote to say that Tagore supported Subhas Bose for reelection as president of Congress if Nehru was working too hard on planning; in this context Chanda said "He (Tagore) has been rather captivated by Dr Saha's ideas of Rational Planning and he is hoping much for the Committee."[52] Bose campaigned for the presidency against Gandhi's wishes, and was reelected president of the Congress in 1939, demonstrating the surprising power of the left factions of the Congress, not just in Bengal but in

[50] Saha Biography, 93. The "I" in the biography is in fact Saha.

[51] The reports of the sub-committees were published as K.T. Shah (ed.), *National Planning Committee: River Training and Irrigation* (Bombay: Vora, 1949), and K.T. Shah (ed.), *National Planning Committee: Power and Fuel* (Bombay: Vora), 1949.

[52] Nehru, *A Bunch of Old Letters,* 308. I am grateful to Leonard Gordon for reminding me of this evidence of relations between Saha, Bose, Nehru, and Gandhi, and for helping me to correct errors in an earlier draft. See his *Bengal, The Nationalist Movement 1876–1940* (New York: Columbia University Press, 1974). See especially Tagore's speech supporting Bose, 287–88.

other regions. But it was not sustainable, and he resigned later in the year, because without support from Gandhi he felt he could not function effectively (and that was probably true). After Bose's resignation from Congress, Tagore called for unity in Bengal behind Bose.[53]

Although Bose was reelected president of Indian National Congress in 1939 against Gandhi's continued opposition, when Bose was forced to resign as president in the same year Saha must have begun to realize that his main political relationship would have to be with and through Nehru. Nevertheless, and despite this departure from Congress, Saha continued to promote Bose's point of view. Nehru was becoming instrumental in the development of Saha's laboratories, particularly in his plan to build an experimental cyclotron; so Nehru was fully exposed to Saha's attitudes on national planning. For instance, in September 1939, Nehru wrote to Krishna Kripalani who was then Tagore's secretary at Santiniketan, about Saha's views. Nehru had read a letter written from Saha to Kripalani and Tagore in which "he has referred to me repeatedly and made various statements regarding me which are bound to convey an entirely wrong impression of what I said in the Planning Committee."[54] Saha apparently wrote that the Planning Committee had endorsed Gandhi's plan for cottage industries to the exclusion of large scale industrialization, that cottage industries would become stuck on ancient techniques, and that Congress leaders consented to foreign management and foreign investment controlling the industrial sector. This critique tested Nehru's complex relationship with the right wing of Congress. Nehru's reply was that the Planning Committee had not encouraged Gandhi's ideas alone, that he personally believed in large-scale industries, that he (Nehru) didn't "represent Gandhiji's viewpoint to any large extent; in my mind there is no essential conflict between the two."[55] Finally, Nehru characterized Saha's view that Congress leaders were puppets in the hands of big industrialists, most of them foreigners:

[53] This tumultuous period is well described in Leonard Gordon, *Brothers Against the Raj* (New York, Columbia University Press, 1990); esp. Chapter 9 "We must sail in different boats" Gandhi versus Bose, 1939–41.

[54] J. Nehru to K. Kripalani, September 28, 1939, in Nehru, *A Bunch of Old Letters*, 390.

[55] Ibid, 391.

[it is] really extraordinary, and shows Professor Saha is not conversant with what has been happening in India. [It is] amazing and displays a lack of appreciation of the whole political, social and economic events in the recent history of India. It is unfortunate that Professor Saha's letter has been written in a spirit which is far from scientific or dispassionate.[56]

From this point on the NPC fell into inactivity due to the war in Europe, particularly because Nehru was preoccupied with other immediate matters (and then put in prison both in 1941, and then after a short time "free," imprisoned in 1942 onwards for the rest of the war). This was the first time scientists had worked in a committee with national leaders, and it left its mark on both sides. Nehru clearly enjoyed the company of many scientists, but probably found Saha's spirit too critical and manners too rough. Nevertheless, the first money Saha received for his new lab was gained through Nehru's intervention in 1941, and came from the trusts of wealthy industrialists whom Saha regularly criticized in print in his *Science and Culture* journal.[57] Responding to Nehru's criticism about his preoccupation with industry, Saha was anxious to point out that he was not planning to neglect the agricultural sector in favor of industry, and said so frequently. In numerous speeches and editorials, he declared his interest in agriculture, and favored industrial development which would make direct contributions to farmers, such as fertilizer factories and dams to provide power for rural electrification. There was, he insisted, no inherent antagonism. But these were side-shows to his main preoccupation with the commanding heights of the economy, the steel, petroleum, chemical, and power, energy, electricity nexus which he believed should be publicly controlled.

In this planning committee scientists imagined the development of scientific institutions in a state that was yet to come. For example, Saha had now spent a year living in each of three powerful and "modern" states, Britain, Germany, and the United States. Scientists also envisaged a laboratory state though they did not (yet) have enough laboratories to realize it. They imagined the power and influence of science (and

[56] Ibid, 394. This is the first instance I have seen of disagreement between Nehru and Saha.

[57] See *Nucleus and Nation*, Chapter 4 "Nehru, scientists, and political planning."

scientists) for "good," even though this was a sustained conceit at the time. With Nehru, they believed India had failed to develop a source of power (such as coal and steam) and for this reason was a backward, not powerful nation. Identifying and harnessing power was their objective. Having done so, they believed they would rightfully inherit the other kind of social and political power which they needed to keep the scientific enterprise growing. They intended to build an environment in which they too could be powerful. They were not quite halfway in 1940, and were stocking committees and guiding commissions with their expertise—Deepak Kumar, historian of the period, says that they had almost established a "scientocracy" by 1940, or at least certainly the idea of one.[58]

This confidence in science came from many quarters: a friend who was not engaged in Saha's planning process wrote his own plea for "resolute optimism" in *Current Thought,* an influential Calcutta quarterly in 1941. Satyen Bose (like Saha) read German, and followed the war very closely; he knew Germany was poised to invade Britain as he wrote this piece. Linking science with civilization, Satyen Bose asked "what our civilization really stands for, and what immutable goal we should set before ourselves?" His carefully reasoned answer is that men of science are now being "called upon to devise means of fighting" (he refers to chemical gas warfare) while in times of peace they should "further the cause of mankind." And, referring to India, "the peculiar difficulties of any nation need not cause permanent despair."[59] At this stage there still was not yet a term like "Bose–Einstein statistics," nor was there a group of particles (eventually named by Paul Dirac) called "bosons" in his honor (Paul Dirac coined this term around the late 1940s). Satyen Bose was, in 1942, still sixteen years away from his election in 1958 as a Fellow of the Royal Society (curiously, as "a statistician"!). Though not a "political scientist" like his friend Saha, Satyen Bose's essay nevertheless gives us an example of the reasoned linking of science with civilization against his perception of the danger of fascism, at the very time

[58] Deepak Kumar, "Emergence of 'Scientocracy': snippets from colonial India." *Economic & Political Weekly* 28 (August 2004): 3893–98.

[59] Satyen Bose, "Science and Civilization" reprinted in *Economic & Political Weekly,* March 23, 1974, 467–68.

Subhas Bose (no relation) was in Berlin negotiating with the German government. Saha knew that the heart of his scientific profession functioned on relatively open international communication, but this openness was coming to an end in his fields of physics in 1940–41. And he had already seen that industrial interests with some venture capital, to whom he was at that moment appealing for big grants to run his cyclotron, were prepared to define Saha's profession and role more narrowly, as being best dedicated to the planning and construction of the (yet unavailable) national state, perhaps a laboratory state.

Saha, Subhas Bose, and Nehru 1941–42

Imagine Saha's surprise when a man whose leadership he was carefully cultivating disappeared suddenly without warning in 1941, and ended up first in Germany and then in Japan, planning to bring a liberating army back into India. In the 1930s Subhas Bose looked like a leader Saha could relate to and manage. Both had been students at Presidency College, though Bose was three years younger and soon went to study at Cambridge like sons of other established Calcutta families. Arrested in a sweep of radical activists and sent to prison in Burma for two years in 1925, Bose returned to India in 1927, and was elected Mayor of Calcutta in 1930. His rise was spectacular. Saha appreciated that Bose opposed Gandhi and still managed to be made president of the Congress in 1938, just when Saha was active in the NPC. Bose's role in Congress was conflictual from then onward, and he left its presidency in late 1939 to form his own loose political coalition, the Forward Bloc. In this fluid environment even M.N. Roy, who had been effectively expelled in 1928 from the official Communist Party but remained a loyal communist outside the party, created his own new Radical Democratic Party in 1940.[60] Subhas Bose thought that Congress should confront "the Raj" during wartime and he pushed the Forward Bloc to do so. He was put in prison and then under

[60] The circumstances leading up to Roy's distance from the official Communist Party are discussed in Sibnarayan Ray, "Introduction," in *The Russian Revolution and the Tragedy of Communism*, Sibnarayan Ray (ed. and tr), M.N. Roy (Calcutta: Renaissance Publishers, 2000), 9–26.

house-arrest for civil disobedience during a December 1940 demonstration against a memorial to the Black Hole of Calcutta. Though Gandhi and the Congress frequently used the same tactics, they (Congress) had not entirely authorized this particular demonstration, and furthermore it was not "legal"; this opportunity was used by the police to arrest Bose. Dressed as an Afghan businessman, and having grown a beard in his "house-arrest," Bose escaped from Calcutta in January 1941 and made his way to the Afghan border, where he expected to make contact with Soviet agents in Kabul. After all the U.S.S.R. was his ideal and it was not yet at war with Germany (the nonaggression pact was not broken until June 1941). Frustrated with Moscow's cautious delay in arranging his next step in March 1941, and still stuck in Afghanistan, Bose soon decided to move to Germany.[61] We do not know what Saha thought of Bose's disappearance in 1941, or of Bose's decision to go to the Nazis for help to get rid of British rule and administration. But in April 1941 Saha would have learned about Bose's new life and location because the Germans arranged for a radio broadcast about Bose to be heard in India

[61] There is evidence that Bose had made contact in 1934 with officials of the German government, the apparatus of which had just been captured by and infused with Nazis activists and Nazi ideas. There he knew both A.C.N. Nambiar and Soumyendranath Tagore, two men active against the building German regime. Nambiar was later to become Bose's right-hand-man in his years of collaboration with the Nazi regime during the Second World War [see Benjamin Zachariah, "Indian Political Activities in Germany, 1919–1945," in *Transcultural Encounters between Germany and India: Kindred Spirits in the 19th and 20th Centuries*, eds Joanne Cho Miyang, Eric Kurlander, and Doug McGetchin (New York: Routledge, 2013), pp. 141–54.]. My own view is that Bose was ambitious and would probably have made contact with any government which appeared to him to have the real potential to contest and/or displace British rule. He had become romantically related to a woman in Vienna named Emilie Schenkl with whom he became secretly married in 1937 and sustained a relationship all the way through his subsequent life in India (1938–41), and with whom he exchanged touching letters which had to pass through the censor. They were reunited on his arrival in spring of 1941. See Sarmila Bose, "Love in the Time of War: Subhas Chandra Bose's journeys to Nazi Germany (1941) and toward the Soviet Union (1945)," *Economic and Political Weekly*, January 15, 2005; also Sugata Bose, *His Majesty's Opponent: Subhas Chandra Bose and India's Struggle against Empire* (London, Allan Lane, 2011).

sometime in April 1941, through which Saha, along with many others, learned about Bose's strange new life.[62]

But Saha must have felt another shock one year later when Japanese troops reached the borders of Bengal near Chittagong in April 1942, having quickly conquered Burma in less than two months. What followed was a series of official British half-measures beginning, in the middle of March 1942, with a special mission to negotiate a new semi-independent status for India (the Cripps Mission). The Americans soon decided also to send a special technical mission to India to appraise its industrial, scientific, and military capacity (popularly called the Grady Mission), not least because U.S. troops were going to be stationed in their thousands in Bengal. This led slowly to a British mission to assure top Indian scientists such as Saha (and Bhatnagar) how much they were admired and valued in Britain. With Japanese air bombing runs on Chittagong and Calcutta, Saha decided to move his family away from the city in late 1942, away from the cyclotron he was building for a new kind of nuclear physics, away from the students he was teaching. And then in mid-1943, at the height of the impact of the Bengal famine, a plan emerged to organize a special tour of Allied research and development facilities in Britain and North America—in which Saha was to be included.[63]

We do know that Saha had been attracted to authoritarian strong-state approaches to social change and industrialization, at least since the founding of *Science and Culture*, we know he supported militants and their armed struggle (including those who had bargained for arms from Germany), but we don't know how he evaluated Bose's move to negotiate with the foreign policy elites in the Nazi government in 1941. Given Saha's early commitment to Bose, which was enhanced in 1938–40 around the NPC, it is an interesting question. Bose was not alone in this attraction to far right ultra-nationalist regimes in the 1930s; there had been admirers of Hitler in Bengal and other parts of India over the preceding decade, but he was certainly the most important leader (a former

[62] See Leonard Gordon, *Brothers Against the Raj: A Biography of Indian Nationalists Sarat and Subhas Chandra Bose* (Calcutta: Rupa, 1997 [1990]), 454–55.

[63] See *Nucleus and Nation* (2010), Chapter 4 "Imagining a Scientific State" and Chapter 6 "Indian Scientists Engage the Empire."

President of Congress) to have left India and made this dramatic and decisive move.[64] Frustrated with German reluctance to get seriously involved in the overthrow of the British in India, Subhas Bose maneuvered in Berlin in January 1943, (eighteen months after his arrival) to persuade the Germans to enable him to meet the Japanese high command. He achieved this a month later via a long and difficult journey in a U-Boat.[65]

Soon after Bose's disappearance from Calcutta in January 1941, Saha therefore had to rewrite his relationships with the Congress movement and its leaders. This re-thinking was forced on him a year later when the Japanese Army was advancing through Burma. Years later Saha wrote to Nehru about their entire working relationship going back to 1936.[66] He reminded Nehru that in 1942 just after Nehru was again sent to prison (along with all the other Congress leaders), Saha named him to be the chairman of the next Science Congress meeting in January 1943; he also reminded Nehru that "most of the prominent men of science in India today, except the Calcutta men, thought that discretion was the better part of valor. Raman, Bhatnagar, Bhabha, Krishnan, etc. all found one excuse or another to keep away" but Saha reminded Nehru that he had put Nehru's picture on the Science Congress presidential table in January 1943 to "demonstrate to the world that we scientists were solidly behind our national leaders in their great struggle."[67] This rewriting of their relationship occurred more than once in their futures, both of them poking at each other (even in Parliament in the 1950s) and then each going home troubled.

Saha began raising money from big industrialists through Nehru in 1941, trying to get his cyclotron working, despite damage to it by a Japanese torpedo in early 1942. His world both closed and

[64] Zachariah, "Indian Political Activities in Germany, 1919–1945."

[65] Gordon, *Brothers against the Raj*, 489–90.

[66] *Nucleus and Nation* (2010), Chapter 13 "A Scientist in the Political System."

[67] M.N. Saha to J. Nehru, December 31, 1954, Saha papers, Saha Institute Archives. However, one is not surprised that people from other parts of India were reluctant to travel to Calcutta; although the evidence of the famous 1943 famine was still two months away, in January the city was threatened with bombing from Japanese airbases in Burma, and train travel was difficult throughout India due to troop movements. But Saha's claim to Nehru was about loyalty not about practical travel arrangements.

internationalized rapidly during the war. He could not travel outside India (not until invited to Britain in 1944, after the Normandy invasion). He was ready to welcome the U.S. Army Corps of Engineers to the Damodar River project which he was helping to plan in 1943; they were already in that part of the world to map it inch by inch and plan a reinvasion of Burma and China. By 1942, working and moving around in Bengal, Saha would have found U.S. troops everywhere, watched carefully by the British administration in an area described by the Calcutta U.S. Consul General in 1943 as "a police state."[68] He was, after the war, very critical of American oil exploration geologists in the mouths of the Ganges River, while also welcoming German experts on steel manufacture and fertilizer/heavy water production.[69]

In 1942, the movements Saha supported were in pieces, there were anti-fascist strains, and anti-imperialist strains, anti-violence strains and anti-capitalist strains; the communists were "un-banned" and relatively "free" because (being aligned with and guided by the U.S.S.R.) they were now allies of Britain against Germany. The Americans were now "in" the war but disagreed with continuing it to restore Britain's imperial interests or colonial structures like India (the surface of almost one-half of which was not really "British" but princely). Saha's hero, Subhas Bose, was not only out of Congress but also "out" of India, and "standing on the trapdoor of history." Saha's other link to power was Nehru, who was now inaccessible in prison. Saha's native place, East Bengal—one of the most neglected areas of British India—was in the eye of a threatening army.

Conclusions

Through this complex and layered overview of the intersection of the role of scientists and science in politics, and the politics of scientists and science on the local, national, and international level, we can begin to uncover the many faces and wide ranging influence of Meghnad Saha.

[68] Richard Aldrich, "Britain's Secret Intelligence Service during the Second World War," *Modern Asian Studies*, 32 (1998): 179–217, see also *Nucleus and Nation*, 108.

[69] *Nucleus and Nation*, Chapter 13.

From his teenage years Saha revealed himself as versatile and increasingly adept at handling contradictions and conflicts—for example, involving himself with revolutionaries on the eve of an exam in which if he performed well he could expect to work in government civil service. (He was, however, barred, at age 22,[70] from writing that exam because of his political activities which were under surveillance, but we do not know if the application was made before or after the attempt to receive smuggled guns in the Sunderbans in June 1915). This handling and balancing, sometimes successful and other times blocked, showed up particularly when the international context was favorable to his kind of risk-taking activism. Saha's internationalism was relatively uncomplicated when he wrote his crucial scientific articles around 1919–22; that first episode was a demonstration of the structural requirement of Indian scientists to not only prove their merit but then also work harder to secure recognition from established competitors in distant and elite (i.e., monarchical) institutions such as the Royal Society and its supporting universities. The international reception of his work was rapid and positive. Ten years later, by the late 1920s, he was receiving international recognition and was voted in as a Fellow of the Royal Society by competitor colleagues who gradually concluded that Saha indeed made a break-through with his idea about selective ionization of the solar corona. Was his scientific internationalism just a familiar kind of "Eurocentricism" in a renewed form? No, it was not, but most of the people researching in his new field (later called astrophysics) in the 1920s lived and work in Europe (including the U.S.S.R.), or in North America. He was at the same time completely dedicated to strengthening the scientific community *in* India, and he was not attempting, through his research efforts, to depart from the country. This was the same time-frame in which Saha cooperated optimistically with parts of an international political movement which was seldom legal and thus mostly underground, and was prepared to use stealth and force. This was the beginning of the high season in India of a publicly disobedient and provocatively nonviolent mode of political action, but following advice from others about scientists staying in their labs, Saha did not go to prison. Although he was almost excluded from certain international scientific circles because of these political

[70] Saha Biography, 7; *Nucleus and Nation*, 28.

commitments and, although some Indian scientists who respected his reputation were fearful of the implications or consequences of Saha's commitments, he persisted.

Like many other Indians in different professional fields, he lived patiently (and impatiently) through a contradiction in which his international journeys and research (e.g., Harvard in 1937) kept refueling his local prestige, yet also had the effect of removing him from local action. When his patience wore thin with the methods and approaches of those who were willing to wait and bargain for independence in the late 1930s, Saha became convinced that he had to translate his international credentials into an instrument to help transform India and build a strong state, and to engage in direct communication with the educated public. He backed Subhas Bose, possibly because he viewed him as *the* leader who would create the socioeconomic environment in which a scientist like Saha could be powerful and effective. In effect he decided to become a "political scientist" (in contrast with his old classmate and friend physicist Satyen Bose, and in great contrast with his rival C.V. Raman). He felt driven to oppose the interests of some wealthy and influential individuals, familiar to him through his national planning work and from whom he desperately needed support for his research in the 1940s. He even quarreled with the one man who was becoming a kind of patron for him, namely Jawaharlal Nehru. Thus he was constantly learning how to make compromises, including seeking and accepting significant funds from two major industrial groups (Tatas and Birlas) which were already profiting economically from the unsatisfactory colonial structures which surrounded him. In fact he had begun as a "simple" internationalist in the 1920s, and by the 1940s had become a key international communicative intermediary for Indian scientists and their institutions, in relation to France, the Soviet Union, and the United States—all without neglecting what he knew really well, namely the British scientific community. But "what is to come" is another story. This story is about how his "politics in science" face flourished along with his "science in politics" face.

About the Editors and Contributors

Editors

Ali Raza received his DPhil from Oxford University and is currently a Research Fellow at the Zentrum Moderner Orient, Berlin. His research centers on the history of leftist movements in undivided Punjab and in the states of India and Pakistan, and on their crossovers and interconnections with other intellectual and political ideas.

Franziska Roy is currently a Research Fellow at the Zentrum Moderner Orient. She studied law, philosophy, and history at Humboldt University of Berlin, completed her MA from the School of Oriental and African Studies (SOAS), London, and received her PhD from Warwick University. Her publications include the edited volume *When the War Began, We Heard of Several Kings* (2011) on South Asian prisoners of war during the Great War, and she has also published on aspects of the global entanglements of South Asia(ns) in the twentieth century.

Benjamin Zachariah is a Research Fellow at the Karl Jaspers Centre for Advanced Transcultural Studies at Heidelberg University. He studied history at Presidency College, Calcutta, and at Trinity College, Cambridge, and is the author of *Nehru* (2004), *Developing India: An Intellectual and Social History, c. 1930–1950* (2005; 2nd edn 2012), and *Playing the Nation Game: The Ambiguities of Nationalism in India* (2011). His current research projects concern Indian exiles in Germany, the global communist movement, and interactions and interconnections among fascists in the interwar period.

Contributors

Robert S. Anderson is Professor of Communication at the Simon Fraser University in Vancouver. He has been studying the social history of the sciences and technologies in India since 1965, and is most recently the author of *Nucleus and Nation: Scientists, International Networks, and Power in India* (2010).

Ana Jelnikar is currently affiliated to the Research Centre of University of Primorska in Slovenia. She received her PhD at SOAS, University of London. In 2012–13, she was the Indian Council for Cultural Relations Fellow at Presidency University, Calcutta. Jelnikar is the translator of the first Slovenian edition of Carl Gustav Jung's *Man and His Symbols*, as well as eight collections of Slovenian poetry. Her recent publications include *Look Back, Look Ahead: Selected Poems of Srečko Kosovel* (co-translated with Barbara Siegel Carlson, 2010) and Meta Kušar's poetry collection *Ljubljana* (co-translated with Stephen Watts, 2010). Jelnikar is the cofounder of the annual *Golden Boat International Poetry Translation Workshop* in Slovenia, which she helped run between 2003 and 2009.

Michele L. Louro is an Assistant Professor of History at Salem State University. She completed her PhD in History from Temple University, Pennsylvania. Her research focuses on twentieth-century South Asia with interests in the intersections between Indian nationalism and internationalism. Her current book project, *Comrades against Imperialism,* situates the anticolonial nationalist politics of Jawaharlal Nehru in relation to the international anti-imperialist mobilizations and networks of the late colonial and interwar period. Research for this project has been funded by the U.S. Fulbright and the Center for the Study of Force and Diplomacy (CENFAD). She has been published in *Comparative Studies of South Asia, Africa and the Middle East* (2013) and *Third Frame: Literature, Culture and Society* (2009).

Maia Ramnath is currently Associate Professor of History and Asian Studies at Pennsylvania State University. From 2008 to 2012 she was Assistant Professor/Faculty Fellow for Global Histories in the Draper

Interdisciplinary Humanities and Social Thought program at New York University. She is the author of *Haj to Utopia: How the Ghadar Movement Charted Global Radicalism and Attempted to Overthrow the British Empire* (2011) and *Decolonizing Anarchism: An Antiauthoritarian History of India's Liberation Struggle* (2012).

Carolien Stolte is university lecturer in Colonial and Global History at Leiden University. She studied History and South Asian Studies at Leiden, the École des hautes études en sciences sociales in Paris, and the Graduate Institute of International Studies in Geneva, and received her PhD from Leiden University. Her research focuses on South Asian intellectual history from a transregional perspective. She is currently interested in histories of internationalism and regionalism during decolonization. In addition, she is managing editor of the journal *Itinerario*.

Index

Acharya, M.P. Tirumal, 16, 64, 66, 67
Afghanistan, 12, 17, 63, 98, 180, 257
agrarian agitation, 118
agrarian societies, 246
agriculture, 51, 254
Ahmad (Ahmed), Muzaffar, 66, 70, 76, 78, 84
Ahmad, Rafiq, 67–68
Akali (Movement), 115–16, 118, 119
Allahabad, 238, 240, 241, 244, 245, 247, 248
All-India Congress Committee (AICC), 174
All-India Trade Union Congress (AITUC), xxxviii, 35, 44, 70, 74–82, 84
Amanullah Khan, Amir of Afghanistan, 17, 63, 98, 180
Anderson, Sir John, 249–50
Anusilan Samity, 237
arms and ammunition, 9, 93, 103, 108, 137, 185, 236, 258. *See also* guns
army: British Indian, 89, 92, 112, 138, 184; German army, 234, Japanese army, 258–59, Indian National Army (INA), 256
Aryan(ism), vii, 168, 177
Asiatic Labour Congress, 80–81
astrophysics, 231, 243, 261
avant-gardes, 194, 224
Azad, Maulana Abul Kalam, 238

Babbar Akali. *See* Akali movement
Baku, 61, 63, 69, 83, 84
Baku Congress, 64–66, 77
Baldwin, Roger, xxxvii, 33, 36–39, 48

Bande Mataram (journal), xxxviii, 124, 126, 128
Barkatullah, Mohamed, 61, 62, 65, 96, 105
Barthes, Roland, 7
Begriff(e) 6. *See also* concepts/terms
Begriffsgeschichte, 6
Benares Hindu University, 180, 181, 240
Bengal Engineering College, 233
Bengal, xiv, 15, 143, 152, 195, 232, 235, 236, 237, 238, 246–47, 253, 258, 260
Berlin India Committee, xvi, 96
Berlin, viii, 8, 9, 11, 12, 16, 28, 29, 30, 31, 33, 35–36, 37, 42, 43, 44, 47, 48, 71, 74, 76, 96, 104, 119, 230, 233–37, 238, 256, 259
Bhatnagar, Shanti (S.K.), 231, 234, 240, 258, 259
bilingual/multilingual, 5, 21, 208
Birlas, 262
Bohr, Niels, 241
Bolshevik Revolution/Russian Revolution/October Revolution, vii, xi, xvi-xvii, xxxv, xxxvii, 33, 43, 57, 62, 81, 87, 94, 95, 101, 104–5, 108, 119, 120, 223, 224–26
Bolshevik(s), Bolshevism, viii, xviii, xxxv, 61, 74, 94, 99, 224, 226
Bombay Plan, 247, 249
Bose, D.M., 232
Bose, Jagadish Chandra (J.C.), 239–40
Bose, Rashbehari (Rash Behari), 17, 64
Bose, Satyen(dranath) (S.N.), 231–32, 236, 255, 262

Bose, Subhas Chandra, 14, 247–53, 256–59, 262

Bose-Einstein statistics, 236, 244, 255

bosons, 255

brahmacharya, 156

Brest-Litovsk, xvii

Brussels Congress. *See* League against Imperialism

Bureau of Transport Workers for the Pacific, 79

Burma, 256, 258–59, 260

Calcutta, 17, 60, 126, 134, 146, 230, 232, 233, 236–38, 240, 247, 248, 256–60

Calcutta University, 13, 233, 235, 240, 247

Caltech, 241

Cambridge, 74, 233, 243, 244, 256

capital(ism), capitalist(s), 23, 32, 41, 45, 50–51, 64, 81, 151, 207, 223, 225–26, 227, 246

carriers of ideas, 2, 10

Casement, Roger, 141

censorship, 21, 237

Chanda, Anil K., 252

Chandrasekhar, S., 243, 244

Chattopadhyay(a), Viren(dranath) ("Chatto"), xvi, xxxix, 9, 12, 15, 20, 31, 44, 46, 65, 76, 83, 96, 105

chemical warfare, 234, 255

chemicals, chemistry, 240, 250, 254–55

Chiang Kai Shek, 173, 180

China, xxxiv, 4, 12, 18, 35, 41, 43, 50, 51, 53, 54, 69, 72–73, 75, 77–80, 107–8, 113, 114, 120, 163, 173, 197, 260

Chinese University for the Toilers of China (Sun Yat Sen University), 108

Churchill, Winston, 243

citizen(s), citizenship, xx, xl, 25, 30, 154, 163, 170–71, 179, 187

Civil Disobedience Movement, 13–14, 45, 257

class(es), xxvii, xxix, xxxvi, xxxvii, 5, 23, 32, 45, 56–58, 78, 79, 107, 111, 119, 122, 128, 129, 155, 172, 174, 175, 223, 224, 226

code-keeper, 236–37, 238, 242

Colombo, 16

colonial state, 10, 24, 40, 54, 111

Communist International of Youth, 108

Communist International/Comintern/ Third International, xxi, xxxiii, xxxviii, 29–30, 46–47, 61, 65, 70, 80, 94, 101, 105–112, 120, 225, 236

Communist Manifesto, 21

Communist Party of India, 64, 96, 238, 256

Communist Party of the Soviet Union (CPSU), 107–8

Communist Party of the USA, 102

Communist Party, Indonesian, 68

Communist Party, Mexico, 96, 237

Communist University of the Toilers of the East (KUTV) (Tashkent), 61, 67–69, 78, 84, 94, 107–8

communist(s), communism, xii, xxii, xxx, xxxiii–xxxviii, 4, 9, 22, 24, 27, 28–35, 39–40, 42–54, 61–62, 65, 71, 76, 83–84, 87–88, 94, 99–100, 101, 103, 109–112, 118, 152, 168, 169, 178, 236, 260

concepts/terms 6–7. *See also Begriff(e)*

Congress Working Committee (CWC), 31, 46, 170

Congress, Indian National, (INC) 23–24, 28, 31, 34–38, 41–42, 44–47, 51–52, 55, 110, 151–53, 155, 166, 172, 173, 253

Connolly, James, 141
cosmopolis, virtual, 192, 207
cosmopolitan(s), cosmopolitanism,
 xxi–xxvii, xxxi, 128–29, 139–41,
 147–48, 161–62, 194, 199, 200, 203,
 239
cottage industries, 249, 253. *See also*
 village economy
Cripps Mission, 258
cyclotron, 230, 253, 256, 258

Dacca (Dhaka), 232, 236, 237, 238, 247
Damodar River project, 260
dams, 251, 254
Dange, S.A., 65, 70, 75–76, 84
Datta, Bhupendranath, 9
Defence of India Act, 15
Depression. *See* Great Depression
Desh Bhagat Qaidi Parwar Sahaik
 Committee, 116, 119
Deshpande, S.V., 81
development, 249, 254, 258,
Dhanushkodi Port, 11, 15
dictator(ship), 43, 154, 180–81, 206,
 226; of the proletariat, 152
Dirac, Paul, 255
discipline, xxxix, 158, 166, 169–71,
 179–80, 186
Donnan, F.G., 234, 240
Dutta, B.K., 238
Dyson, F.W., 242

East Bengal, xl, 237, 248, 260
Economic Review of the Soviet Union
 (journal), 17
Eerde, 150
Eggert, John, 233–34
Einstein, Albert, 23, 230–34, 236
electricity, electrification, 247, 248,
 254. *See also* energy

elite(s)/nonelite, xix, xxix–xxx, 1, 3, 6,
 9–10, 20–21, 95, 102, 122, 191–92,
 258
Empire: Austro-Hungarian, 198, 199,
 203; British, xv, xviii–xix, 8, 9 13,
 42, 44, 49, 91, 95, 100, 104, 112–15,
 121–22, 128, 140, 161, 174, 234;
 Ottoman, xvi, 62
energy, 254; of youth, 157, 166, 179,
 182; libidinal energy, 125, 145–46
engineer(s), 11, 12, 15, 18, 235, 248,
 251, 260
eugenic(s), xxxix, 14–15, 21,153, 160,
 162, 187
European thought/civilization/ideas/
 tradition, 3, 28, 194, 207
Evershed, J., 242
exile, xiv, xxx, xxxv, 8–9, 12, 16–17, 29,
 30, 57, 61, 64, 66, 76, 80, 88, 105,
 128, 143, 205, 244

Fanon, Frantz, 221, 222, 224
fascism, fascist(s), xii, xxi, xxx, xxxii,
 xxxiv, xxxvi, 2–3, 9, 50–51, 118,
 122, 153, 164, 178, 181–83, 186,
 204, 208, 220, 255
Fimmen, Edo, 33, 37, 47, 75
First World War (Great War), xvi,
 xviii–xix, xxxiii, xxviii, 2, 8, 17, 30,
 36, 50, 97, 107, 112, 129, 151, 162–
 63, 165, 196, 200, 238
flood control, 247
Forward Bloc, 256
Foucault, Michel, xxxi, 7, 144
Fowler, Alfred, 241, 242
Fowler, R.H., 241, 244
Friedrich Wilhelm University (Berlin),
 234
Friends of Soviet Russia Society, 68

Gandhi vs Lenin, 84

Gandhi, Mohandas Karamchand, 3, 14, 16, 23, 102, 144–45, 180, 220, 238, 245, 248–50, 252–53, 256–57

Gandhian(s), Gandhism, 3, 14, 31, 148, 152, 150, 172, 175; Gandhian nonviolence, 185

Germany, xxviii, 8, 14, 30–31, 35, 87, 107, 151, 181–82, 232–42, 252, 254–58, 260

Ghadar (journal), 92, 141,

Ghadar Party, Ghadarite(s), xv–xvi, xxxviii, 8, 61, 92–96, 99, 102, 105–6, 111, 113–16, 118, 119, 125, 145

Ghate, S.V., 79, 84

Ghosh, Aurobindo, 14

Ghosh, Sailendranath, 15, 237

Gide, André, 191

global history, xxii, xxv

Great Depression, xxviii, xxxiv, 51, 165, 246

Great War. *See* First World War

Greater East Asia, 18

Greater India Society, 57, 72

Guha, Ranajit, 3, 10

guns, 108, 236, 261. *See also* arms and ammunition

Gupta, Manmathnath, 145

Gupta, Monoranjan, 13–15

Gupta, Nalini, 70, 236–38

Gupta, Shiva Prasad, 47

gymnasium, 14. *See also* physical fitness, physical culture

Haber, Fritz, 234

Hamburg, 106

Hamburg Zoo, 9

Hankou/Hankow, xxxvii, 75, 79, 83, 113

Har Dayal, xvi, 8–9, 92, 132, 144

Harbin, 19

Hardikar, Narayan Subbarao, 166, 172–73, 179, 180, 183, 185

Hijrat Movement, xvii, 62, 97, 99, 105, 118

Hindu Mahasabha, 155, 181

Hindustan Association, Berlin, 12

Hindustan Ghadar Dhandora (journal), 113

Hindustan Socialist Republican Army (HSRA), 122, 149

Hindustani Seva Dal (HSD), xxxix, 153, 156–57, 166, 169–70, 172–74, 177, 183, 185

history of ideas, xxiv, 2, 15, 20

Hitler State, xxxiii–xxxiv

Hitler, Adolf, xxxiv, 30, 52, 171, 180, 182, 258

hydro-electrical power, 251

idioms, 4, 85, 118, 211, 212

impact-response theory, 4

India House, xvi, 8, 67, 96, 127

Indian Revolutionary Association, 64–65

Indian Science News Association, 249

Indian Sociologist (journal), xvi, 96

Industrial Workers of the World (IWW) ("Wobblies"), 95

industrialisation, industrial(ism), 45, 51, 82, 97, 142, 175, 192, 230, 235, 246, 248–51, 253, 254, 258

industrialists, 246–47, 249, 253–54, 259

intellectual history, intellectual histories, xxiv, xxxvi–xxxvii, 1–2, 7, 15, 20

intelligence (agencies), 10, 17, 68, 70, 74, 103, 106, 109, 120, 166–67, 239, 241–42

intention(ality), 5, 6, 59
intermediate histories, xxix–xxxi, 1, 7, 15
International Federation of Trade Unions (IFTU), 33–34, 58, 77, 80, 82
ionization, 233, 234, 243, 261
iron and steel, 251
irredentism, Italian, 205
Italy, 181–83, 198, 203–5

Japan, xxxiv, 17–19, 21, 32, 35, 41, 64, 68, 78, 107, 128, 175, 197, 256–59
Jeans, James, 241–42
Jinnah, Muhammad Ali, 234
Joglekar, K.N., 75, 78, 84
Joyce, James, 201–2, 205
Jugantar, 236–38, 242

Kabul, 59, 96, 104, 257
Katju, K.N., 250–51
khadi, khaddar, 16, 148, 249
Khaksar(s), xxxix, 122, 155, 165, 169, 171
Khan, "Dada" Amir Haider, 101
Khilafat Movement, xvi, xxxv, 62, 97, 238
Khudai Khidmatgar (Red Shirts), 155, 167
Kirti (journal), 86, 88, 94, 116–18
Kirti Kisan Party (KKP), 86, 94, 115–16, 118–20
Komagata Maru, 90
Koselleck, Reinhart, 6
Kosovel, Srečko, xxxix–xl, 189, 191–227
Kranti (journal), 87
Krestintern (Peasants International), 108
Kripalani, Krishna, 253

Krishnamurti, Jidu, 150–51
Krishnavarma, Shyamji, xv–xvi, 8, 96, 127
Kyoto, 18

laboratories, 21, 154, 234, 253–54
laboratory state, 254, 256
language game, 4
lascar(s), xix, xxxviii, 100–102, 105–6
League Against Imperialism (LAI), xxxiii, xxxvii, 23–42, 44–47, 49–50, 52, 55, 60, 71, 74, 76, 80, 81, 83–84, 120
League of Nations, xxxiii, 26, 30, 58, 150–51, 204
legitimation, xxxviii, 5, 110,
Lenin University for Marxian and Leninist Studies (Moscow), 67–68, 110
Lenin, Vladimir, 43, 46, 51, 64, 69, 105, 108, 152, 180, 225
Leninist, xvii, 69, 110
Lindemann, F.A., 242–44
linguistic innovations, 5
Ljubljana, 191, 200–202, 205, 207, 212
London Treaty, 203
London, xvi, 8, 11, 29, 31, 41, 52, 74, 96, 127–28, 132, 230, 233–35, 236, 239–41, 244

Madras, 11, 15, 167
Majid, Abdul, 62
Malaviya, Madan Mohan, xxxv
Malthus, Malthusian(ism), 159, 162
Manchester, 16
Manchukuo, Manchuria, 18–19, 83, 180
Marxist(s), Marxism, 69, 94, 108, 110, 205, 215, 223–25
masculinity, 161. See also virility

Mashriqi, Allama (Inayatullah Khan), 171, 173
Matthai, John, 249
Meerut Conspiracy Case, xxxvi, 76, 83
Mein Kampf, 21
metropole, metropolis, 4, 31, 41, 74, 128, 142, 155, 161, 192
militia, 18385. *See also* paramilitary organization
Millikan, Robert, 241
Milne, E.A., 243, 244
Minkowski, Hermann, 232
mixed economy, 249
modernism, 158, 194
modernity, 142, 157, 180, 190, 192, 214, 218, 227
Moscow, xxxvii, 33, 41, 43, 47, 59, 61, 66–70, 82, 94, 99, 102, 104–6, 108–112, 115, 117, 236, 248, 257
muhajir(s), xxxviii, 63, 66, 84, 98–100
Mukherjee, Abani, 64, 66, 84
Mukherjee, Jatin ("Bagha Jatin"), 236–37
Mukherji, Asutosh, 235
Munich, 14, 182–83
Munich Pact, xxxv
Muscular Christianity, 161
Muslim National Guards, 155, 169
Mussolini, Benito, xxxiv, 52, 152–53, 180–82

Naidu, Sarojini, 31, 96, 133, 184–85
Nair, A.M., 18
nama-sudra, 245
Nambiar, A.C.N., 9
National Academy of Sciences (Allahabad), 248
National Planning Committee (NPC), 245, 248, 251–52, 254, 256, 258; Power and Fuel Sub-Committee,

NPC 252; River Transport and Irrigation Sub-Committee, NPC, 252.
nation-building, 155, 172
Nazi(s)(m), National Socialism, National Socialist(s), xxxiv, 2, 9, 14, 21, 29–30, 257–58
Nazi-Soviet Pact, xxxv
Nehru, Jawaharlal, xxxv–xxxvii, 20, 23–25, 27–55, 75–76, 111, 164, 168, 170, 173, 185, 244–45, 258, 250, 252–55, 259–60, 262
Nehru, Motilal, 184
Nernst, Walther, 234
New Deal, 246
New Forward (journal), 17
Nietzsche, Nietzschean, 159–60
Nobel Prize for Chemistry, 234
Non-Cooperation Movement, xxxv, 97, 220
North Western Frontier Province (NWFP), 97, 155, 167
nuclear institute, 230

O'Seasnain, Brian Padraic, xxxix, 124, 126–27, 133, 136, 138–42, 144, 146–47, 149
Obeidullah Sindhi. *See* Sindhi, Maulvi Obeidullah
October Revolution. *See* Bolshevik Revolution
Orientalism, 139, 141–42, 147, 197
Osaka, 18
Outer Mongolia, 19
Oxford, 68, 74, 180, 242, 243

pacifist, pacifism, xiv, 12, 32, 160
pan-Asianism, xxxvi, 16, 18–19, 64, 68, 71–72
Pan-Asiatic League, 17, 71, 120

Pan-Islamic, Pan-Islamism, xii, xvi
Pan-Pacific Labour Congress, 79
Pan-Pacific Trade Union Secretariat (PPTUS), xxxvii, 60, 66, 71, 75, 77–84
Pan-Pacific Worker (journal), 81
paramilitary organization, 153–54, 165. *See also* militia
Paris, xxxviii, 8, 31, 33, 35, 36, 38, 43, 74, 87, 96, 104, 124, 126, 127, 128, 143, 235
Peshawar Conspiracy Case, 62
physical culture, 156, 170, 172, 175, 187
physical fitness, 15, 154, 175
physics, 62, 230, 235–36, 239, 242, 247, 256, 258
Planck, Max, 234
Pocock, J.G.A., 5
police state, 260
police, xxii, xx, 10, 11, 13, 19, 59, 72, 89, 102, 112–13, 120, 128, 165, 171, 204, 216, 237, 257
Pondicherry, 14
Portsmouth, 247
Pound, Ezra, 191
Pratap, Raja Mahendra, 12, 16–20, 96, 113
Presidency College (Calcutta), 256
Principles of Relativity, 232
Profintern, 60, 65, 71, 75, 77–80, 82–83, 108, 278
Propaganda, 16, 41, 44, 45, 67, 69, 70, 103, 108, 116–17, 120
Punjab(i), xxxviii, 86, 88–90, 92–94, 97, 101–2, 106, 111, 112, 115, 117–23, 129, 167, 179
Puntambekar, S.V., 180

Rab, Abdur, 63–65
race, racial, xxxi, xxxvii, 14, 15, 21, 23, 36, 58, 90–91, 99, 101, 129, 132, 142, 177, 184, 201, 202, 203, 205, 208, 210, 217, 222
Radical Democratic Party, 256
Rai, Lajpat, xxxv, 179
Raman, C.V., 231, 239–41, 259, 262
Rashtriya Swayam Sevak Sangh (RSS), xxxix, 122, 154, 165, 167, 171–72
Ray, Prafulla Chandra (P.C.), 240, 250
Red Army, 67, 108
Red International of Trade Unions. See Profintern
Rockefeller Foundation, 241
Roy, M.N., 65–67, 99–100, 105, 236–37, 256
Roy, T.K., 11
Roy, Taraknath, 11
Royal Society (London), xl, 230, 239–44, 255, 261
Russell, Henry, 235, 241
Russia. *See* USSR, Soviet Russia, Soviet Union, Russia
Rutgers, S.J., 65
Ryan, Frank, 141
Ryan, John, 80, 84

Sacco and Vanzetti, 39, 86–87, 123
Saha Equation, 236
Saha, Meghnad, xl, 175, 229–62
Sahai, Raghupati, 174, 177
San Francisco Conspiracy Case, 93
Santiniketan, 252, 253
Sanyal, Nalinaksha, 151–53, 164–65
Saraswati Press, Calcutta, 13
Saussure, Ferdinand de, 6
Savarkar, Vinayak Damodar, 8
Science and Culture (journal), 175, 248, 249, 252, 254, 258
Second International, xv, 77
Second World War xi, xli, 9, 53, 111, 167, 171, 224
self-defense, 170, 183–84

semantic range, 5, 7
semiology, semiological, 7
Sen, Satyendra Bimal, 15
Seva Dal. *See* Hindustani Seva Dal
Shafiq, Muhammad, 62
Shah, Akbar, 63
Shah, Masood Ali, 63, 66, 68, 84
Shaha, A.K., 247, 248
Sheffield University, 11
Sindhi, Maulvi Obeidullah, 59, 96
Singh, Dasaundha, 113
Singh, Santokh, 92–95
Sinha, Bejoy Kumar, 105
Sino-Japanese War, 84
Skinner, Quentin, 5, 6
Slavs, 203, 208, 210; Balkan Slavs, 209,
 210
Slovenes, 199, 201–5, 208, 211, 220
Smedley, Agnes, xxxix, 129, 173
Social Darwinism, 153, 159, 162. *See
 also* struggle for existence
social history, social histories, xxxvi, 1,
 2, 20, 162
socialist(s), socialism, xii, xiv, xxi,
 xxxiii, xxxvi, xl, 22, 24, 32, 34, 35,
 41, 44–46, 49, 51, 61, 95, 100, 107,
 121, 127, 128, 141, 164, 168, 175,
 205, 229
Sokols, Sokol Movement, 173
Sommerfeld, Arnold, 234, 252
South-Slavic Kingdom of Serbs, Croats
 and Slovenes, 203
Spencer, Herbert, xvi, 159
spiritual Darwinism, 160
Sportintern (Sport International), 108
Spratt, Philip, 103
Stakhanov, 248
Stalin, Josef, 43, 46, 51, 52, 54, 69, 77,
 248
Stalinist, Stalinized, Stalinization, xxxiii,
 xxxvi, 4, 9, 111,

stellar spectral sequence, 243
struggle for existence, 162, 175
subaltern, xxix, 2–3, 25, 104, 122, 140,
 190
Sun Yat-Sen, 152, 173, 180
Switzerland, 8, 31, 37, 242
synchronic/diachronic, 6

Tagore, Rabindranath, xl, 57, 129, 142,
 189–99, 201, 207–8, 210–19, 222–
 24, 226, 234, 252–53
Tagore, Soumyendranath, 9
Tashkent, xxxvii, 59–62, 64–67, 69, 99,
 104
Tatas, 262
teleology, teleological, 2, 4
Tennessee Valley Authority (TVA),
 247
terrorist(s), terrorism, xiv, 8, 13, 14,
 122
Thengdi, D.R., 75, 78–79, 84
Third International. See Comintern
Third Period/Popular Front, xxxiv, 60,
 82–83, 224
Tirumal Acharya, M.P. *See* Acharya,
 MP Tirumal
Totalitarianism, xxxiv
translation (conceptual), 5–7, 21, 146
translocal, xxv
transnational, xxi, xxii, xxiv, xxv, xxxi,
 25, 117, 121, 125, 216
Trieste, 199–205, 207, 209–10, 212, 220
Trotsky, Leon, 68, 78

Ukil, Dr M, 13–15
United States of America (USA), xv,
 xxv, xxx, 8, 32, 35–37, 39, 50, 53,
 87, 90, 92–93, 101, 102, 107, 113,
 141, 147, 179, 183, 247, 254, 262
universal(ism), universalist, xxxi, 114,
 119, 121, 162, 194–95, 213, 221–23

University of London, 233–34, 240
US Army Corps of Engineers, 260
Usmani, Shaukat, 67, 68, 70, 84, 98–99
USSR, Soviet Russia, Soviet Union, Russia, xxx, xxxiii-xxxv, 17, 19, 32, 42–43, 50, 56, 59, 61–62, 80, 82–85, 94, 96, 98–99, 102–3, 106–8, 110, 168, 226, 246, 262

Victorian values, 161, 167
Vienna, 201, 232
village economy, 246. *See also* cottage industries
virility, 145, 157. *See also* masculinity
Visvesvaraya, Mokshagundam, 251
Vivekananda, Swami, xv, xxxiv
volunteer(s), xxxix, 154, 156, 158, 165–70, 179, 184–85, 187
Volunteer, The (journal), 172–75, 180

Walker, Gilbert, 241, 242, 244
Weimar (Republic), 8, 30

Whang, Kungshu, 17
White Russians, 19
Wilsonian, xvii, xviii; Wilsonian internationalism, 57
Workers and Peasants Party, 71, 78, 237. *See also* Kirti Kisan Party
World Youth Peace Congress (WYPC), 150, 151
World Youth Tour, 163

Yang Chin-tsang, 18
Yeats, W.B., 134, 141–43, 191
Young Men's Christian Association (YMCA), 181
Youth, 97, 99, 137, 150, 151, 155–58, 163–66, 169–70, 179, 181–82; youth corps 153; youth movement 152, 154, 160, 164, 165, 169, 175, 185–87
Yugoslavia, 191, 203, 205–6
Zamindar (journal), 62
zeitgeist, 15, 20, 122, 161, 186
Zeitschrift für Physik, 235